TULIPA

A Photographer's Botanical

CHRISTOPHER BAKER

TEXT BY WILLEM LEMMERS
AND EMMA SWEENEY
ESSAY BY MICHAEL POLLAN

To Hannah, who began her life among 1000 tulips

I wish to thank the following people:

Wim Lemmers, my guide and teacher of all things "Tulip," for the many cold mornings in the fields

The growers in the Netherlands, who supported this project with an endless supply of perfect tulips and a wealth of knowledge

Peter Workman, for looking at these photographs and having the vision to see a book

Ann Bramson and Amy Gash, for their patience, and for making the book an actuality

Emma Sweeney, for putting into words the meaning this work has for me and Wim

Mary Shanahan, for being "Mary," and for her inimitable, elegant eye

Gregory Wakabayashi, for sharing his aesthetic knowledge

Odette, my wife, my love, for everything

—CHRISTOPHER BAKER

CONTENTS

ACKNOWLEDGMENTS 5

PHOTOGRAPHING TULIPS 9
Christopher Baker

THE TULIP AND ITS TRESPASSES 17
Michael Pollan

A GROWER'S PERSPECTIVE 23
Willem Lemmers

ANATOMY OF A TULIP 31

THE PLATES

EARLY FLOWERING
PLATES 1–33

MID-SEASON FLOWERING
PLATES 34–78

LATE FLOWERING
PLATES 79–137

THE STORIES

CLASSIFYING TULIPS 186

EARLY-FLOWERING TULIPS
Early-Flowering Species 188
Kaufmanniana Group 194
Fosteriana Group 200
Single Early Group 204
Double Early Group 208

MID-SEASON FLOWERING TULIPS
Mid-Season Flowering Species 214
Darwinhybrid Group 216
Triumph Group 222
Greigii Group 248

LATE-FLOWERING TULIPS
Lily-flowered Group 258
Parrot Group 262
Fringed Group 268
Single Late Group 274
Double Late Group 284
Late-Flowering Species 288
Viridiflora Group 292

NEW INTRODUCTIONS 296

MUTATION-RELATED TULIPS 298

LIST OF 500 TULIPS 302

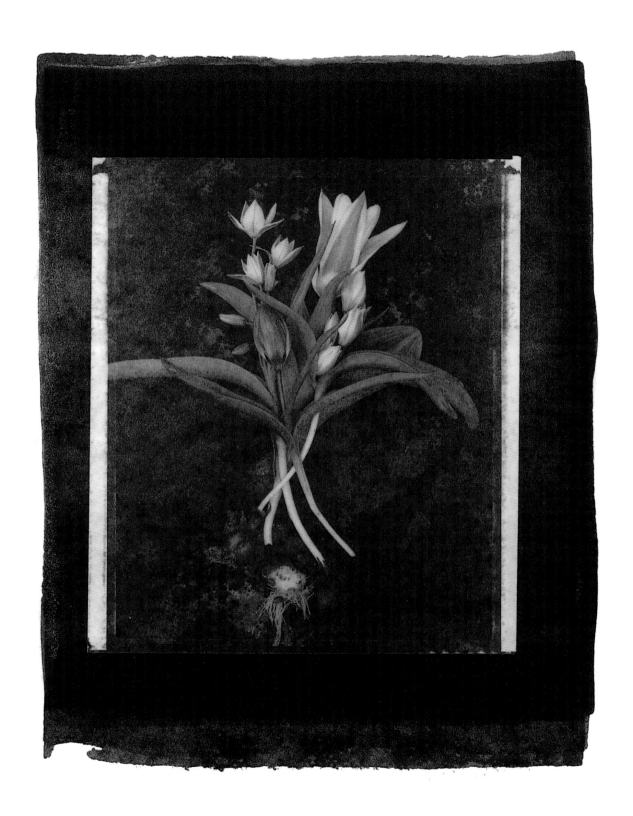

Tulips in the fields of Holland

PHOTOGRAPHING TULIPS
Christopher Baker

SOMETIMES, ON A WARM NIGHT, when the stillness is broken by a breeze that brings up the smells of wet earth and new growth, I am reminded of my days in Amsterdam and my garden of tulips. There is one night in particular that comes to mind: It was toward the end of the tulip season, and for weeks I had been photographing almost every hour that there was light, trying to keep up with an early spring. Our terrace had taken on a surreal quality, blooming from one end to the other with hundreds of perfect tulips. A friend observed that it looked like the garden of an obsessed collector. The flowers stood on tables in glass jars, in wooden crates wrapped in newspaper to hold the stems perfectly straight. There were potted plants fresh from the greenhouses, and tulips taken just hours before from the fields, soft earth still clinging to the roots. This garden that celebrated a passion for a single flower spilled over from the terrace and into our apartment. It wound a path down the long hallway where flowers cooled for photography. The path continued through the living room, ending in a long line of tulips in glass beakers on the windowsill. Below them flowed the Prinsengracht Canal.

Amid the frenzy of blooming tulips that last week of April, my daughter, Hannah, was born, and this night I remember so well was the twilight of her first day. In a state somewhere between exhaustion and exhilaration, I lay among the tulips on the terrace stones, staring up into the dark blue of the night sky. It was Queen's Day in the Netherlands, and the sounds of celebration continued well into the morning hours. I fell asleep watching the clouds coming quickly off the ocean, casting strange shadows on my tulips as they went. That night I dreamed of an impossible garden where black tulips, tulips with a hundred petals, species tulips three feet tall all flourished. In my dream I heard them growing in the night.

I did not come to the tulip by way of a garden. It was the great illustrated botanicals of the late eighteenth century that drew me to this flower. Before choosing photography as a career, I had studied to be a

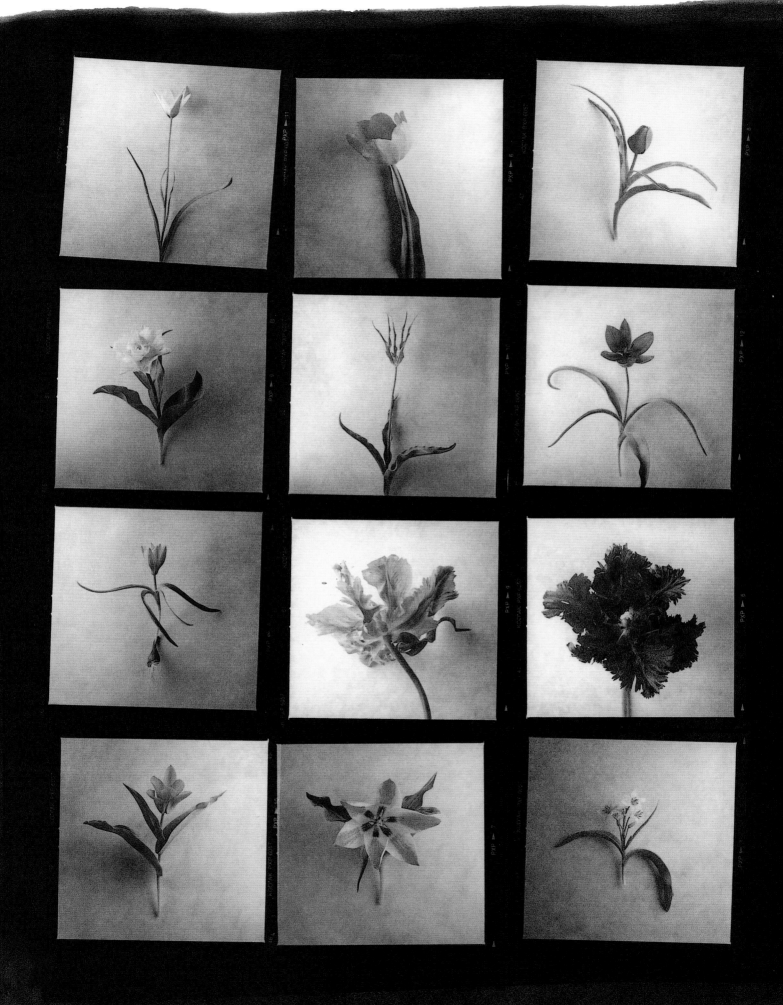

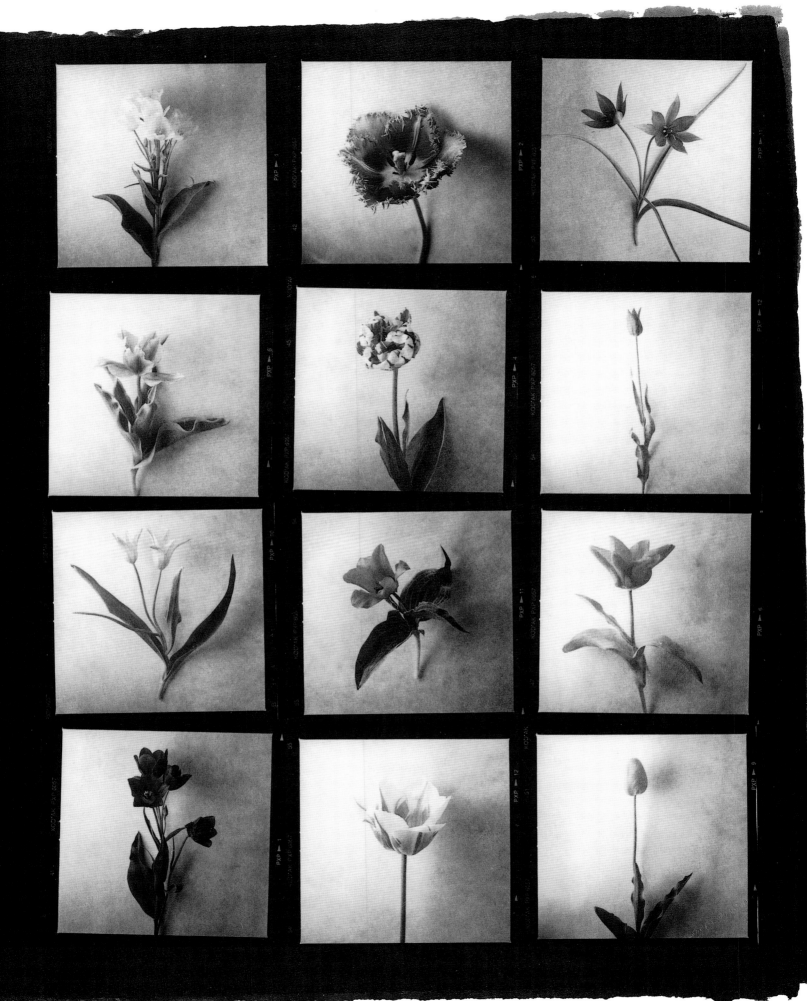

botanist, and I referred to these books often. Illustrators such as Nikolaus Joseph Jacquin *(Selectarum Stirpium Americanarum Historia)* and Giorgio Gallesio *(Pomona Italiana)* composed their work with such perfection, they inspired me to attempt a serious botanical work illustrated with photography.

Late one spring, on a whim, my wife and I took a train to Amsterdam from our home in Paris. We had a yearning to see tulips and visit the Keukenhof Garden. Once there, again on a whim, we changed our plans and made our way to the smaller Leiden Botanical Gardens, driving through fields of incredible color to view the collection of species tulips. It was at Leiden that I first saw *Tulipa sylvestris,* which comes out of the ground with its bud to one side, bent like a horse's head in a medieval woodcut. Planted en masse in a field of long grass and flowering apple trees, as they were in Leiden, these tulips appeared like a herd of small yellow horses rising out of the moss and grass. It is still one of my favorite tulips. That morning, I saw the possibilities of the tulip as a subject for a photographic botanical. We made plans to move to Amsterdam in the fall.

I spent the following months in plant libraries and horticultural centers in Europe, researching the botanical history of the plant. In my reading I also discovered the dark character the tulip plays in a bizarre social history. It is not a romantic flower like the rose. The tulip struck a more dramatic figure at its social prime, becoming the object of obsessive collecting in western Europe. In the Netherlands, I contacted botanists and growers, as well as experts with scholarly knowledge of the tulip. Many of these people directed me to a man named Wim Lemmers as the one I should consult with on a definitive tulip botanical. When I finally met him, it was obvious to me at once that Wim was the perfectionist I wanted to collaborate with on this project.

Wim grew up with the art of cultivating tulips. It has been a part of his family history for generations. His knowledge is so immediate that if you hand him a tulip—any tulip—he can outline its history and provenance, merits and faults, without a moment's hesitation. It took some convincing, however, to persuade Wim that this project was the one for him. He wasn't sure that it was even attainable. I think this was because

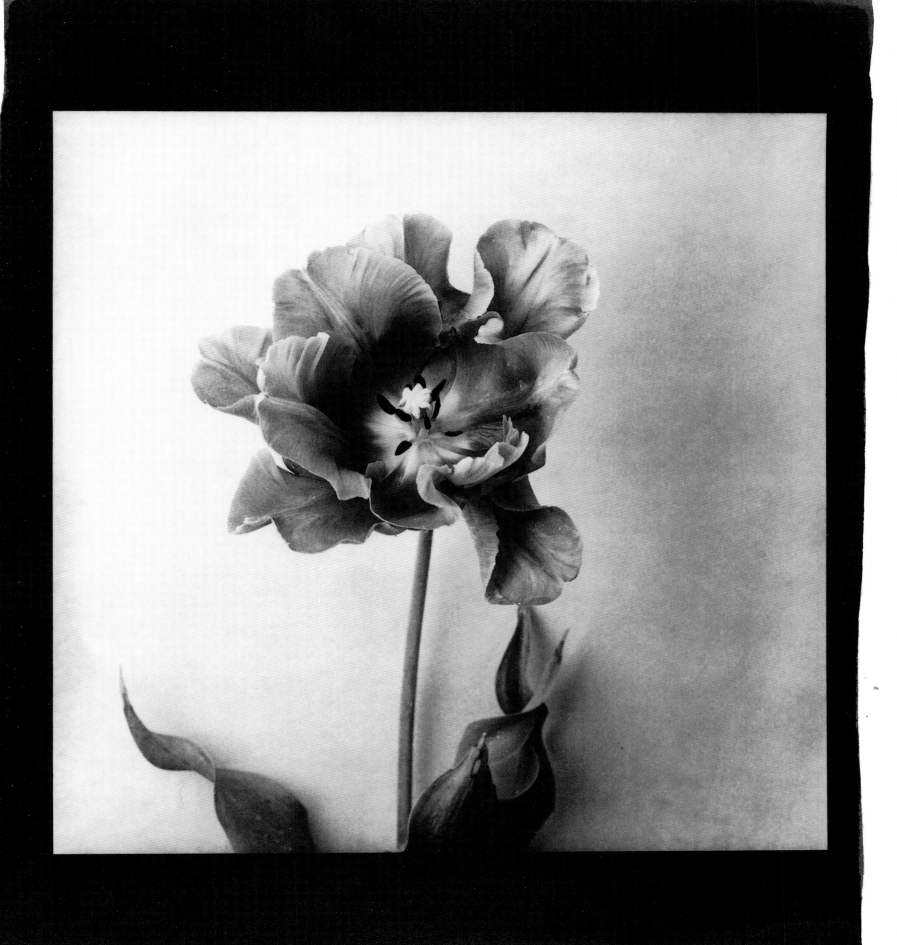

he knew, far better than I, the full scope of what we would have to record. When he finally agreed, he opened the door for all of us to the private world of tulip growers. As in the early botanicals, our aim was to produce a true and full representation of a plant family, for growers and gardeners all over the world.

During the months of January and February, we traveled up and down the countryside, visiting greenhouses. There, we met with the growers of forced tulips, produced for the great tulip exhibitions in the Netherlands. Wim began the selection process, finding faultless examples of each type of tulip for me to photograph. I began bringing the groups of potted plants back to our terrace, and our garden began. My wife observed the flats of tulips being brought in more and more frequently, and listened to me talk my tulip talk. She told me I had joined the Cult of the Tulip.

In the half-light of a morning in early March, Wim and I drove to a field of frosty ground. I followed him as his eyes scanned the earth, and then as he made his way to the center of the field. There it was: the first tulip, which had, against all reason, pushed its way into the cold air and weak light and bloomed. As the season progressed, each day brought a parade of tulips. Everywhere we went, they surrounded us: Fields became blocks of solid color; gardens bloomed quietly in half-hidden courtyards; tulips mingled in window boxes and decorated the houseboats. They were sold canalside from long barges, and they rode around the city in wicker bike baskets. Suddenly, it seemed as if the whole country was blooming tulips.

By early spring, I was out before dawn each day to meet Wim. It was during these early-morning meetings that I received an education about the tulip genus. He would explain as we walked what characteristics we were searching for, pointing out the shortcomings and strengths of the plants as we went along until we found the perfect one. After finding a few flawless examples, we would get into his car and move on to the next field and begin the process all over again.

At night my wife and I attended prenatal classes and practiced our breathing, counting in Dutch. As we walked home along the canals, the air grew warmer. Behind lace curtains, we glimpsed vases bursting with

tulips. On our terrace, the garden was taking shape, growing in squares and rectangles of color. The wooden flats filled with plants from the fields covered the stones. By mid-April we began pressing the flowers between pages of our daily newspaper to make space for more. At night, I rocked Hannah to sleep surrounded by flowers and told her how close she came to being named Tulipa. When I closed my own eyes to find sleep, I saw nothing but tulips. The warm weather became hot weather, which took us by surprise. In late May there was a sudden dwindling of plants, and then finally, our terrace was as empty as that March field.

FILM, PRINTS, PRESSED PLANTS: This is what remains of my time in the Netherlands with Wim and the tulips. It is also a record of the effort spent by botanists and growers to produce the vast selection of tulips available to us today. It is my hope that this book will help define what a tulip is for the new millennium, and give gardeners the knowledge to understand and enjoy the tulip in all its forms.

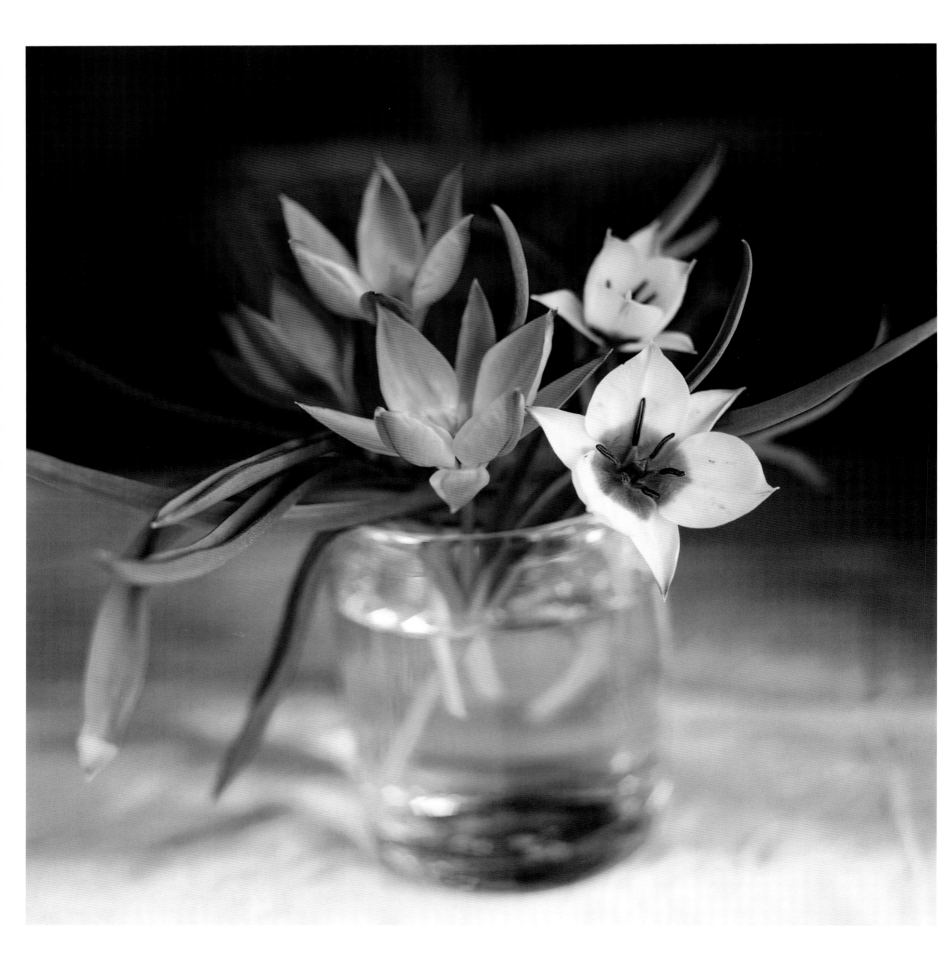

The Tulip and Its Trespasses
Michael Pollan

THERE ARE FLOWERS, and then there are flowers: flowers around which whole cultures spring up, flowers with an empire's worth of history behind them, flowers whose form and color and scent, whose very genes, carry reflections of our ideas and desires through time like great books. To take on the changing colors of human dreams is a lot to ask of a plant, which may explain why only a small handful of them have proven themselves willing and interesting enough for the task. The rose is one such flower; the peony is another; the orchid would certainly qualify. And then there is the tulip. These are our canonical flowers, the Shakespeares, Miltons, and Tolstoys of the plant world, the floral elect that have survived the vicissitudes of fashion.

What sets them apart from the run of charming daisies and pinks and carnations? Perhaps more than anything else it is their multifariousness. Some perfectly good flowers simply are what they are, singular and, if not completely fixed in their identity, capable of ringing only a few simple changes on it: color, say, or petal count. Prod it all you want, select and cross and reengineer it, but there's only so much a coneflower or even a lotus is ever going to do. Fashion is apt to pick up and drop such a flower rather than remake it in some new image. By contrast, the rose and the orchid and the tulip are capable of reinventing themselves again and again to suit any change in the political or aesthetic weather. The rose, flung open and ravishing in Elizabethan times, obligingly buttoned herself up and turned prim for the Victorians. Technically the same flower, and yet completely different in form and character.

It isn't obvious that the tulip belongs in the company of these flowers. That's because in its twentieth-century incarnation the tulip has usually appeared as a simple thing, a blunt and gaily colored orb massed in the landscape—so many blobs of pigment on a stick. I'm thinking of the run-of-the-garden-center modern tulip, the tall, fat Triumphs (of marketing if not taste) that my parents used to buy in mesh bags of fifty and then pay me a few pennies per bulb to bury in the pachysandra.

I would press and twist the bulb planter into the root-congested earth until the heel of my hands whitened into a pillowy blister. October's investment of effort reliably yielded the interest of spring's first important color. These tulips were definitely flowers for kids. No other flower was so simple to draw, and the straightforward spectrum of colors they came in never failed to toe the Crayola line. They were uncomplicated, accessible, and, if easy to grow, easy to grow out of, too.

But that is only one kind of tulip, and while it may be the tulip our time deserves—this mass-produced eye candy, its parabolic curves as deeply etched into popular consciousness as those of a Coke bottle—it is by no means all the tulip has done or can do. (One glance at the book you hold will make that much clear.) Before I learned something of their past and possibilities, I could make no sense of the fact that these bulbs had once been more precious than silver, that otherwise reasonable people had gone mad for the flowers (and not only in Amsterdam but, at various times, in London and Paris and Constantinople), and that several languages have felt the need for a word to denote what in English we call tulipomania. The cheery lollipops sticking up in my parent's pachysandra did not even hint at this mystery.

The mystery, for me at least, didn't begin to yield until I started to look at tulips individually. It flatters any flower to be brought indoors and really looked at, but none so much as the tulip, whose ubiquity has made it oddly hard to see. It is no accident that botanical illustrators, and photographers, have so often brought their scrupulous eye to bear on this particular flower: It rewards that particular gaze like no other.

To show what I mean, let me bring that gaze to bear on a single tulip—the 'Queen of Night' sitting before me on my desk this late May morning. 'Queen of Night' is as close to black as a flower gets, though really it is a dark and glossy maroonish-purple, so dark it appears to draw more light into itself than it reflects—a kind of floral black hole. In the garden, depending on the angle of the sun, the blossoms of a 'Queen of Night' may read as positive or negative space, a flower or the shadow of a flower.

This particular specimen exhibits the classic form of a single tulip: six petals arrayed in two tiers (three interior petals cupped inside

three outer petals) that draw a vaulted sphere around the flower's sexual parts, simultaneously advertising and sheltering them from view; each petal is at once a flag and a curtain, drawn. Together the six concave petals fit together to make an aloof, almost glamorous blossom; inviting neither touch nor smell, we're asked to admire it from a cool distance. The fact that 'Queen of Night' has no scent (not many tulips do) seems appropriate: It is designed expressly for the delectation of the eye.

The curving stem, nearly as stunning as the flower it holds aloft, is graceful, but graceful in a specifically masculine way. This is not the grace of a woman's neck so much as it is that of stone sculpture or, even better, the curving steel cables on a suspension bridge. The curve seems economical, purposeful, inevitable in its structural logic, even as it changes with time. A horticulturally inclined mathematician could probably represent the stem of my tulip in a differential equation.

As the day warms the petals pull back to reveal the flower's interior space and organs. These too appear logical. Six stamens—one per petal—circle around a sturdy pedestal, each of them extending, like trembling suitors, a powdery yellow bouquet.

Crowning the central pedestal (called a "style") is the stigma, a pursed set of slightly crooked lips (usually three) poised to receive the grains of pollen; sometimes a glistening droplet of liquid appears on the stigma, suggesting receptiveness. Everything about tulip sex seems orderly and intelligible; there is none of the occult mystery that attends the sexuality of, say, a bourbon rose, or a doubled peony. One imagines a bumblebee forced to stumble around in the dark, getting himself tangled up in the floral bedclothes. Which is precisely the idea, of course, but it is not the tulip's idea.

In this I think lies a key to the distinctive personality of the tulip—and of its cult of admirers. Compared to the other major flowers, the tulip is a surpassingly cool character. It is classical rather than romantic or, to borrow the useful dichotomy drawn by the Greeks, it is that rare Apollonian figure in a horticultural pantheon mainly presided over by Dionysus. Certainly the rose and peony are Dionysian flowers, deeply sensual, captivating us as much through the senses of touch and smell as sight. The unreasonable multiplication of their petals (one

Chinese tree peony is said to have more than three hundred) defies clear seeing or good sense; the sheer profusion of folds edges toward incoherence. To lean in and inhale the breath of a rose or peony is momentarily to leave our rational selves behind, to be transported as only a haunting fragrance can transport us.

The tulip by contrast is all Apollonian clarity and order. It's a linear, left-brained sort of flower, in no way occult, explicit and logical in its formal rules and arrangements (six petals corresponding to six stamens) and conveying all this rationality the only way one could: through the eye. The clear, steely stems hold the flower up in the air for our admiration, positing its lucid, linear form over and above the dubious earth. The blossoms float serenely above the turmoil of nature; even when they expire, they do so with aplomb. Instead of turning to mush, like a spent rose, or a used Kleenex, like peony petals, they cleanly, dryly, and, often simultaneously, shatter.

Nietzsche described Apollo as "the god of individuation and just boundaries." Unlike the great mass of flowers, a tulip stands as an individual in the landscape or vase: one blossom per plant, each blossom perched atop its stem like a head; lower down the figure come the leaves—precisely two in most botanicals, and deployed very much like limbs. Depending on the attitude of the leaves and the stem—militarily erect, or curving forward confidentially—the tulip commands a dancer's repertoire of gesture. It makes sense that the tulip was one of the first flowers to have its cultivars individually named.

In the Greek mind, the Dionysian was usually associated with the female, the Apollonian with the male. Biologically most flowers are bisexual, containing both male and female organs, yet in our imaginations they tend to be on either one team or the other. You can walk through a garden and decide: boy, girl, boy, girl, girl, girl. The canonical flowers seem to me almost always female. Except, that is, for the tulip.

Of course, like all our (Apollonian) efforts to order and categorize nature, mine goes only so far before the (Dionysian) pull of things as they really are begins to take its inevitable toll. I mentioned the orderly arrangement of petals and stamens on the 'Queen of Night' on my desk, yet when I went back into the garden to cut another I noticed the bed was

full of perversities. Here were mutant 'Queen of Nights' with nine and even ten petals, stigmas with six lips instead of three, and in one case a leaf streaked with deep purple, as if it had stolen a shot of pigment from the petals overhead. As everyone who grows a lot of them knows, tulips are subject to eruptions of biological irrationality—chance mutations and color breaks and sports. The extraordinary multifariousness of the tulip, a flower one early authority claimed nature liked to play with like no other, is in large part a result of this wondrous instability.

A few weeks ago I passed through Grand Army Plaza in Manhattan, where a large bed had been planted with thousands of fat yellow Triumphs, arranged with dulling parade-ground precision. I'd read that, even today, when tulip growers strive to keep their fields free of the virus that causes the flower to break, it still occasionally happens, and there in the depths of the bed, row 27, file 36, I spotted one: a brilliant eruption of red on a yellow ground. It wasn't the most handsome of breaks, but the flare of carmine leaping up from the base of that one bloom stood out among those conformists like an exuberant clown, pulling the rug out from under the dream of order that flower bed was meant to represent.

It was breaks such as these that helped fire the tulipomania that consumed Holland in the 1630s, a speculative frenzy that, like the breaks themselves, would seem to represent an outbreak of the Dionysian in the strict Apollonian world of the tulip. And that it may be, though it's worth noting that tulipomania was a frenzy not of consumption or pleasure but of financial speculation, one that took place in the most stolid bourgeois culture of the time. The tulip's occasional excesses, in other words, are relative, exciting to us in direct proportion to their anomaly. The color break I spotted in Grand Army Plaza was very much like that, an extravagance that would go unnoticed if not for the exquisite precinct of order—of petal, of blossom, of plant—in which it intervened. Extravagant means to cross a line, lines of course being one of Apollo's special domains. In this may lie a clue to the abiding power of the tulip, a flower that forms some of the most elegant lines in nature and then, in spasms of extravagance, blithely steps across them.

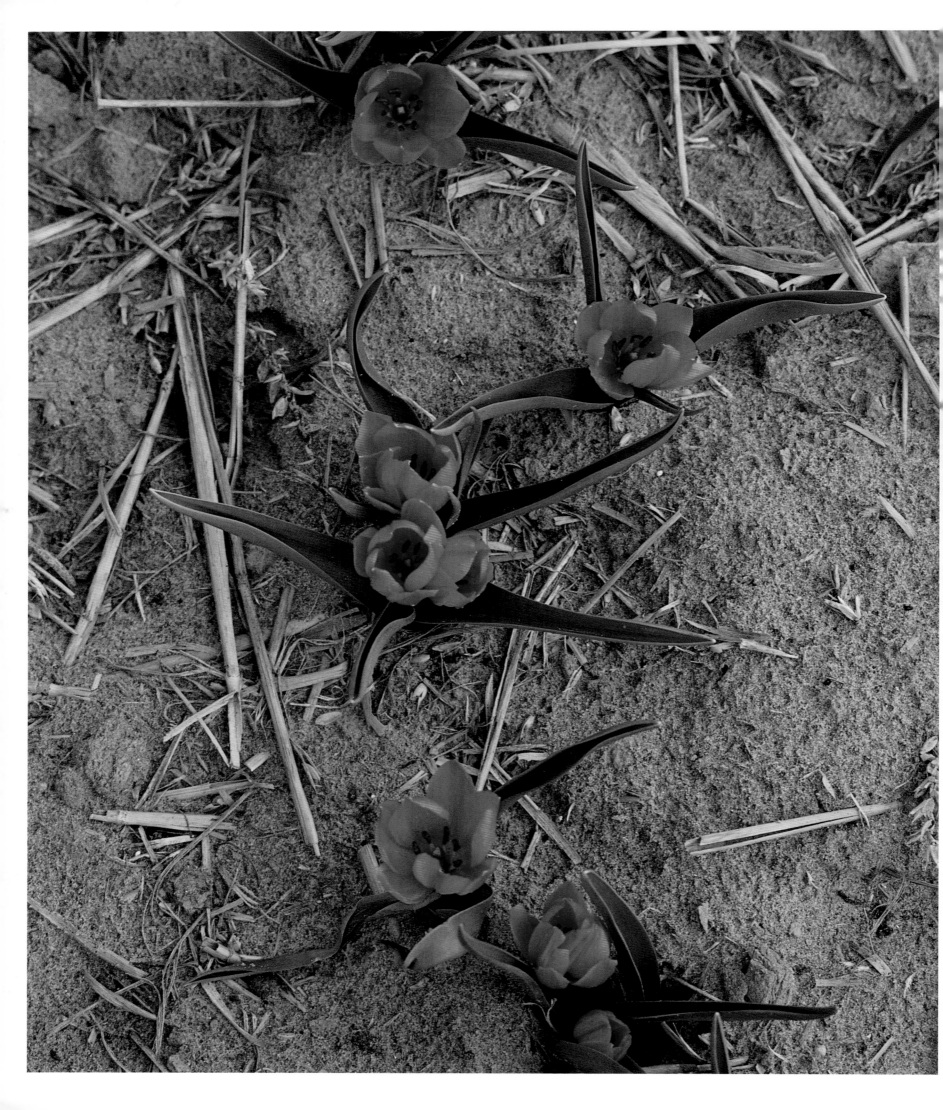

A Grower's Perspective
Willem Lemmers

I SPENT MY CHILDHOOD surrounded by bulb fields and the people who grew bulbs. In fact, I still live in the village in which I was born, and I am still surrounded by tulips. Our postmark proudly proclaims "Lisse: The Center of the Bulb District." Situated between Haarlem to the north and Leiden to the south, Lisse is one of many bulb villages on the west coast of Holland. As a young boy, I used to pass the large buildings near the harbor where bulb auctions were held and watch as the bulb-filled crates were loaded onto boats headed for Rotterdam and Amsterdam. I would pick up a bulb or two that had fallen from a crate, plant it in our backyard, and when it bloomed, ask my father or grandfather the name of the flower.

Growing up in bulb families in Lisse, young children such as myself often spent the summers in the bulb sheds, cleaning bulbs, singing and shouting. When a summer shower came, the bulb growers would join us to wait it out, and I enjoyed listening to their stories about the old days. I thought the bulb growers were very friendly and affable and I didn't doubt that I would grow up to raise bulbs.

The bulb growers you will meet in these pages, such as the Schoorl family—grandfather Leen, son Jan, grandson Leo—were part of my childhood. The Schoorls owned land adjacent to ours and raised several varieties, including the very popular Single Early tulips 'Christmas Marvel' and 'Christmas Dream.' The Nieuwenhuis family lived in Lisse, too, and although I didn't know them, everyone in town knew of this important family that pioneered fascinating methods such as using X rays to bring about mutations. Many other growers came from the surrounding bulb villages and other towns in Holland farther north.

All my life I have listened to the stories of the bulb growers—how D. W. Lefeber created the much celebrated Darwinhybrid tulips and how Jan J. Kerbert's hybridizing efforts helped develop the Triumphs, a group of tulips that now claims 45 percent of all the tulip fields in Holland. How Maarten Kamp grew so many 'Brilliant Star' tulips that he was nicknamed the "Star King." It gives me great pleasure to share these stories here.

Lisse is the home of the famous Keukenhof Garden, where each year over eight hundred thousand visitors come to see the colorful displays of tulips. It was created in 1949, just four years after the "hunger winter" following World War II, when so many Dutch starved to death. I can remember as a young boy seeing people who had walked all the way from Amsterdam and other cities in Holland to the bulb fields just for a tulip or crocus bulb to eat. A boiled tulip bulb is actually sweet-tasting, and crocus bulbs can be ground into flour and used for baking. During the war, as the need for food grew, bulb growers such as my father planted potatoes and vegetables. Although we were forced to give a percentage of our food to the German government, we developed ways of hiding it so we could feed the hungry Dutch first. We were more fortunate than others who did not have land, and we often shared our meals of boiled potatoes and baked beans.

Before the war broke out, my father and his brother had built up a good nursery, Lemmers Brothers, growing tulips, daffodils, anemones, gladioli, and hyacinths. Our bulb fields, located just outside town, were bordered on one side by the Keukenhof Woods (now the site of the Garden), which consisted mostly of beech woods and dunes, and on the other side by the Schoorl fields. I spent most of my teenage years working for my father in the fields. As I was the eldest son, it was natural that I should work for my father, who had also left school at twelve to go to work.

When my father was a boy in 1915, our family did not own a nursery, so my father worked for another bulb grower and my grandfather was foreman for still another. Each evening after my father and grandfather had finished their work, they went out to the fields my grandfather had rented and, by the light of a lamp held by my father, tilled and cultivated the land, planted and dug bulbs. Among the varieties my grandfather grew was 'El Toreador,' a very rich orange double tulip with a lighter edge, no longer in cultivation. This was a difficult tulip to grow and because of that always received a good price—about twenty-five Fls. each, good even today. My grandfather built up his own reputable nursery in this way, and by the time he retired and my father took over, six or seven people worked for him.

A few years after I joined my father and uncle in the nursery, I was called up for military service and left home for two years. When I returned,

I went back to work for my father but decided to make plans to start my own nursery business. My father had other brothers in the business, and by now my uncle had many children who would take over.

I purchased bulbs with the four hundred Fls. earned from military service and planted them on my father's fields. While I continued to work for my father, I set aside one day a week for myself, tending to my bulbs and increasing the stocks until I had enough bulbs to start my own nursery. I began in this fashion in 1955, and around 1960 bought my own land.

Bulb growing was very different then. We did all the work by hand—we had no tractors or other machines—and when we could, we hired work gangs to dig or spade our fields. In the winters, the hired help dug the bulb trenches, about fifty to sixty centimeters (two spades) deep, and during the rest of the year when they showed up looking for work, we would hire them to help with planting, plowing, digging, fertilizing, and spraying. As winter approached again, they would return to help us cover the fields with straw to protect the bulbs from sudden frosts and thaws.

Today these and other chores are done by machines. In the 1960s and 1970s, I grew a stock for *T. kaufmanniana* and the bulbs produced "droppers," new bulbs that sunk about ten to fifteen centimeters farther into the soil. When you dug into the soil to find the bulb, all you would find was an old bulb skin and a few offsets and you had to dig twice as deep to search out the droppers. However, today's machines are capable of locating droppers and it is no longer a problem for the growers.

While mechanization has been a terrific boon to bulb growers, it hasn't solved every problem, and one job is still done by hand: roguing out diseased plants. I will never forget watching Leen Schoorl walk through his bulb fields in his wide trousers with big pockets, looking for diseased plants. When he found one, he would break it off and put it in one of his pockets. Even today this important job must be done by hand.

I have always enjoyed growing and learning about species tulips, and now that I have retired, I have spent much of the last five years traveling all over the world to see the wild plants in situ. My friend Kees Visser of Sint Pancras developed several new species of tulip cultivars and was very successful with cultivars of *T. pulchella*. While Visser never traveled outside Holland, he kept up a correspondence with many people from

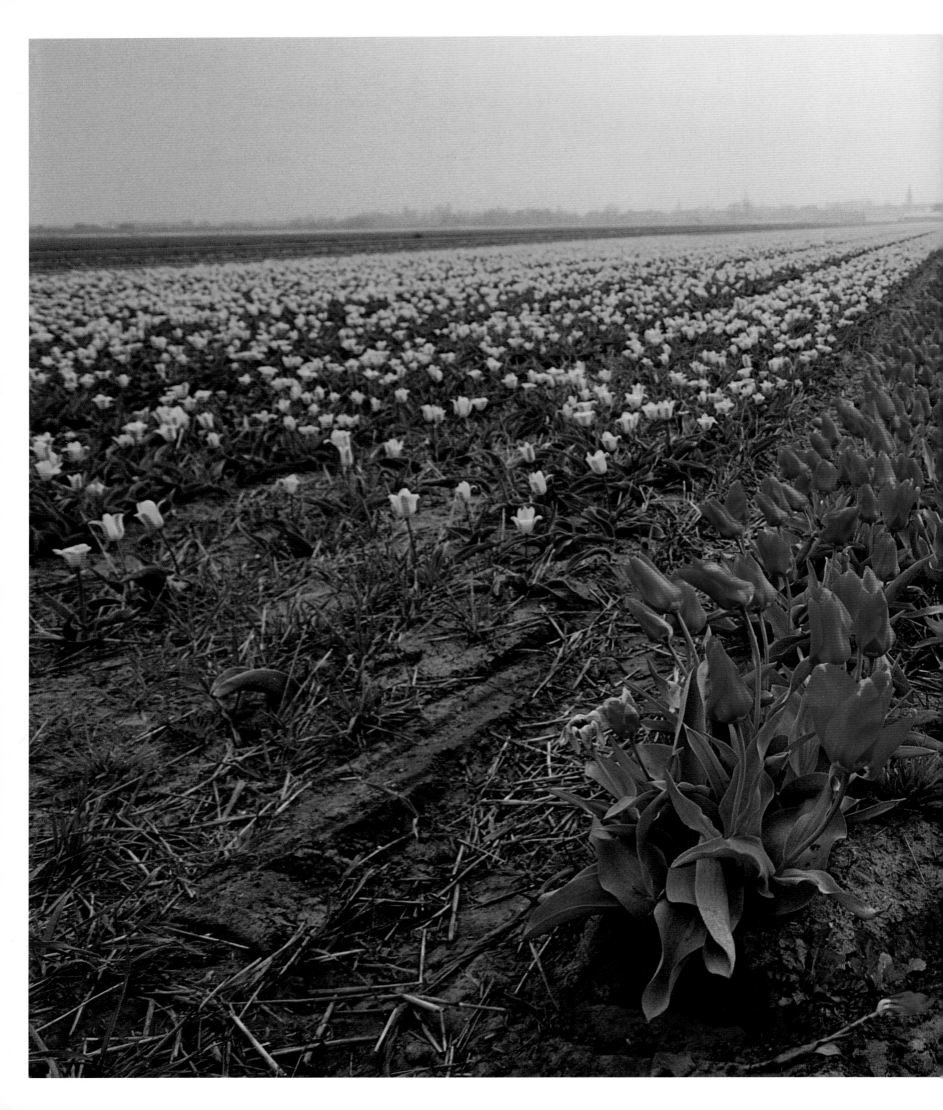

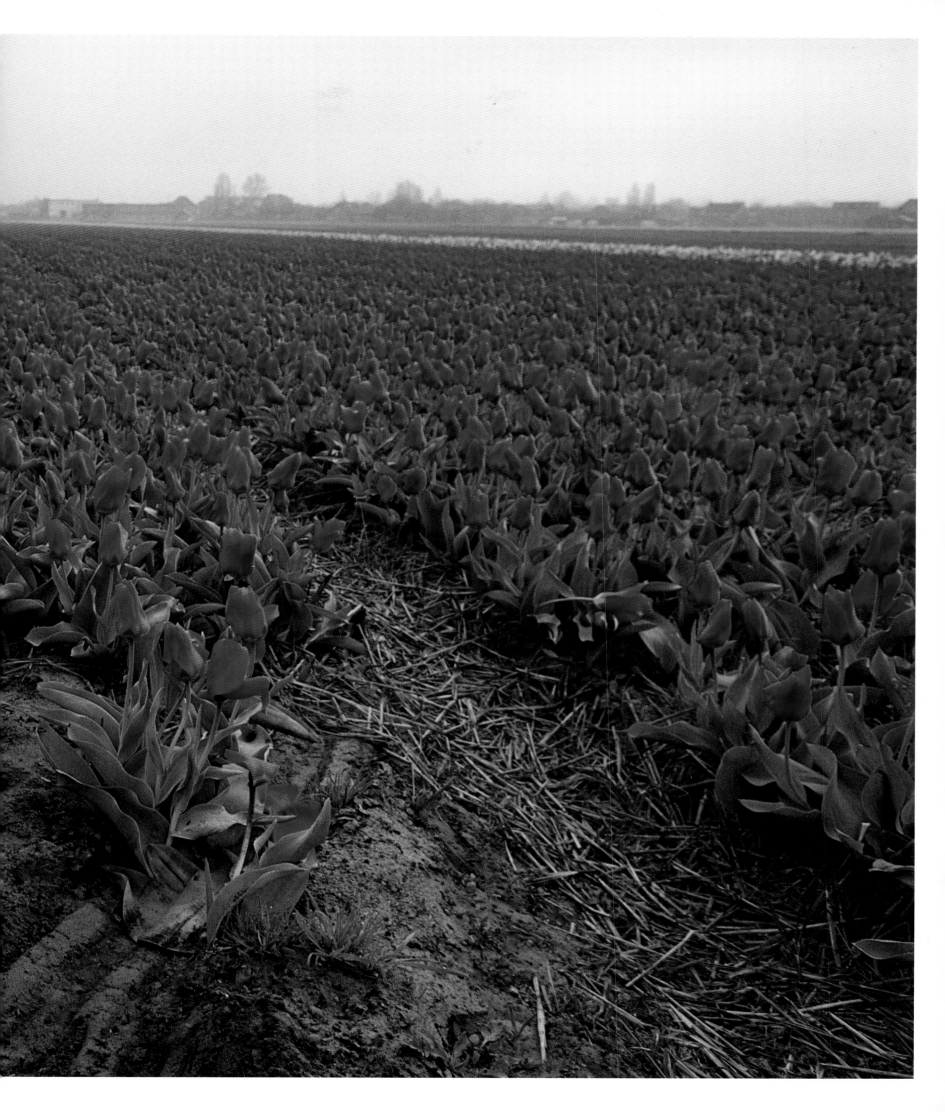

botanical gardens all over the world and other plant lovers who shared his passion for species tulips. Each week he discussed the bulbs he was growing and developing with his colleagues and eventually created a bulb museum to preserve the very old and exotic tulips he was growing. Along with other growers, I visited the bulb museum often to learn about new species tulips. Kees Visser was a generous and honest provider of new stocks, who shared his knowledge freely and helped to establish the market today for these charming species tulips.

Still, growing species and species-related tulips—the Fosterianas, Greigiis, and Kaufmannianas—is not nearly as valued today by the Dutch bulb growers as growing tulips that can be forced and sold as cut flowers. This is unfortunate because much of the existing stock in Holland is grown from clones, and when the clones go—some are now about eighty to ninety years old and showing signs of aging—those tulips will disappear. The forcing industry has had a great impact on Dutch bulb culture, and, in fact, all the newest bulbs are tested first for their forcing capabilities. Though bulbs in Holland are grown either for the forcing market or for gardens, what we call the "dry bulb market," it is more economically feasible for growers to concentrate on growing bulbs for the forcing market. When we sell cut flowers that were produced from forced bulbs, we keep the bulbs and replant them for three to four more years. When we sell our dry bulbs to the garden market, however, we diminish our stock with the sale of every bulb.

We have a saying, "Forcing tulips are multipurpose and can be used for forcing *and gardens*, but garden tulips cannot always be used for forcing." As a result, the forcing market is the more stable and reliable, and the majority of hybridizers today concentrate on breeding Triumphs, the best forcing variety because of their sturdy flowers and strong stems, and because they require only two weeks in the hothouse, whereas most other tulips require twice that time.

The demand for year-round tulips as cut flowers is so great, in fact, that for the past ten years, young bulbs are exported from Holland in July and August to countries in the southern hemisphere such as Australia or the south island of New Zealand, or, less often, to South Africa and Chile, where they will grow for a year or two. Yet another region where bulb growing has expanded over the years is the western part of the United

States and Canada, where growers (many of Dutch origin) are now cultivating tulips and other bulbs for the forcing market. Tulips are being grown in large numbers is the Puget Sound area north of Seattle, Washington.

For this book, I made every attempt to search out information on hybridized tulips. In some cases the parents are published, and in others are recognizable (as in the Greigii and Fosterianna hybrids and the Greigii and Early Single tulip crosses). But beyond that it is just a guess. In the past and even today it is not uncommon for the breeders to cross-pollinate different tulips but make no note of the parents. We are not like the orchid growers, who are, for the most part, a leisure class, with time to make such records—or better yet, hire someone to do it. We never had enough time to make notes and usually felt our time was best spent *making* the crosses instead of recording them. This has proved unfortunate, because tulips do not live forever, and without records the crosses cannot be replicated.

When there are no records, we look to similar parents to make crosses. However, hybridizing is expensive—it generally takes five to seven years for a seed to flower—and when you consider the additional risks posed by rain, frost, heat, waterlogging, and diseases, every year presents another chance of failure and perhaps financial loss. It is no wonder today so many growers and hybridizers have formed consortiums such as Hybrida and Vertuco, two groups formed by growers, to offset these expenses.

When I began in the bulb business, there were about twelve thousand bulb growers. Today there are just three thousand. But then when I started out, half a hectare, the equivalent of about one and a half acres, was considered a sizable acreage for one man to work. When I retired in 1994, two men could work ten hectares with the help of mechanization.

In describing the tulips for *Tulipa*, I looked back over my forty years as a bulb grower, consulted other bulb growers, and read everything I could find. In addition to selecting the tulips I feel are most important and providing descriptions for each, I hope I have shed some light on the Dutch bulb growers. We are a quiet people, diligent, even serious, or so I am told. Even so, I can still remember the laughter I heard in the bulb shed when the rain splashed onto the tin roof as I listened to the men tell their stories. This, then, is my effort to tell the story of tulips and the people who grow them.

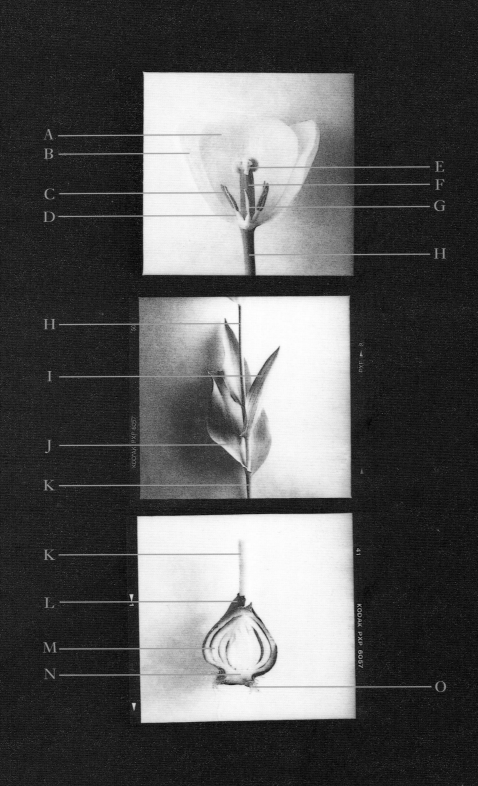

ANATOMY OF A TULIP

Flower

TEPALS

Tulip flowers have three petals and three sepals. All look alike and are also called tepals. The largest flowers sometimes have eight; double tulips have even more.

 A Inner Tepal (petal)
 B Outer Tepal (sepal)

STAMEN

Tulip flowers with eight tepals have eight stamens.

 C Anther
 D Filament

PISTIL

Tulip flowers have a single, superior pistil with three carpels.

 E Stigma
 F Ovary
 G Style

Stem

 H Neck *The stem between the flower and the upper leaf.*
 K Leg *The stem beneath the basal leaf.*

Leaves

Tulips have two to five leaves, which can be variegated, mottled, undulated, form rosettes, be upright, or lie on the ground.

 I Secondary Leaves
 J Basal Leaf

Bulb

 L Outer Tunic
 M Bulb Coats
 N Basal Plate
 O Roots

THE PLATES

The following 137 color portraits have been carefully chosen to illustrate the diversity and exquisite beauty of the tulip. Selected specimens are arranged according to blooming sequence—from the early-flowering species tulips that appear in early spring, followed by the mid-season bloomers, on through to late spring when the late-flowering varieties appear. Ranging from the diminutive, often multistemmed species tulips to the tall and robust garden tulips, the following portraits demonstrate the breadth of possibilities of the genus called *Tulipa*.

T. humilis
Early-Flowering Species
[PLATE 1]

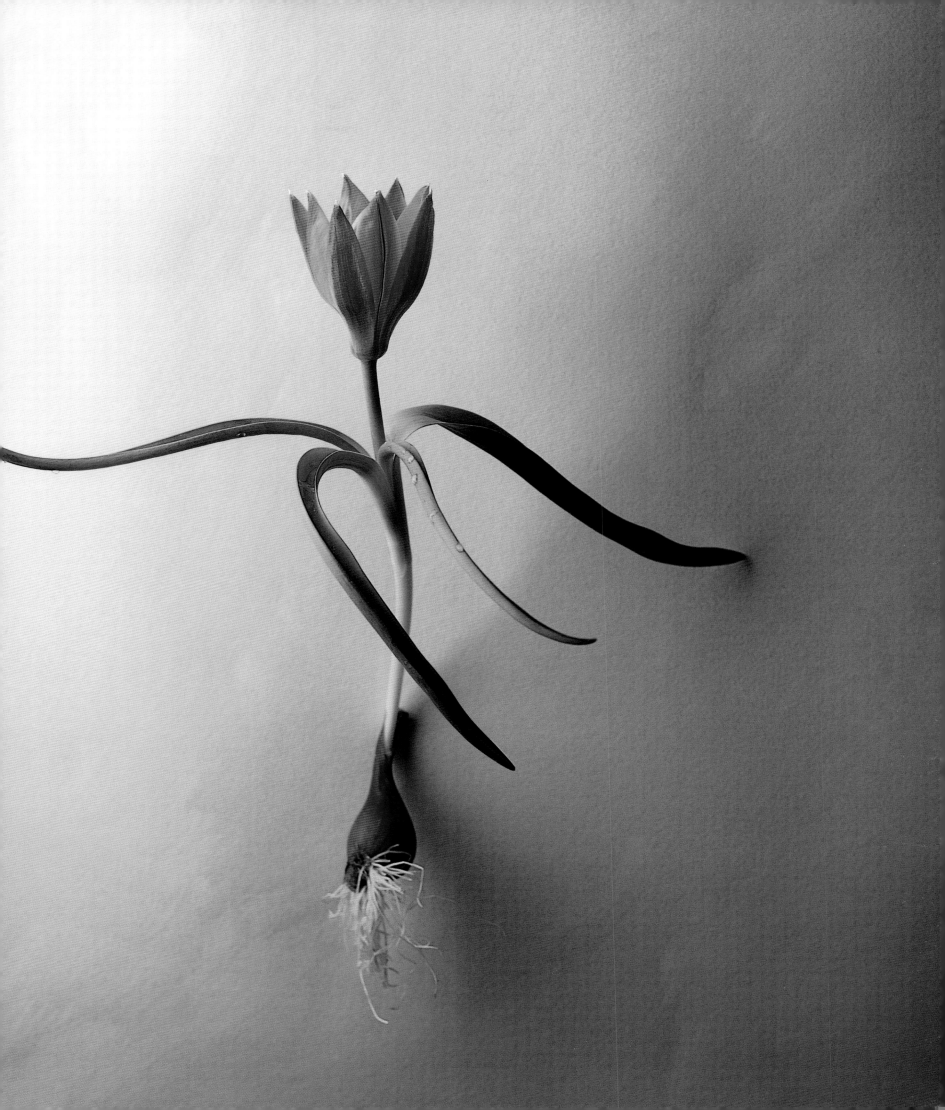

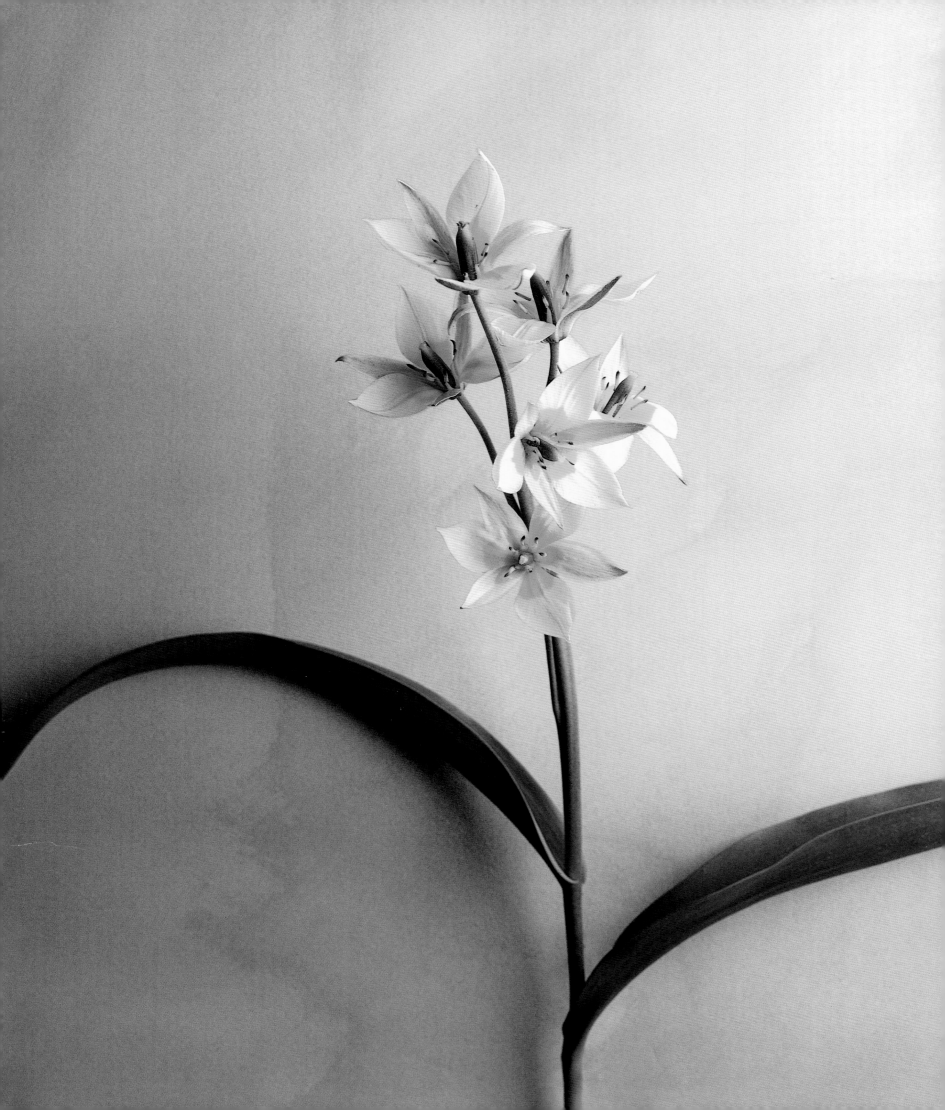

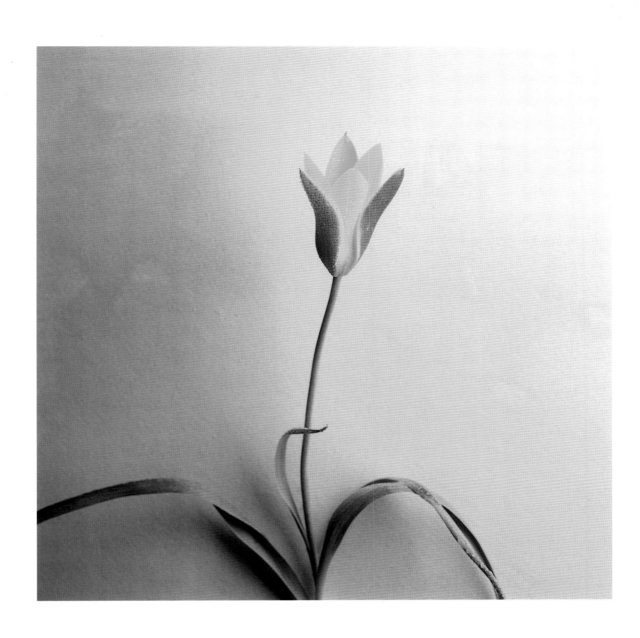

T. clusiana **var.** *chrysantha*
Early-Flowering Species
[PLATE 3]

T. turkestanica
Early-Flowering Species
[PLATE 2]

T. clusiana
Early-Flowering Species
[PLATE 5]

T. praestans 'Fusilier'
Early-Flowering Species
[PLATE 4]

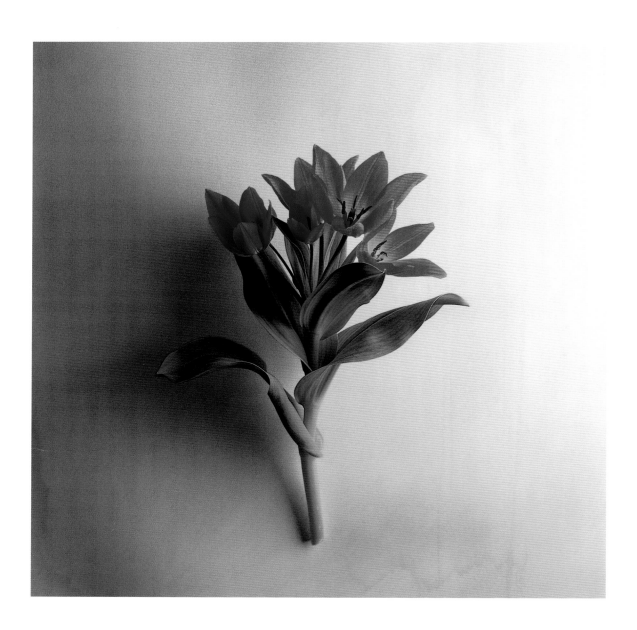

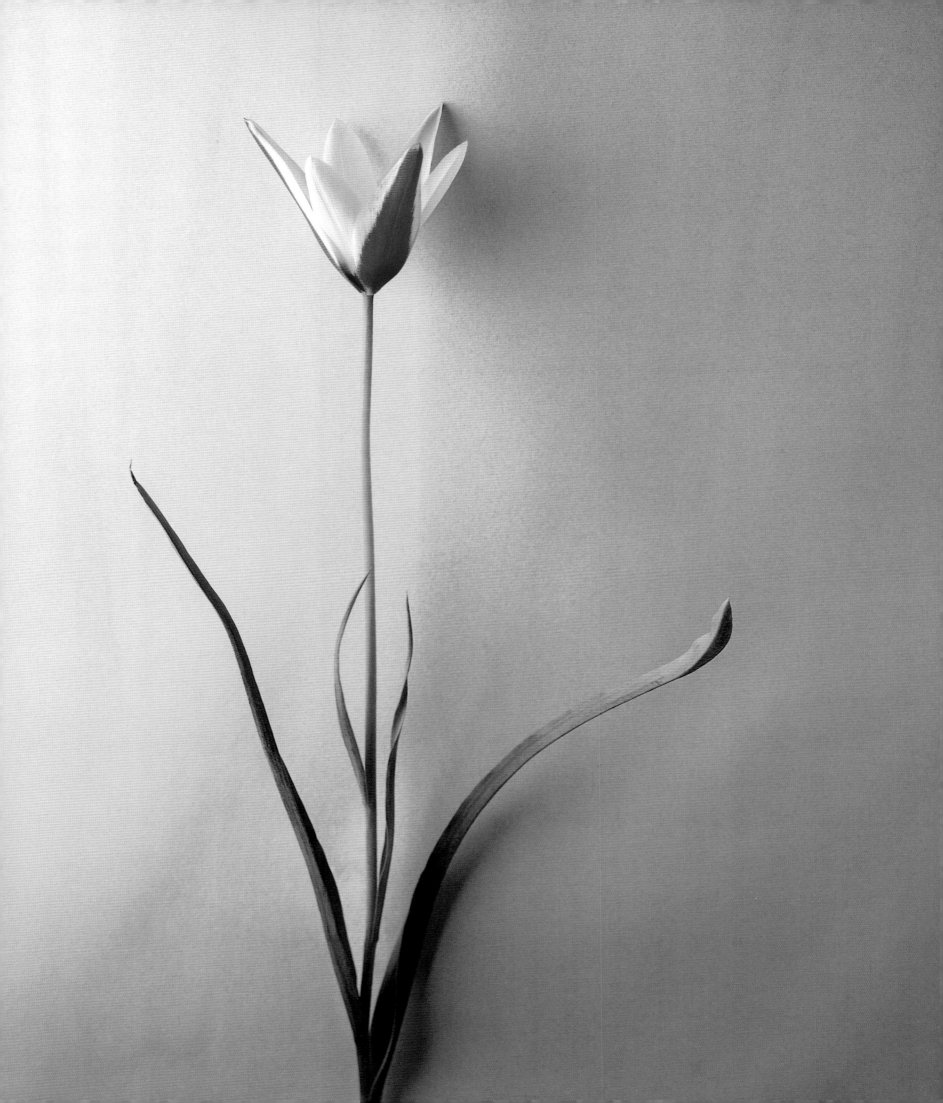

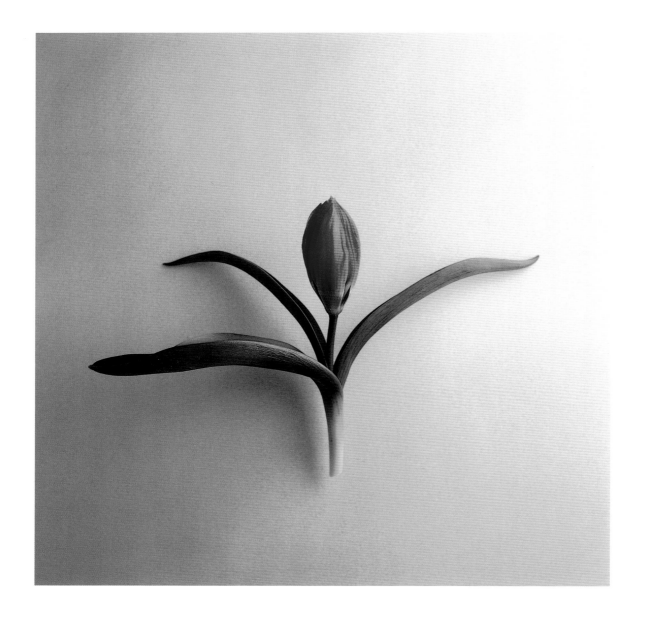

T. humilis 'Violacea Black Base'
Early-Flowering Species
[PLATE 6]

T. schrenkii
Early-Flowering Species
[PLATE 7]

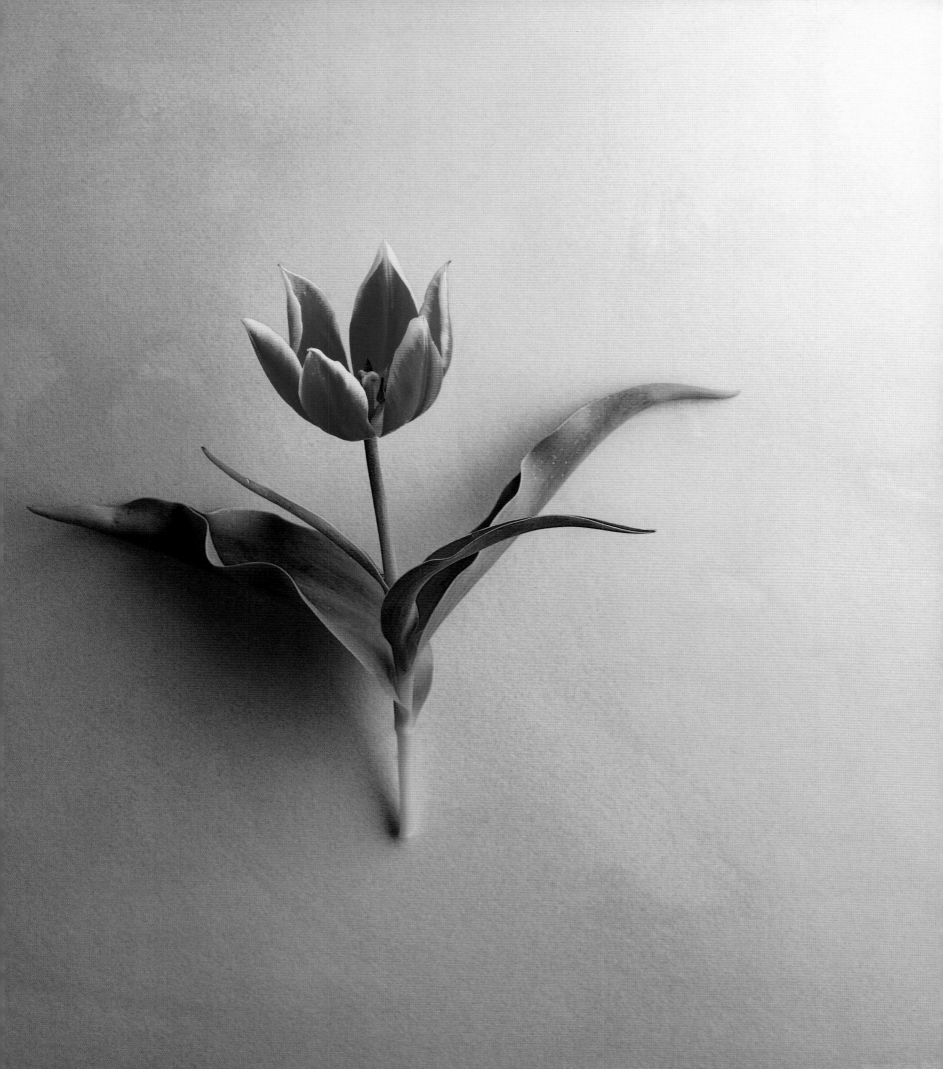

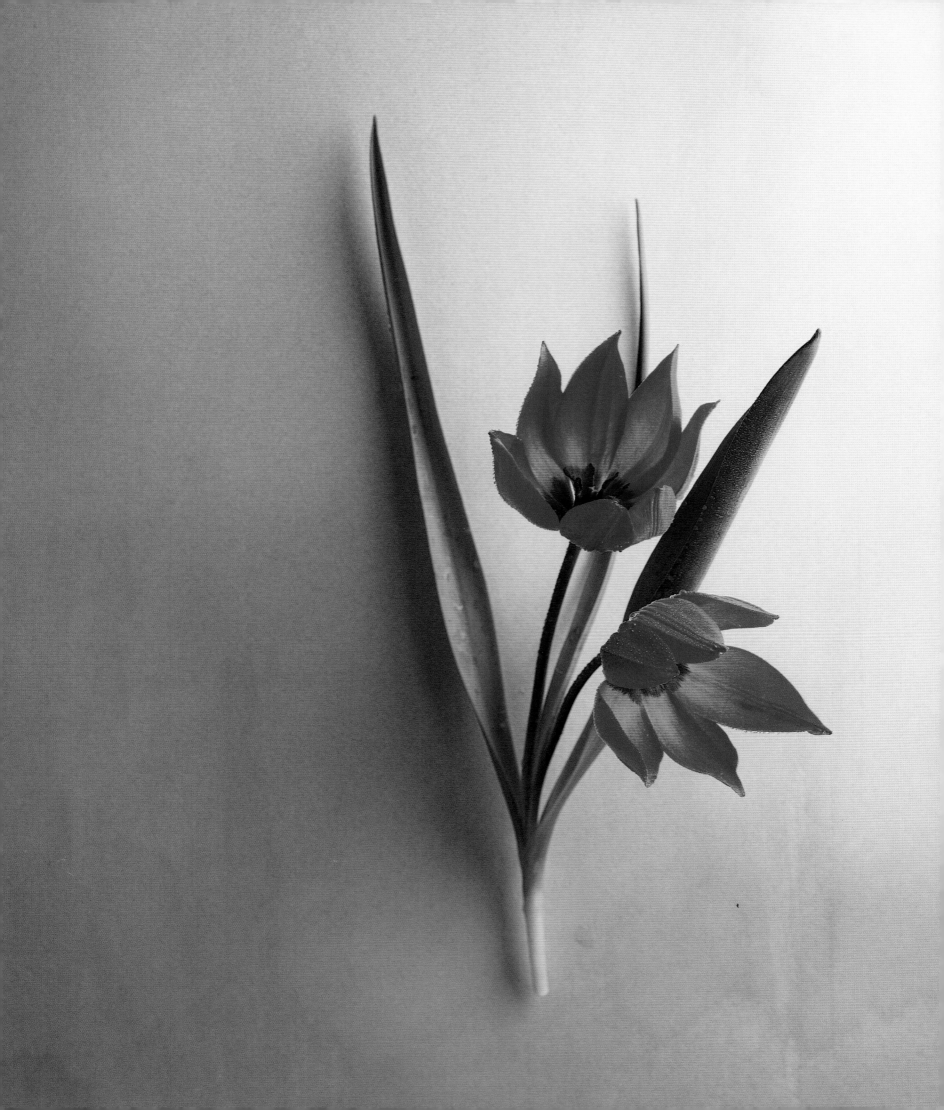

ZEPHYR
Early-Flowering Species
[PLATE 8]

T. humilis 'Alba Coerulea Oculata'
Early-Flowering Species
[PLATE 9]

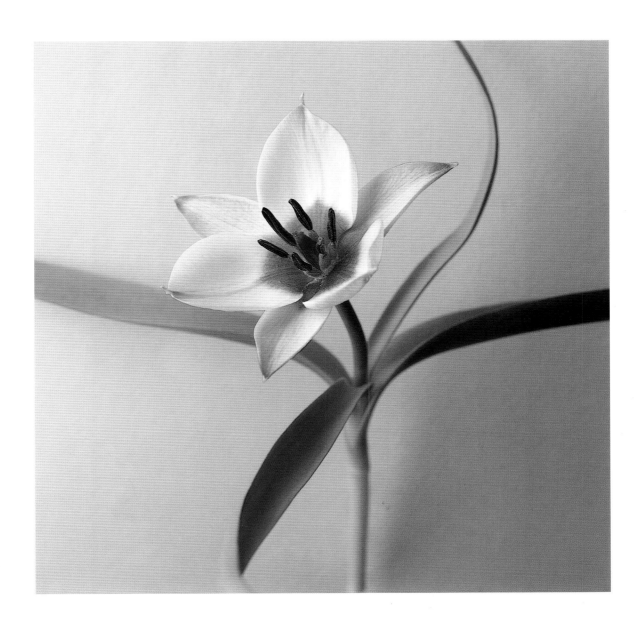

SHOWWINNER
Kaufmanniana Group
[PLATE 11]

GOLDEN DAYLIGHT
Kaufmanniana Group
[PLATE 10]

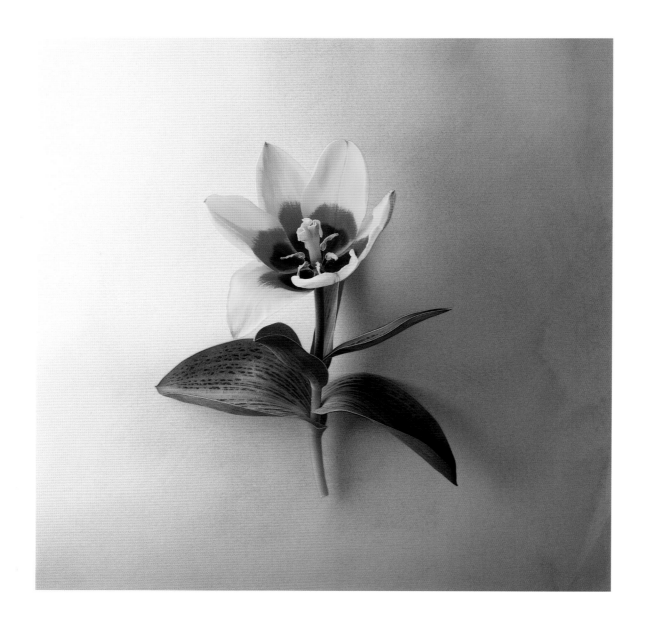

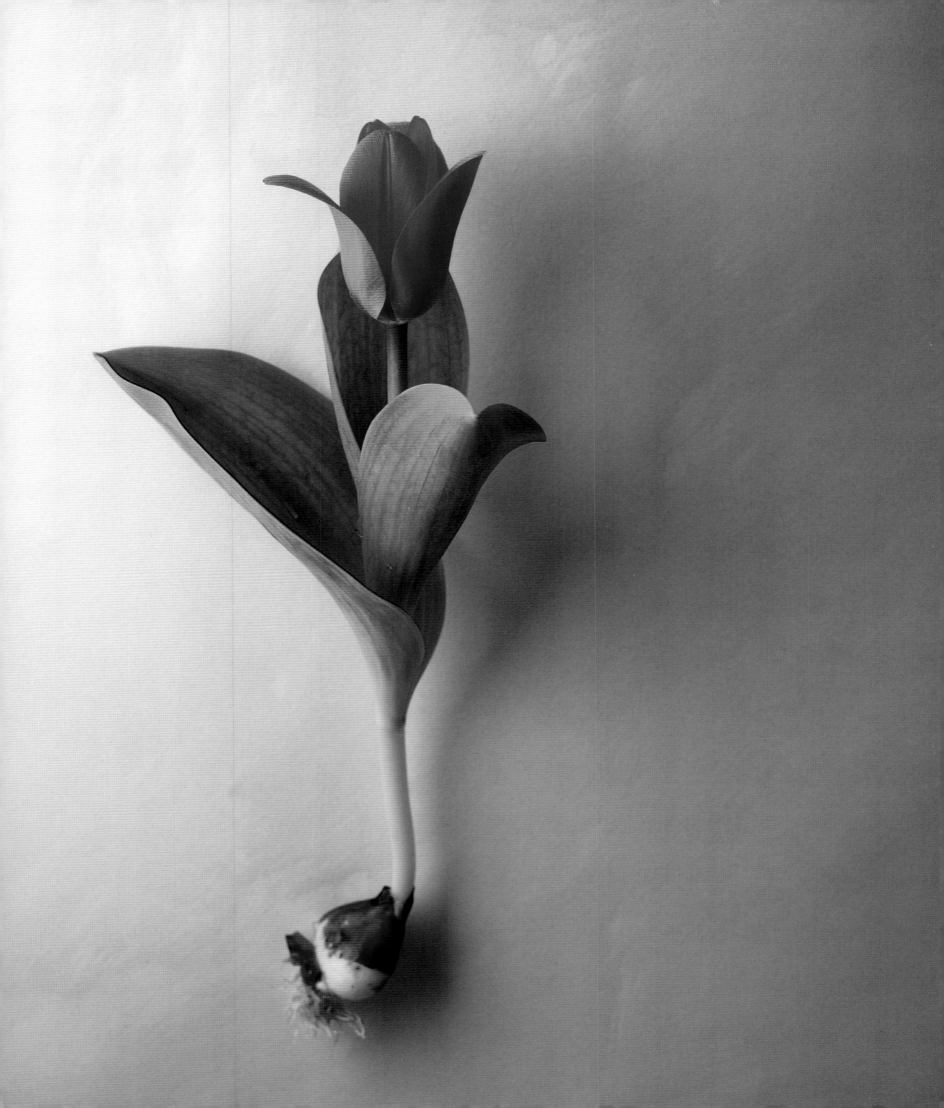

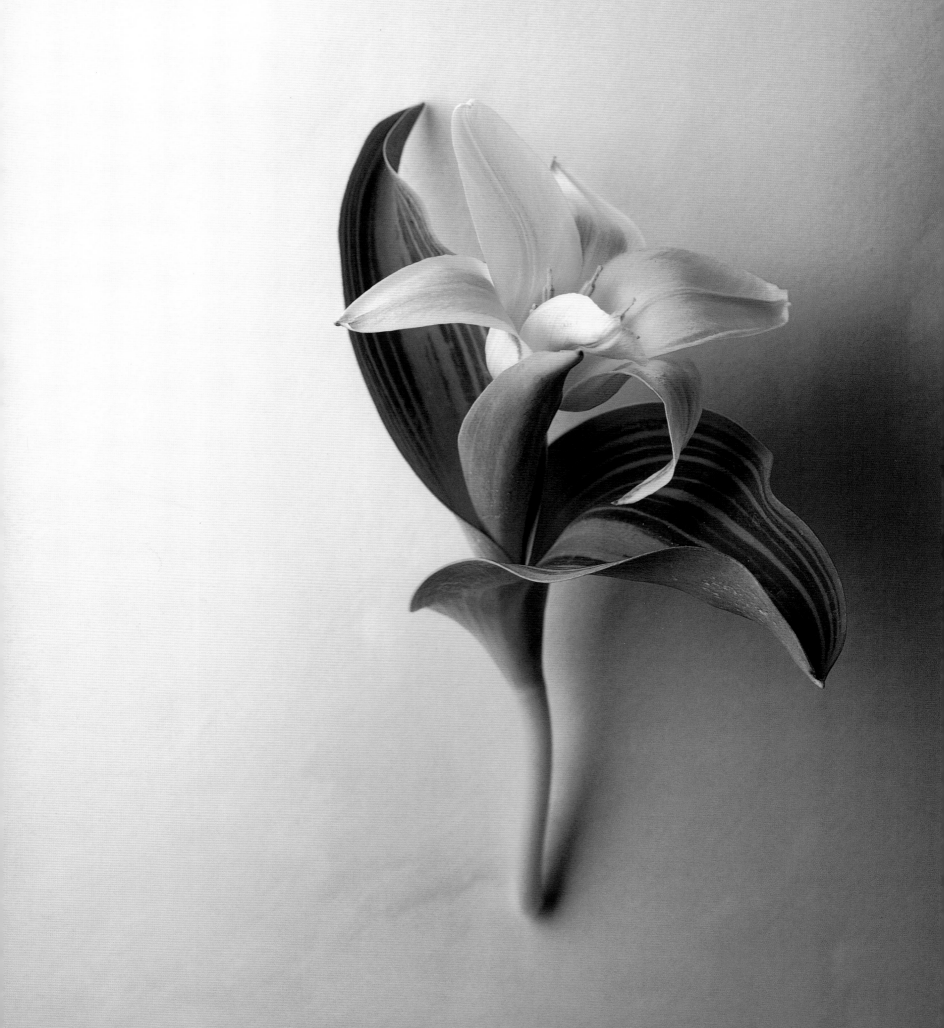

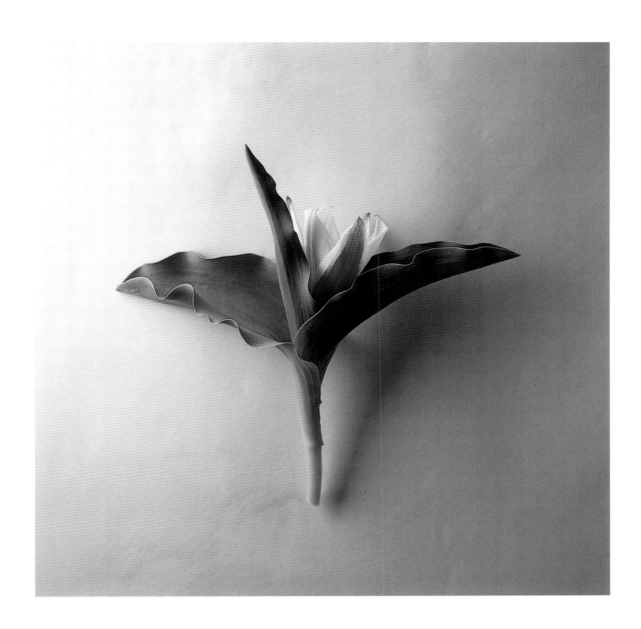

ANCILLA
Kaufmanniana Group
[PLATE 13]

JOHANN STRAUSS
Kaufmanniana Group
[PLATE 12]

CORONA
Kaufmanniana Group
[PLATE 14]

GLÜCK
Kaufmanniana Group
[PLATE 15]

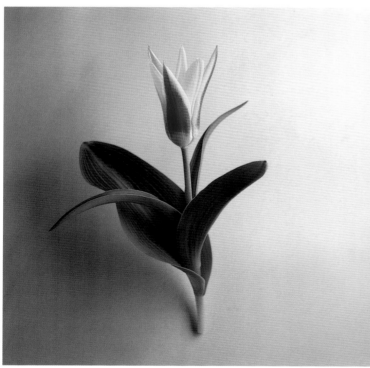

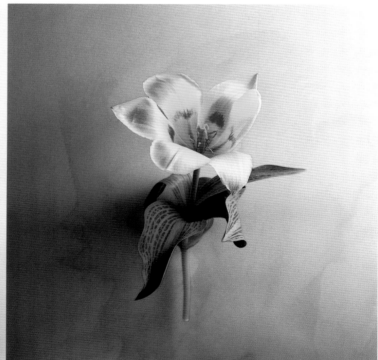

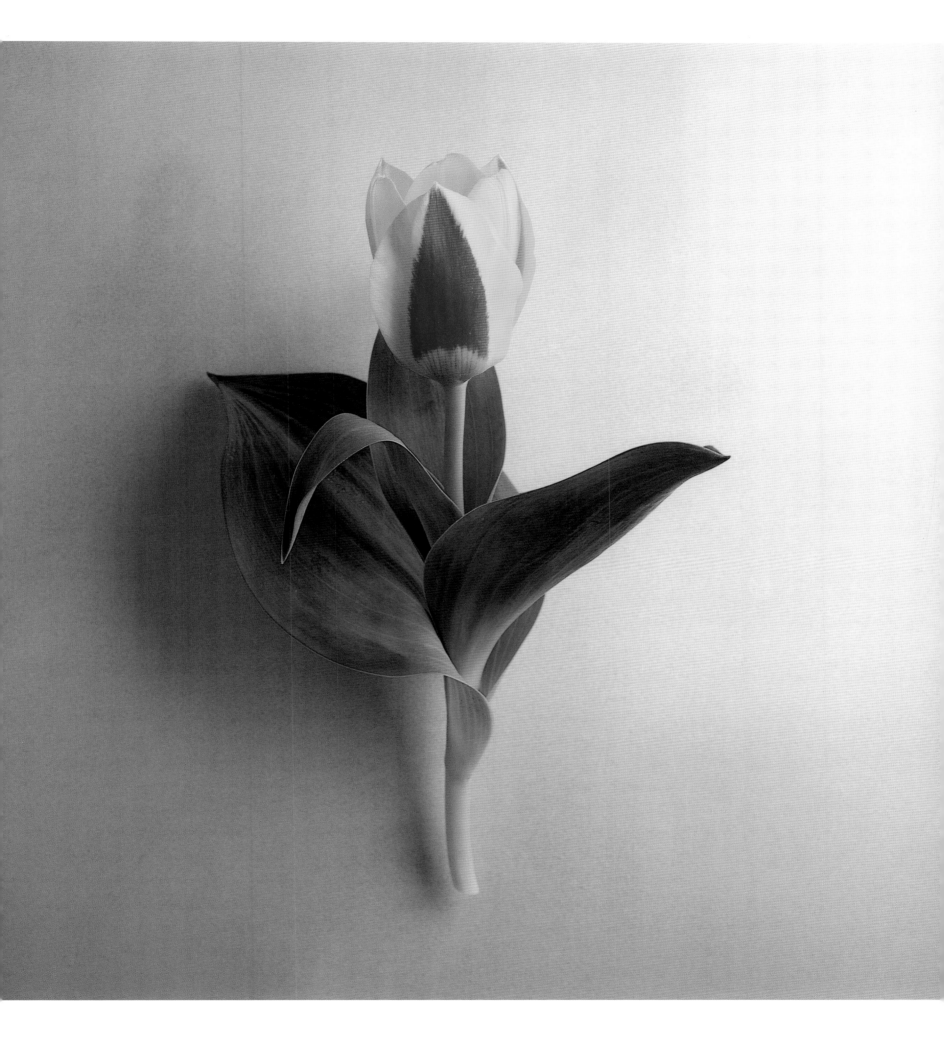

MADAME LEFEBER
Fosteriana Group
[PLATE 17]

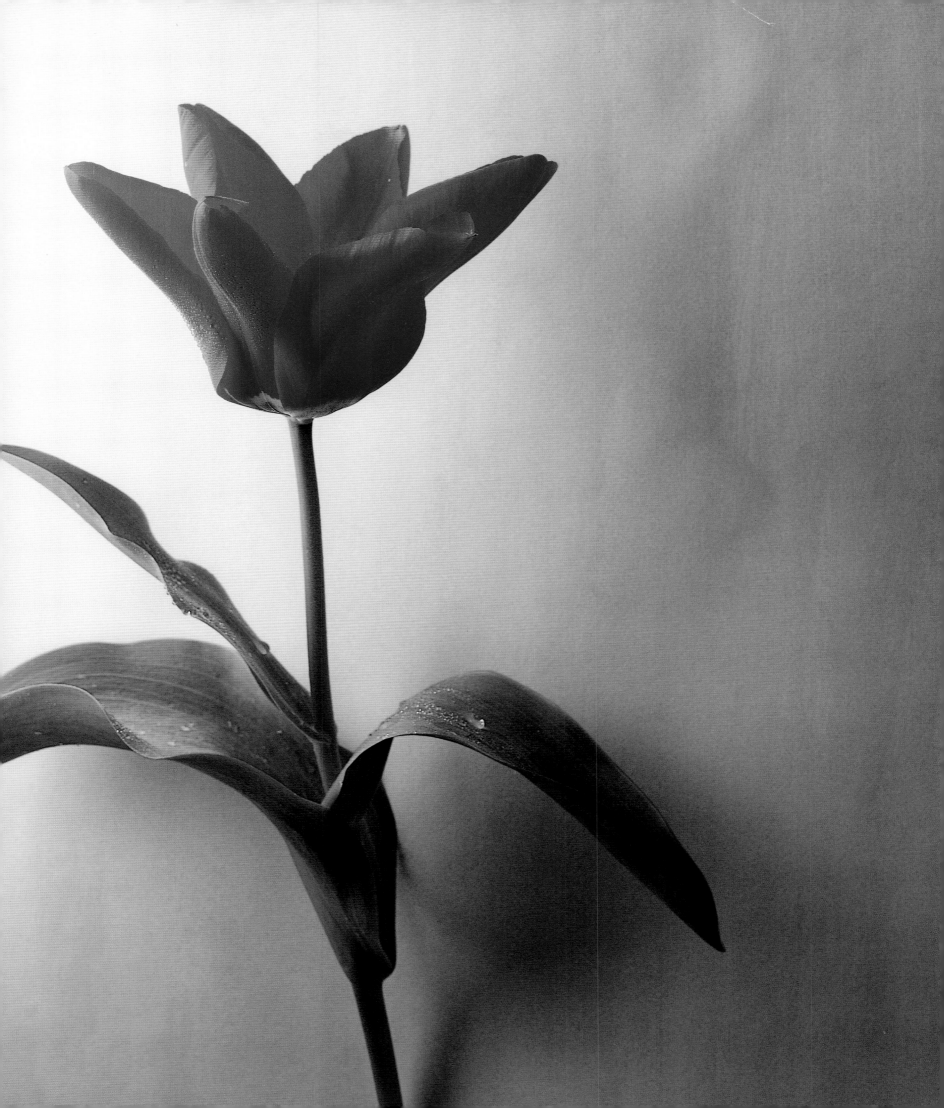

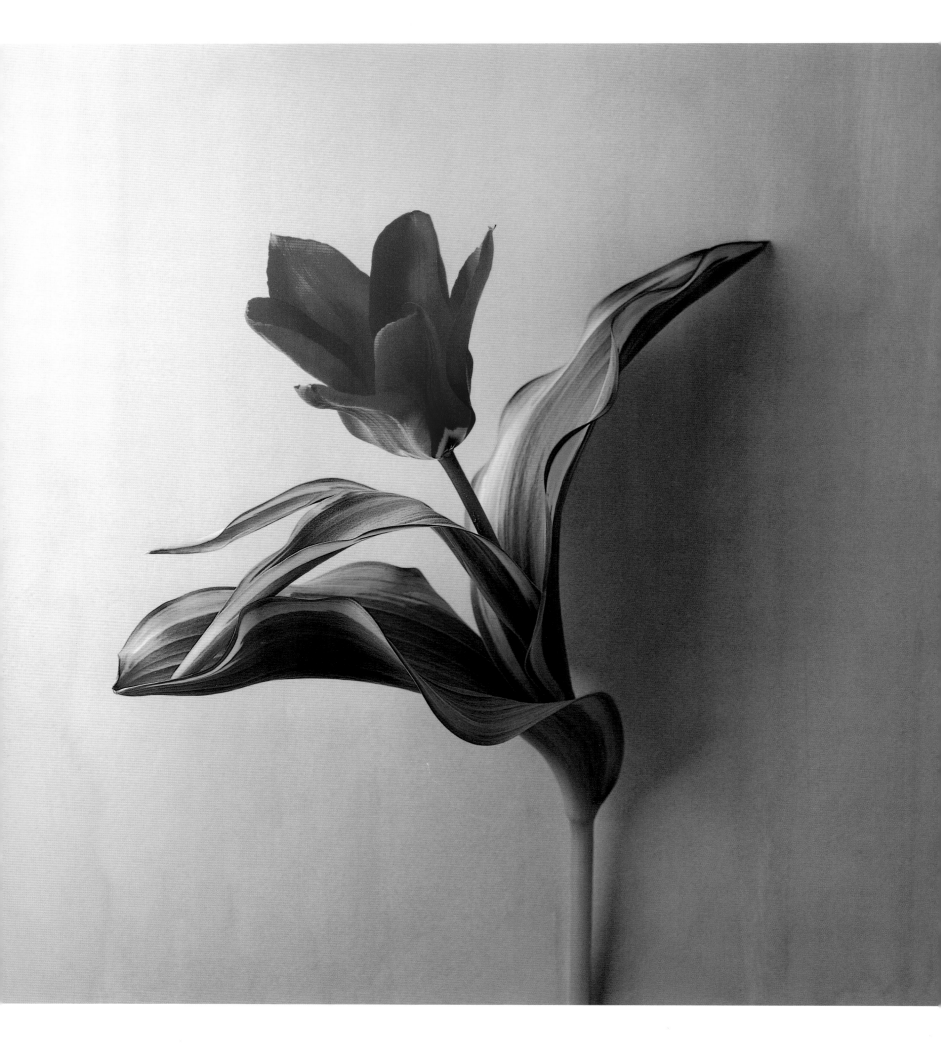

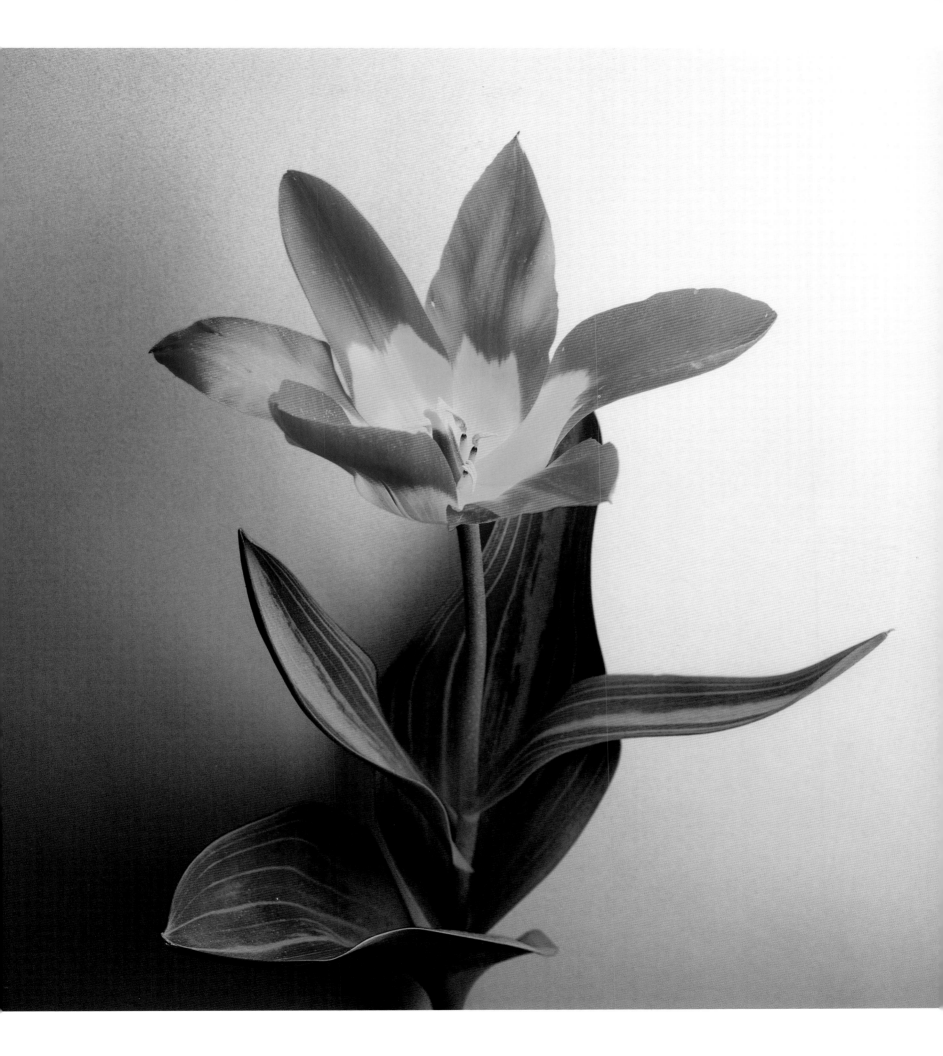

PRECEDING PAGES

ROBASSA
Fosteriana Group
[PLATE 18]

JUAN
Fosteriana Group
[PLATE 19]

PURISSIMA
Fosteriana Group
[PLATE 20]

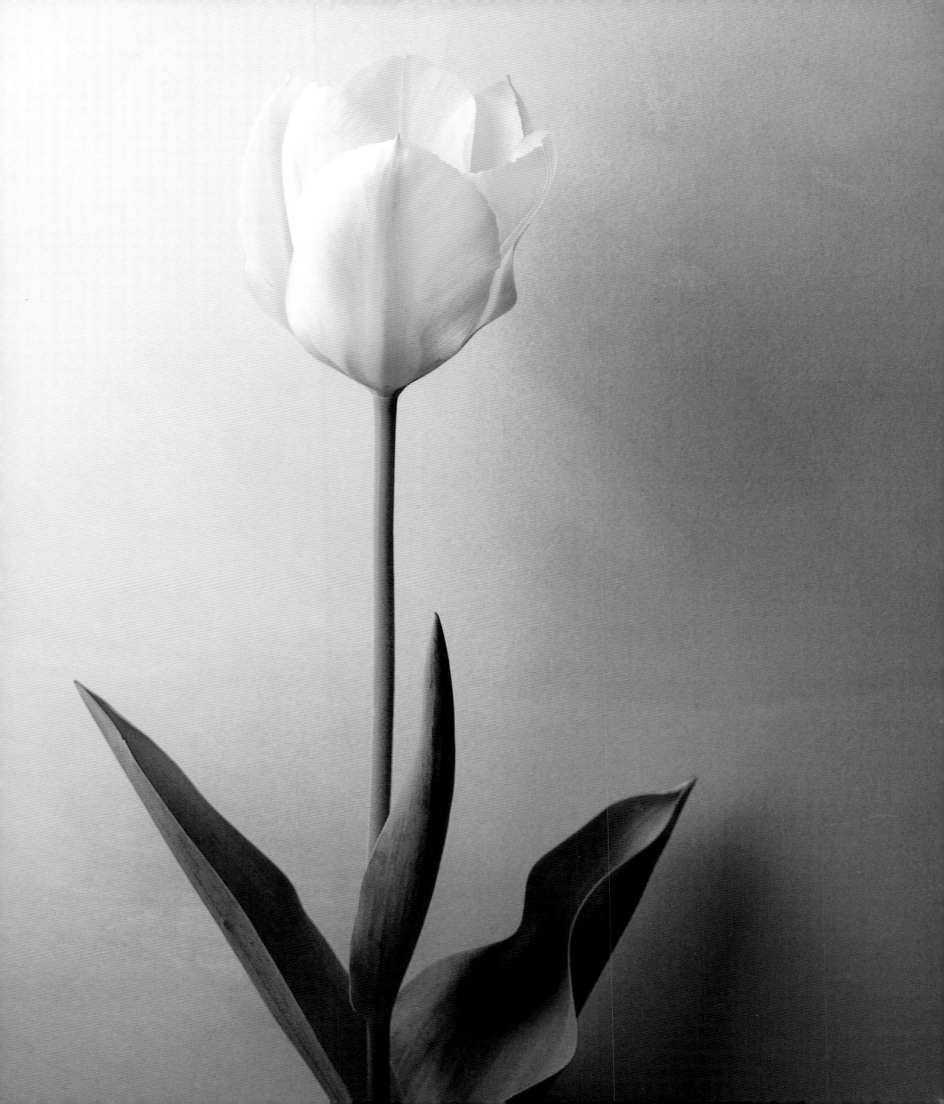

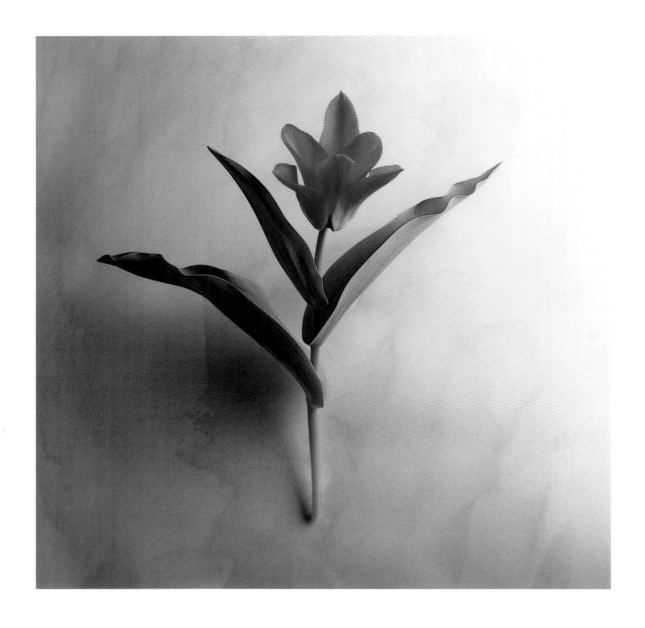

Sʏʟᴠɪᴀ ᴠᴀɴ Lᴇɴɴᴇᴘ
Fosteriana Group
[ᴘʟᴀᴛᴇ 21]

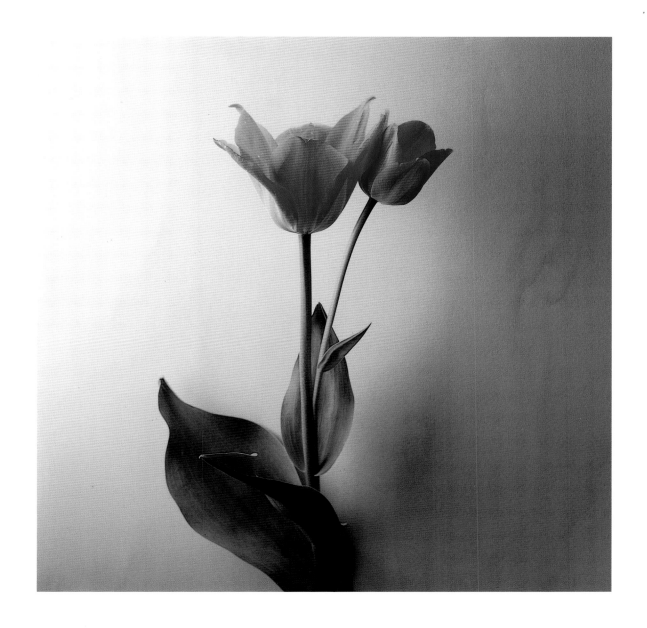

ORANGE EMPEROR
Fosteriana Group
[PLATE 22]

BRILLIANT STAR
Single Early Group
[PLATE 23]

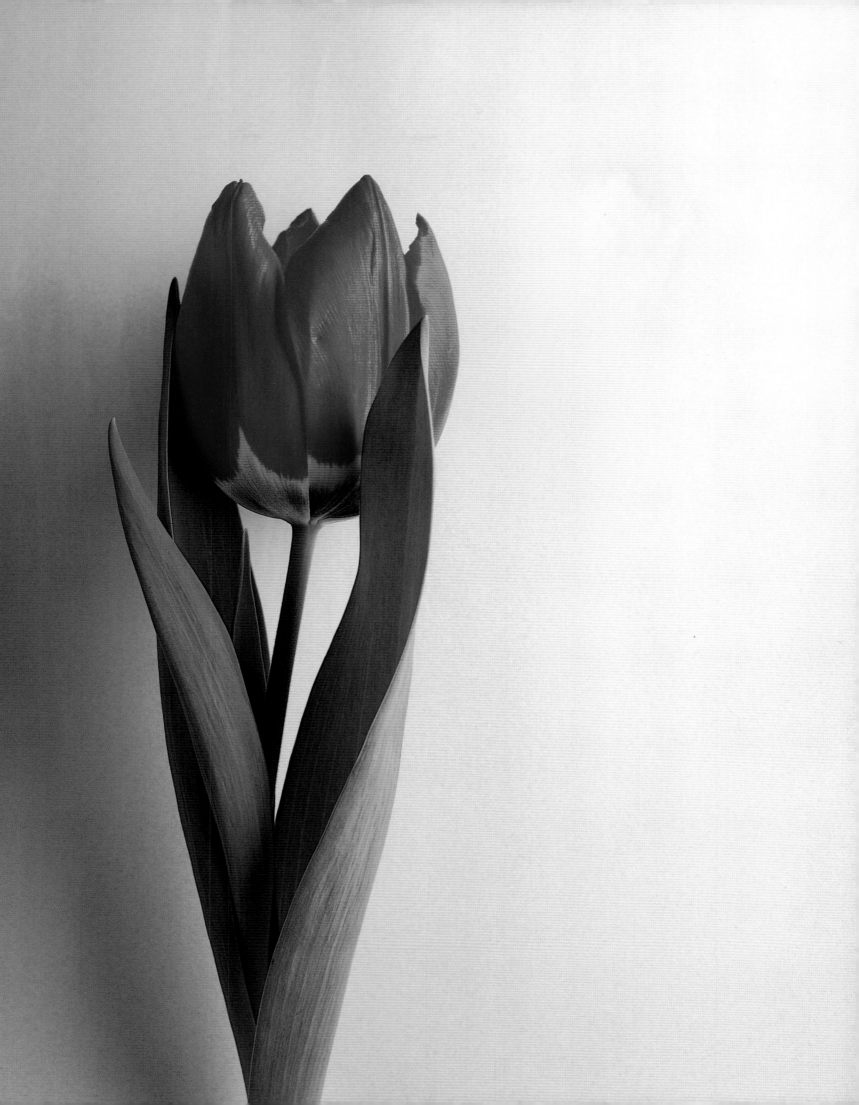

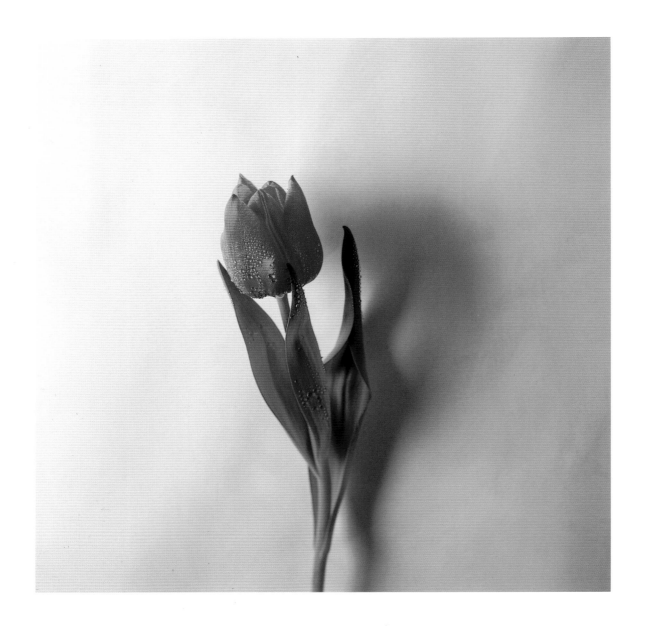

CHRISTMAS MARVEL
Single Early Group
[PLATE 24]

KEIZERSKROON
Single Early Group
[PLATE 25]

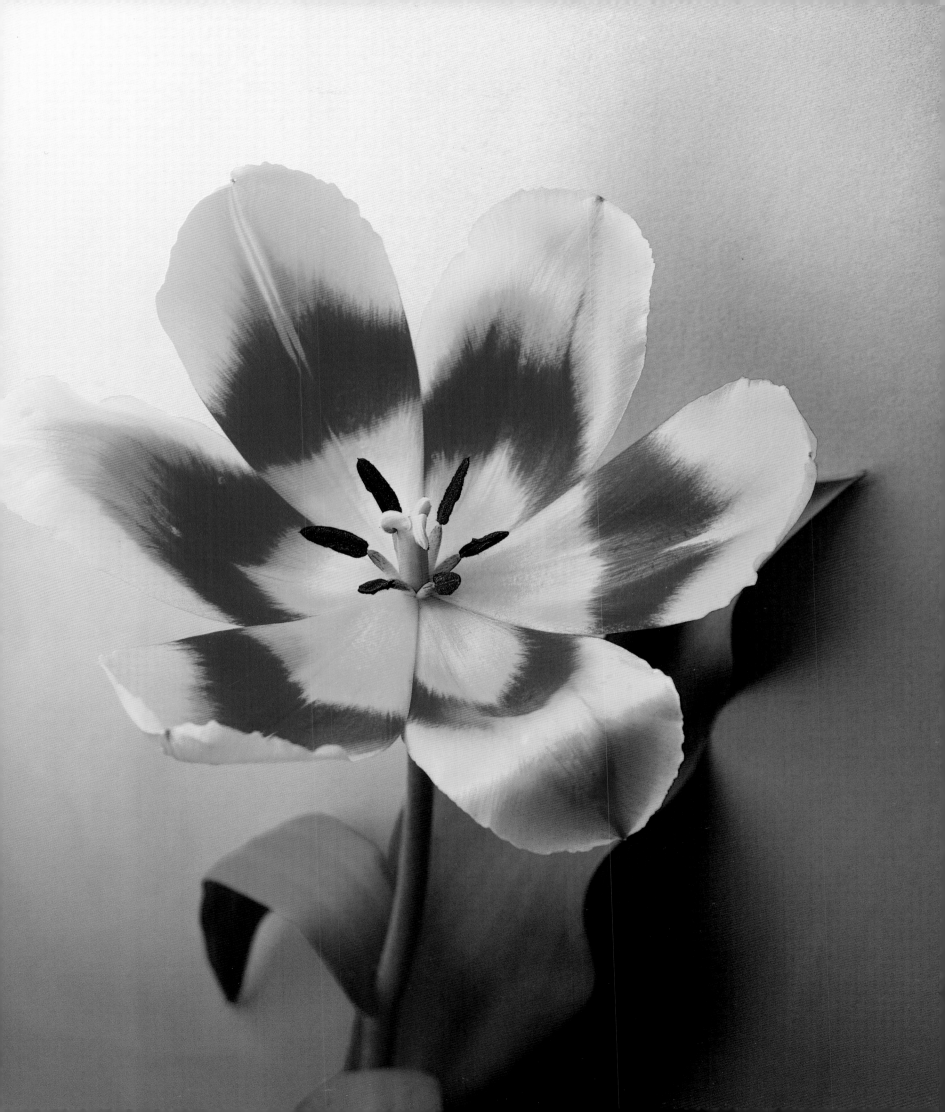

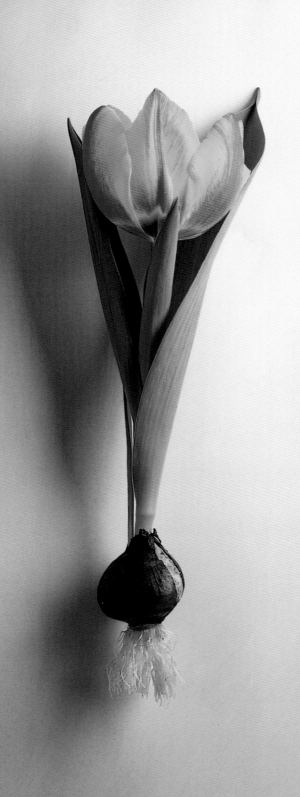

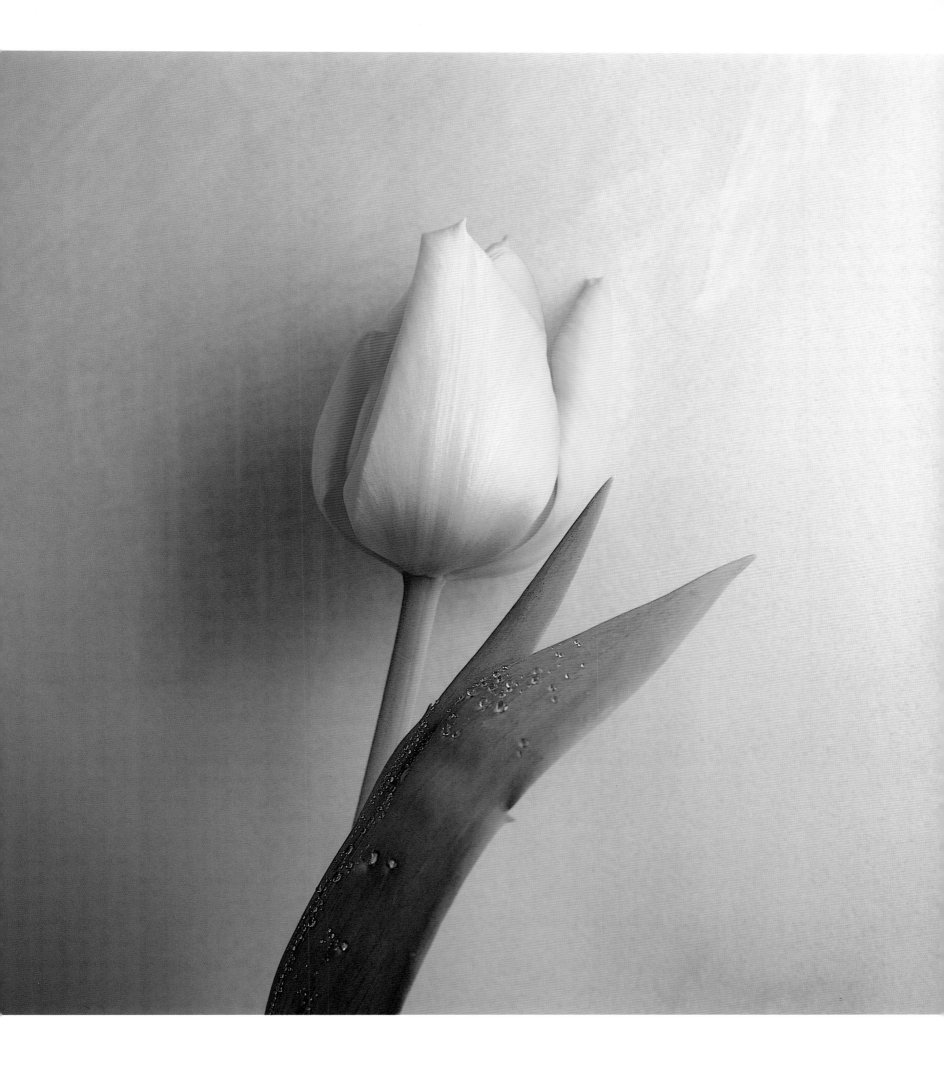

PRECEDING PAGES

FLAIR
Single Early Group
[PLATE 26]

APRICOT BEAUTY
Single Early Group
[PLATE 27]

MURILLO
Double Early Group
[PLATE 29]

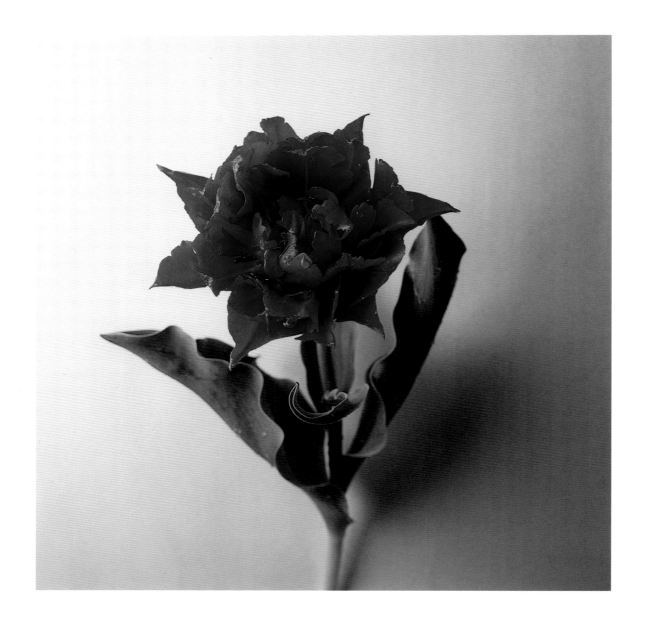

DAVID TENIERS
Double Early Group
[PLATE 28]

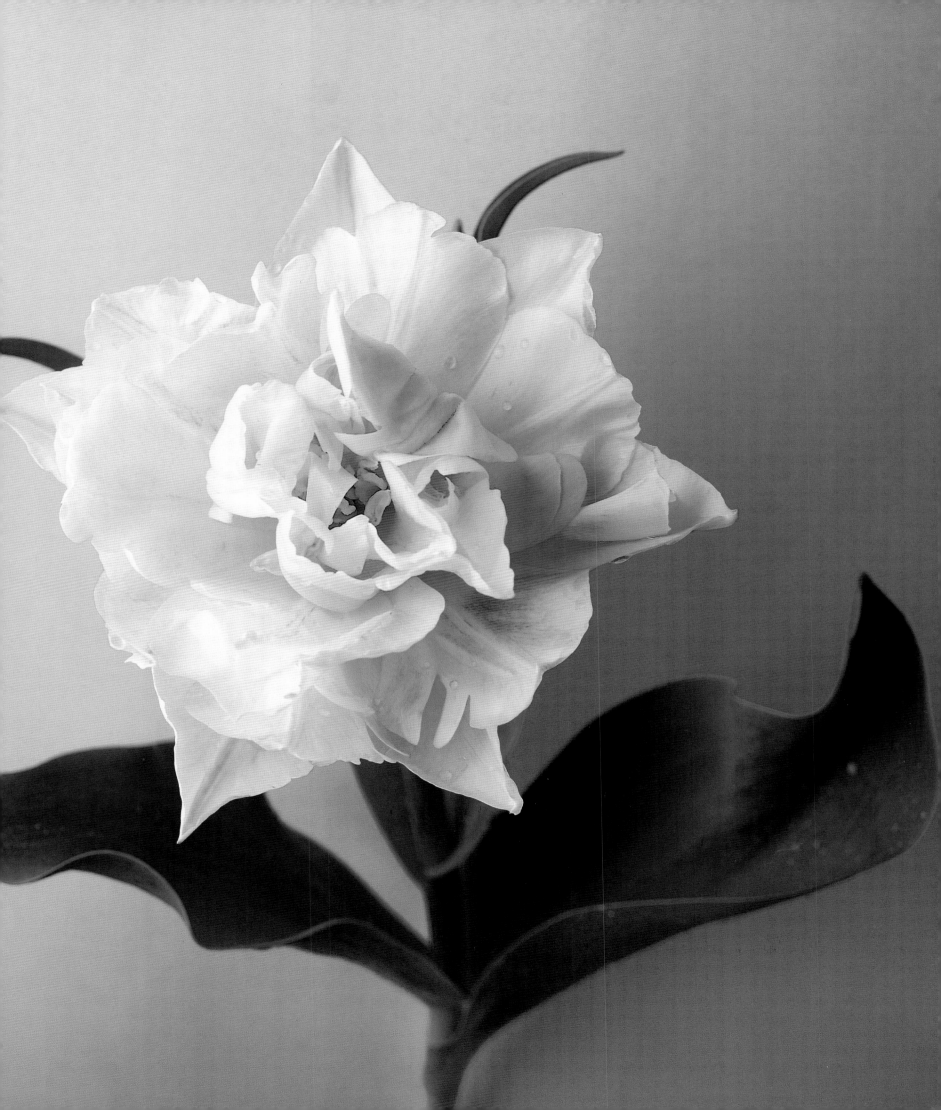

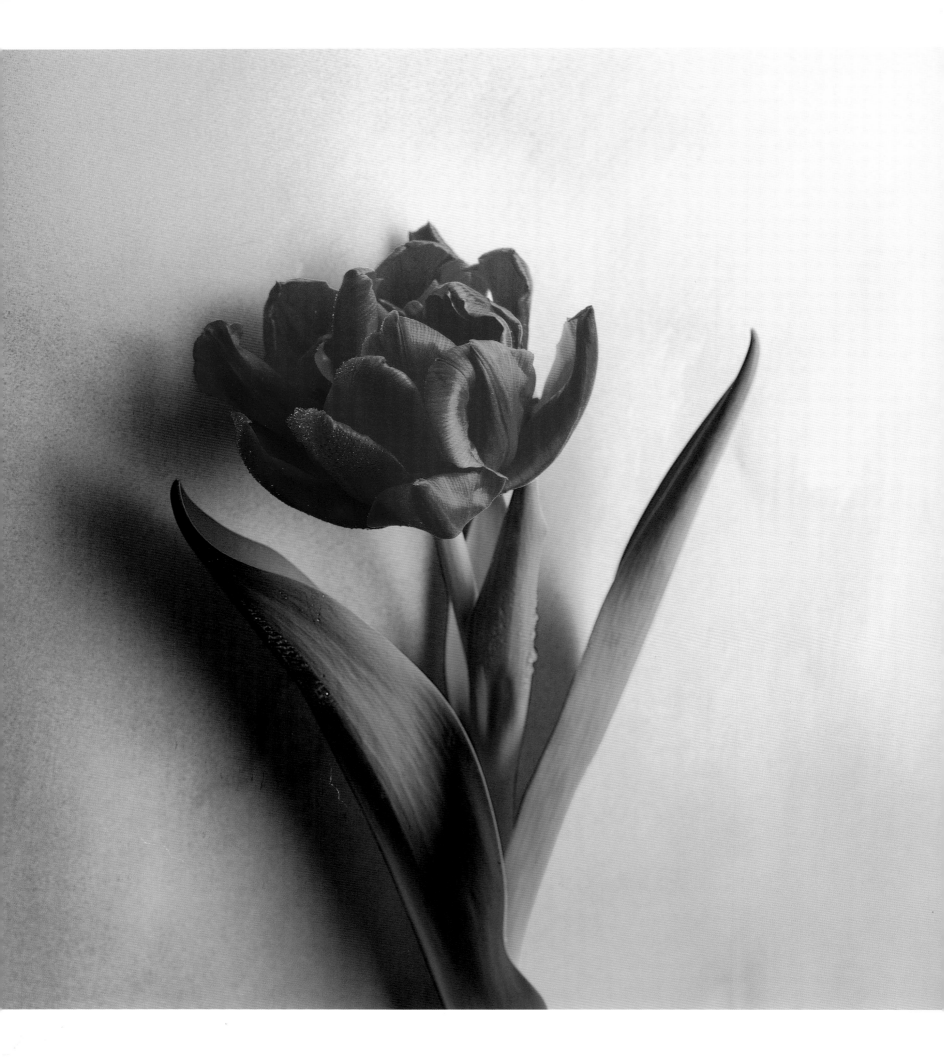

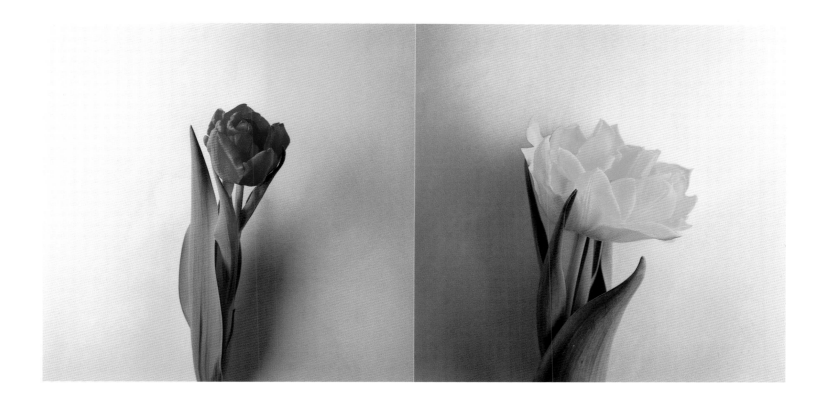

ARIE ALKEMADE'S MEMORY
Double Early Group
[PLATE 31]

MONTE CARLO
Double Early Group
[PLATE 32]

STOCKHOLM
Double Early Group
[PLATE 30]

MONSELLA
Double Early Group
[PLATE 33]

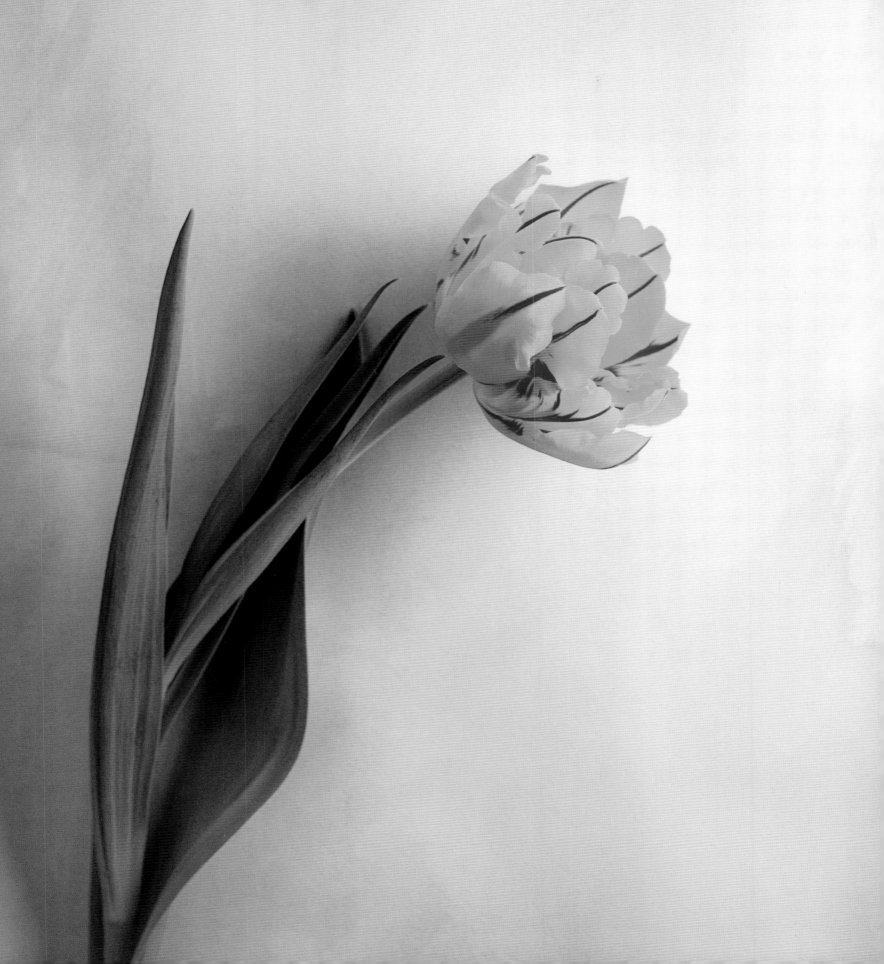

T. ferganica
Mid-Season Flowering Species
[PLATE 34]

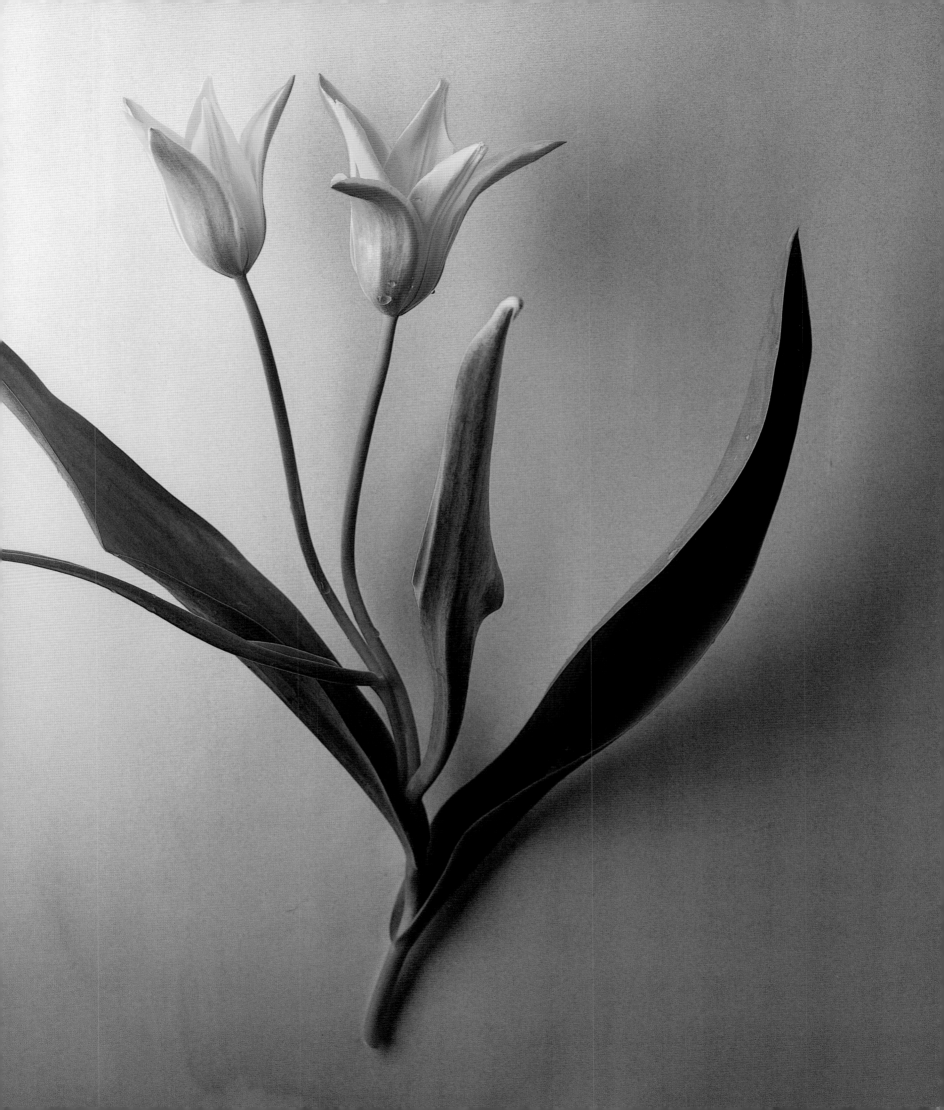

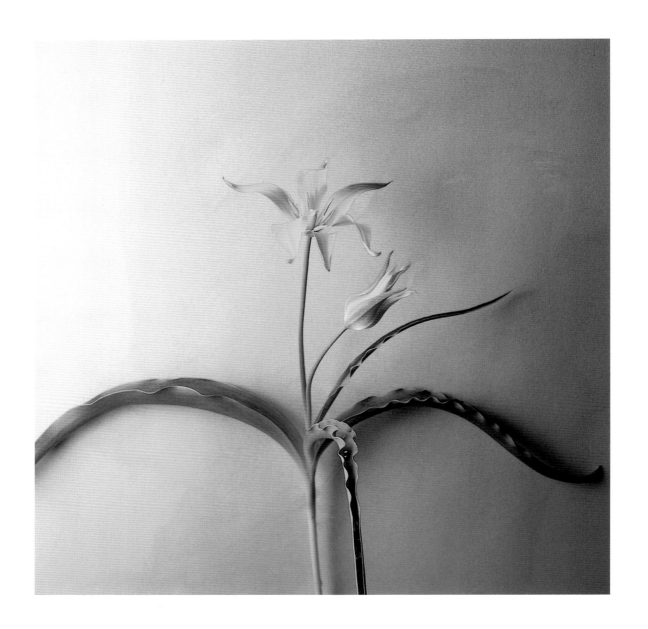

T. kolpakowskiana
Mid-Season Flowering Species
[PLATE 35]

T. wilsoniana
Mid-Season Flowering Species
[PLATE 36]

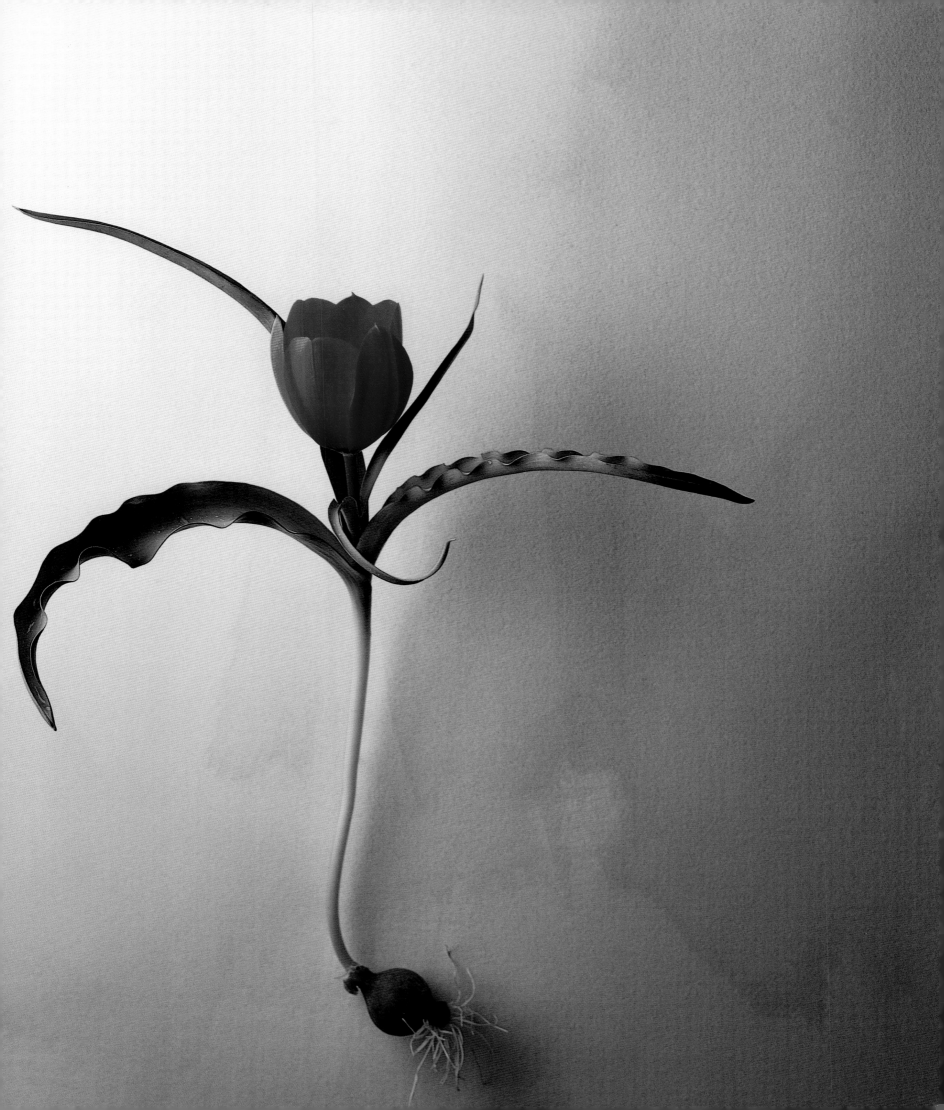

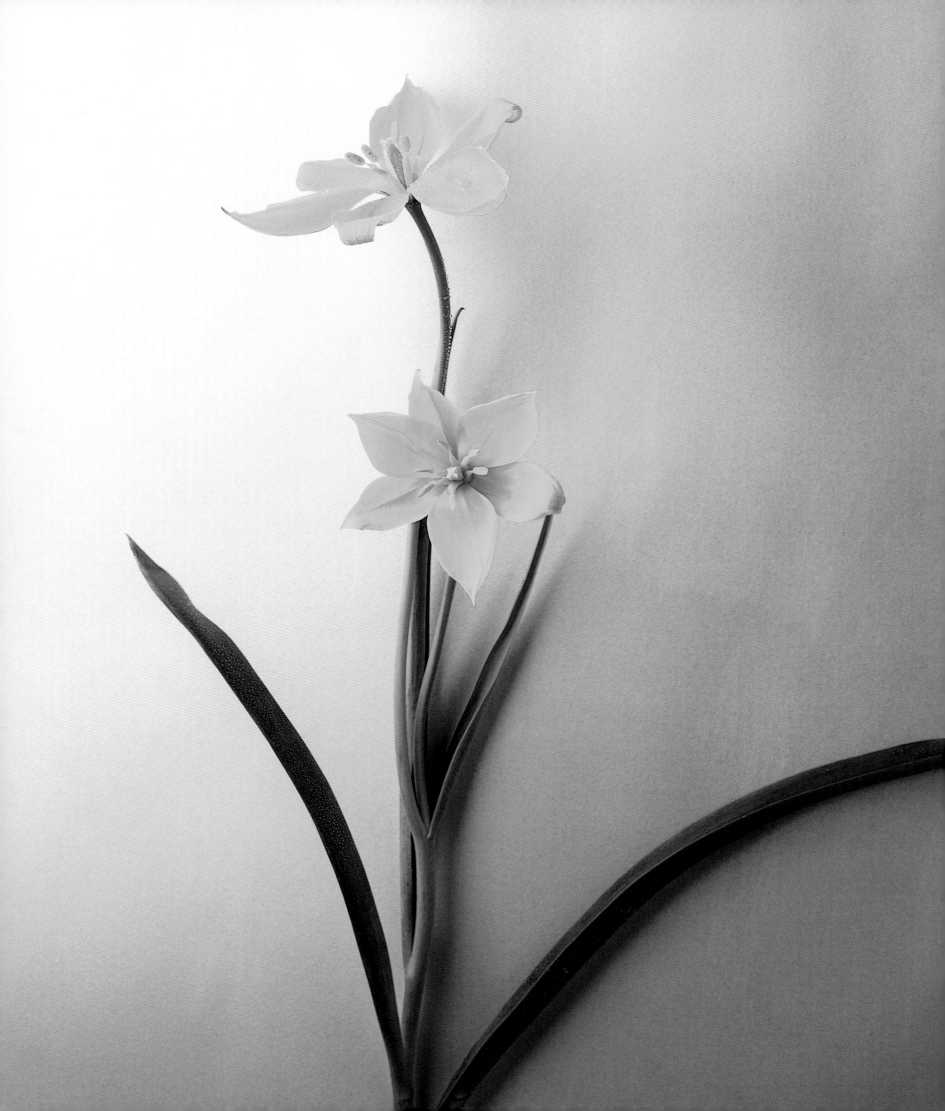

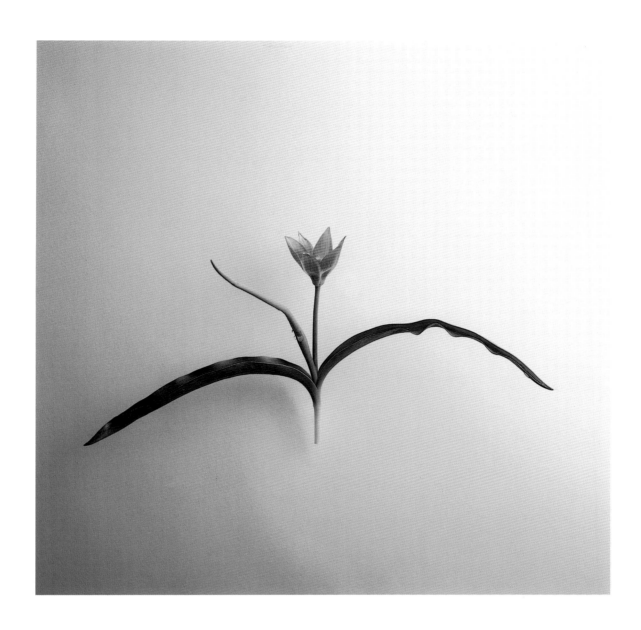

T. aucheriana
Mid-Season Flowering Species
[PLATE 38]

T. sylvestris
Mid-Season Flowering Species
[PLATE 37]

AD REM
Darwinhybrid Group
[PLATE 39]

FOLLOWING PAGES

PINK IMPRESSION
Darwinhybrid Group
[PLATE 40]

TENDER BEAUTY
Darwinhybrid Group
[PLATE 41]

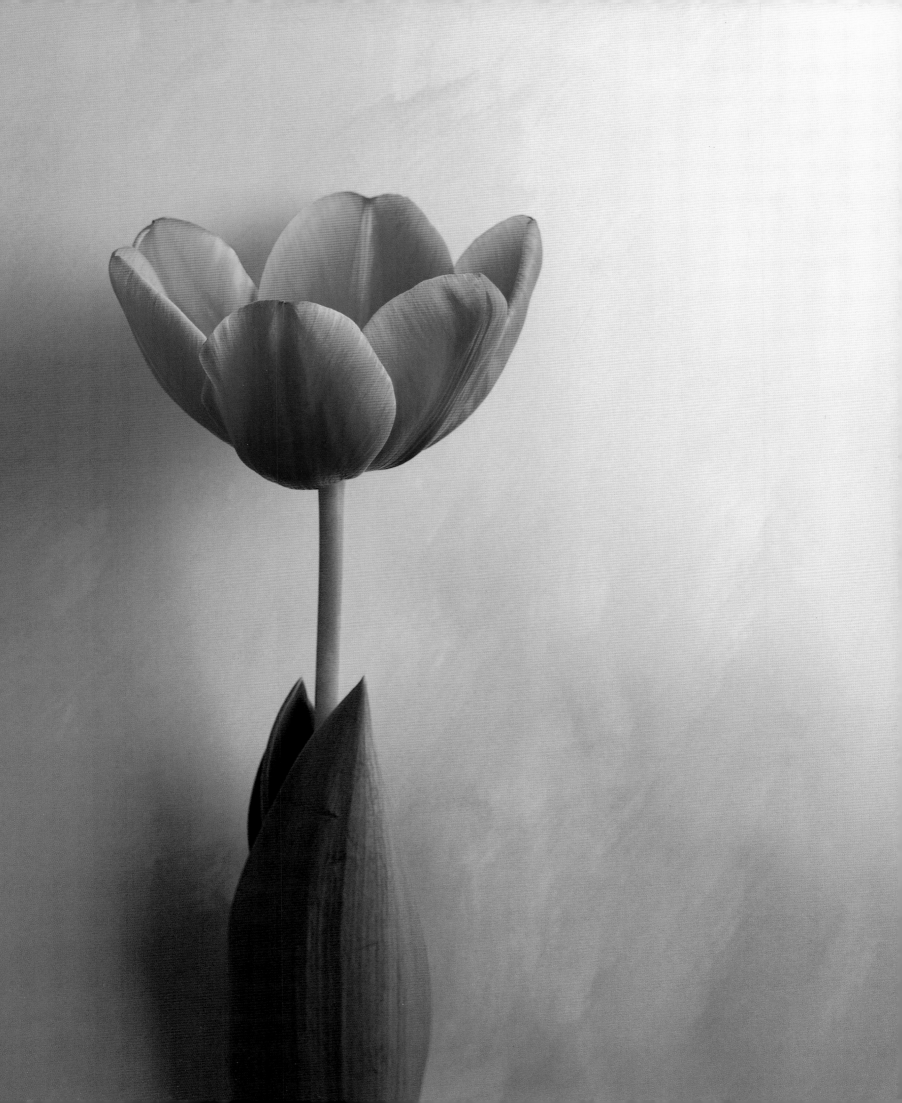

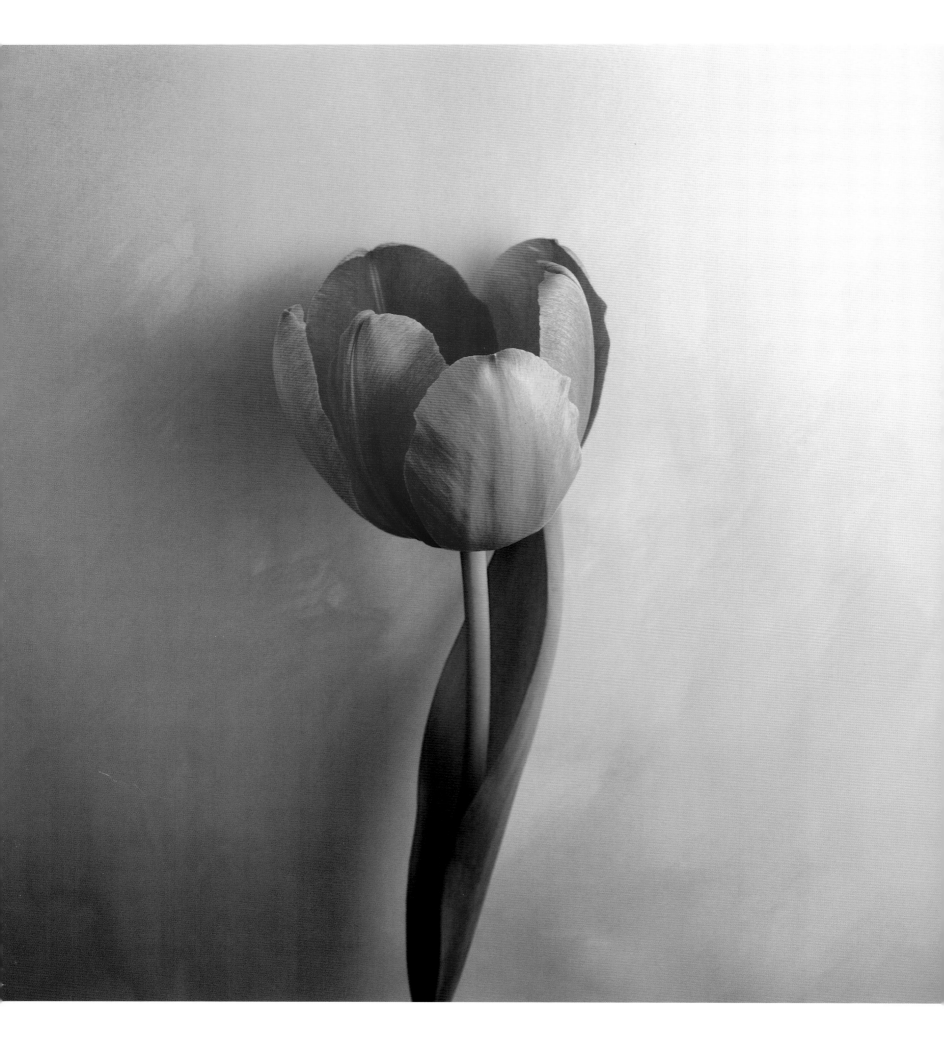

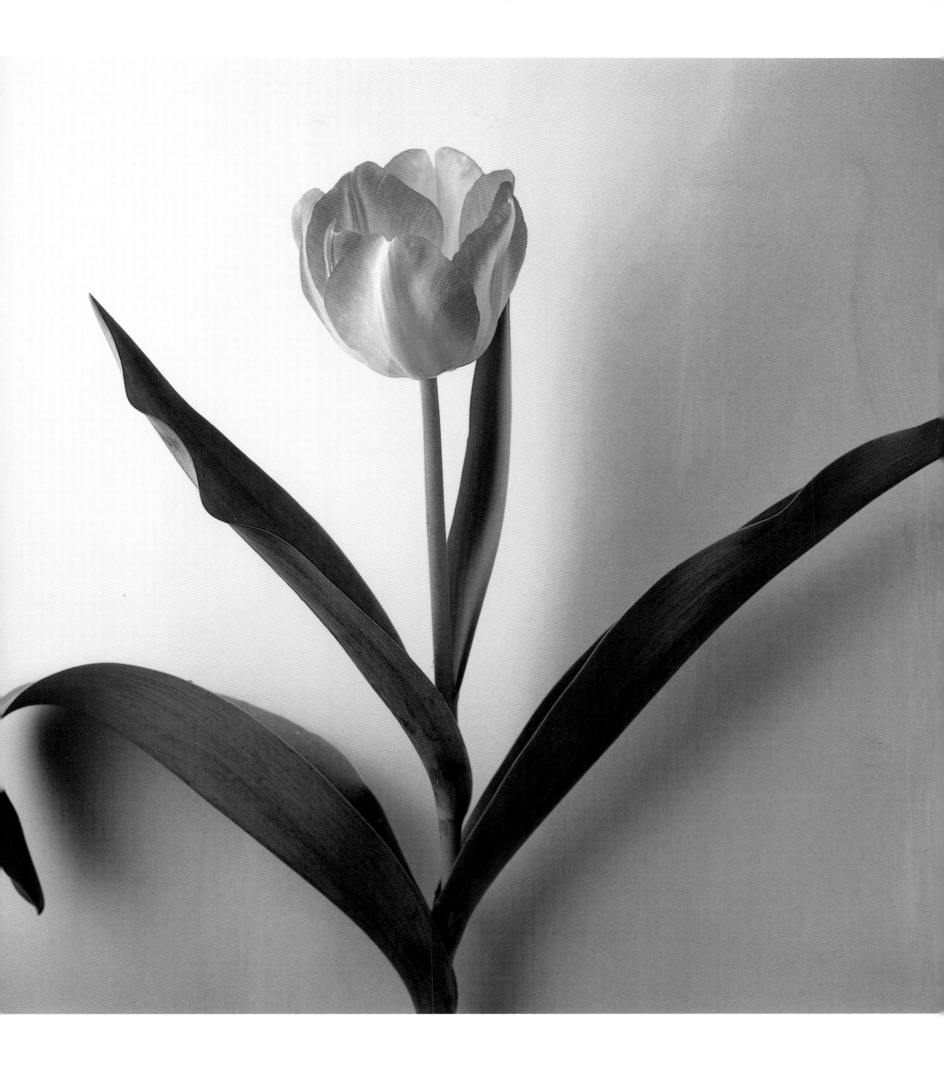

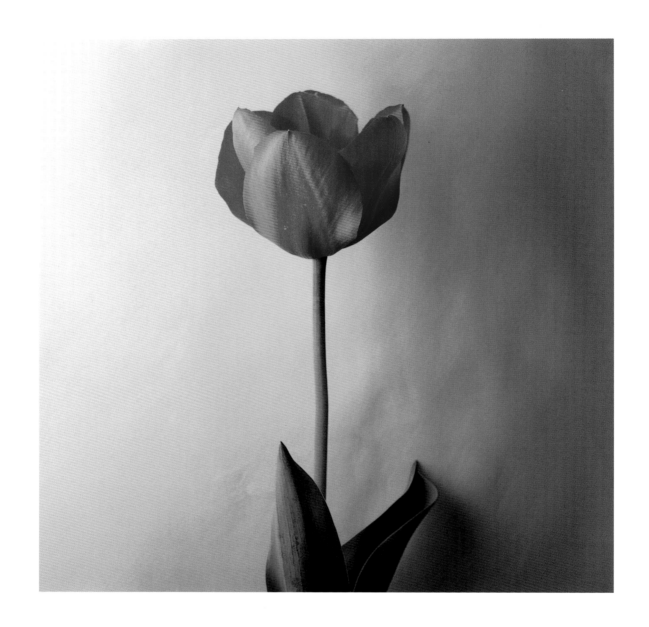

HOLLANDS GLORIE
Darwinhybrid Group
[PLATE 42]

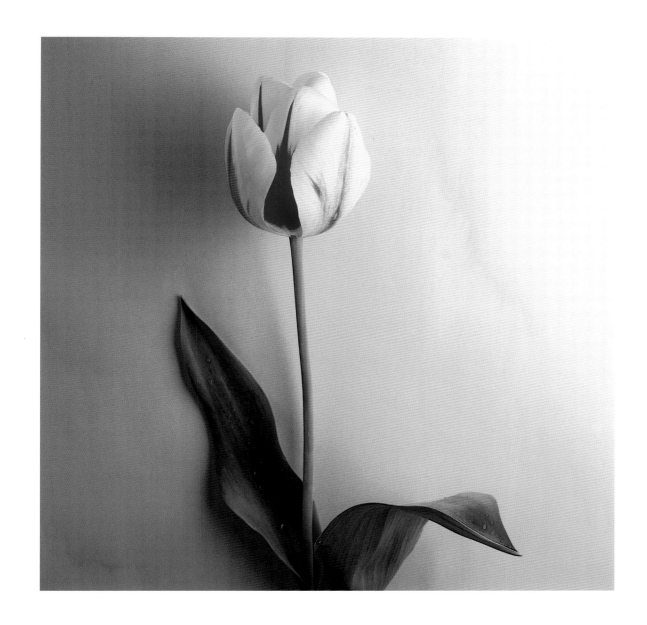

BURNING HEART
Darwinhybrid Group
[PLATE 43]

APELDOORN
Darwinhybrid Group
[PLATE 44]

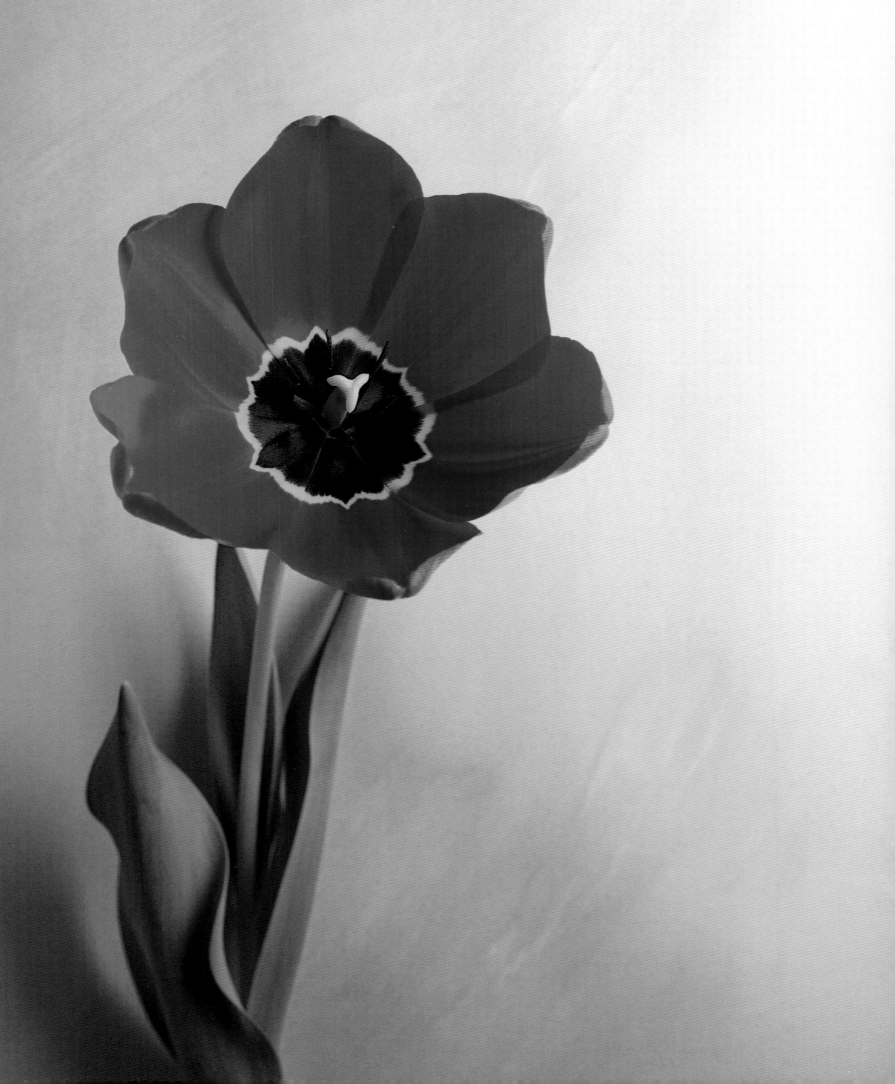

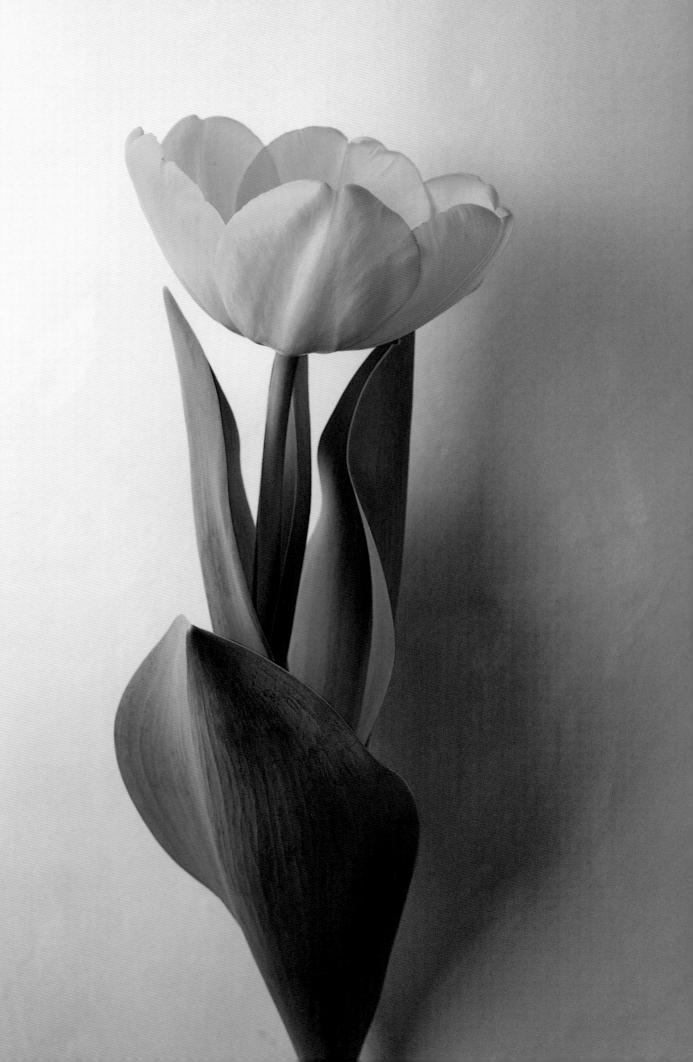

GOLDEN APELDOORN
Darwinhybrid Group
[PLATE 45]

ORANJEZON
Darwinhybrid Group
[PLATE 46]

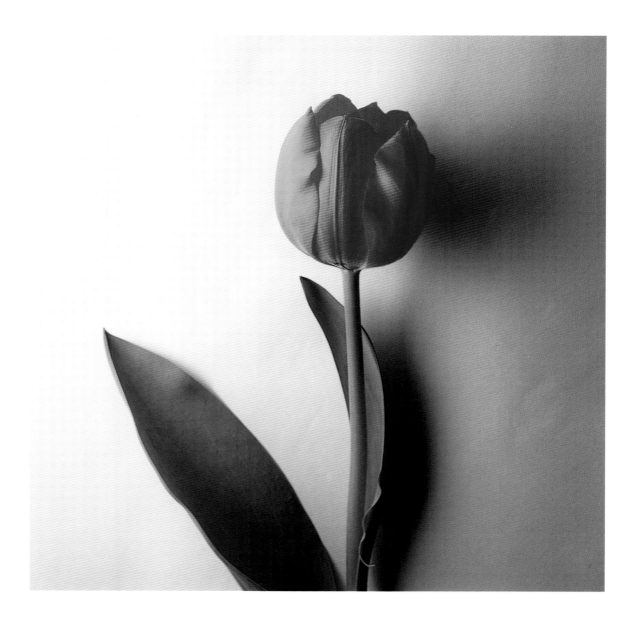

AFRICAN QUEEN
Triumph Group
[PLATE 47]

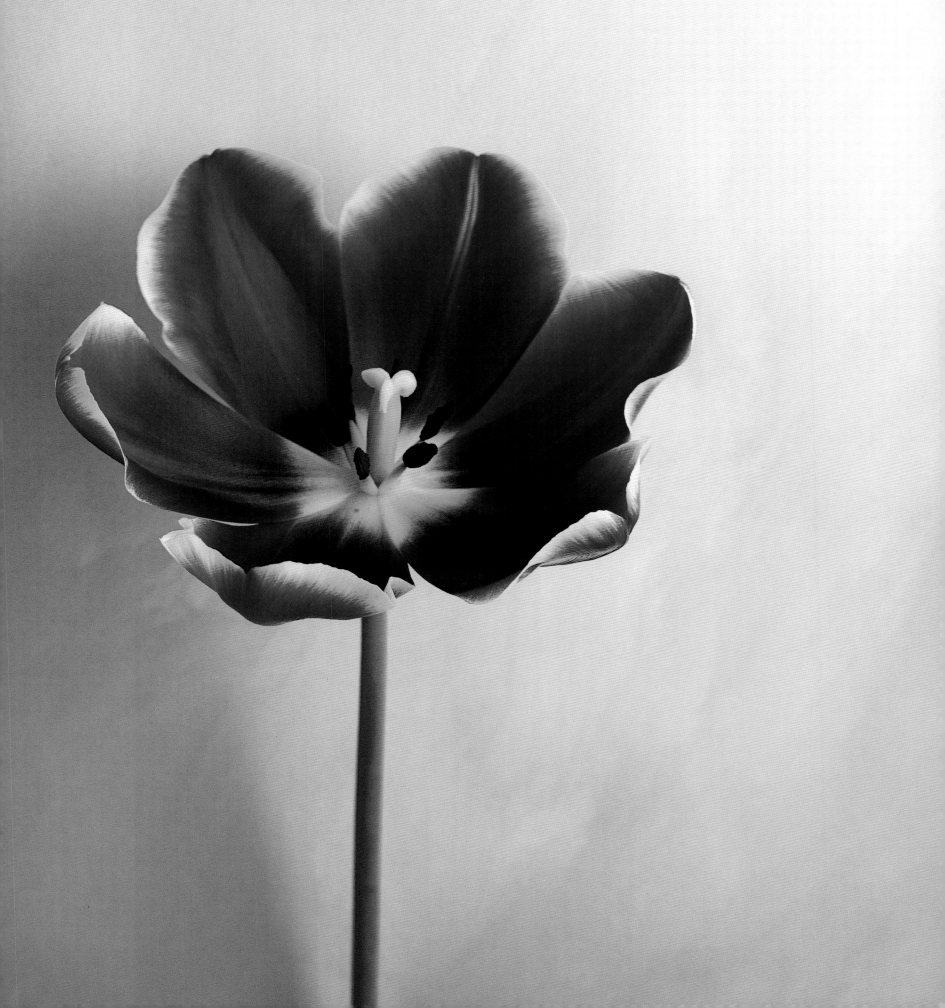

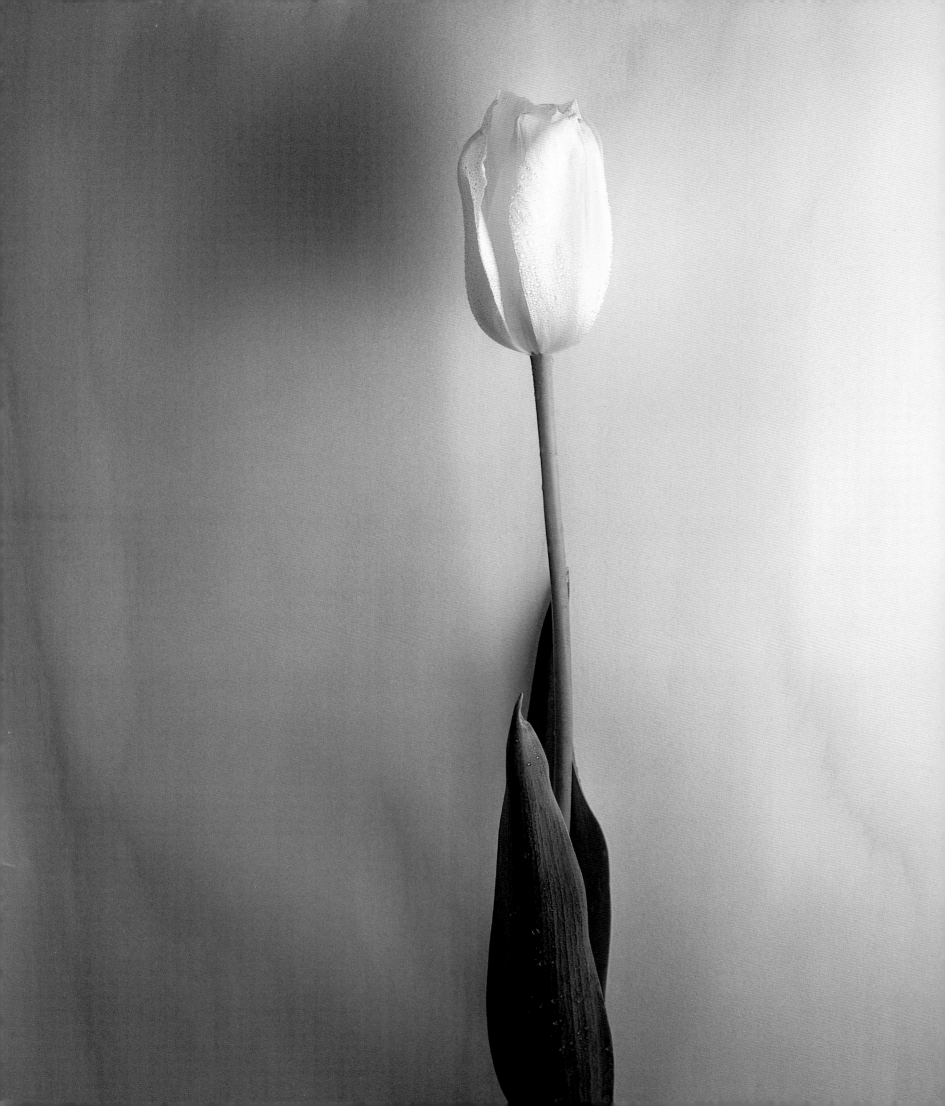

FRANÇOISE
Triumph Group
[PLATE 48]

PEER GYNT
Triumph Group
[PLATE 49]

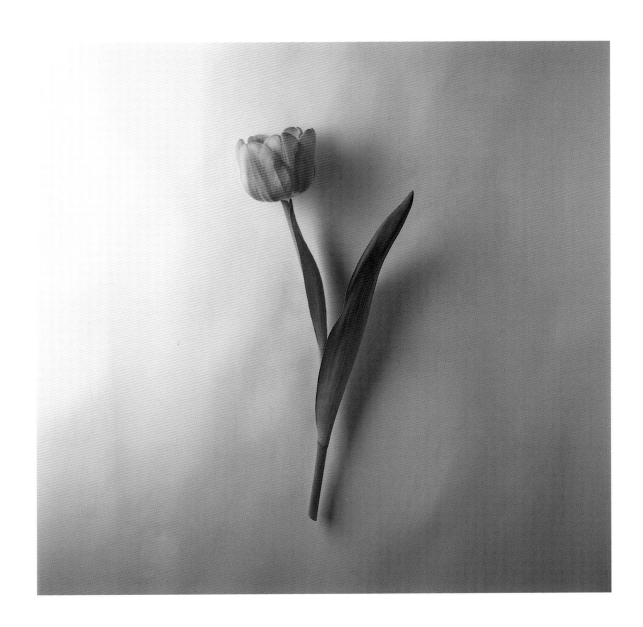

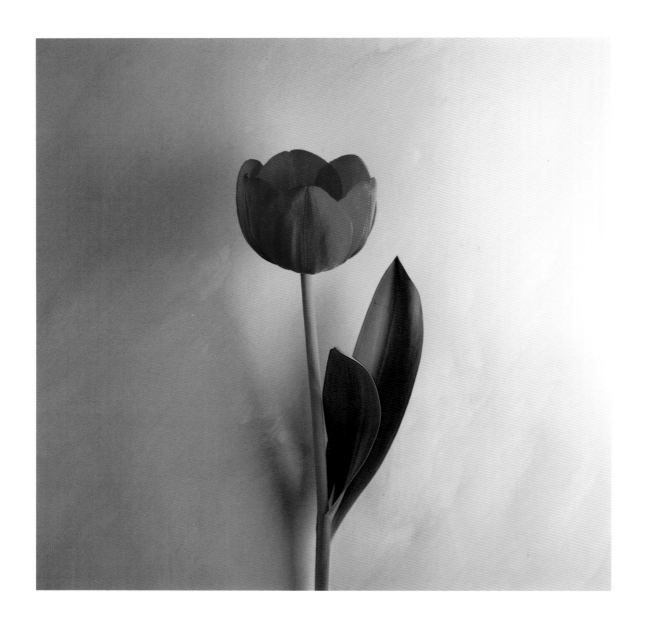

SEVILLA
Triumph Group
[PLATE 50]

HAPPY GENERATION
Triumph Group
[PLATE 51]

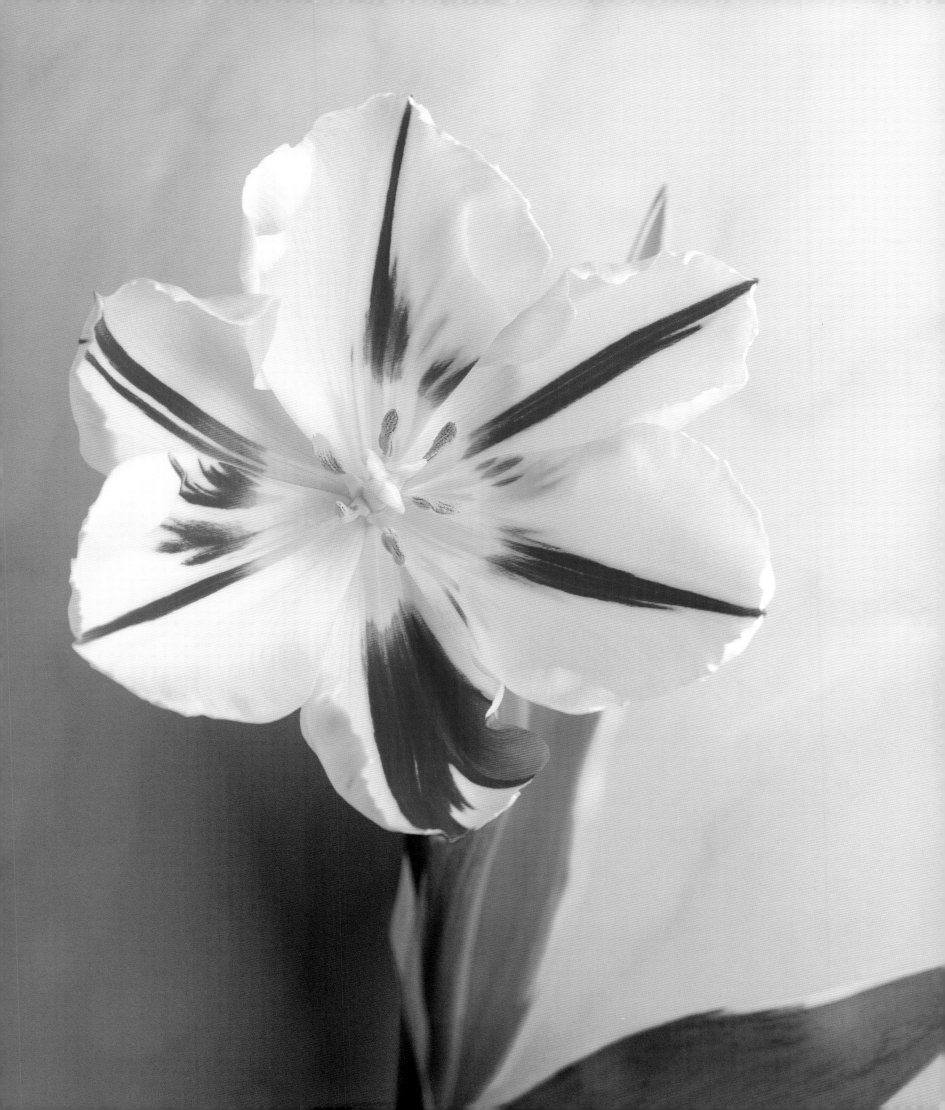

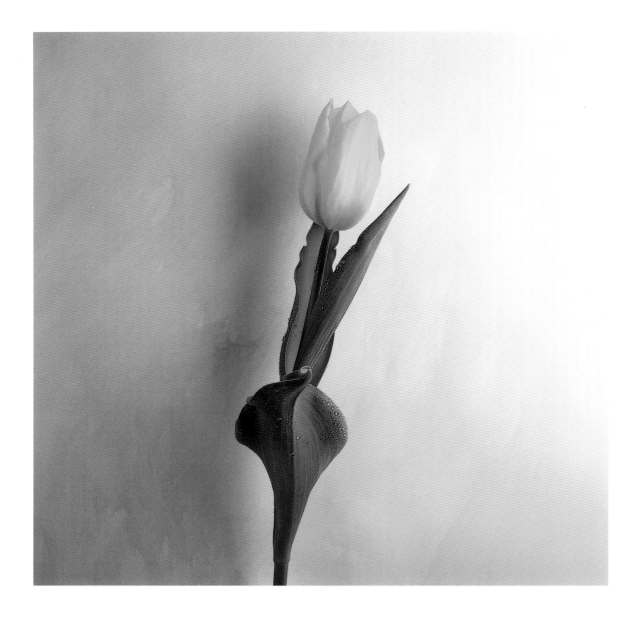

STRONG GOLD
Triumph Group
[PLATE 52]

PROMINENCE
Triumph Group
[PLATE 53]

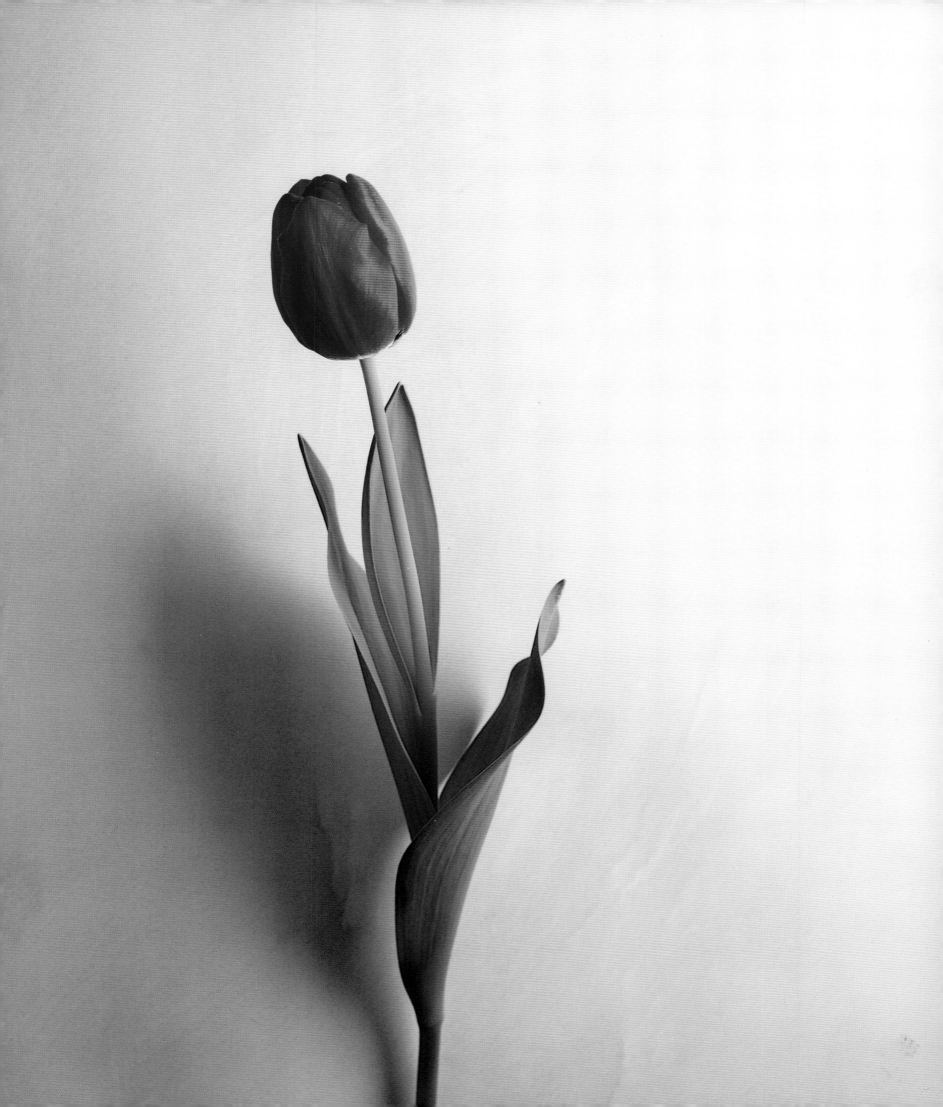

PRINCESS VICTORIA
Triumph Group
[PLATE 54]

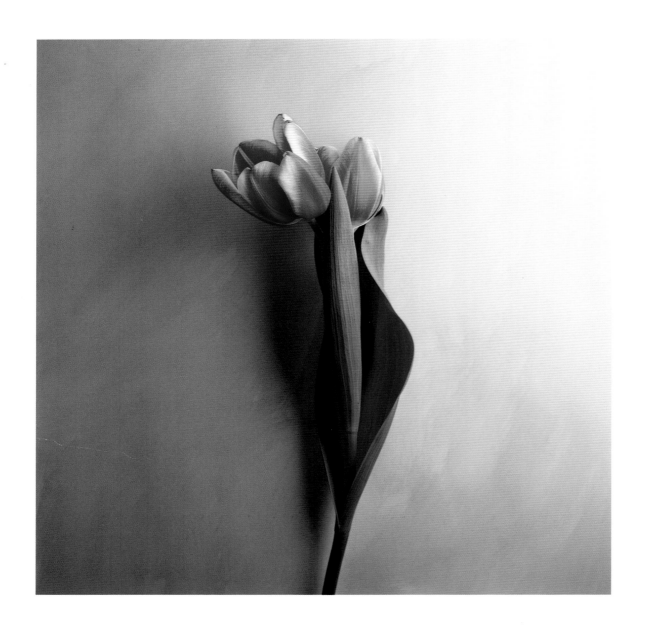

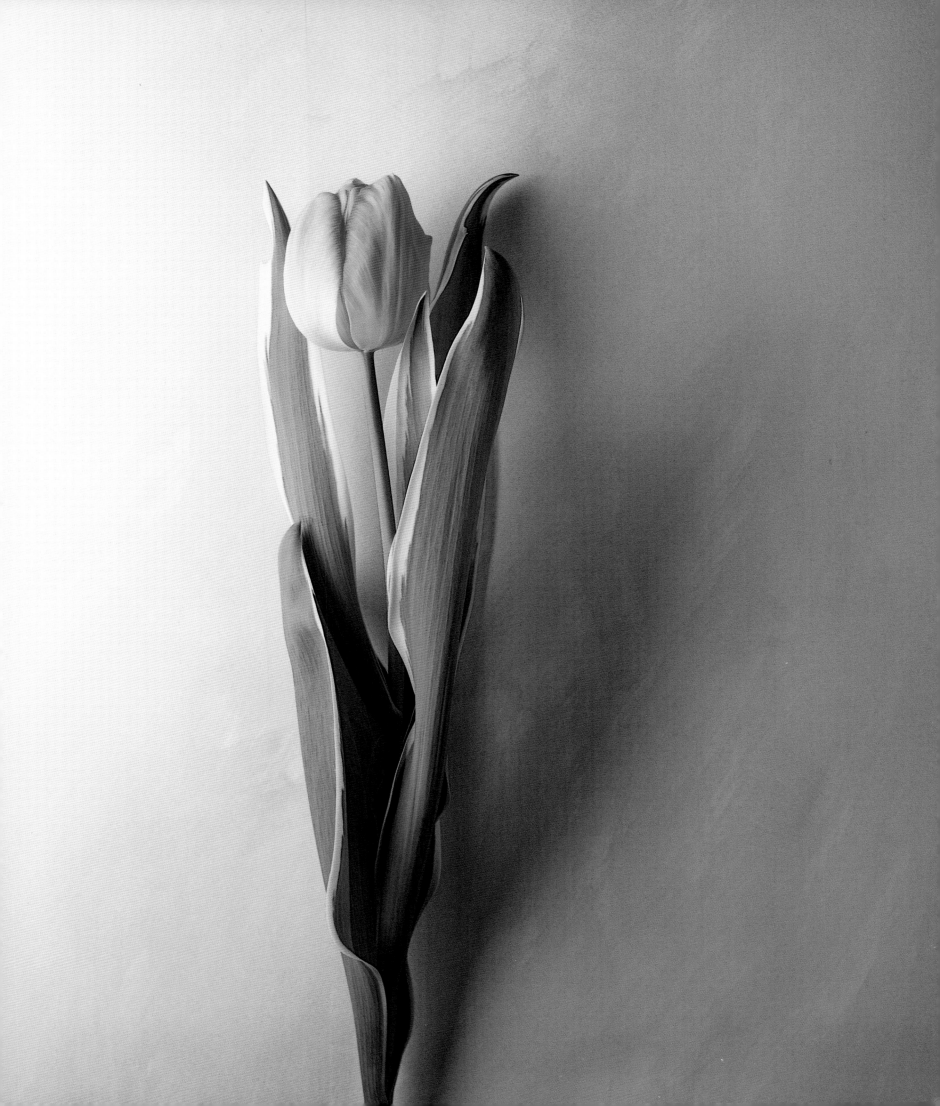

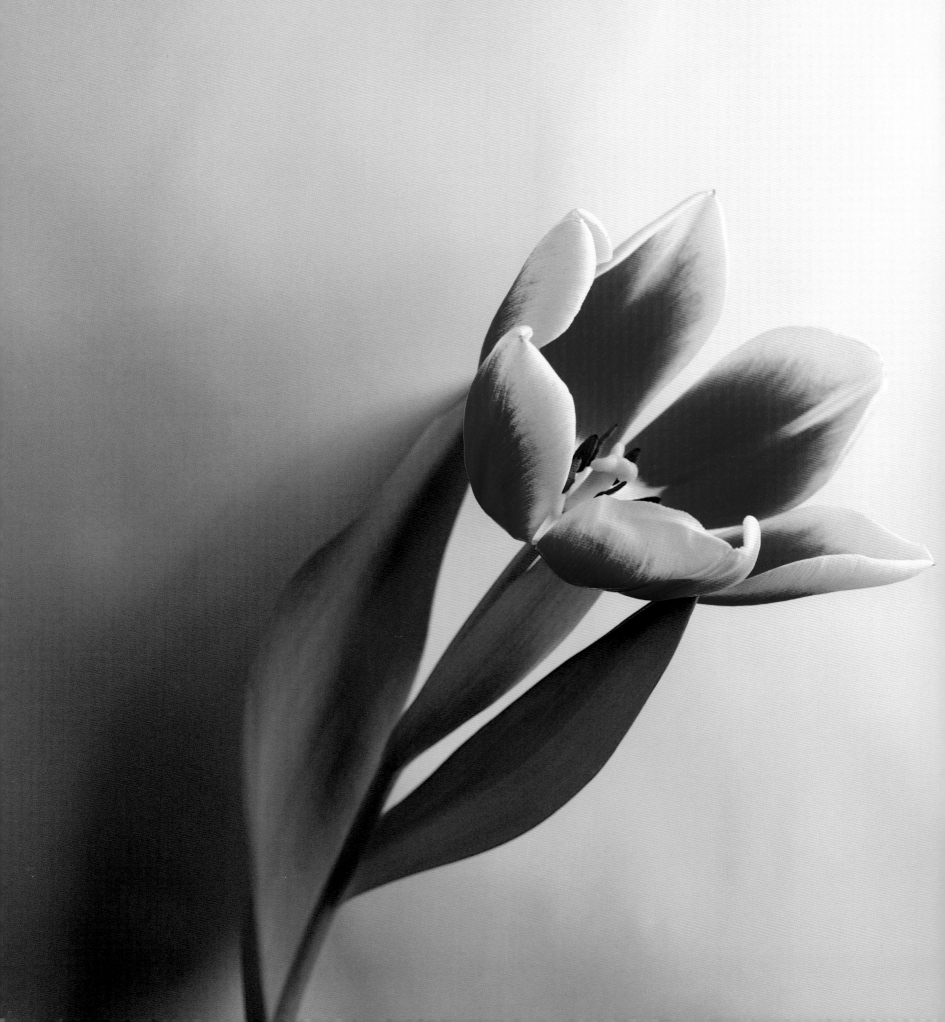

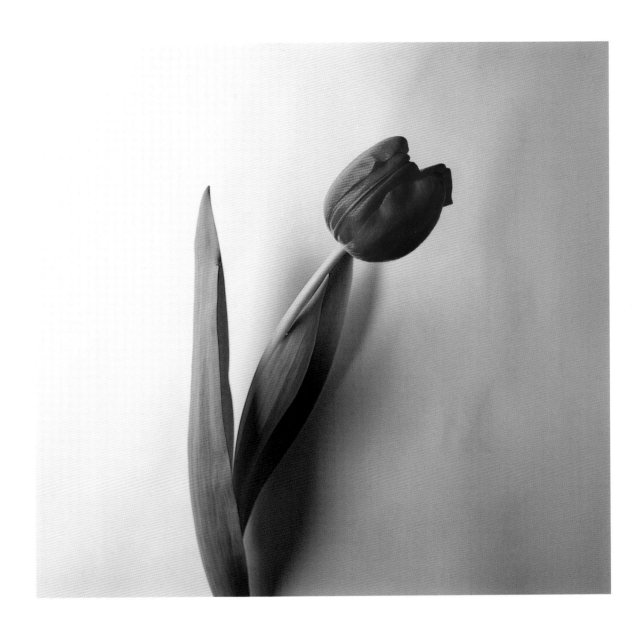

ARIE HOEK
Triumph Group
[PLATE 57]

LUSTIGE WITWE
Triumph Group
[PLATE 56]

ORANGE BOUQUET
Triumph Group
[PLATE 58]

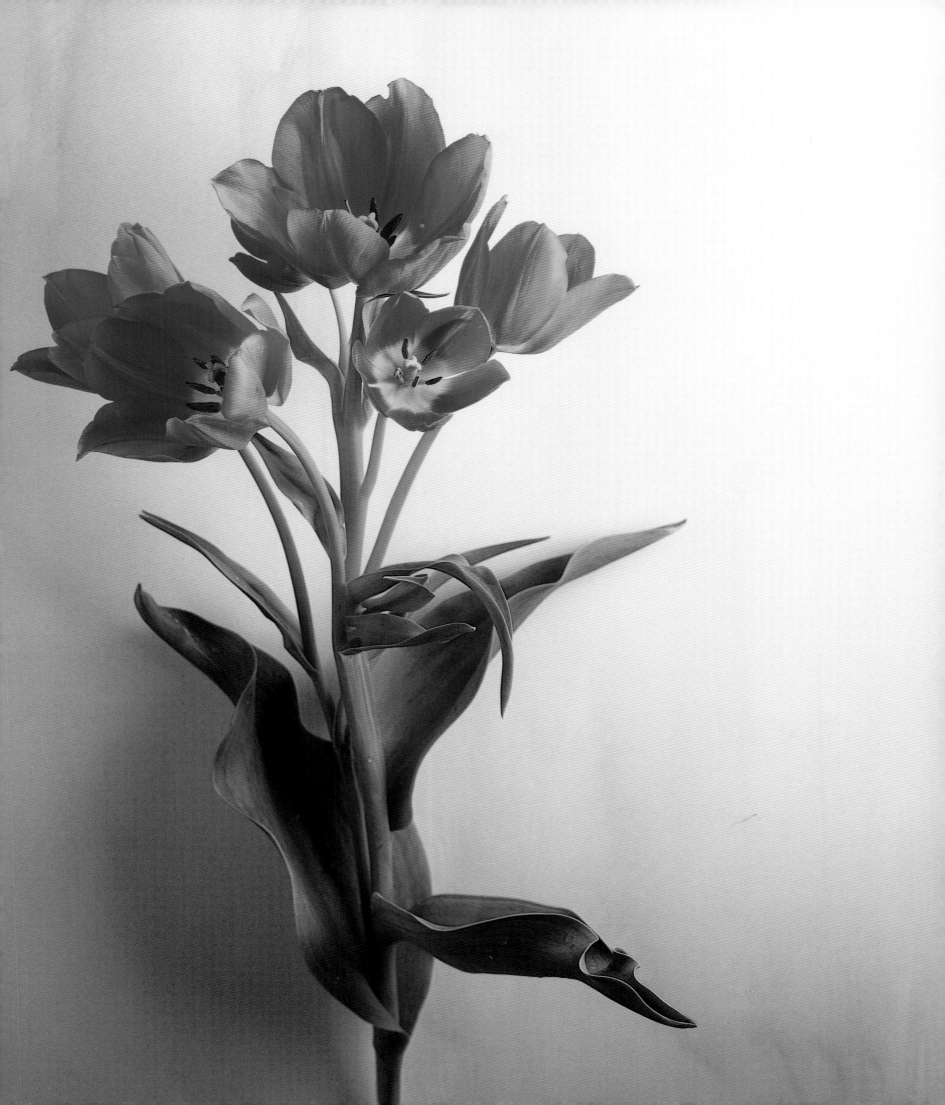

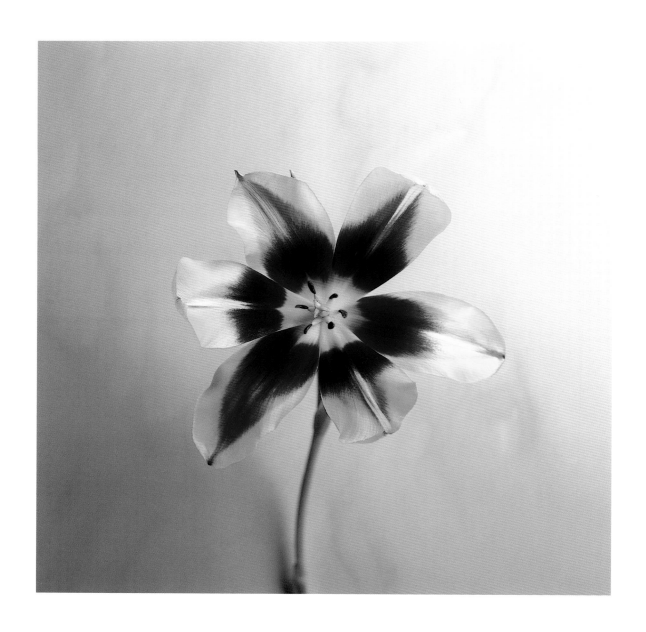

GAVOTA
Triumph Group
[PLATE 59]

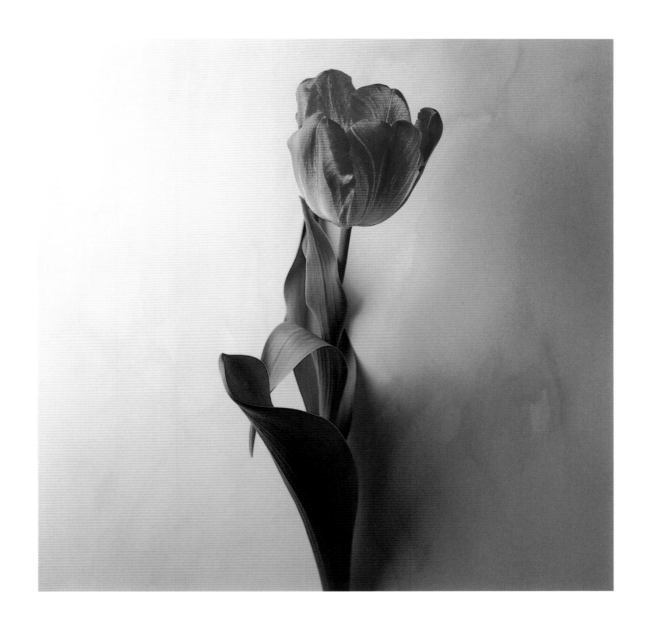

MONTEVIDEO
Triumph Group
[PLATE 60]

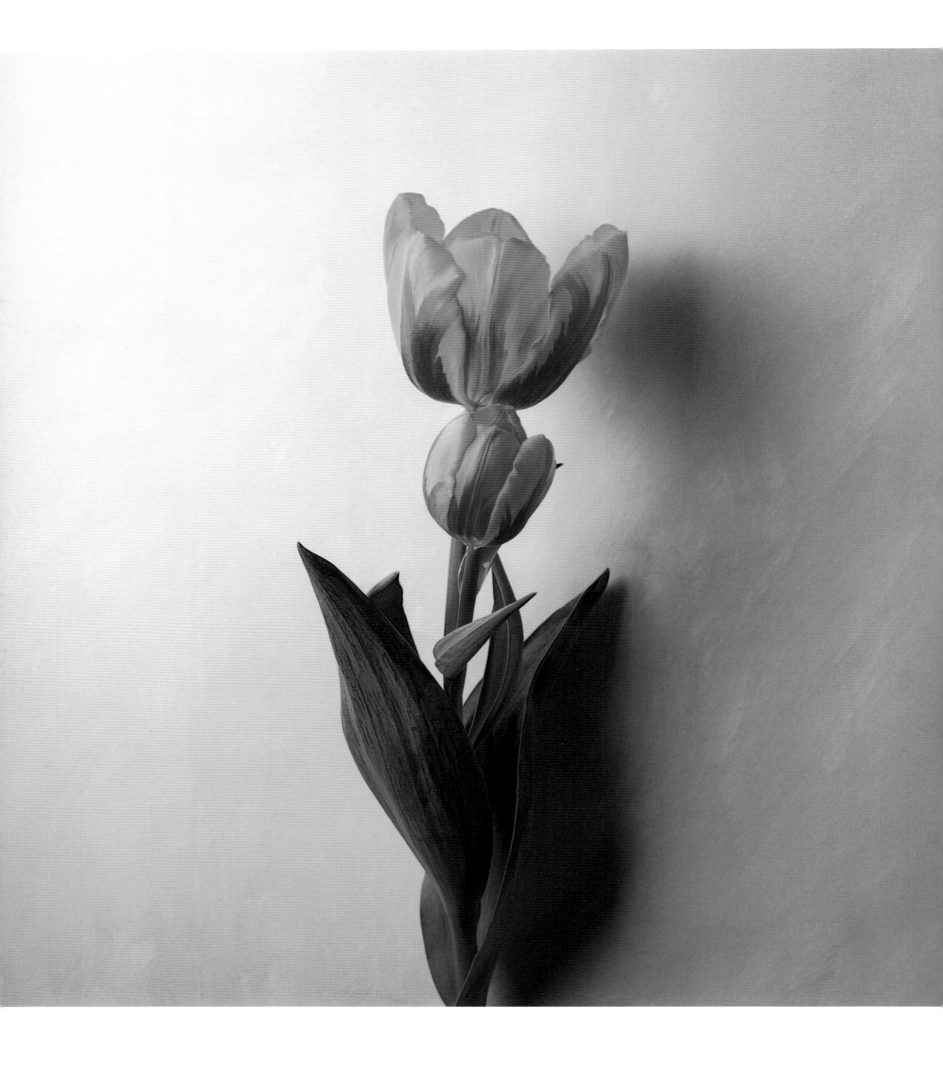

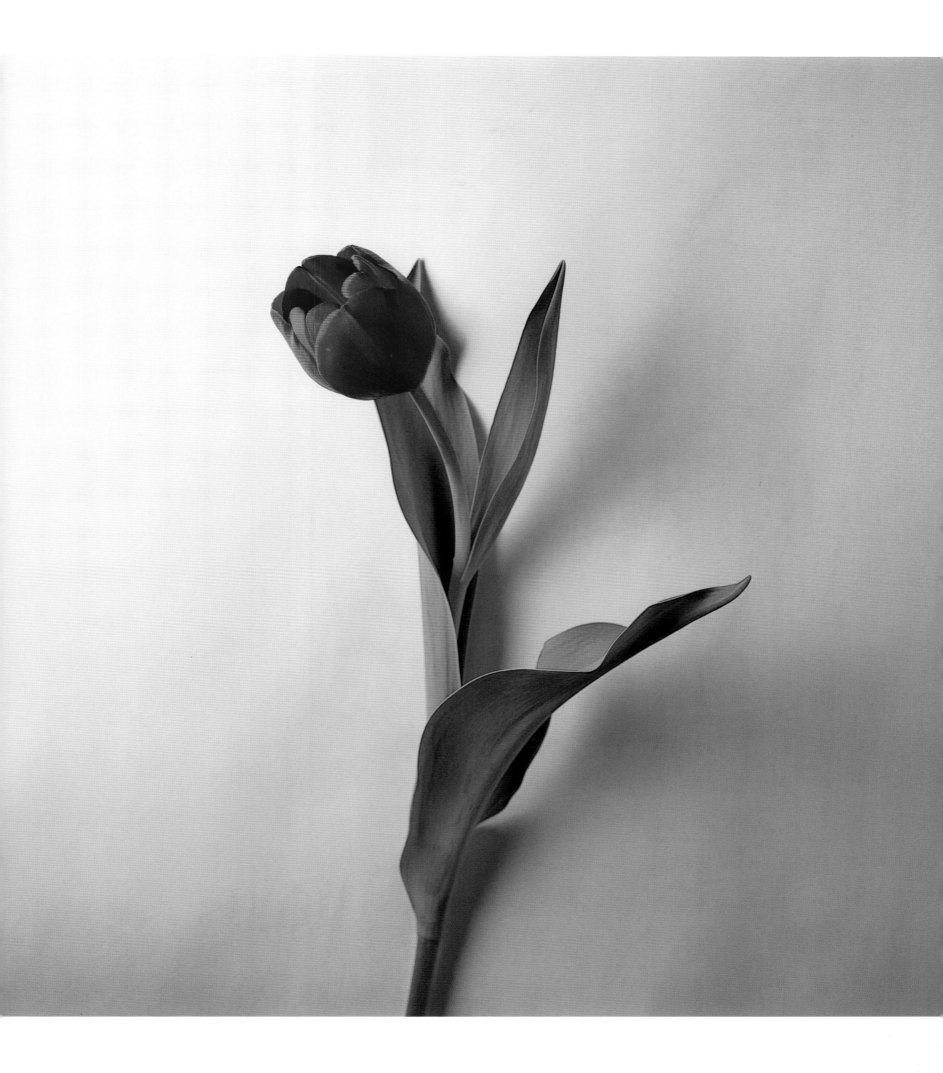

PRECEDING PAGES

PRINSES IRENE
Triumph Group
[PLATE 61]

ATTILA
Triumph Group
[PLATE 62]

BARONESSE
Triumph Group
[PLATE 64]

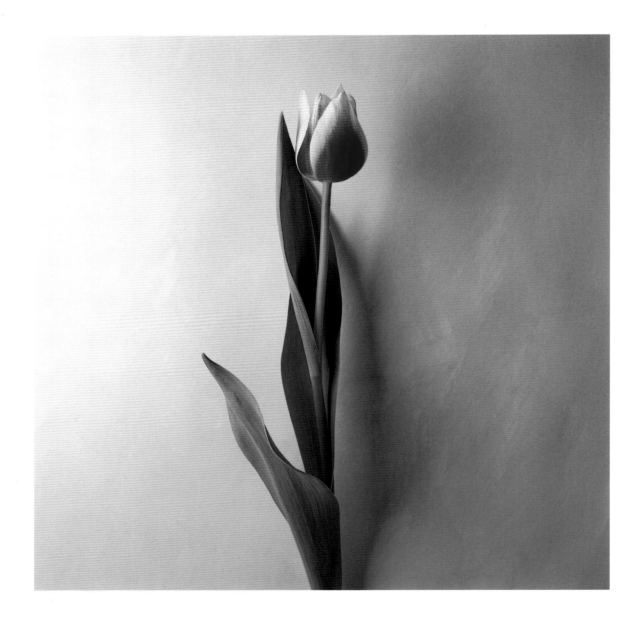

DREAMING MAID
Triumph Group
[PLATE 63]

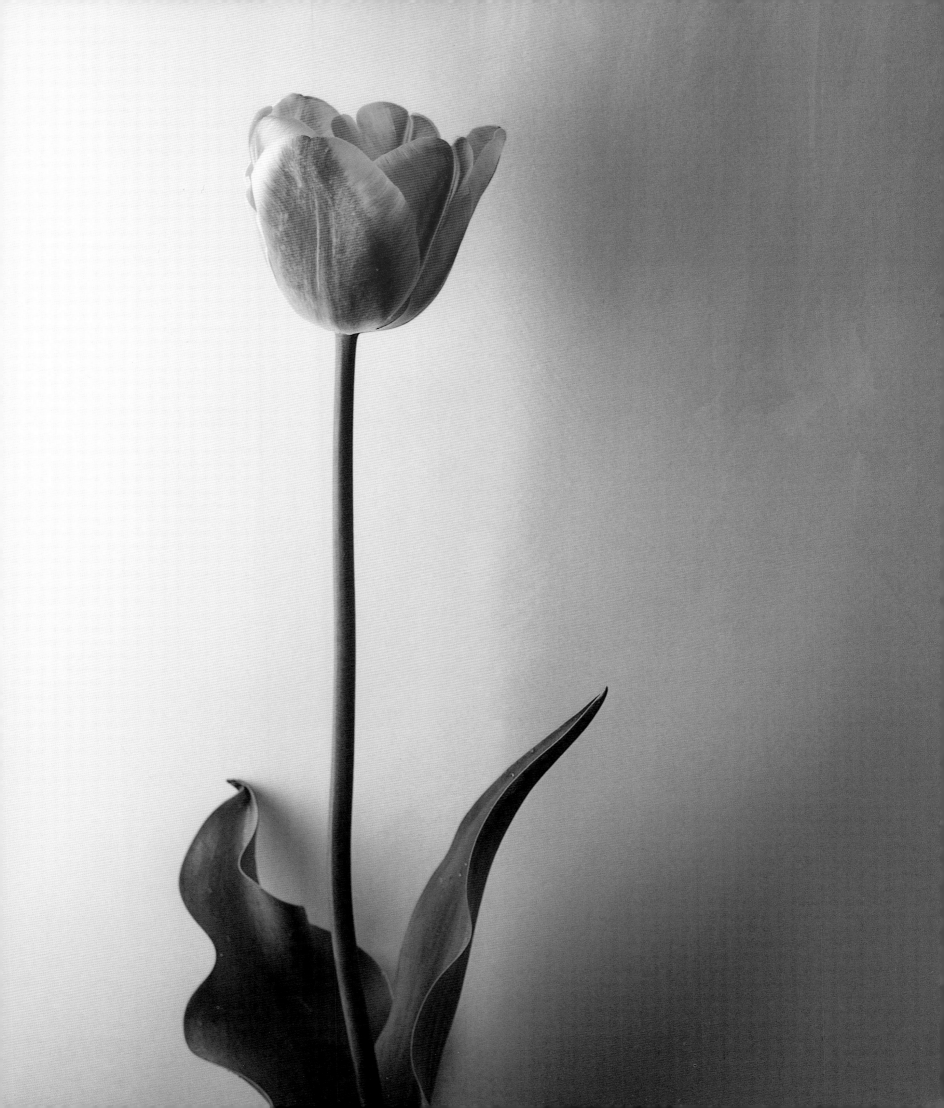

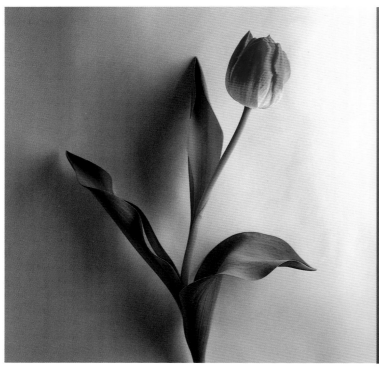

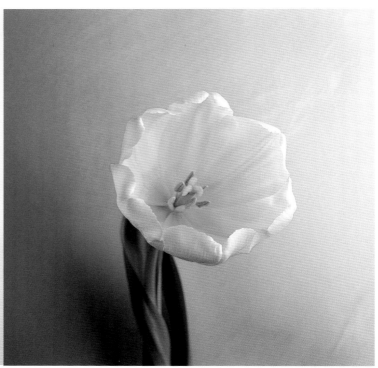

BLENDA
Triumph Group
[PLATE 65]

WHITE IDEAL
Triumph Group
[PLATE 66]

HAPPY FAMILY
Triumph Group
[PLATE 67]

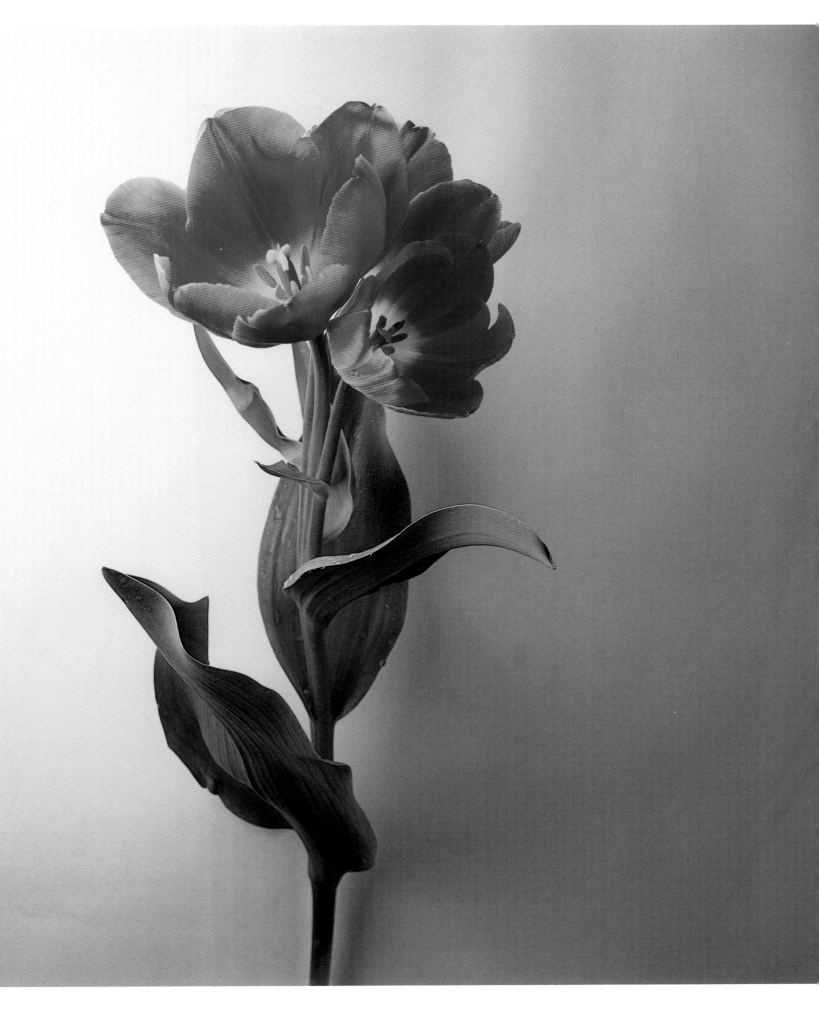

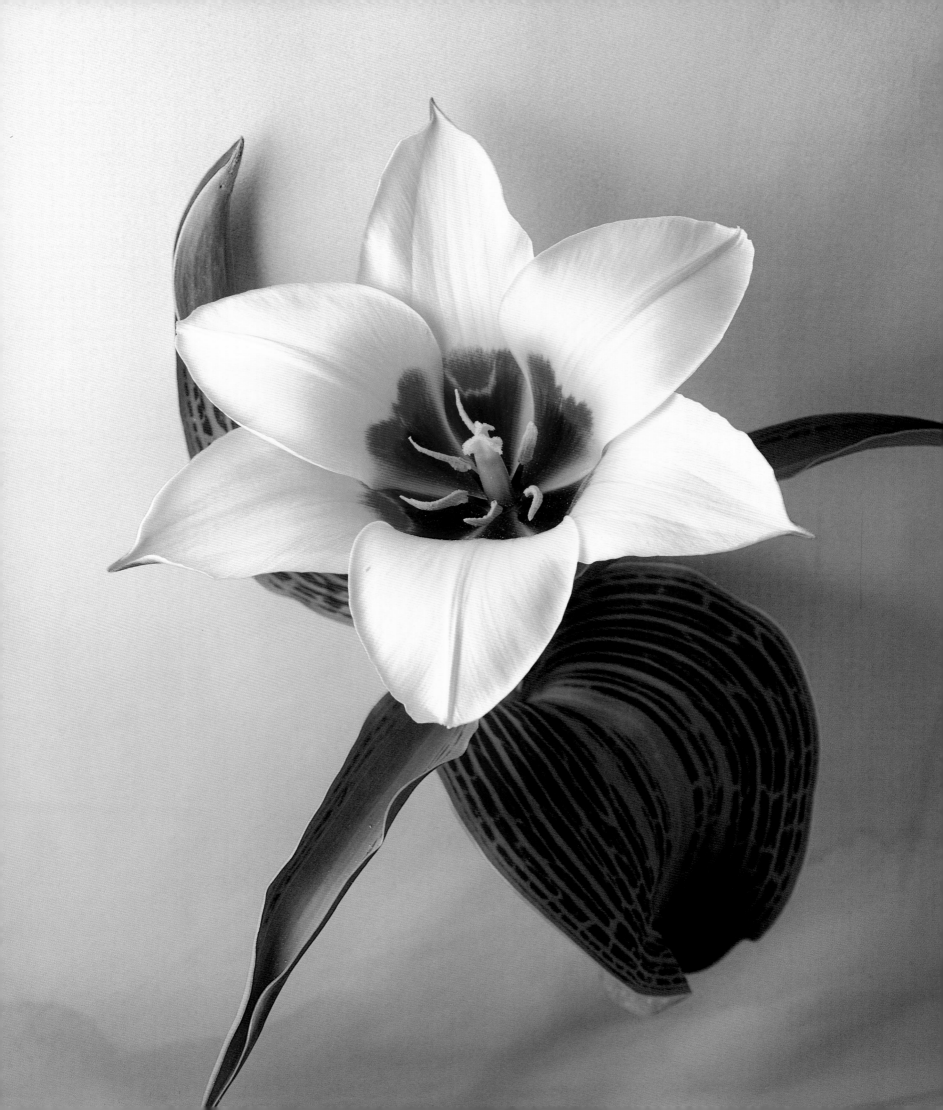

CHINA LADY
Greigii Group
[PLATE 68]

FOLLOWING PAGES

RED RIDING HOOD
Greigii Group
[PLATE 69]

GOLDEN TANGO
Greigii Group
[PLATE 70]

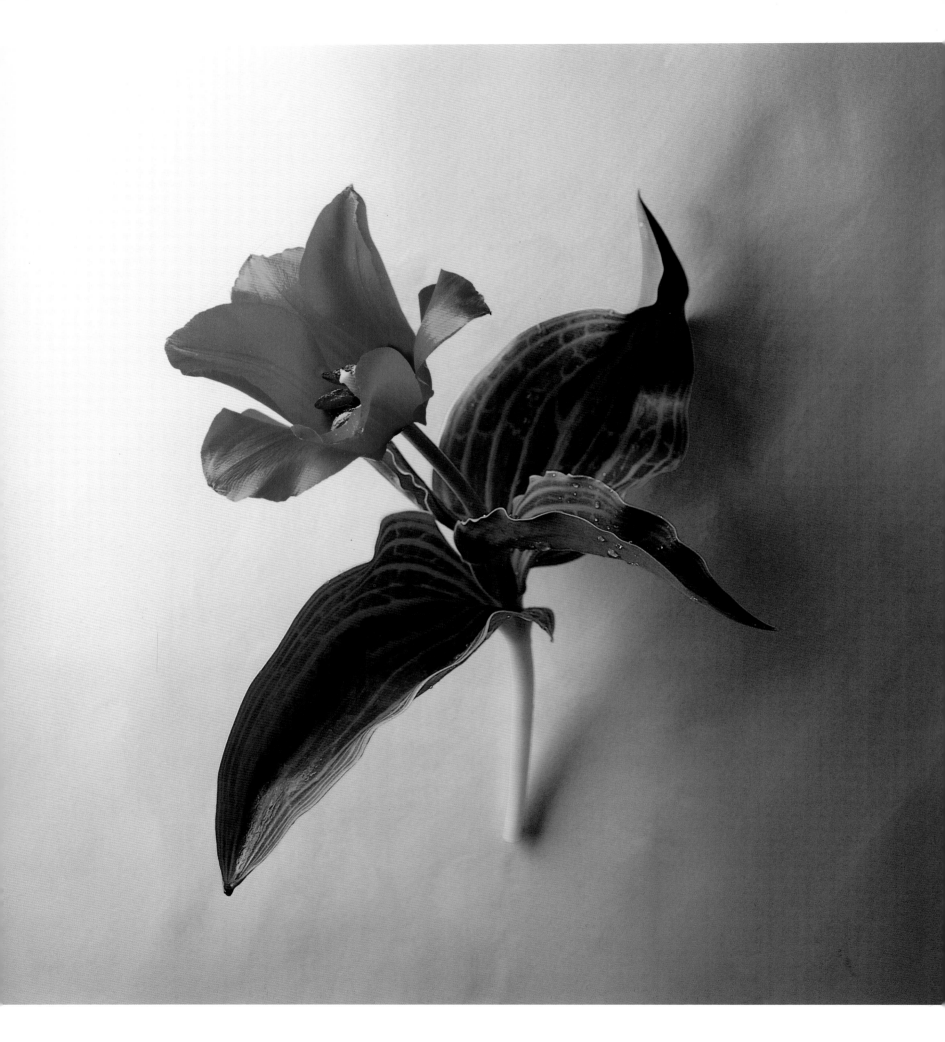

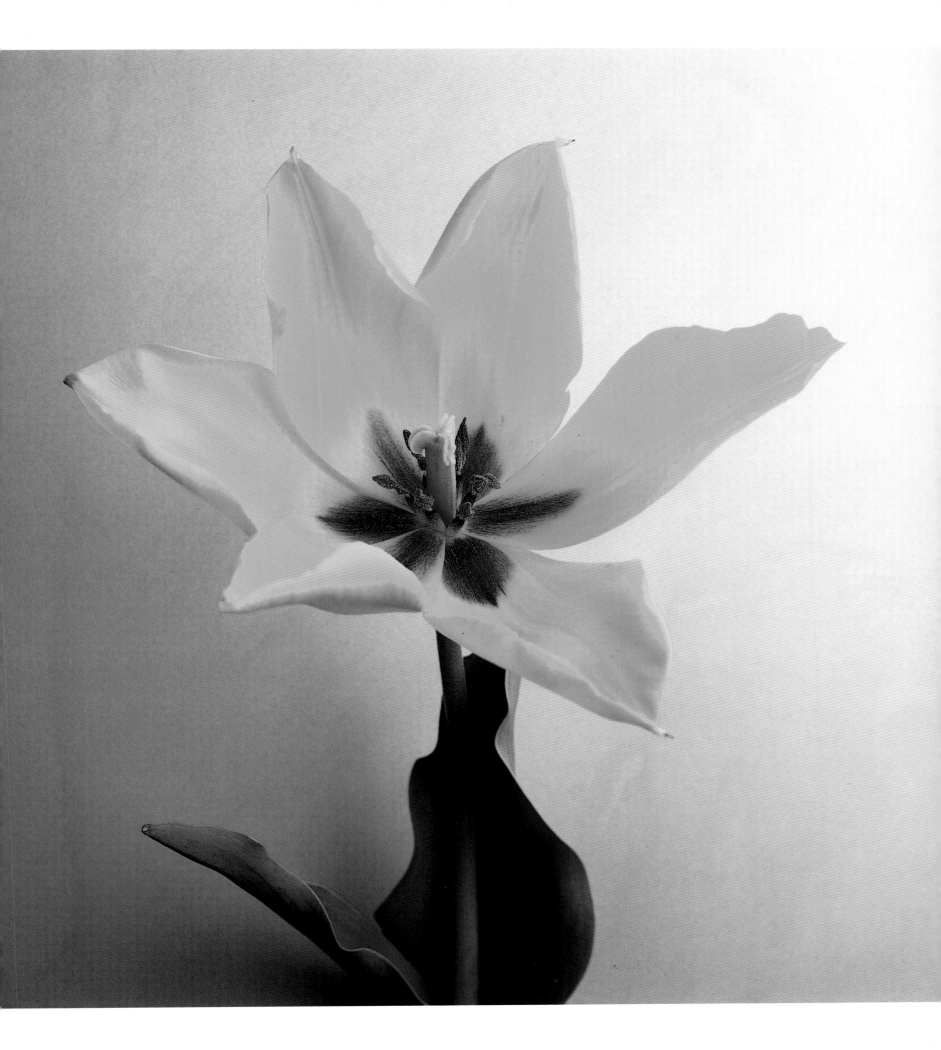

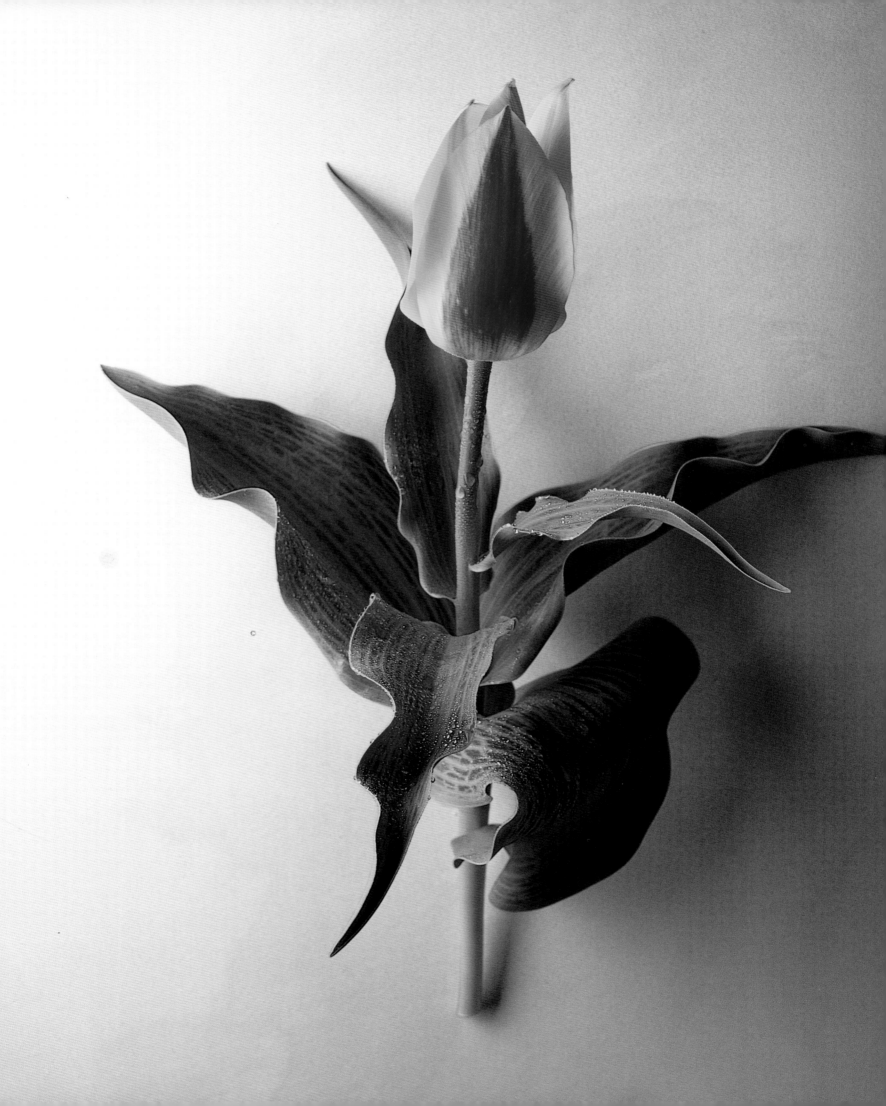

BELLA VISTA
Greigii Group
[PLATE 71]

TORONTO
Greigii Group
[PLATE 72]

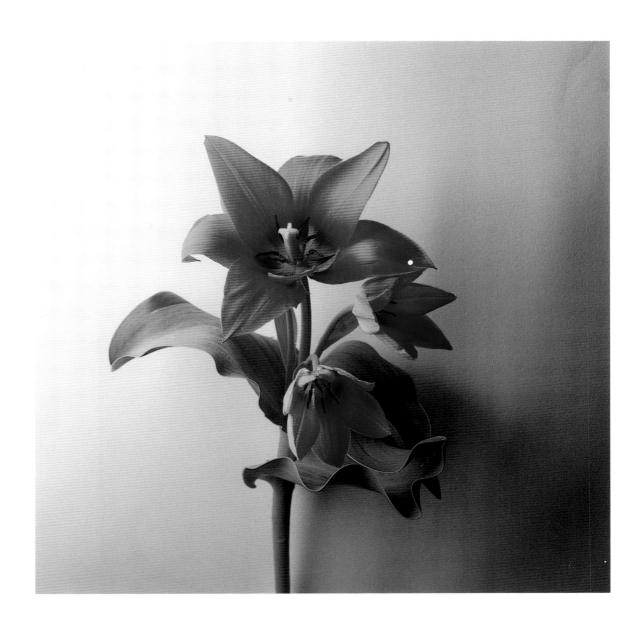

CORSAGE
Greigii Group
[PLATE 73]

FOLLOWING PAGES

PLAISIR
Greigii Group
[PLATE 74]

LONGFELLOW
Greigii Group
[PLATE 75]

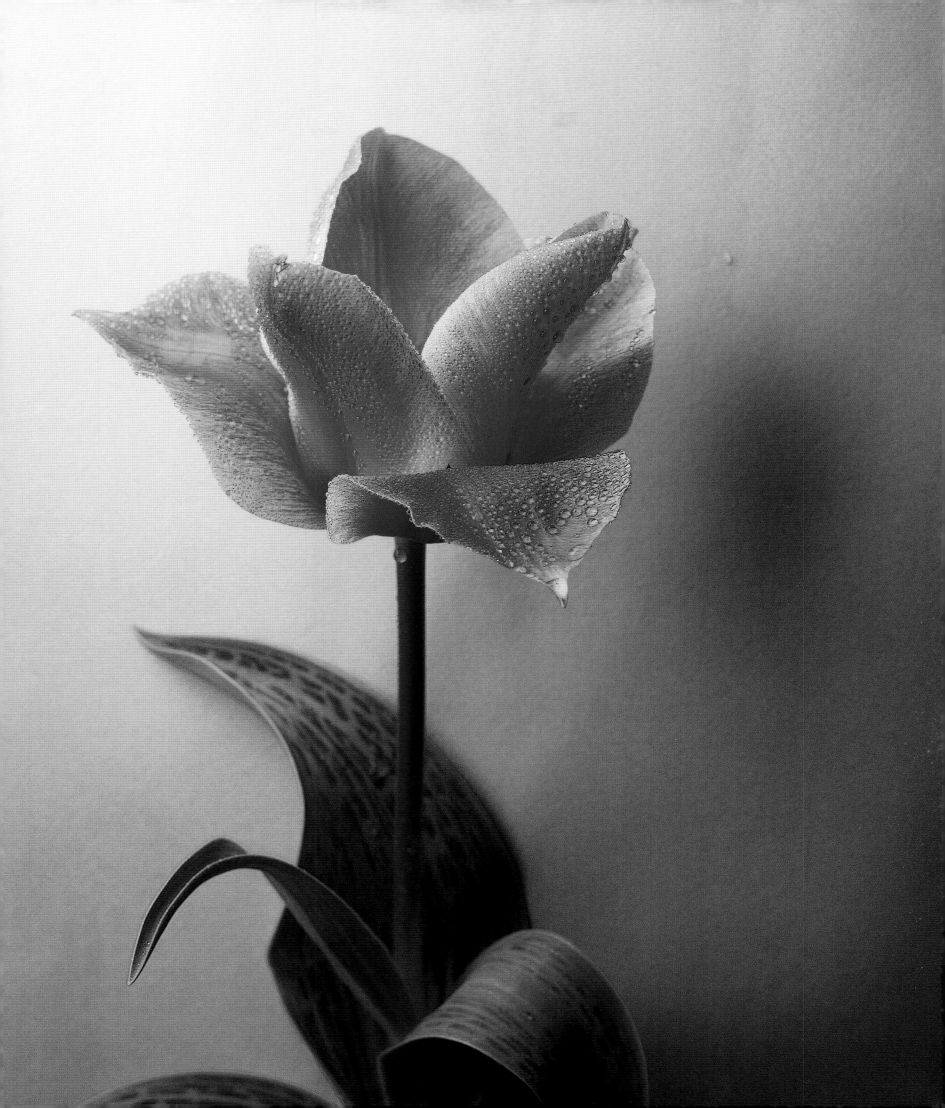

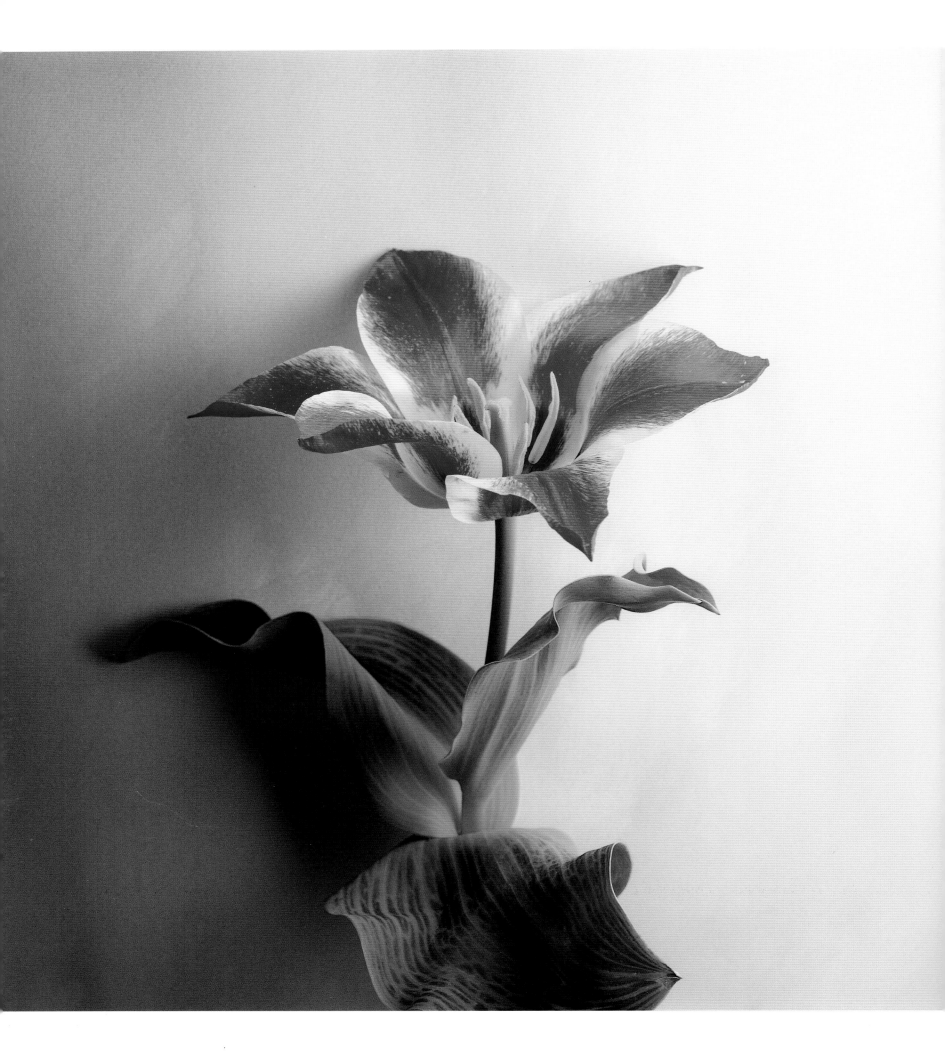

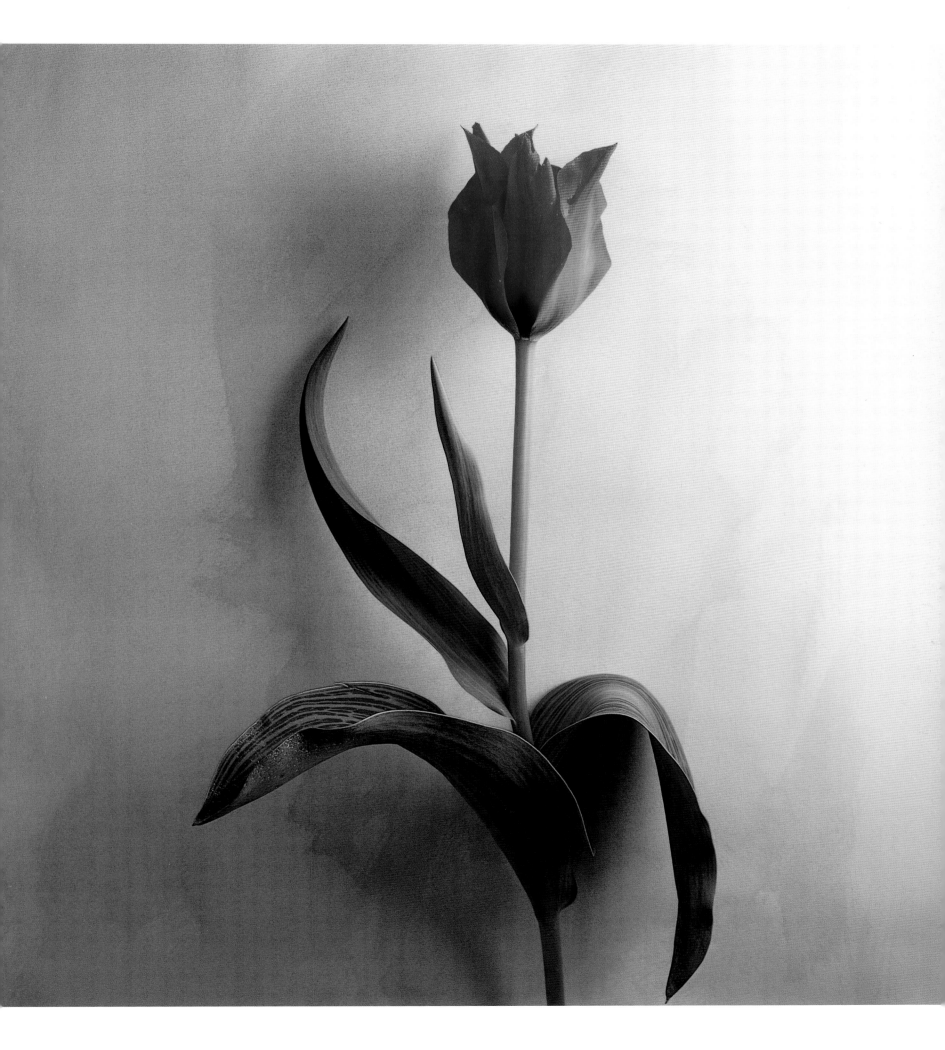

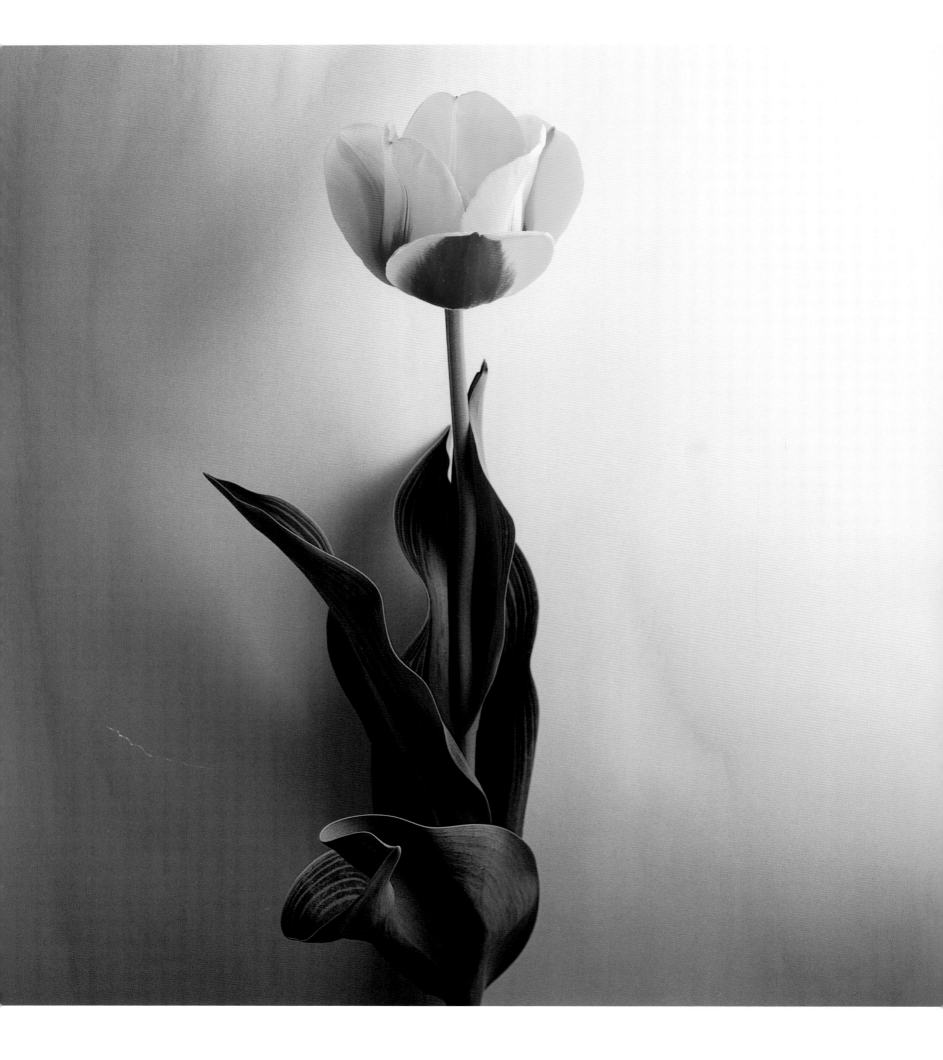

ORIENTAL SPLENDOUR
Greigii Group
[PLATE 76]

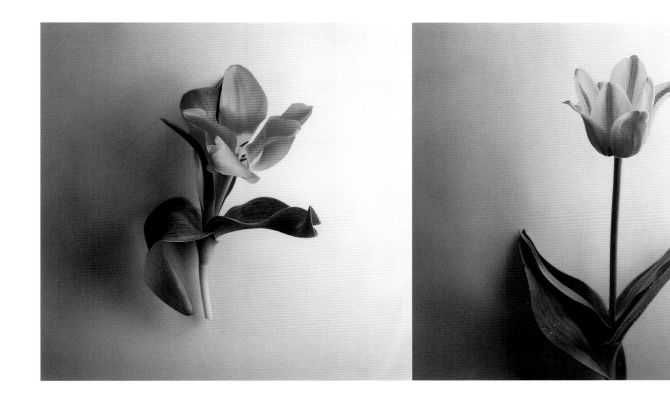

PERLINA
Greigii Group
[PLATE 77]

CAPE COD
Greigii Group
[PLATE 78]

WEST POINT
Lily-flowered Group
[PLATE 79]

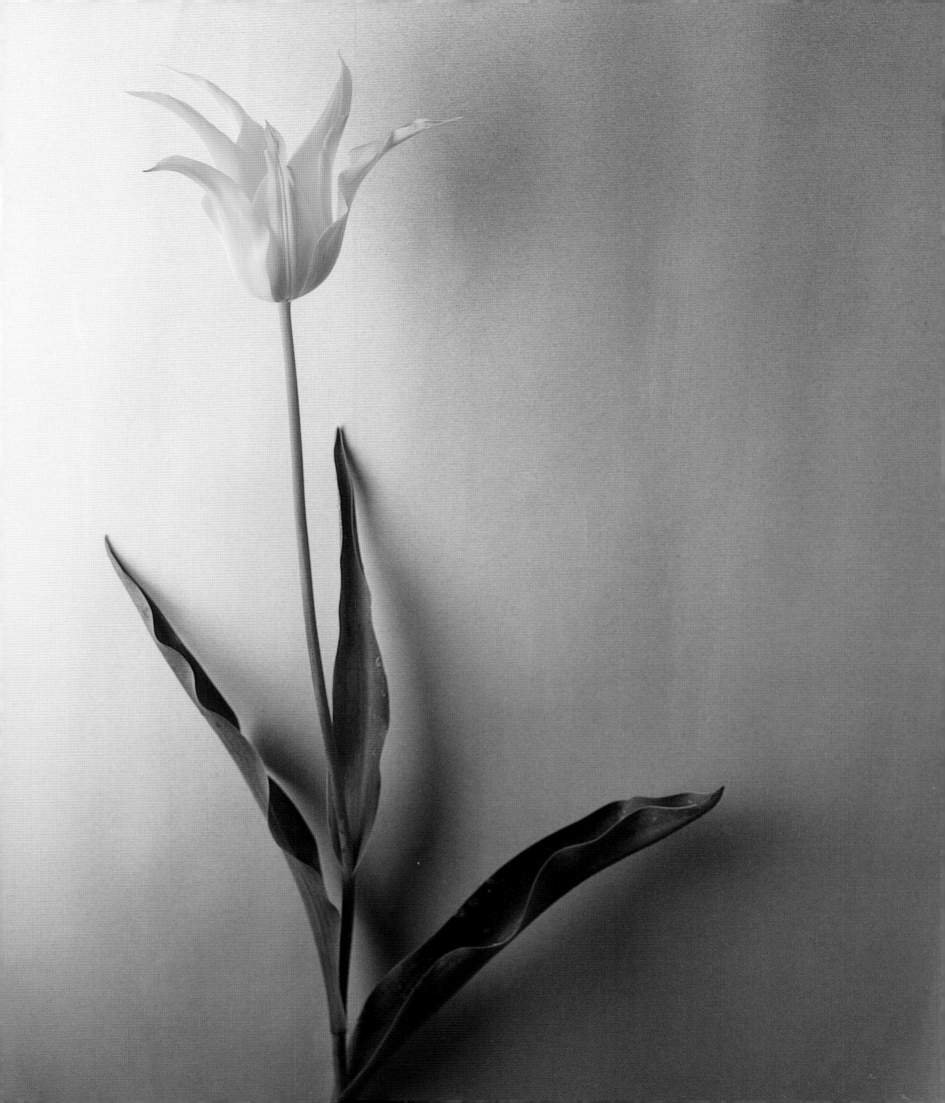

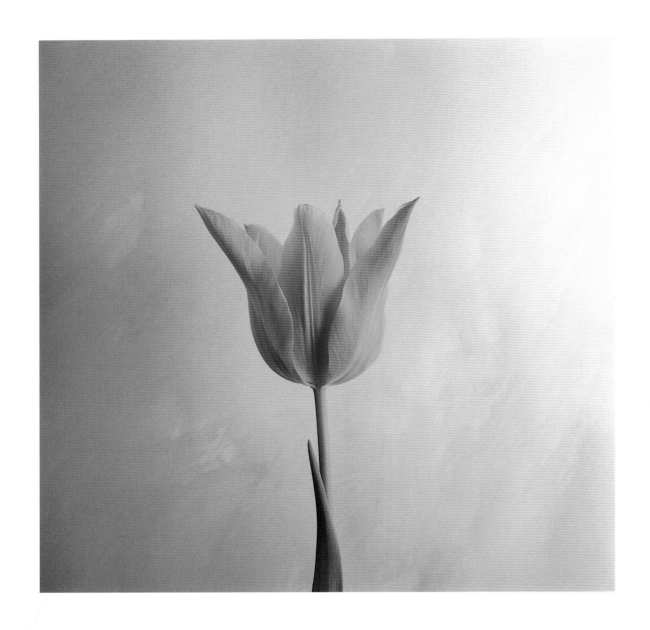

BALLERINA
Lily-flowered Group
[PLATE 80]

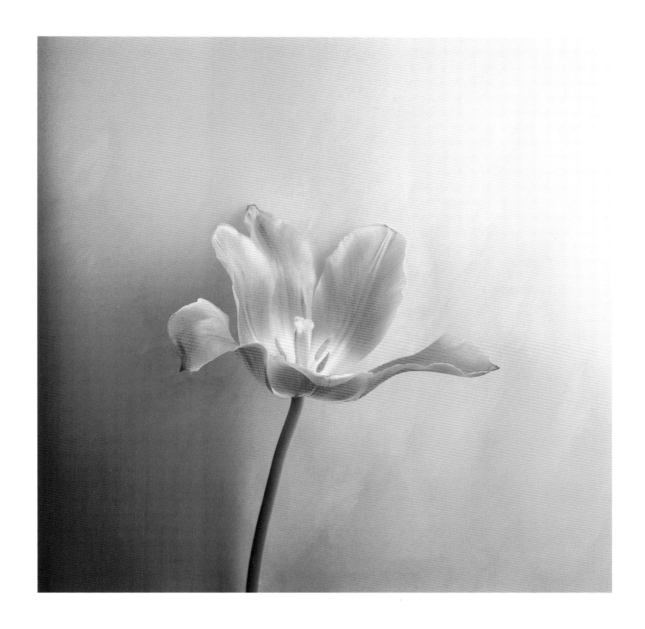

CHINA PINK
Lily-flowered Group
[PLATE 81]

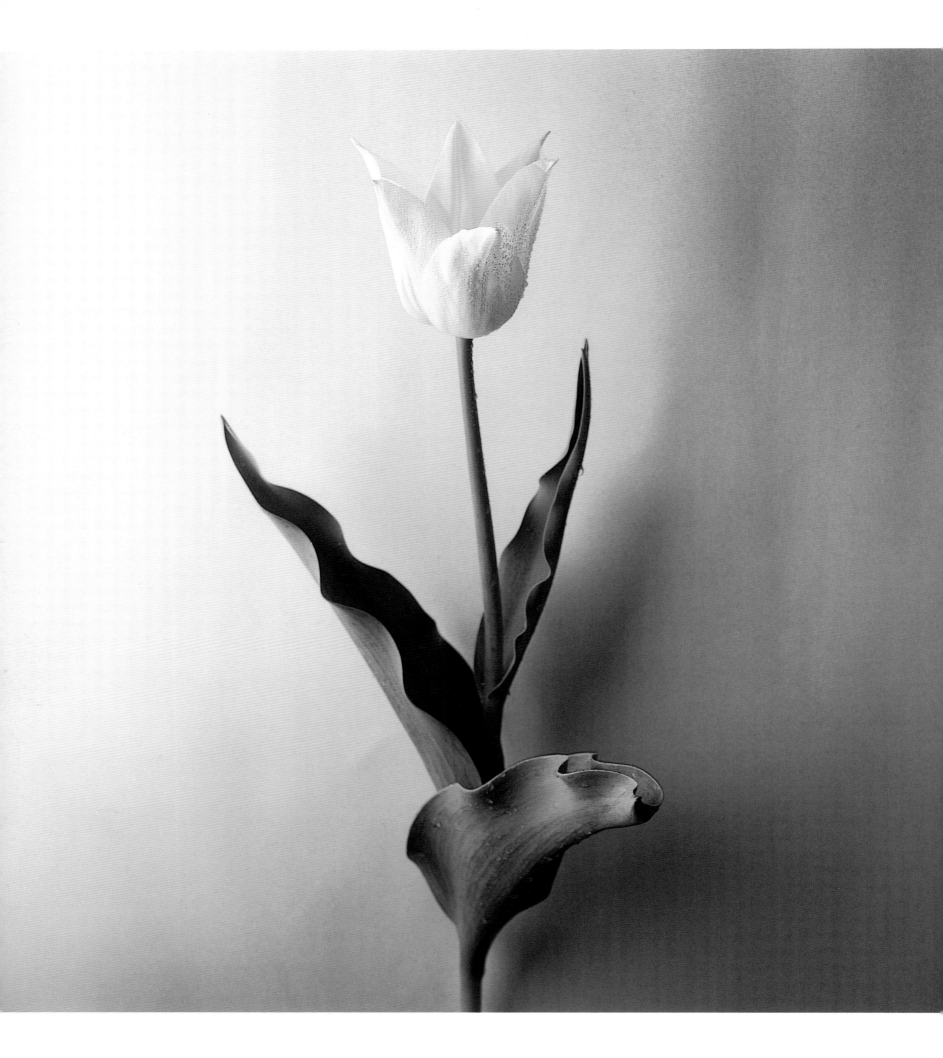

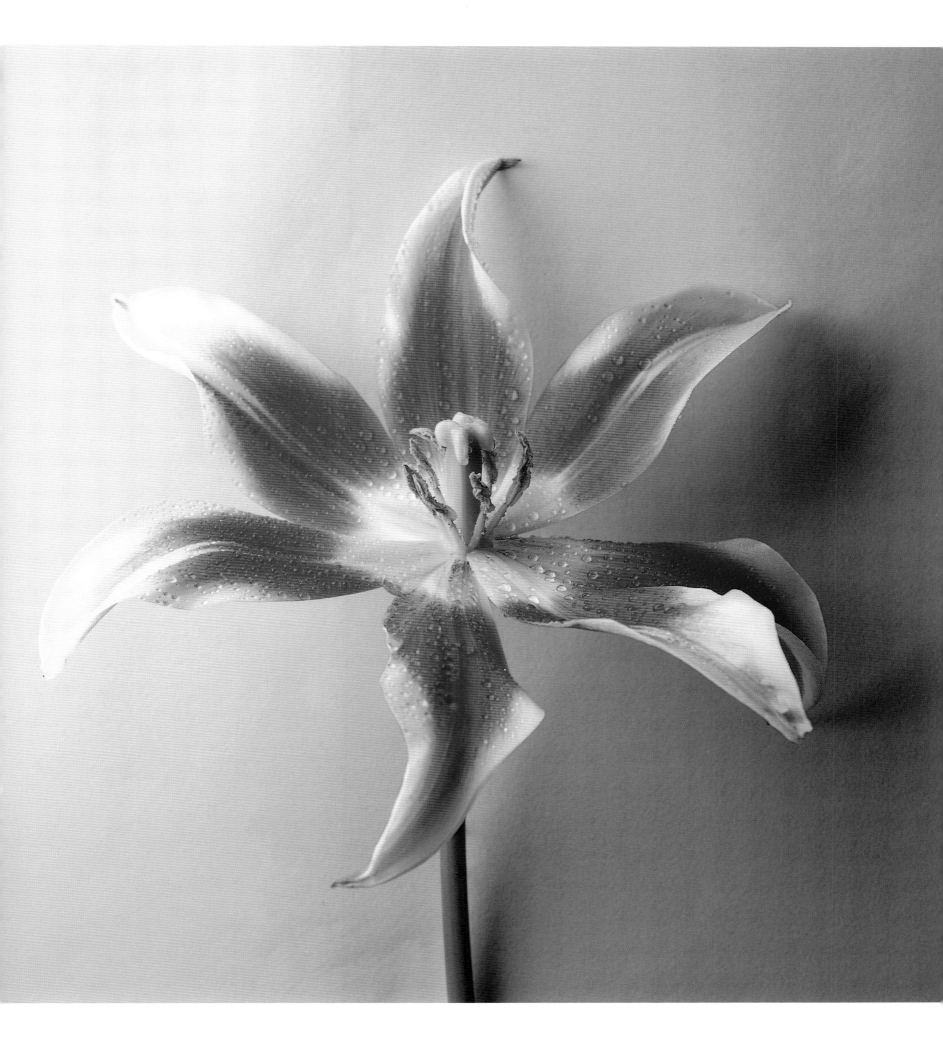

PRECEDING PAGES

WHITE ELEGANCE
Lily-flowered Group
[PLATE 82]

BALLADE
Lily-flowered Group
[PLATE 83]

MAYTIME
Lily-flowered Group
[PLATE 86]

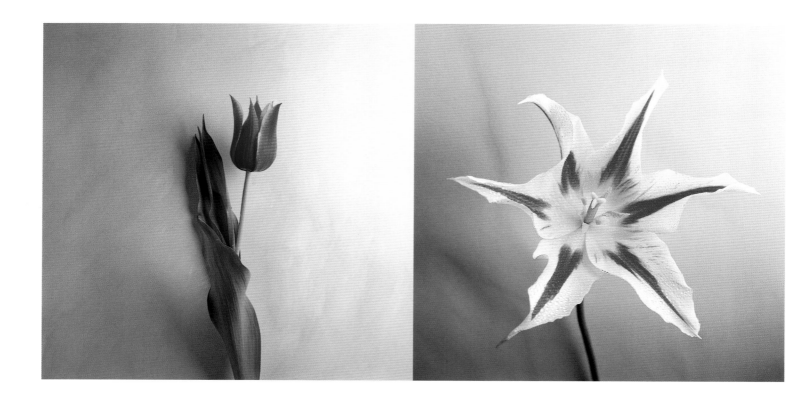

QUEEN OF SHEBA
Lily-flowered Group
[PLATE 84]

MARILYN
Lily-flowered Group
[PLATE 85]

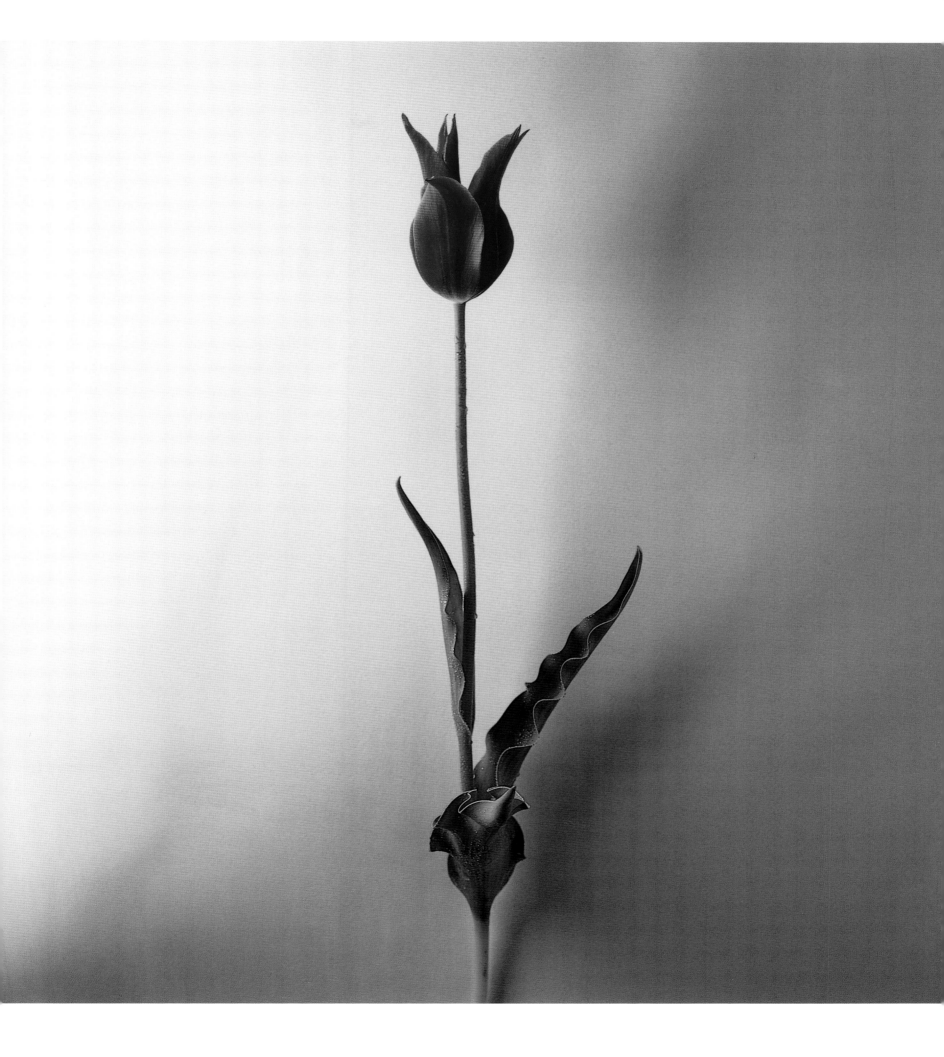

FLAMING PARROT
Parrot Group
[PLATE 87]

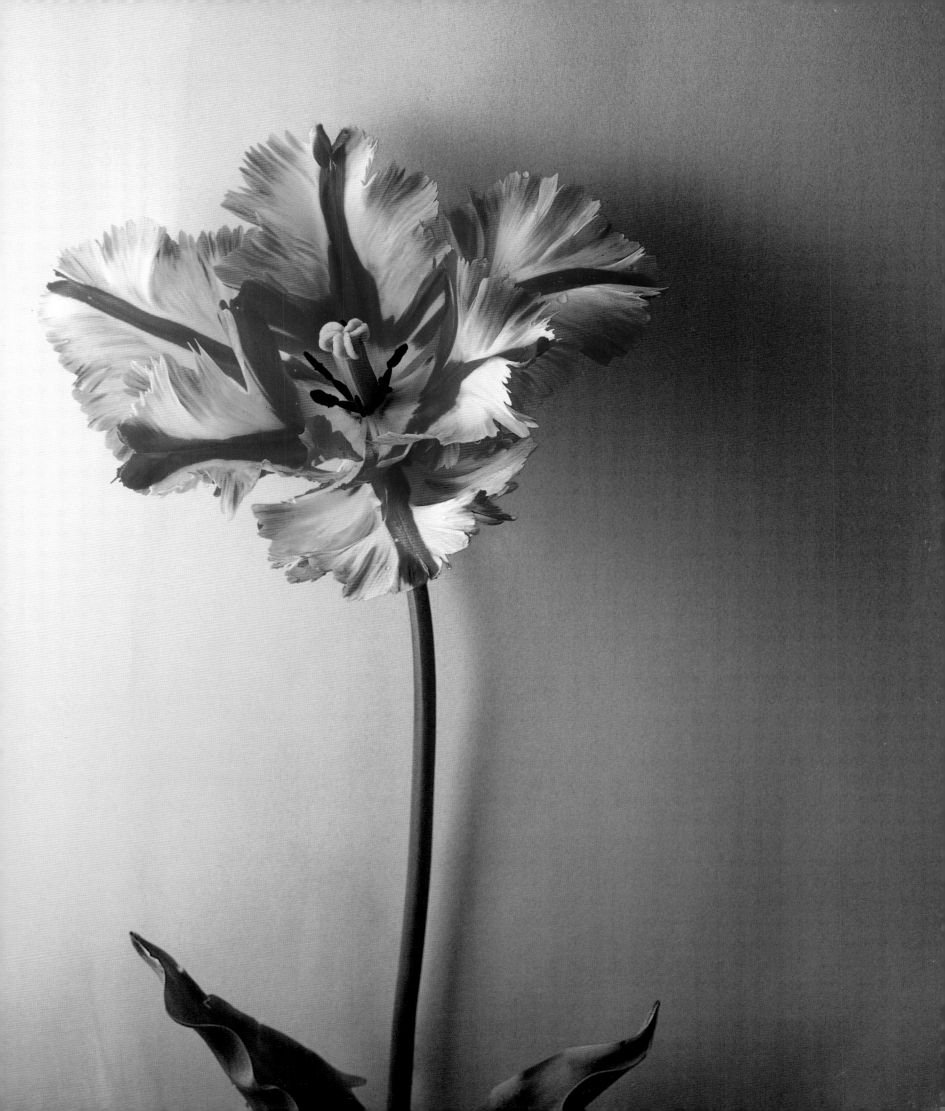

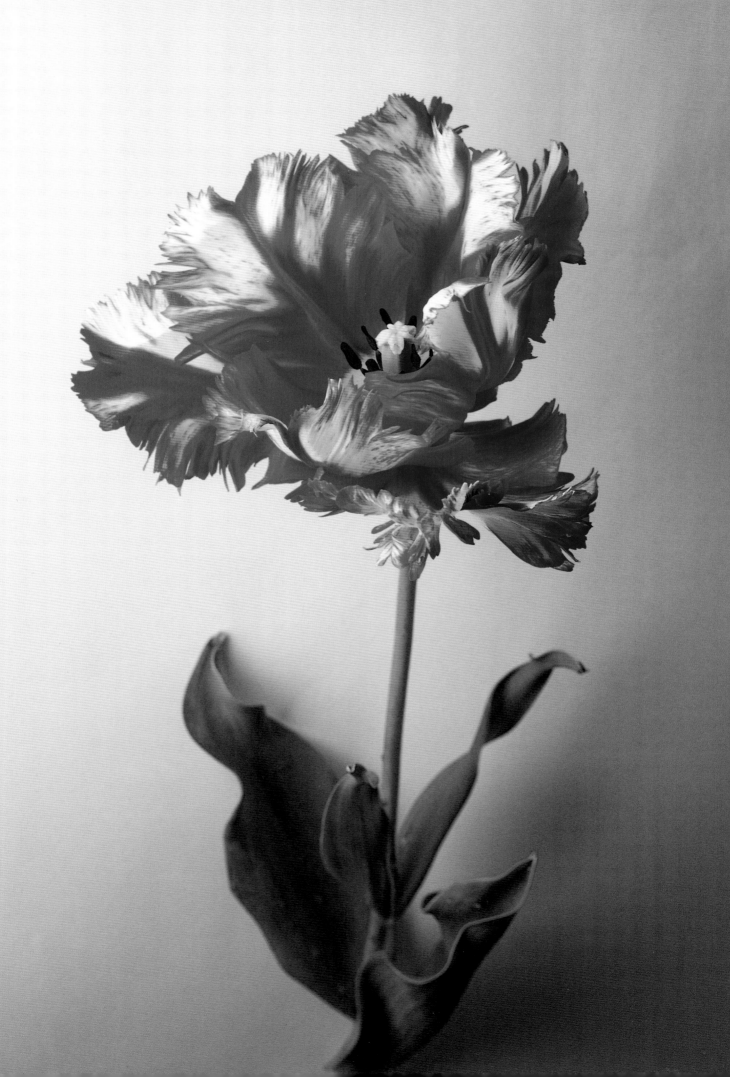

LIBRETTO PARROT
Parrot Group
[PLATE 89]

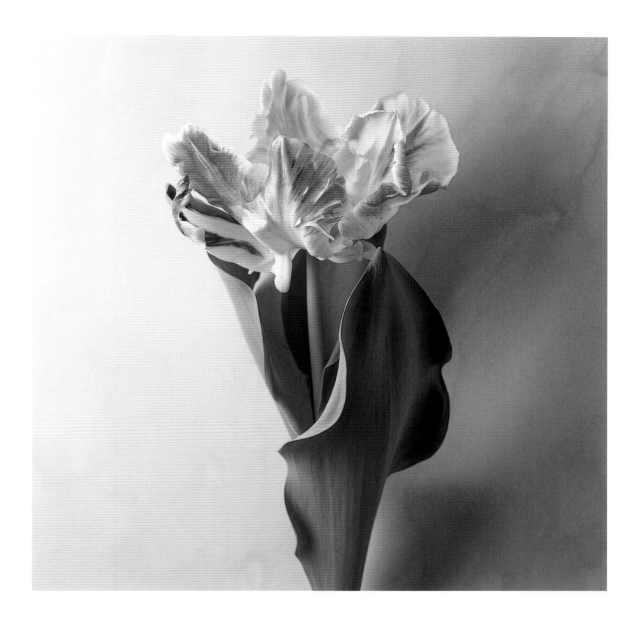

FOLLOWING PAGES

BIRD OF PARADISE
Parrot Group
[PLATE 90]

ESTELLA RIJNVELD
Parrot Group
[PLATE 88]

BLACK PARROT
Parrot Group
[PLATE 91]

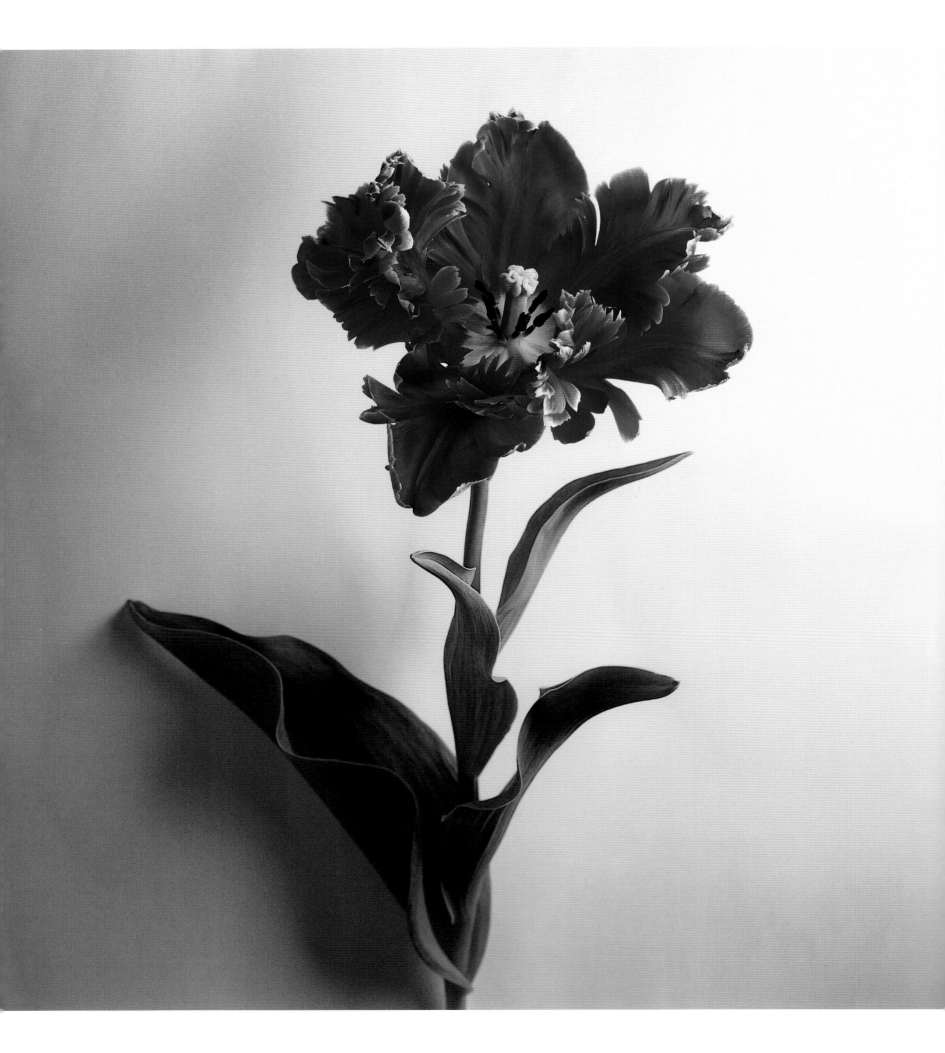

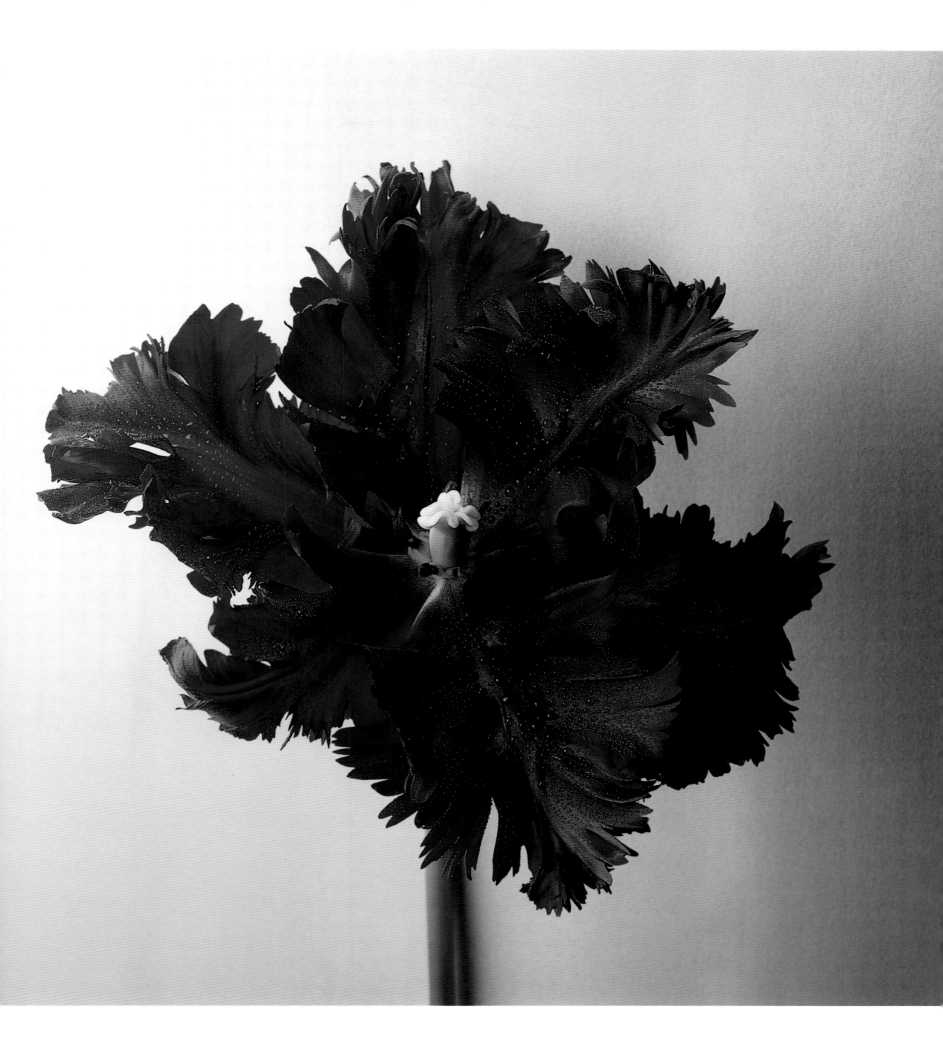

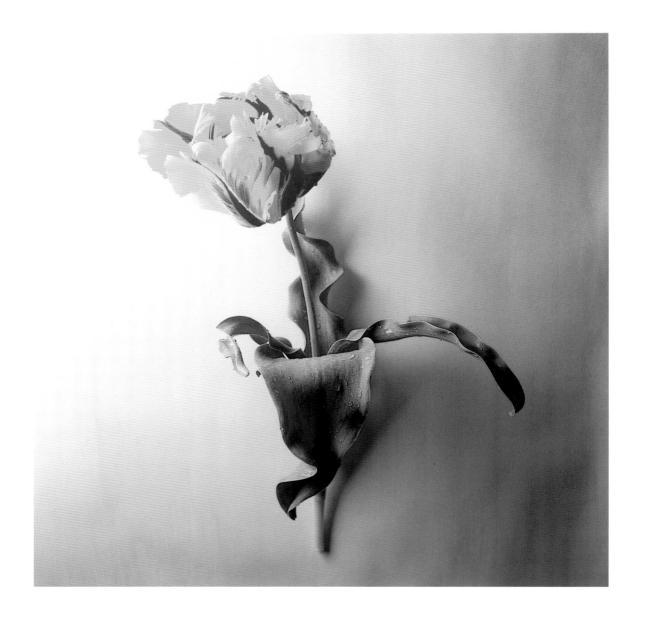

TEXAS FLAME
Parrot Group
[PLATE 92]

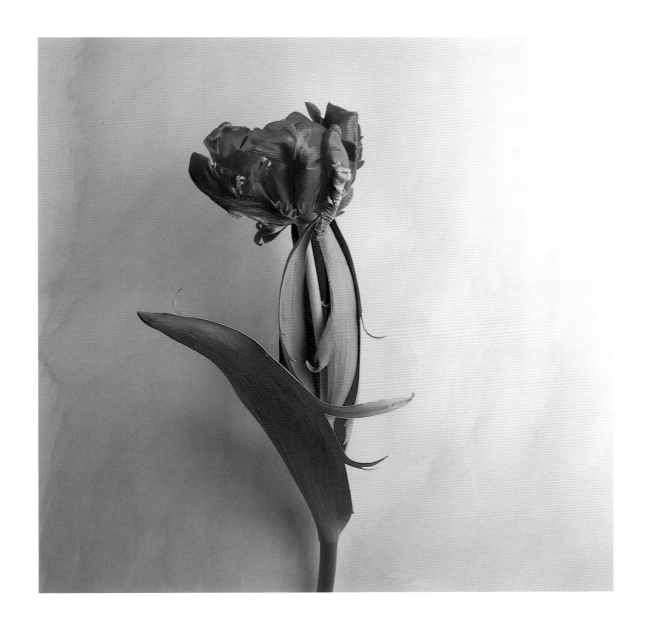

ROCOCO
Parrot Group
[PLATE 93]

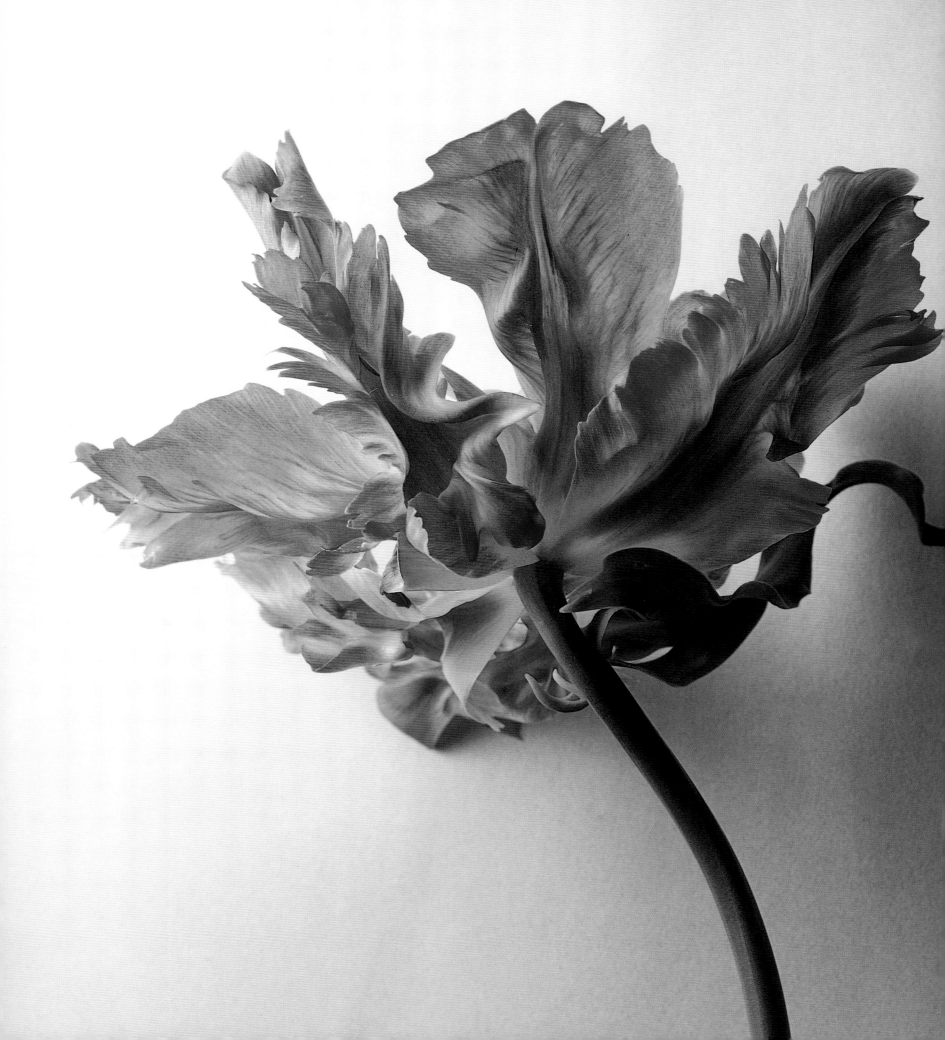

GREEN WAVE
Parrot Group
[PLATE 94]

MADISON GARDEN
Fringed Group
[PLATE 95]

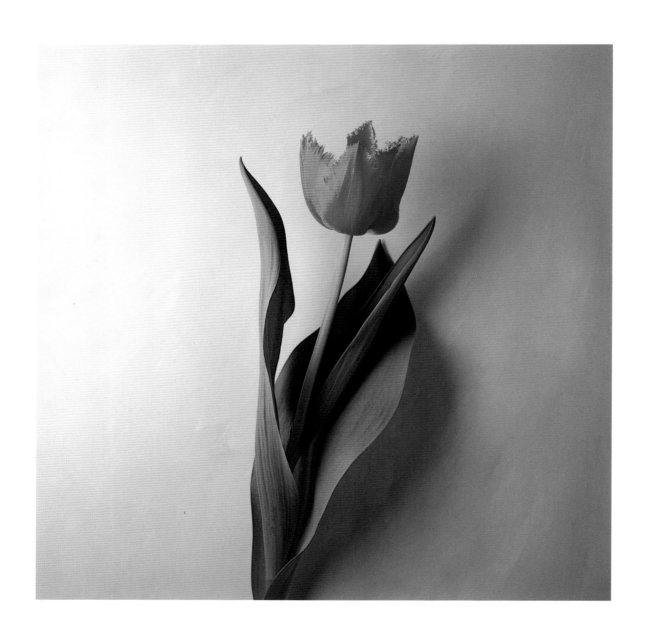

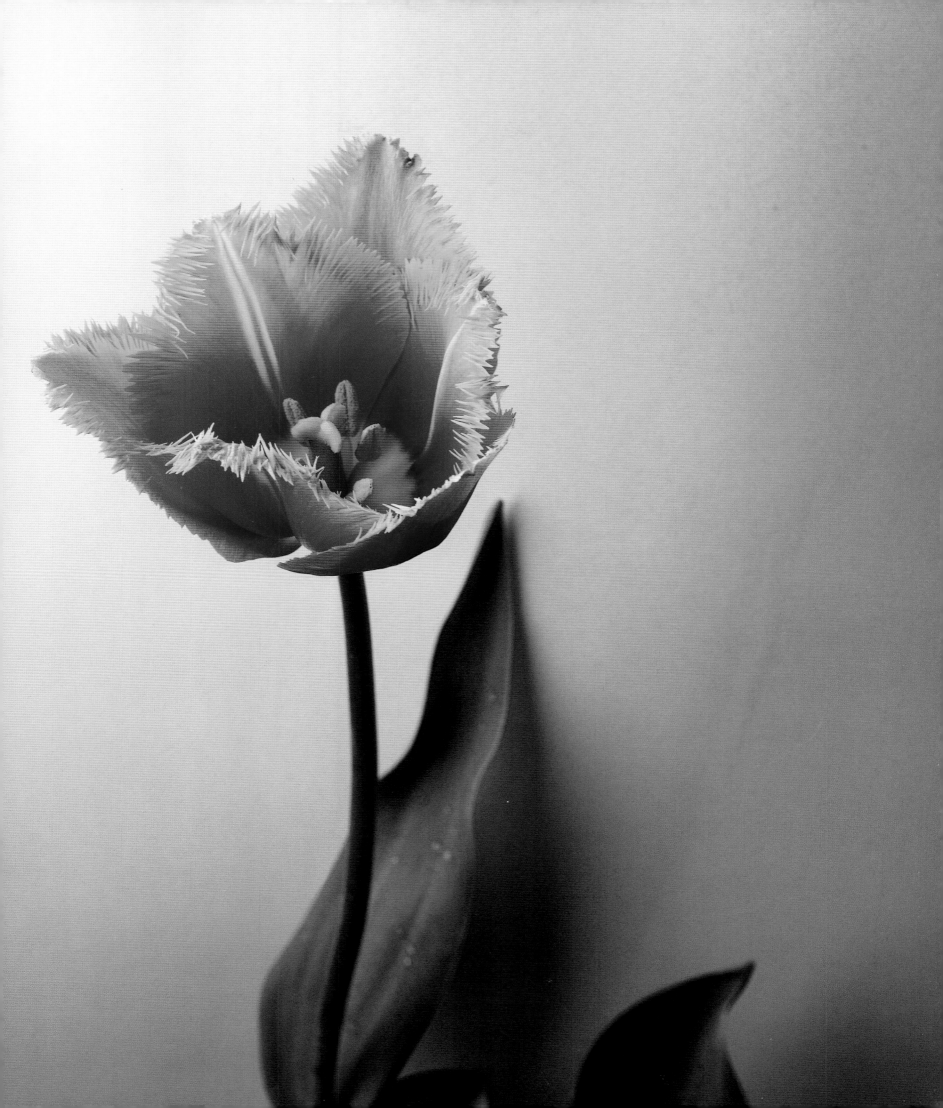

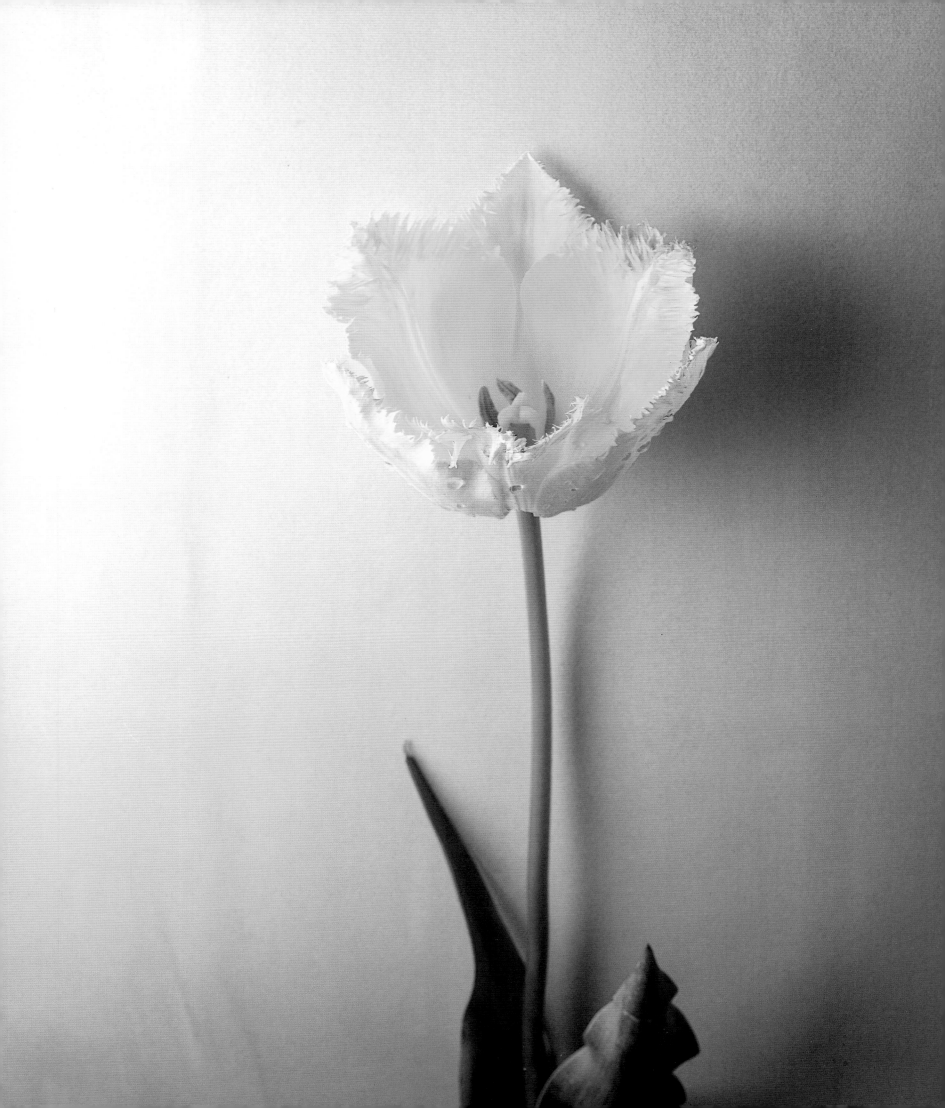

MAJA
Fringed Group
[PLATE 97]

BURGUNDY LACE
Fringed Group
[PLATE 98]

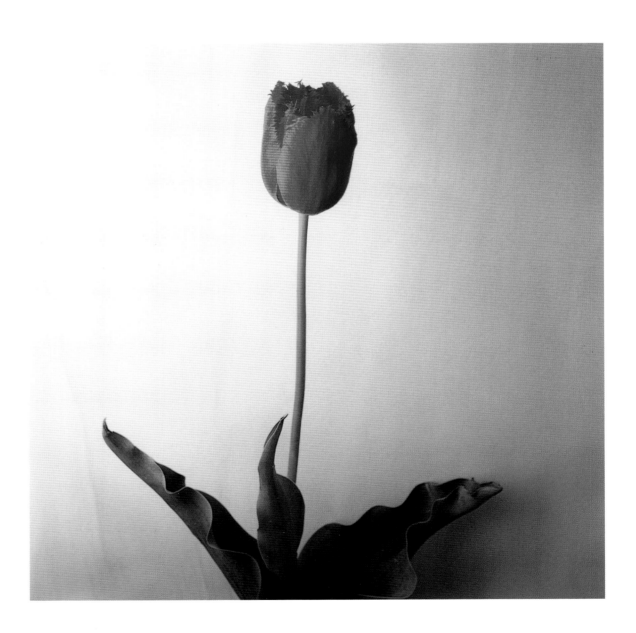

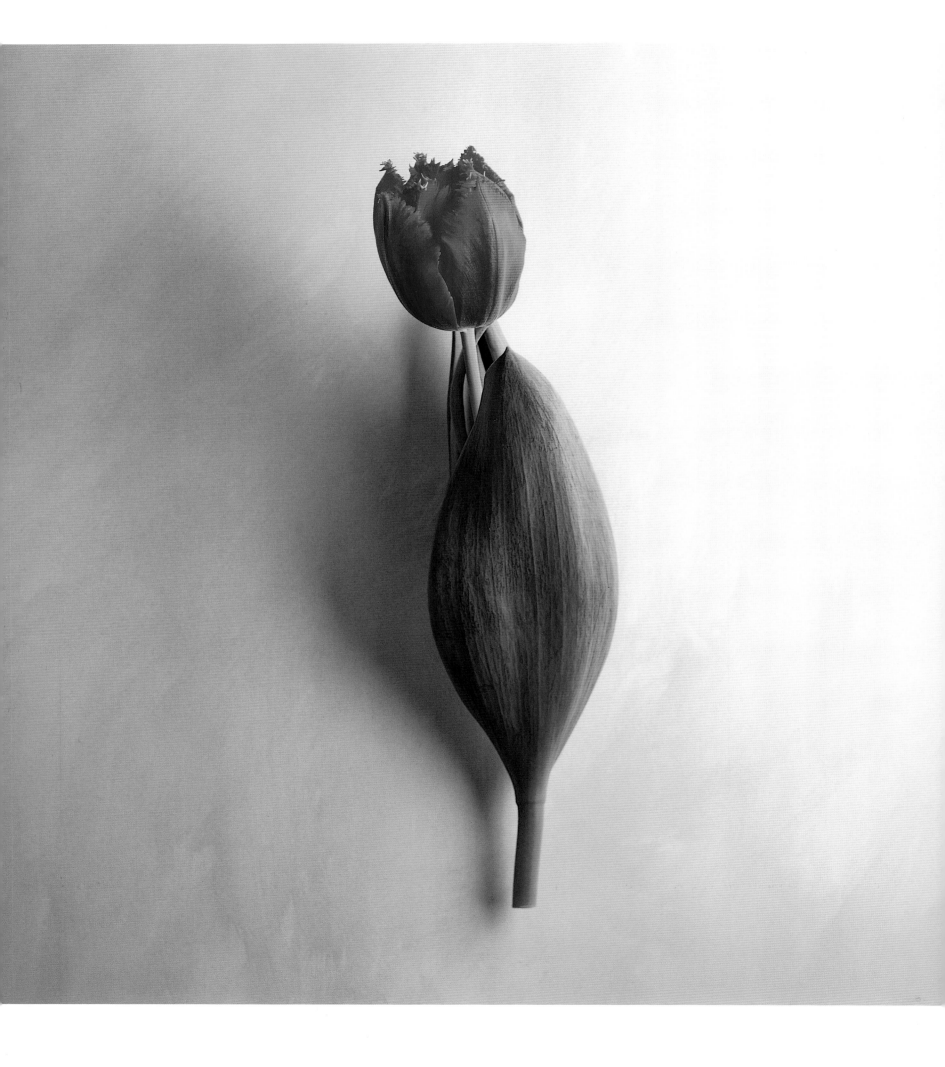

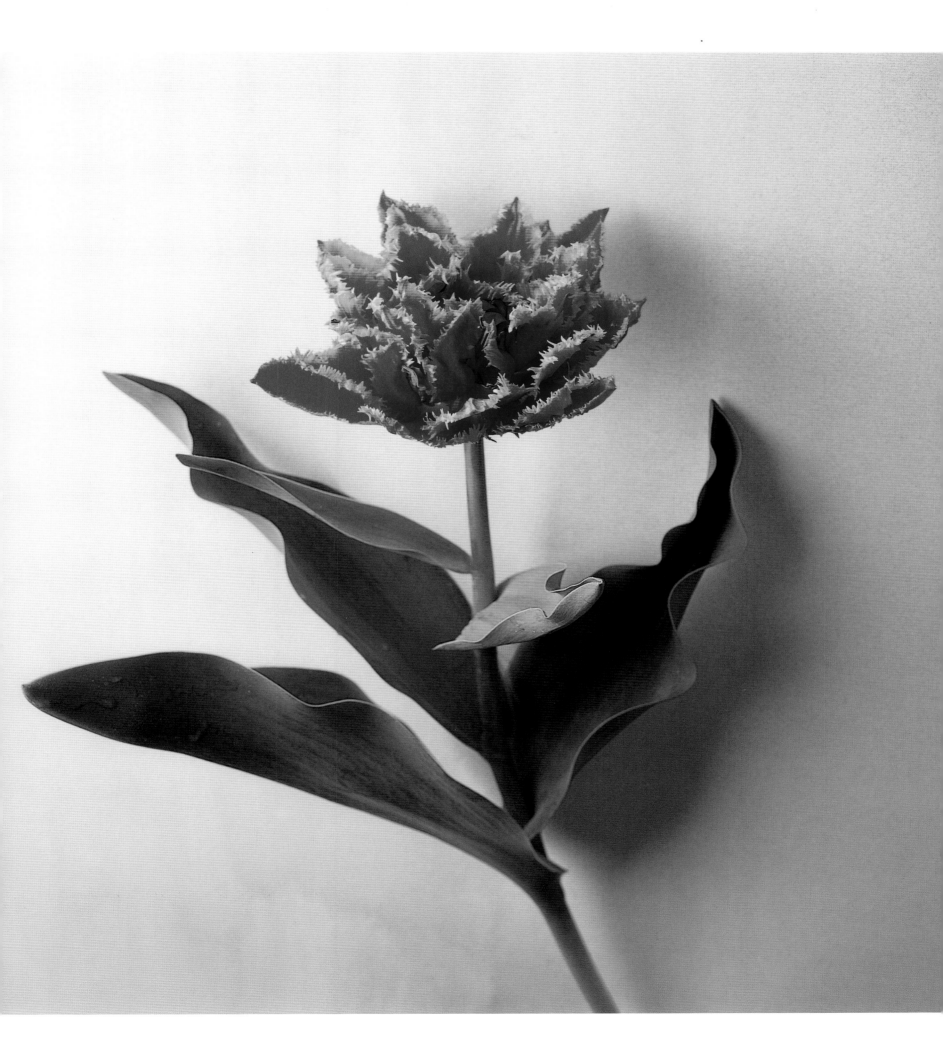

ARMA
Fringed Group
[PLATE 99]

FRINGED BEAUTY
Fringed Group
[PLATE 100]

SORBET
Single Late Group
[PLATE 101]

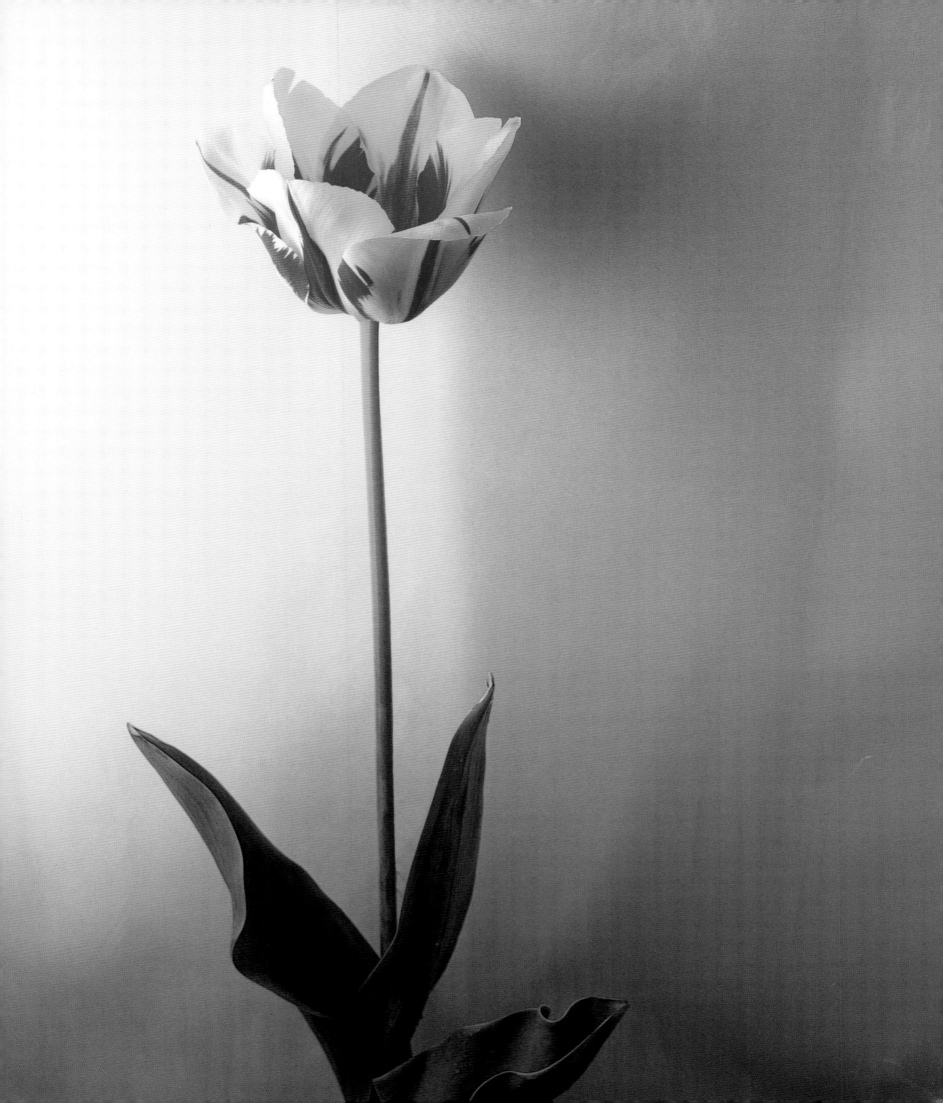

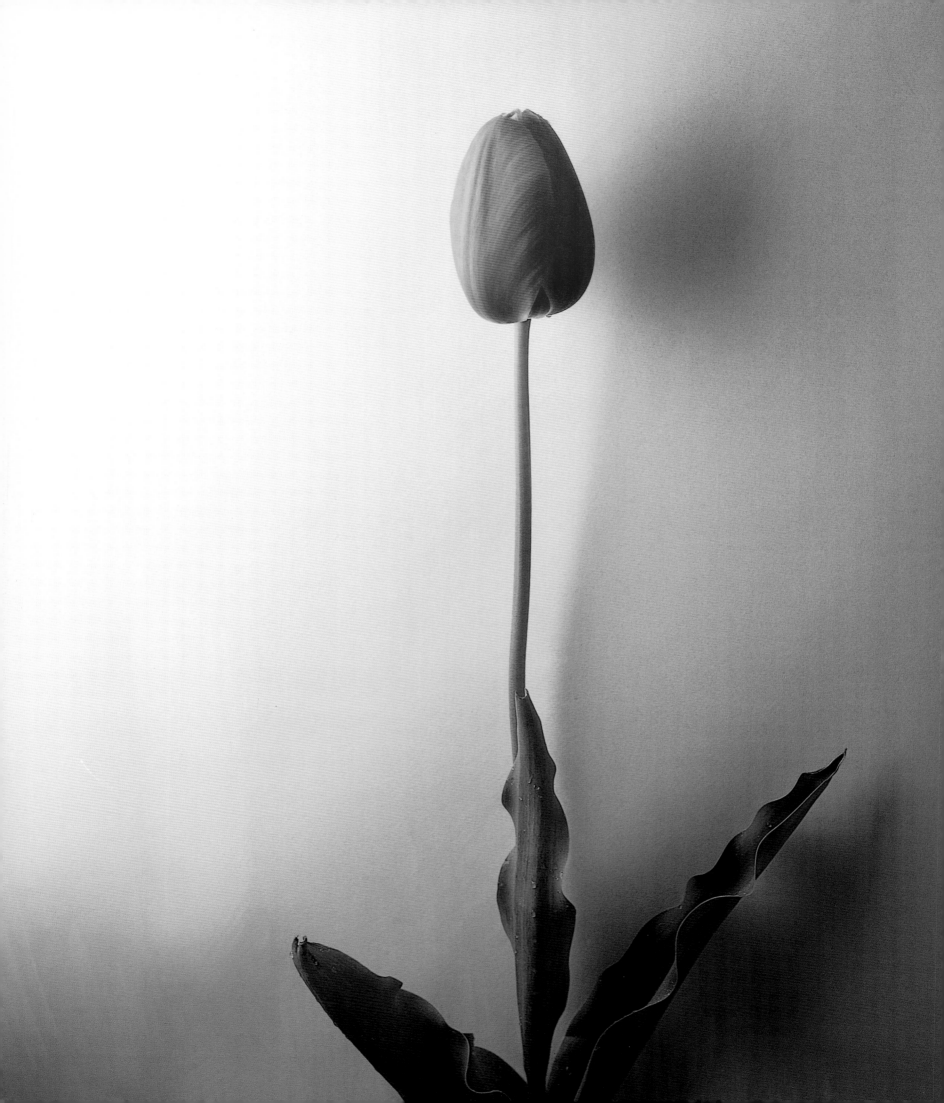

MENTON
Single Late Group
[PLATE 102]

BLUSHING BEAUTY
Single Late Group
[PLATE 103]

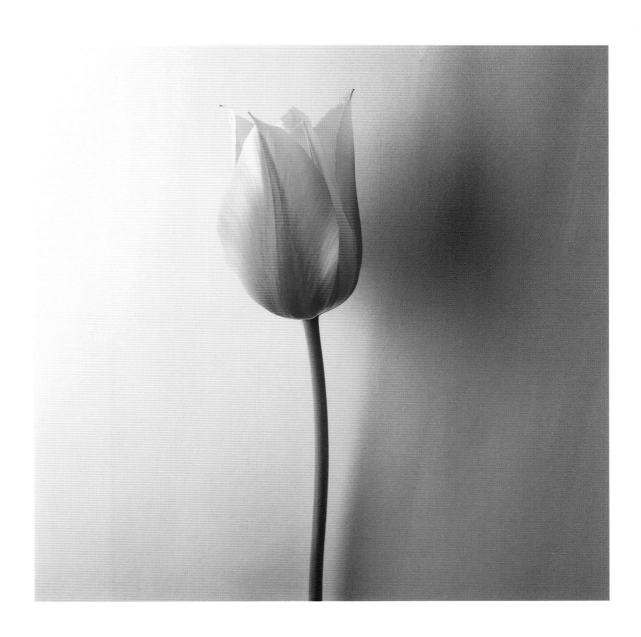

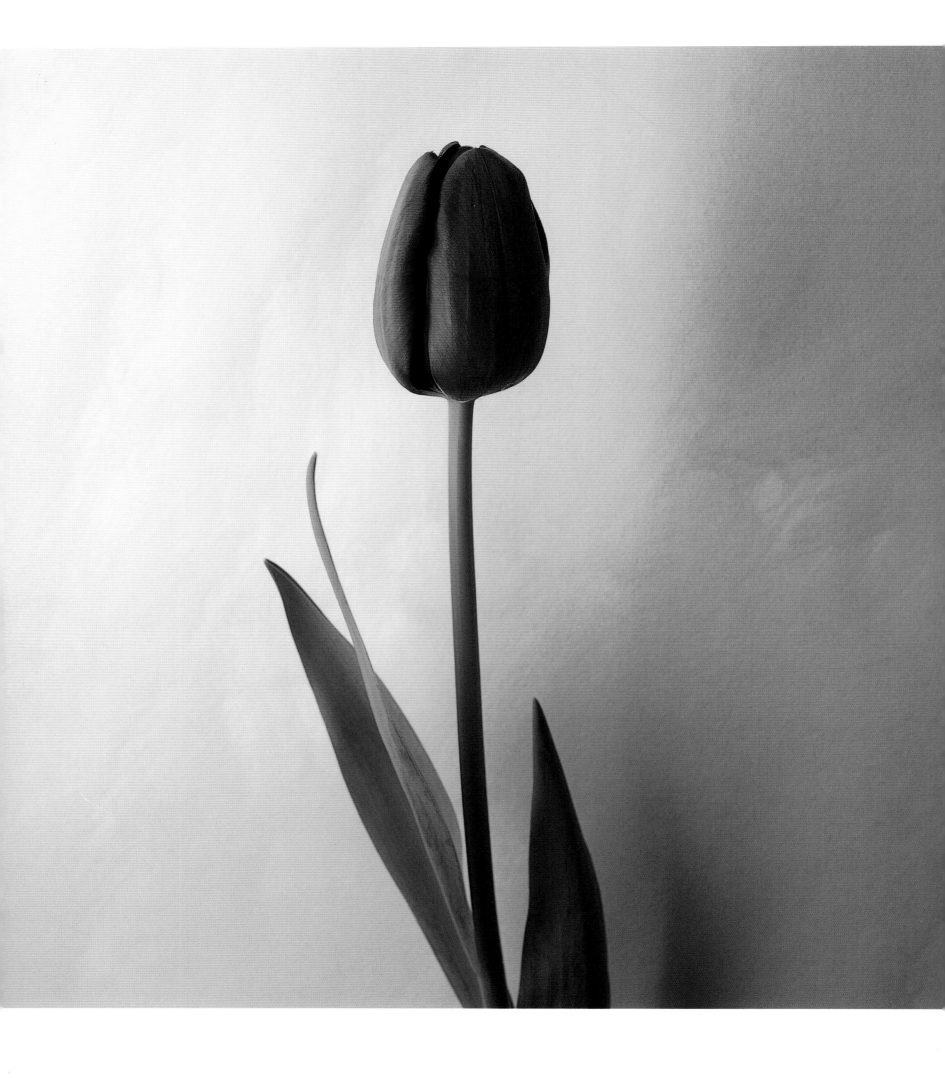

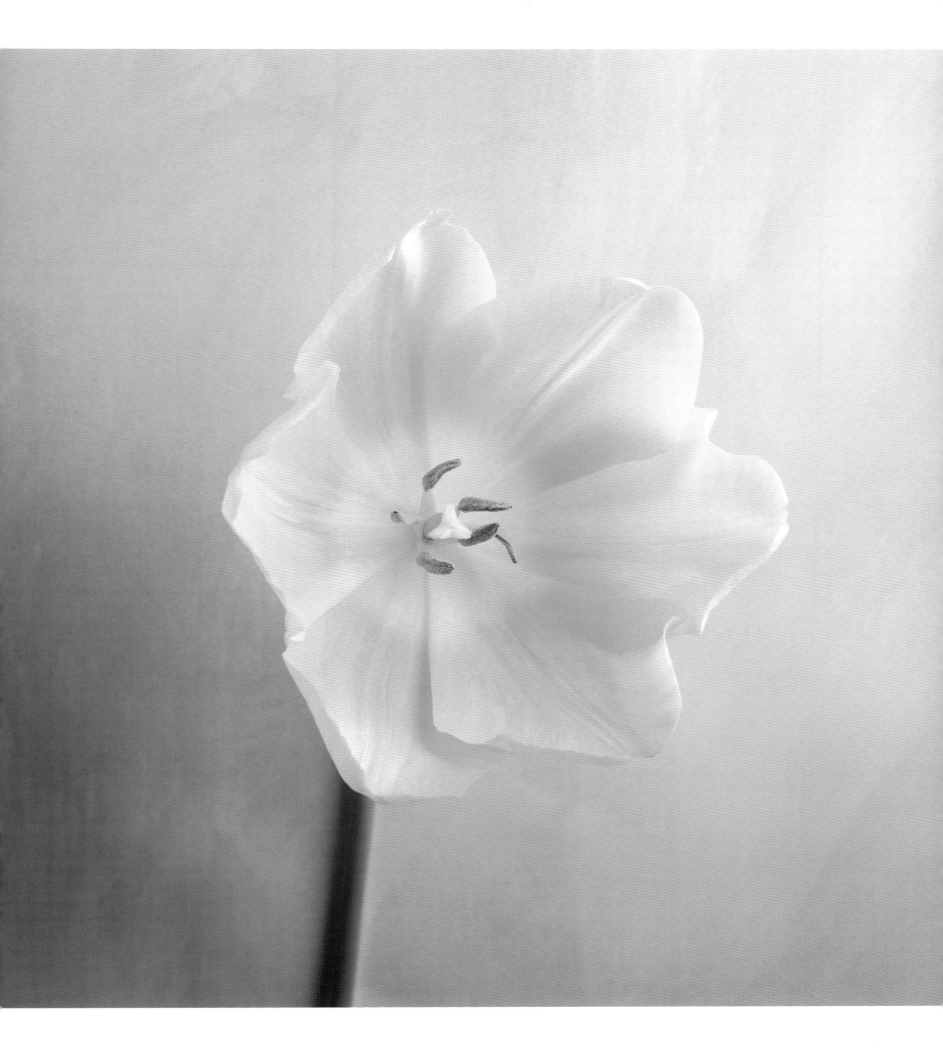

PRECEDING PAGES

QUEEN of NIGHT
Single Late Group
[PLATE 104]

PINK JEWEL
Single Late Group
[PLATE 105]

PICTURE
Single Late Group
[PLATE 107]

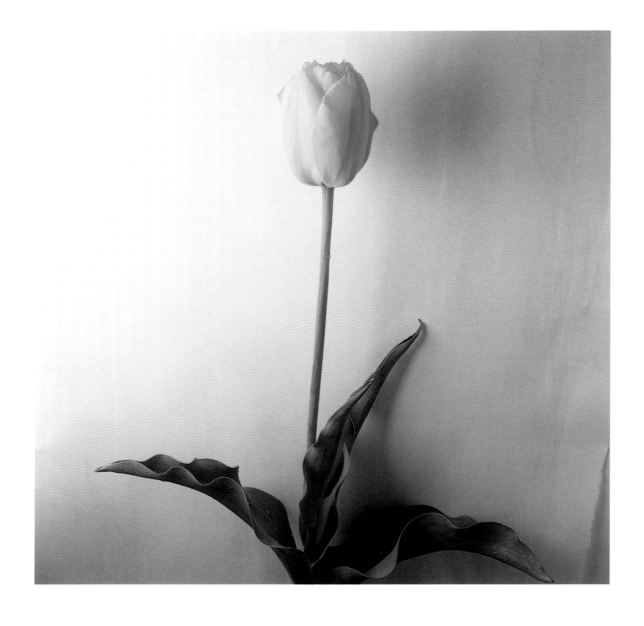

BIG SMILE
Single Late Group
[PLATE 106]

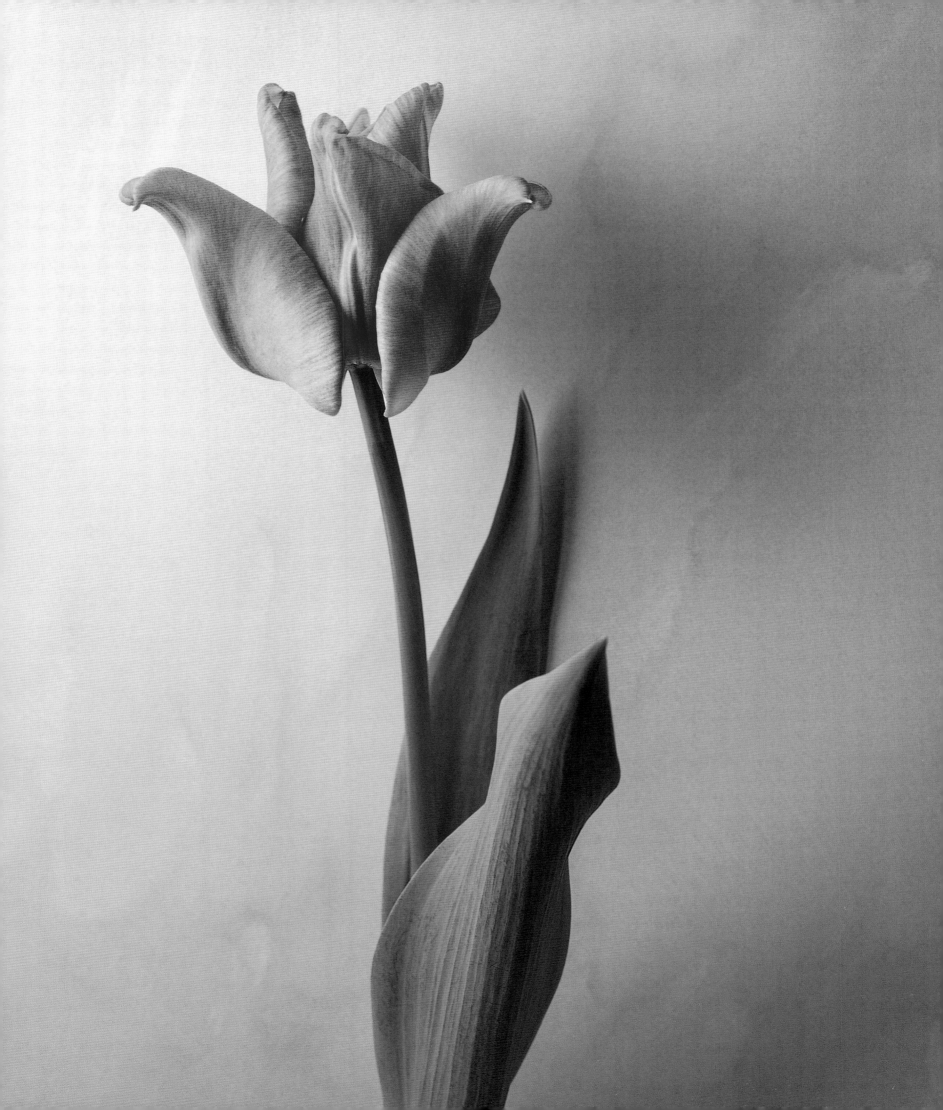

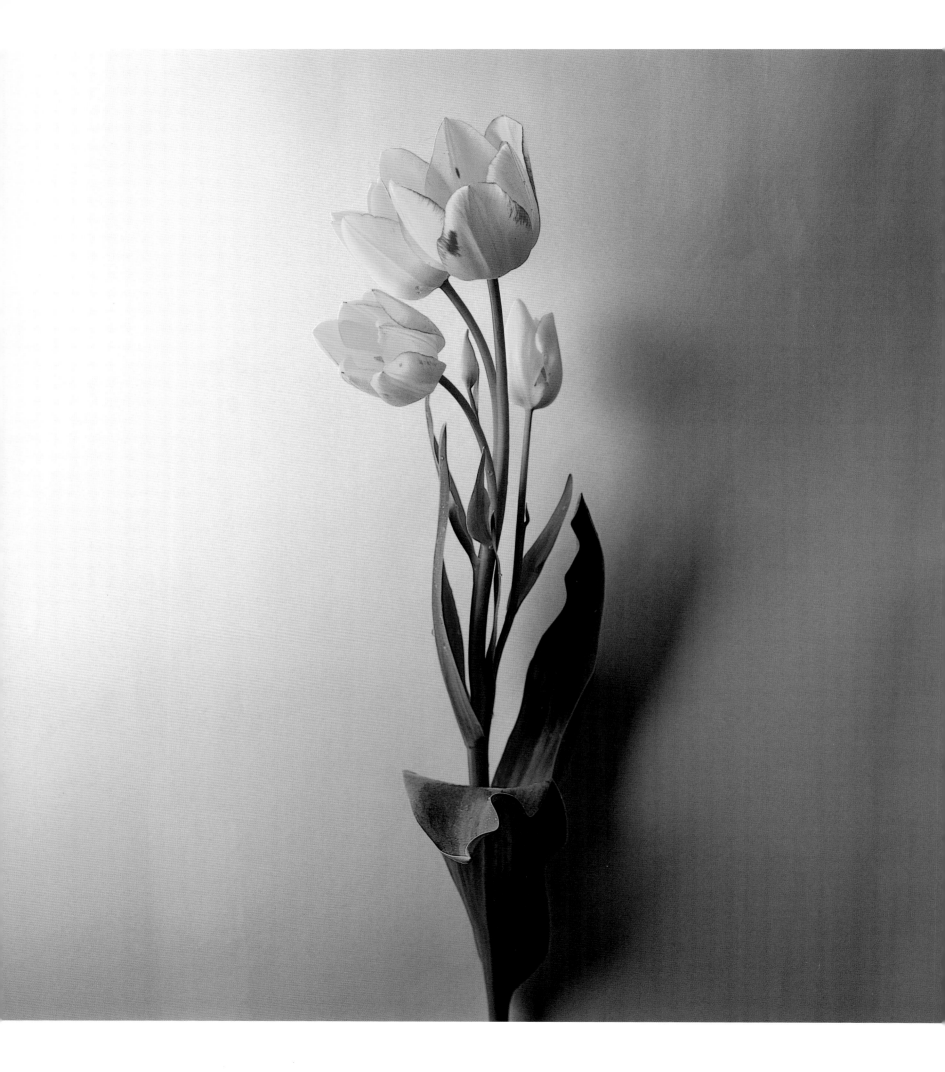

GEORGETTE
Single Late Group
[PLATE 108]

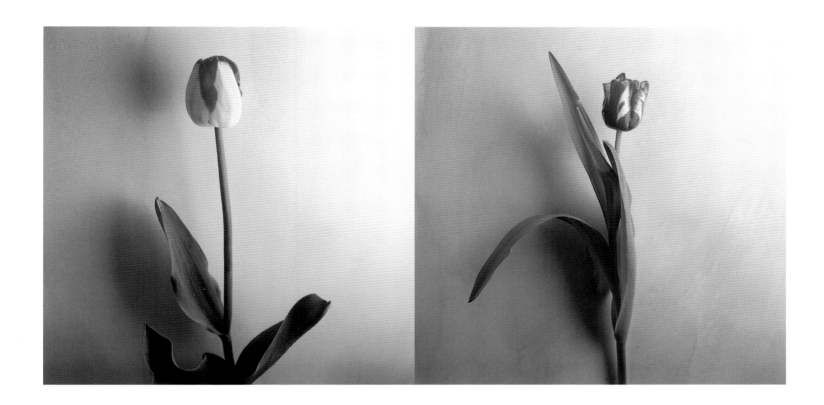

DREAMLAND
Single Late Group
[PLATE 109]

CORDELL HULL
Single Late Group
[PLATE 110]

CARNAVAL DE NICE
Double Late Group
[PLATE 111]

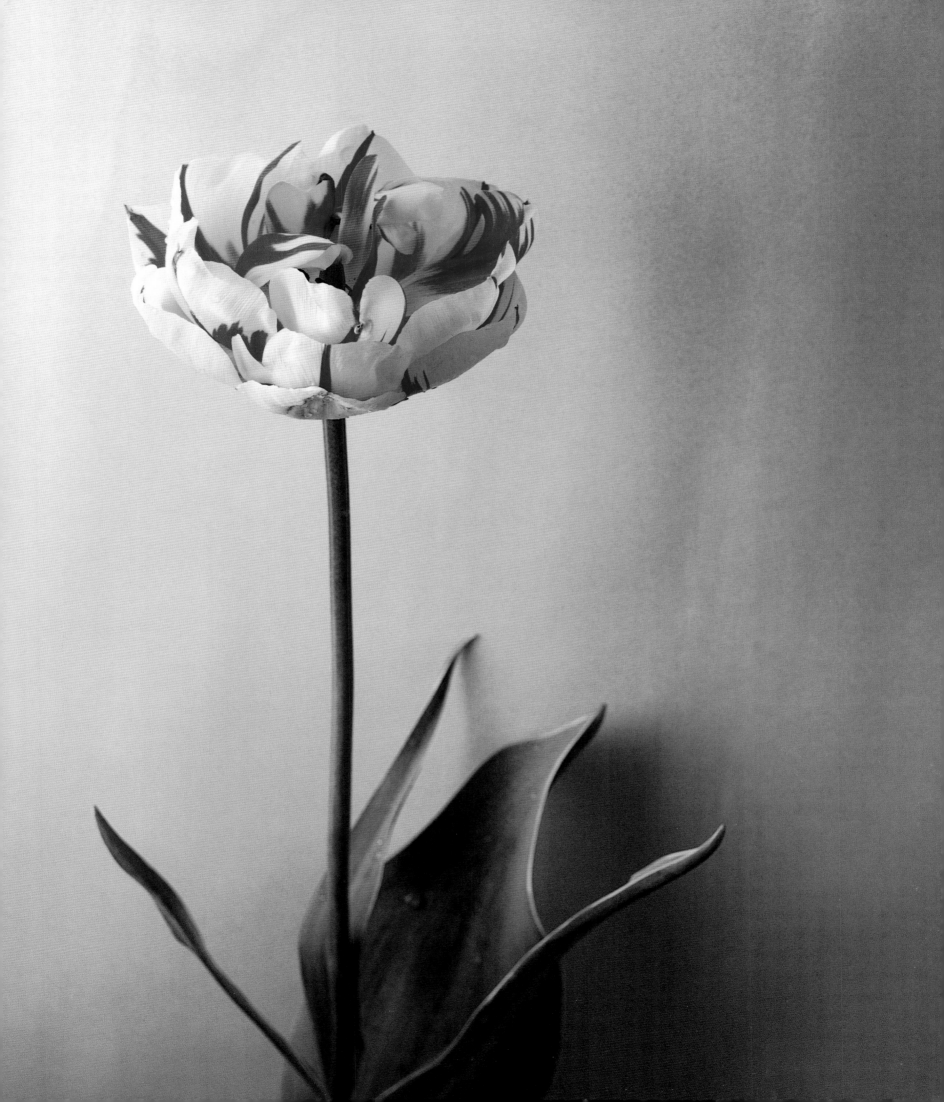

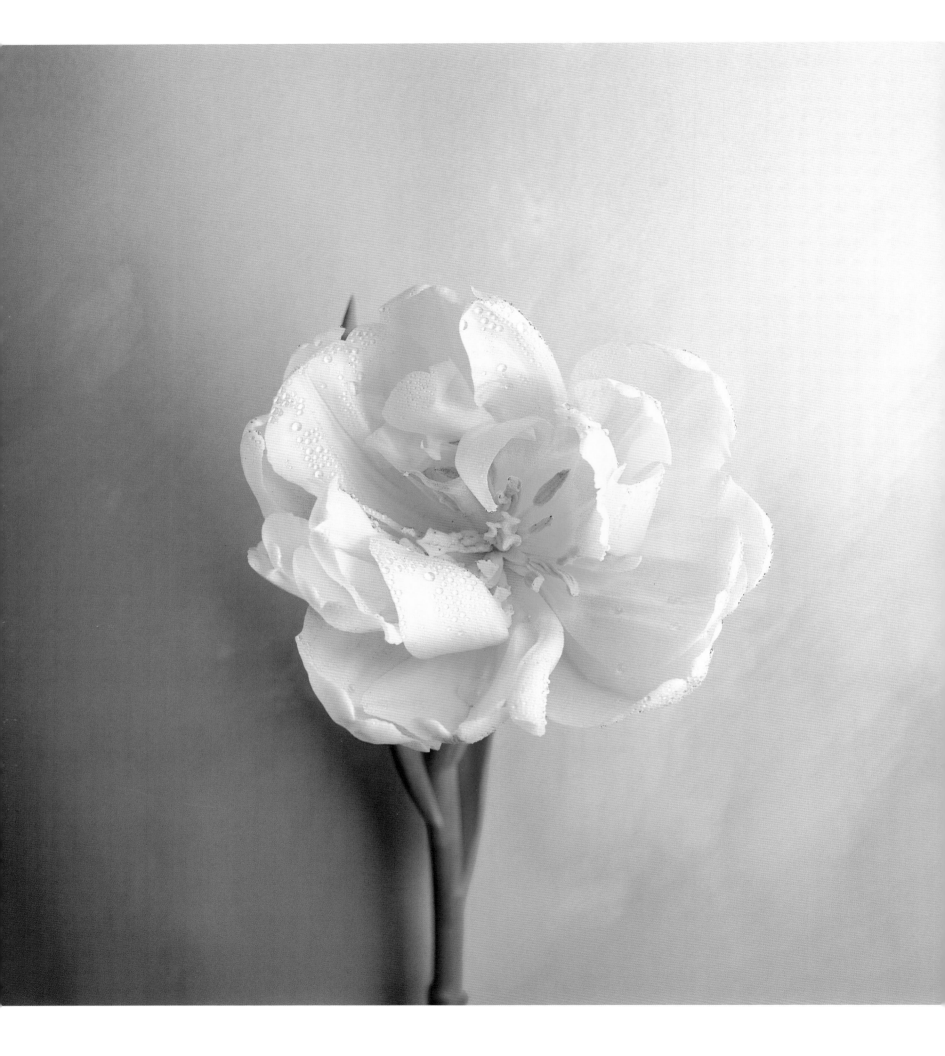

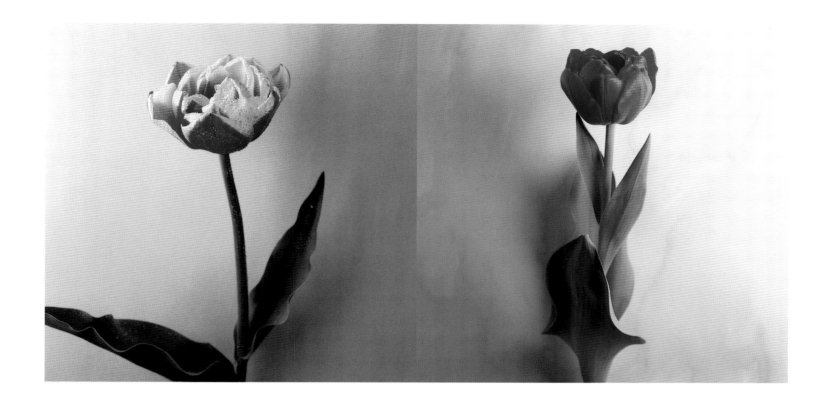

WIROSA
Double Late Group
[PLATE 113]

RED NOVA
Double Late Group
[PLATE 114]

CASABLANCA
Double Late Group
[PLATE 112]

T. orphanidea
Late-Flowering Species
[PLATE 115]

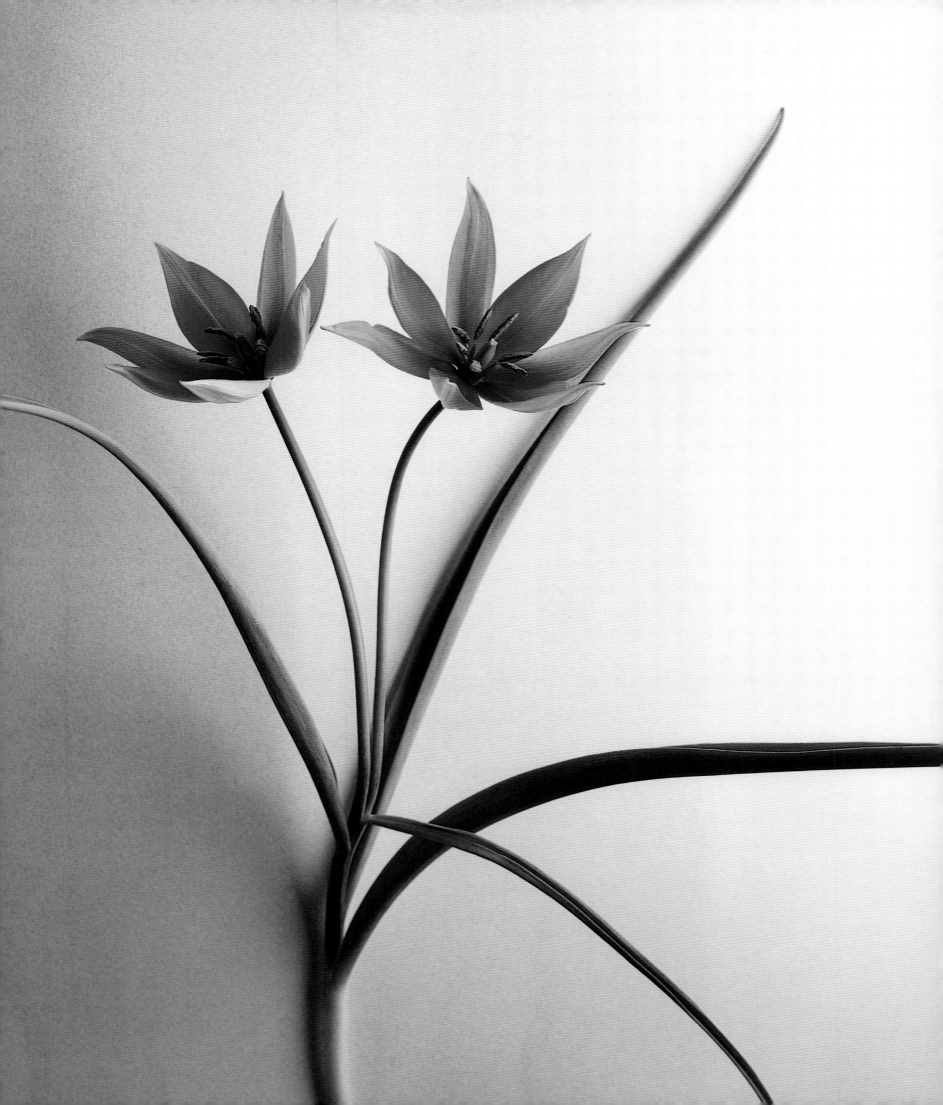

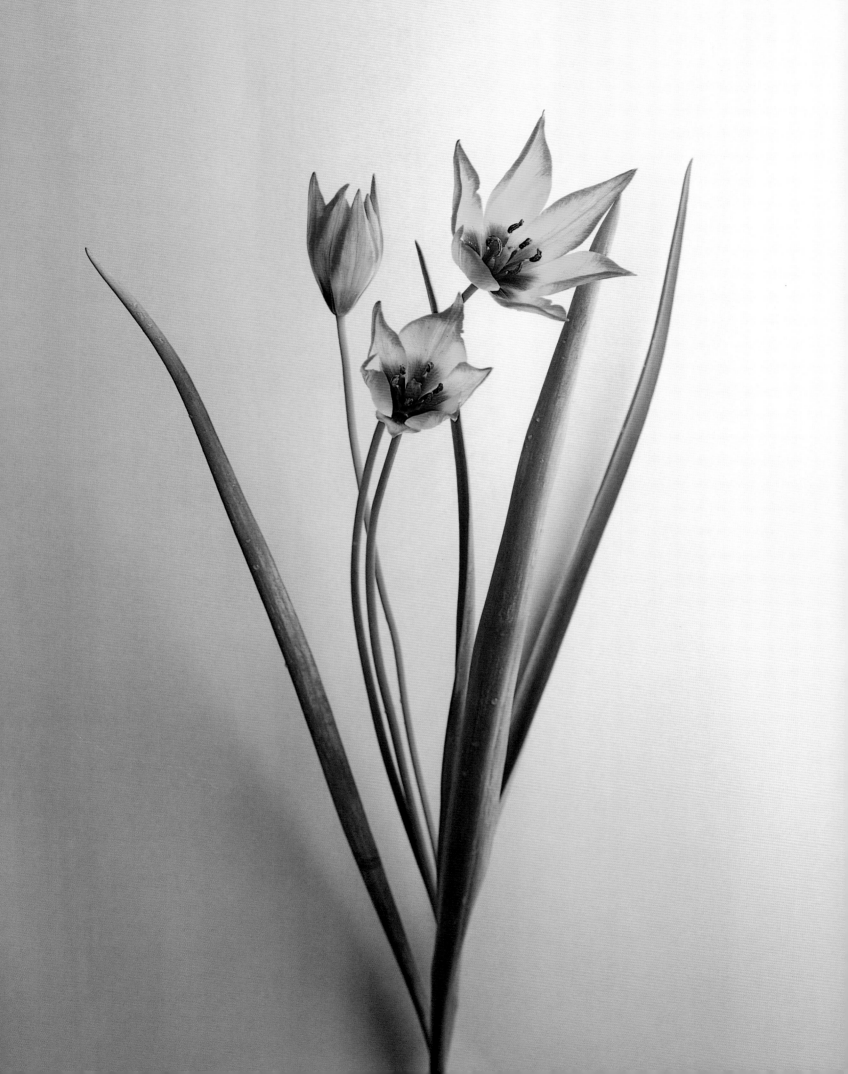

T. orphanidea 'Flava'
Late-Flowering Species
[PLATE 116]

FOLLOWING PAGES

T. didieri
Late-Flowering Species
[PLATE 118]

T. marjolettii
Late-Flowering Species
[PLATE 119]

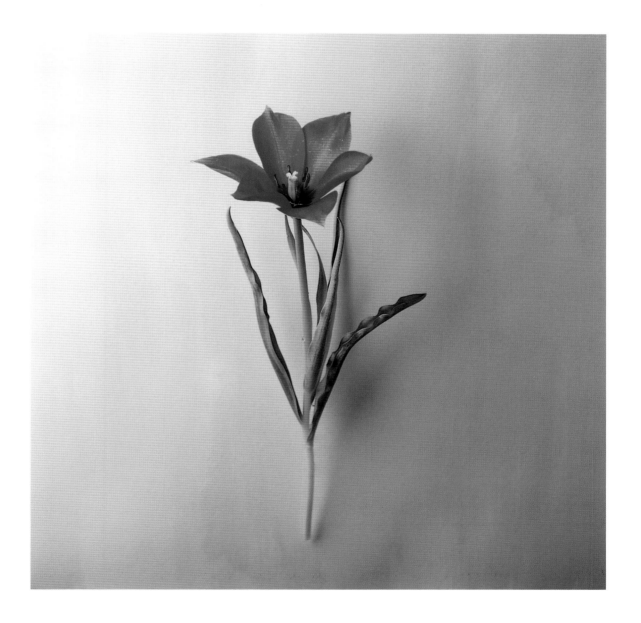

T. linifolia
Late-Flowering Species
[PLATE 117]

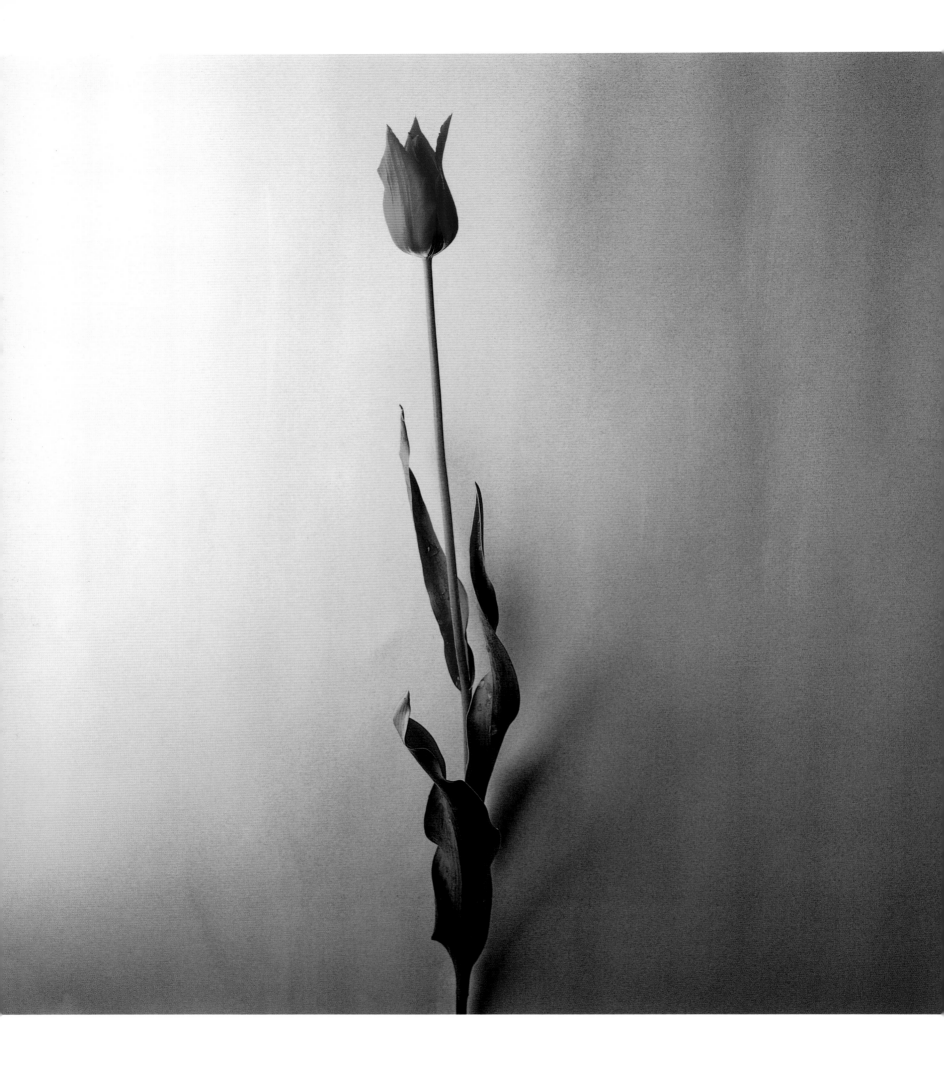

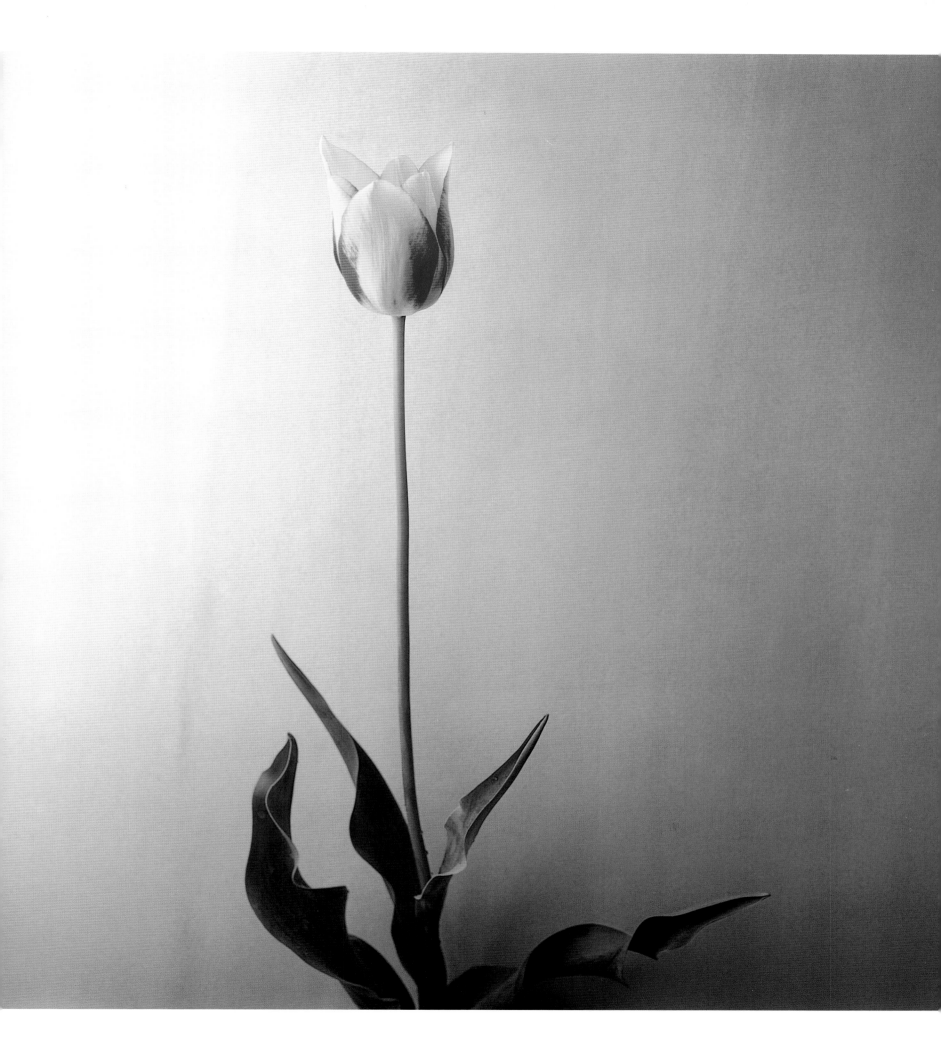

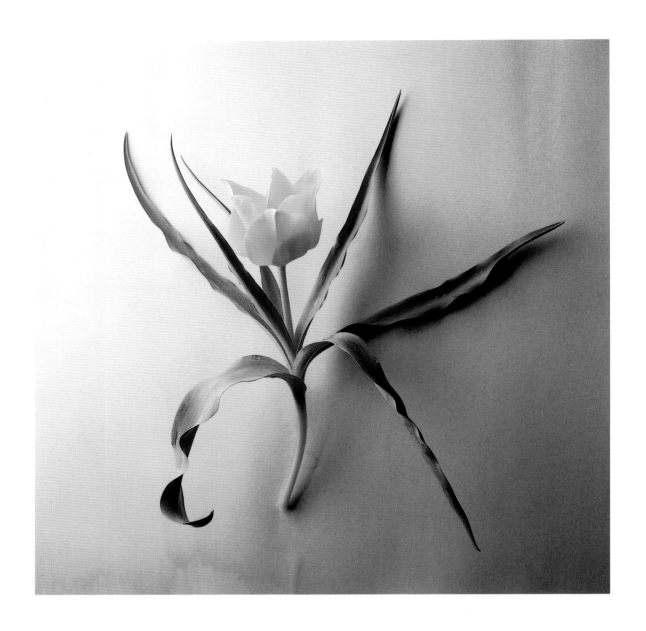

T. batalinii 'Bright Gem'
Late-Flowering Species
[PLATE 120]

T. hageri 'Splendens'
Late-Flowering Species
[PLATE 121]

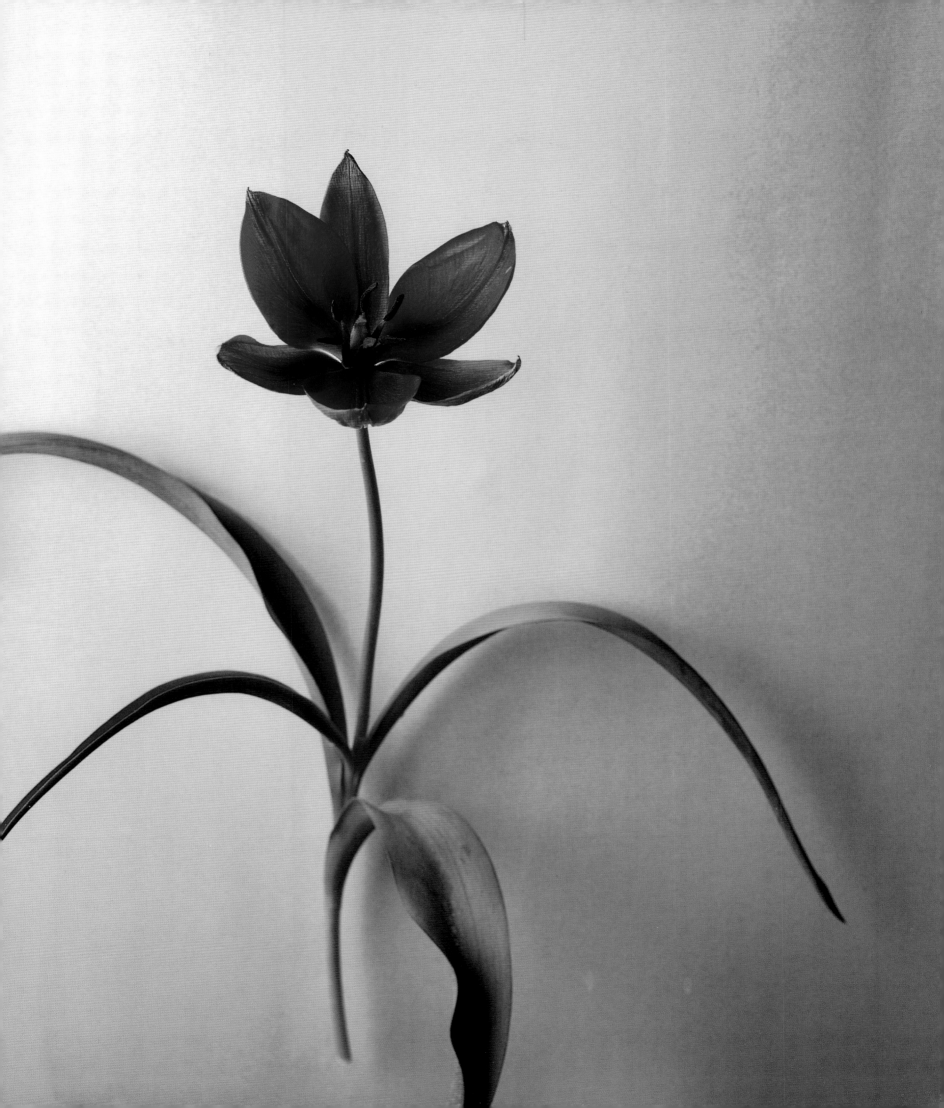

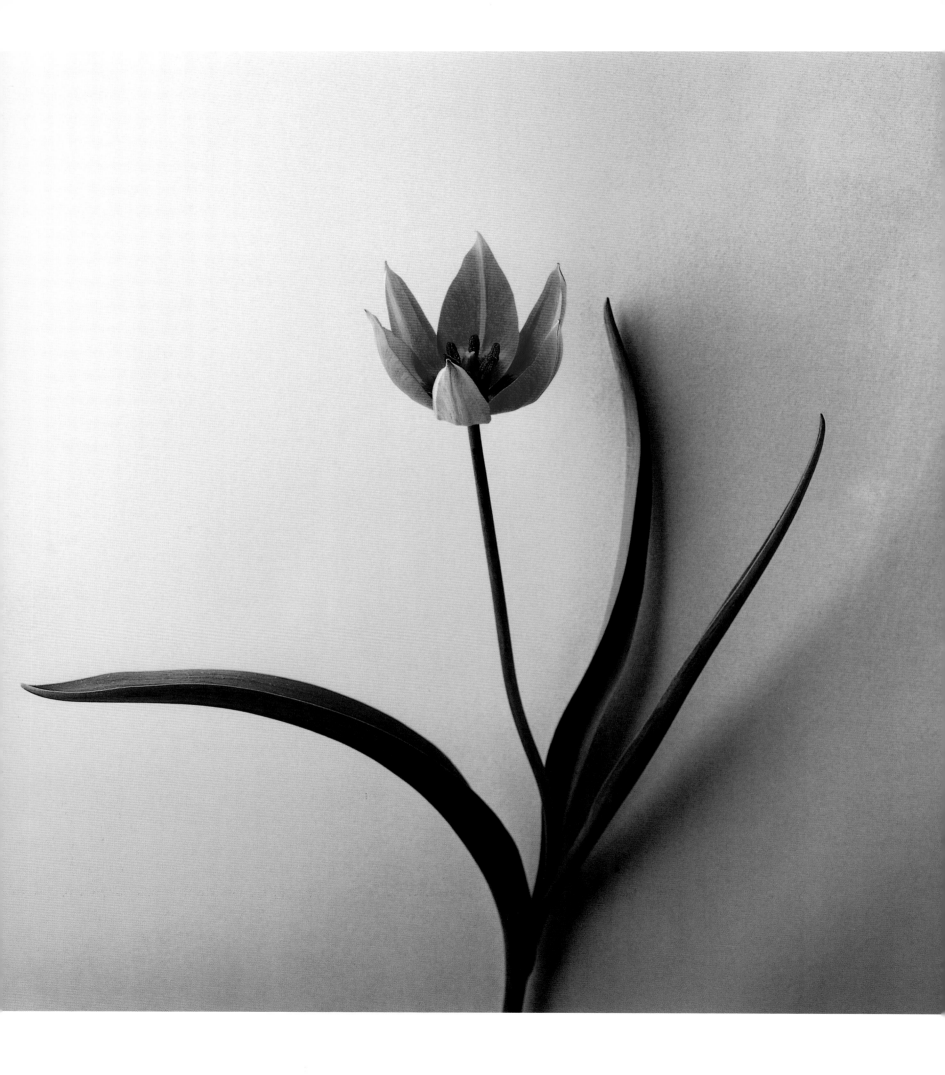

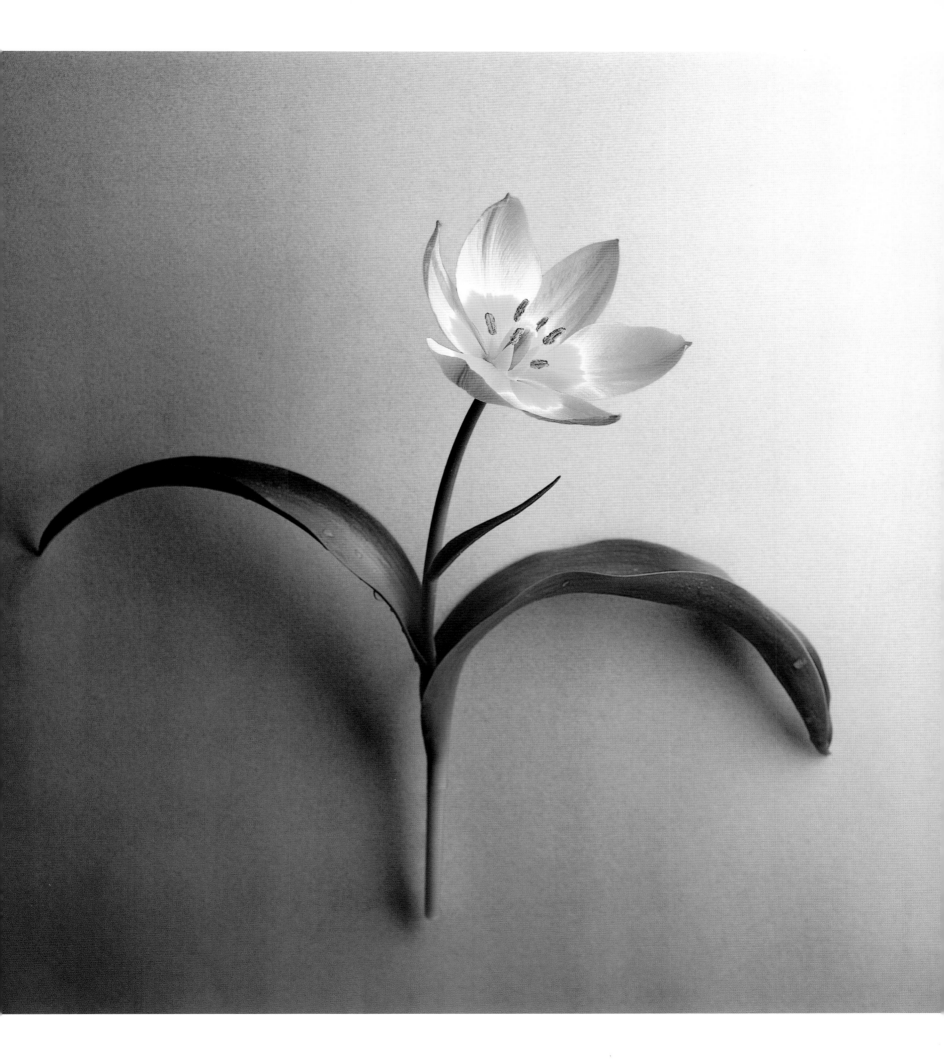

PRECEDING PAGES

T. whittallii
Late-Flowering Species
[PLATE 122]

T. bakeri 'Lilac Wonder'
Late-Flowering Species
[PLATE 123]

T. acuminata
Late-Flowering Species
[PLATE 125]

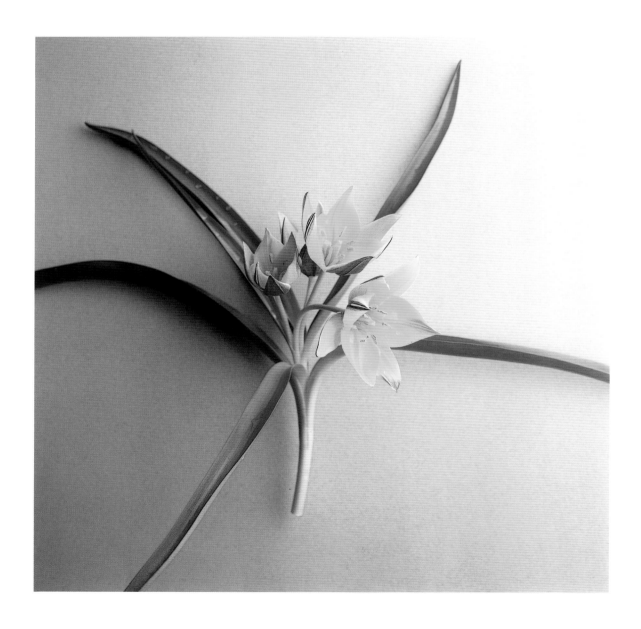

T. urumiensis
Late-Flowering Species
[PLATE 124]

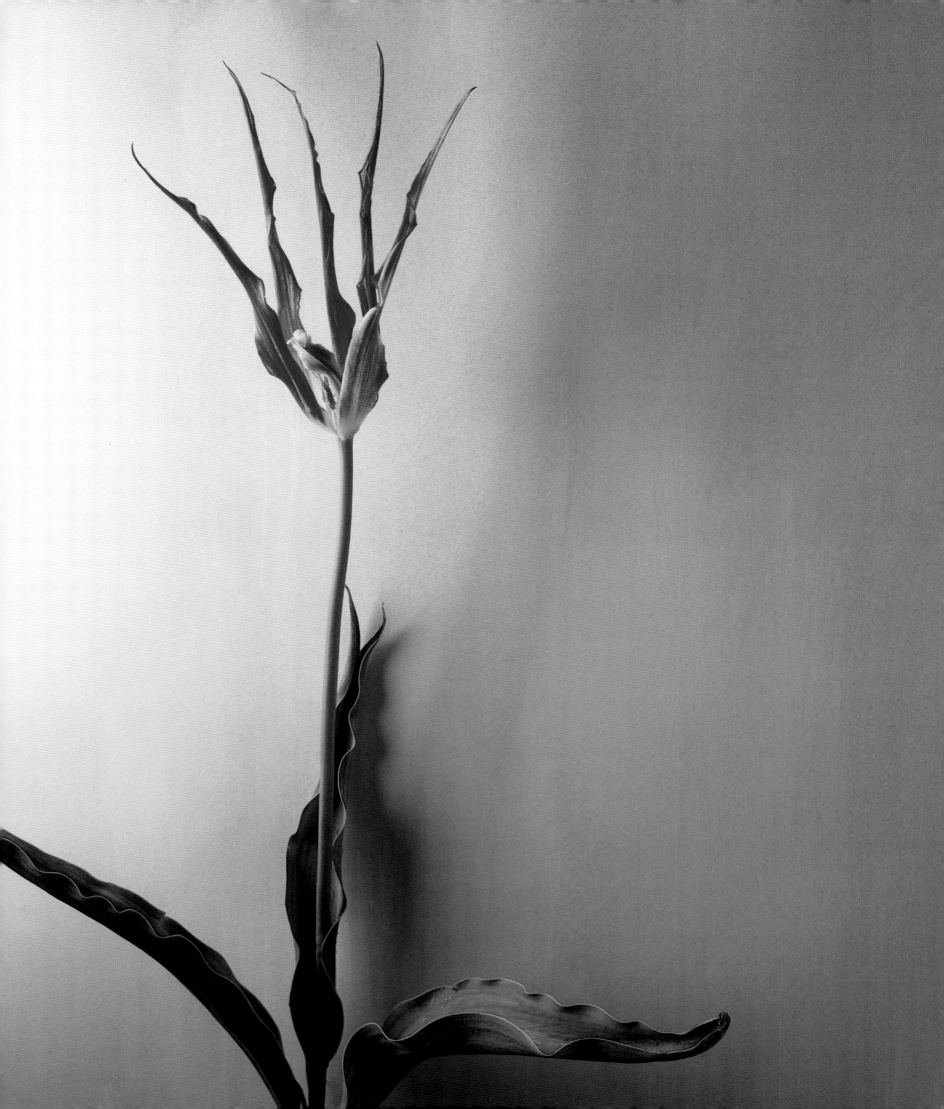

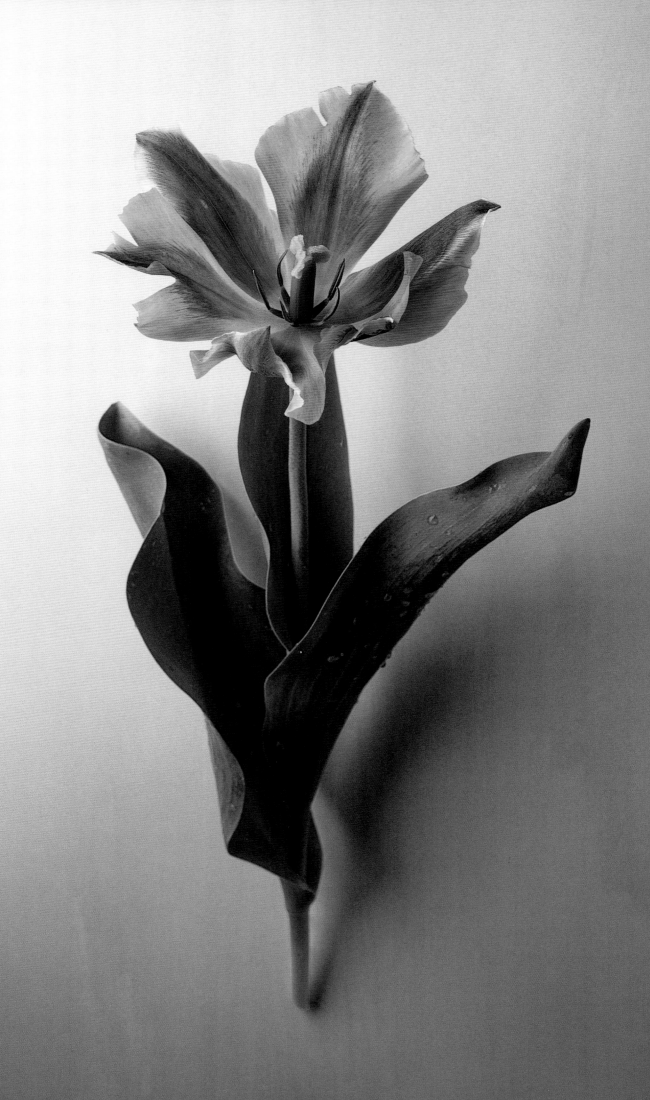

ARTIST
Viridiflora Group
[PLATE 126]

FOLLOWING PAGES

EYE CATCHER
Viridiflora Group
[PLATE 127]

CHINA TOWN
Viridiflora Group
[PLATE 128]

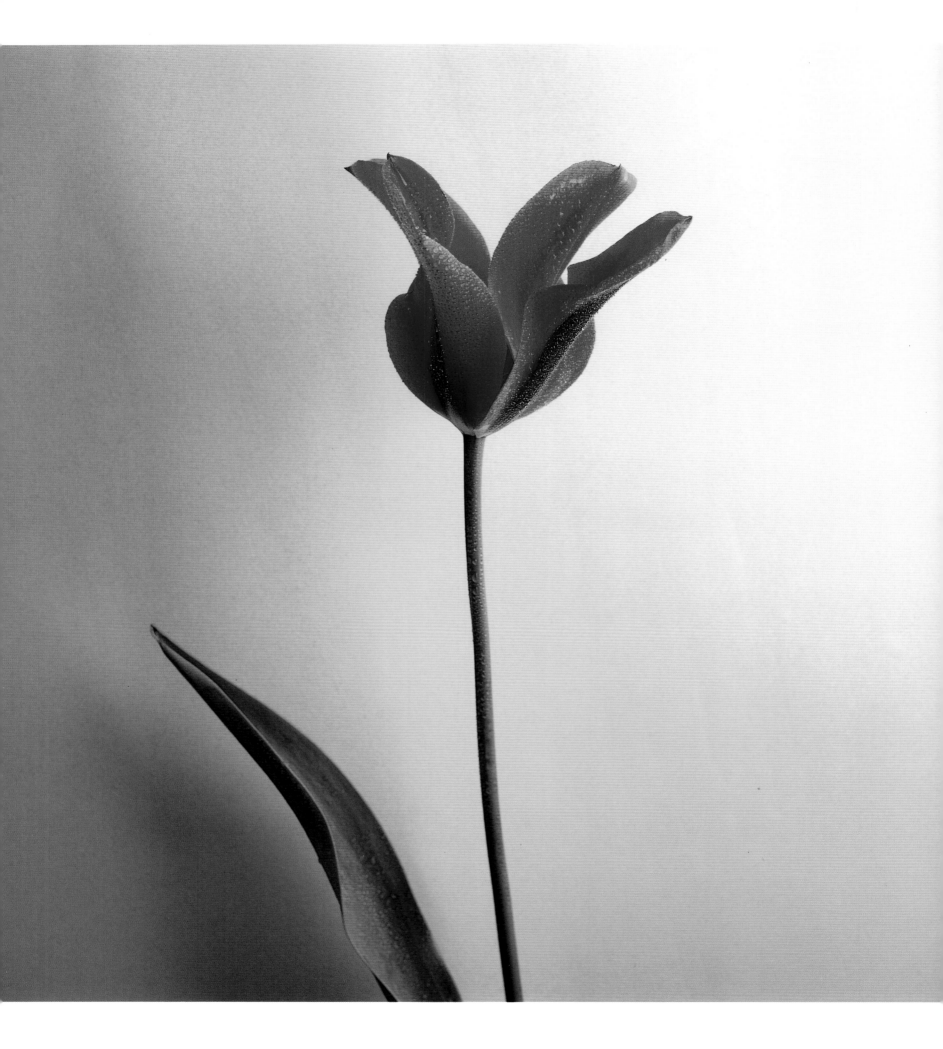

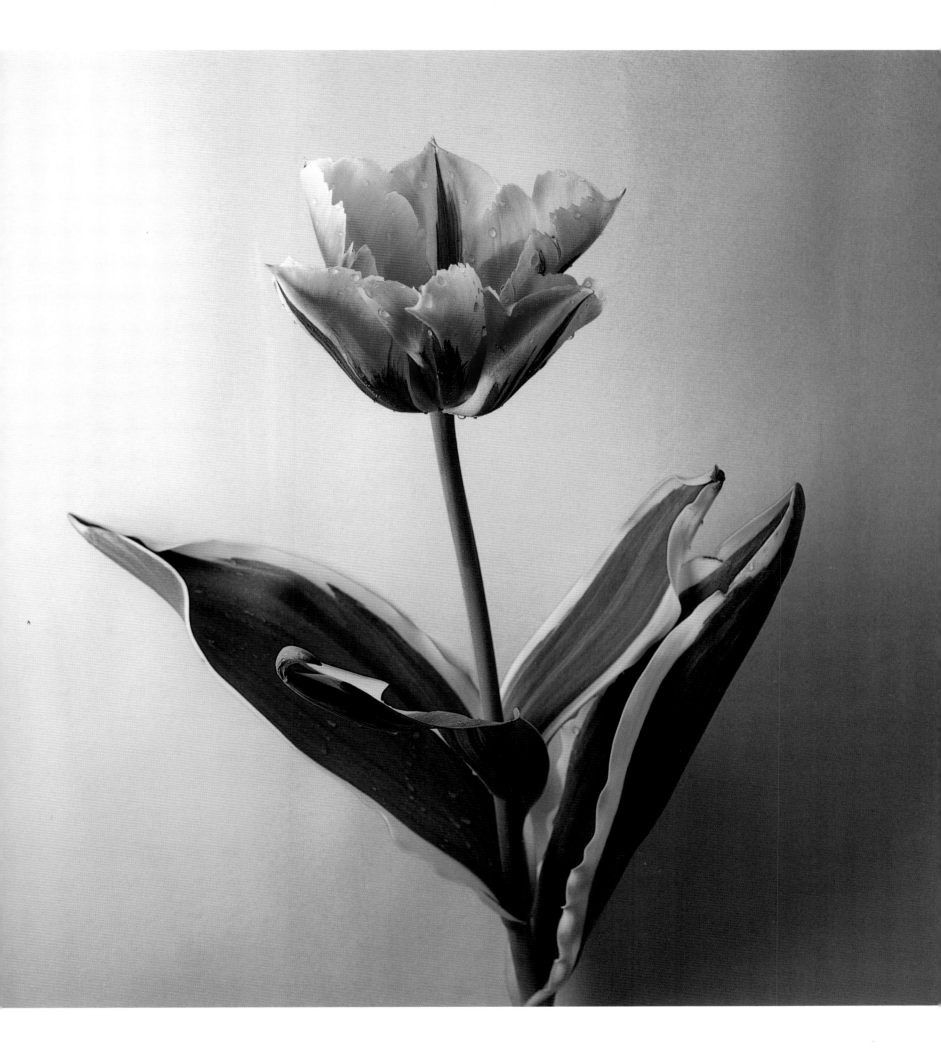

T. sprengeri
Late-Flowering Species
[PLATE 129]

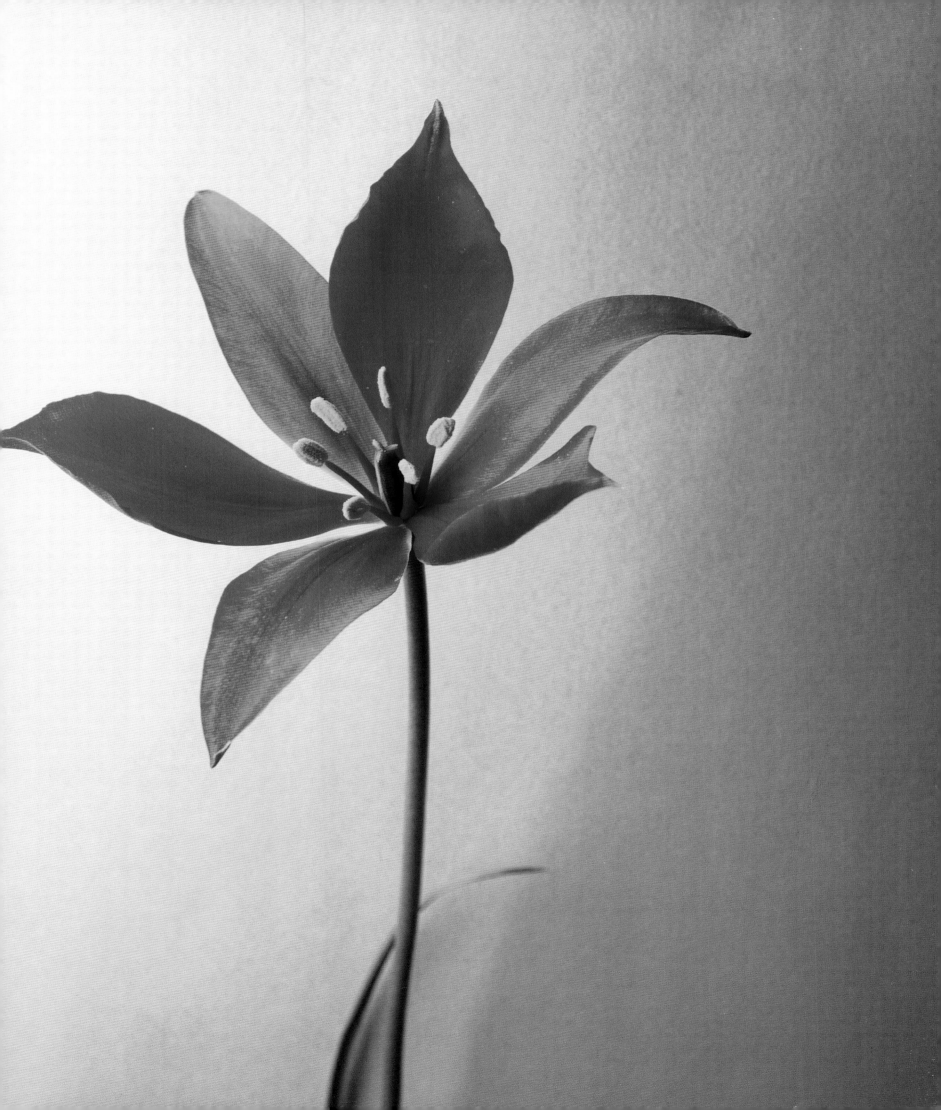

BEARDED AND FRINGED TULIP
New Introductions
[PLATE 130]

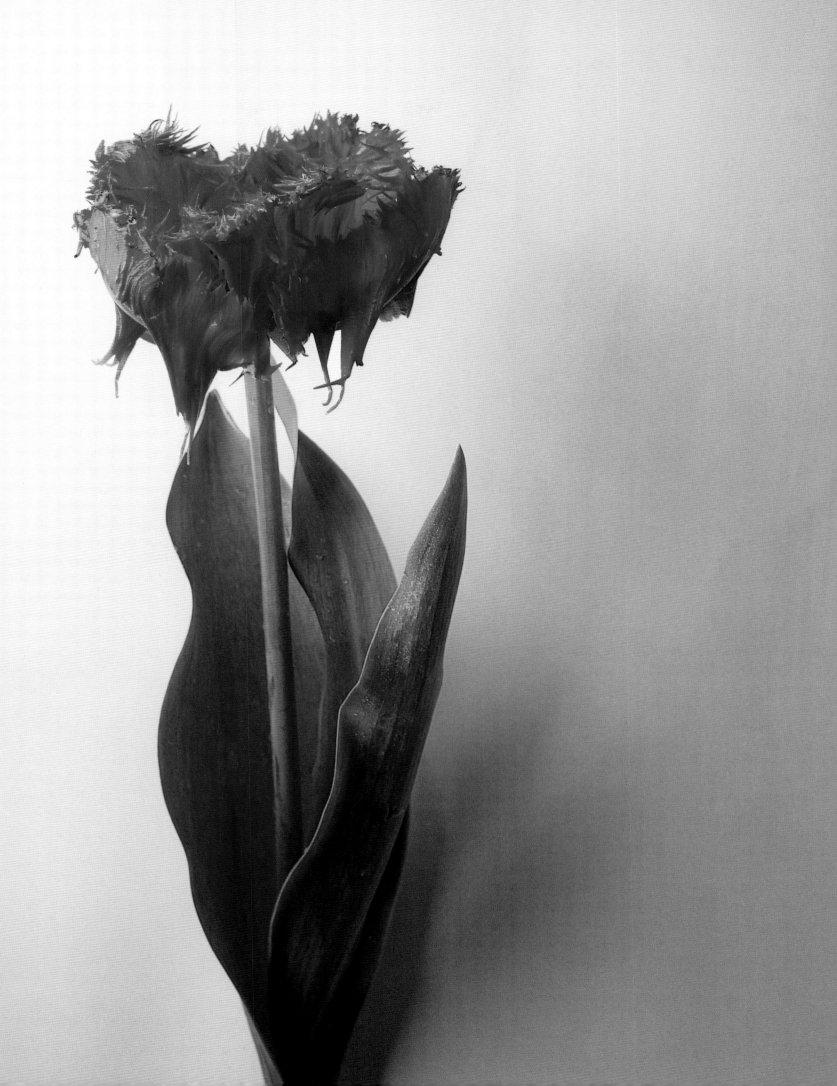

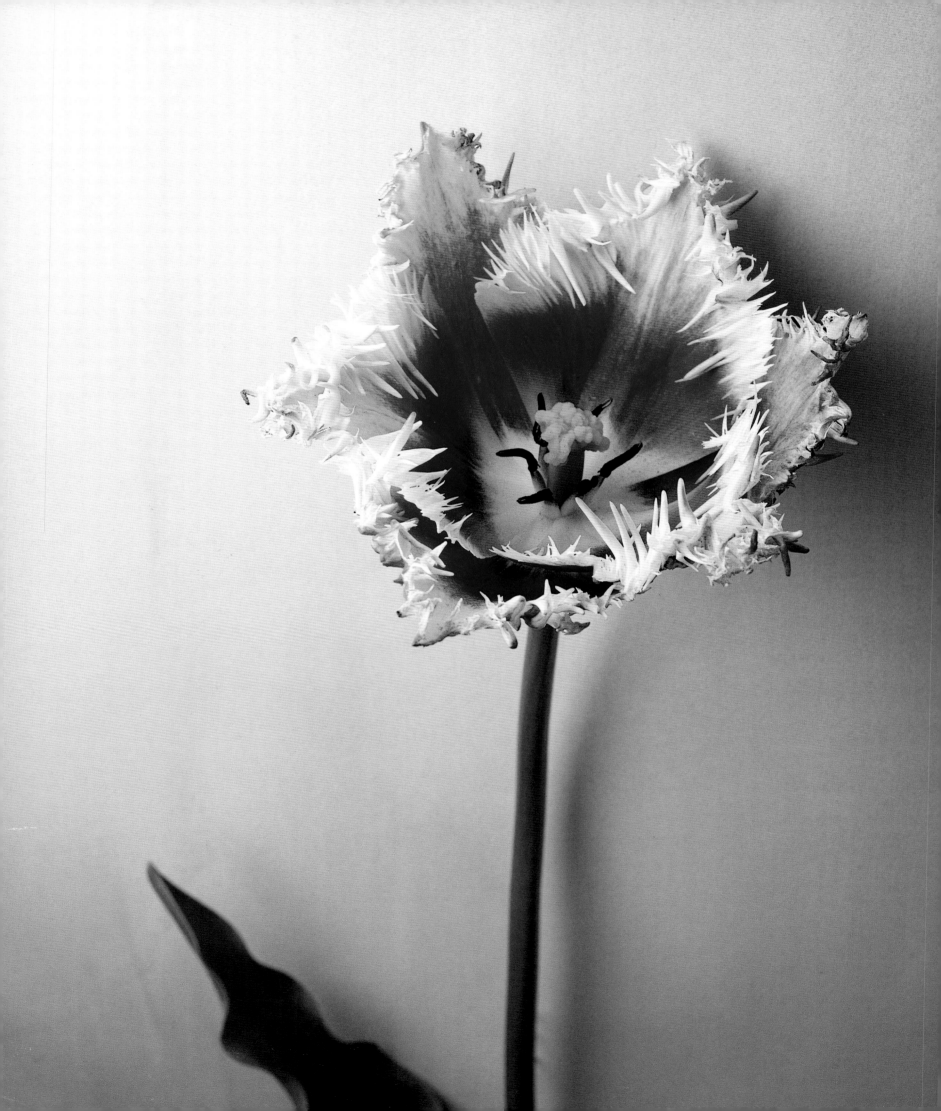

HEAVILY FRINGED TULIP, 'CUMMINGS'
New Introductions
[PLATE 131]

FRINGED PARROT TULIP
New Introductions
[PLATE 132]

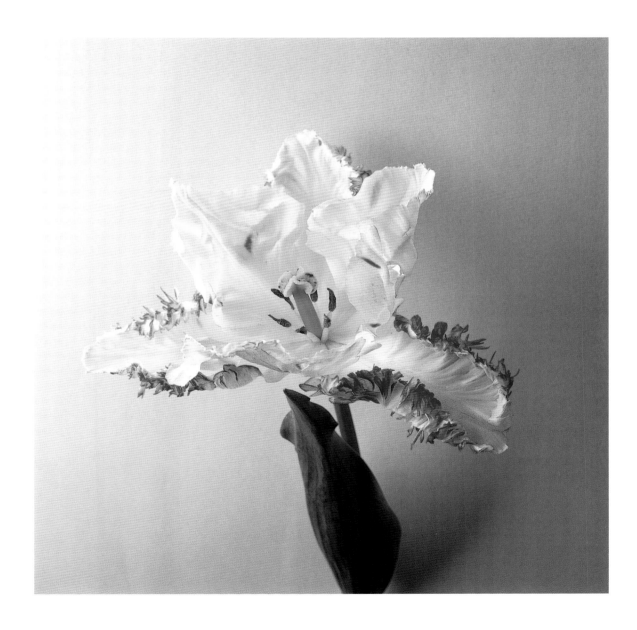

CABBAGELIKE TULIP, 'ICE CREAM'
New Introductions
[PLATE 133]

FOLLOWING PAGES

DOUBLE FRINGED TULIP
New Introductions
[PLATE 134]

DOUBLE PARROT TULIP
New Introductions
[PLATE 135]

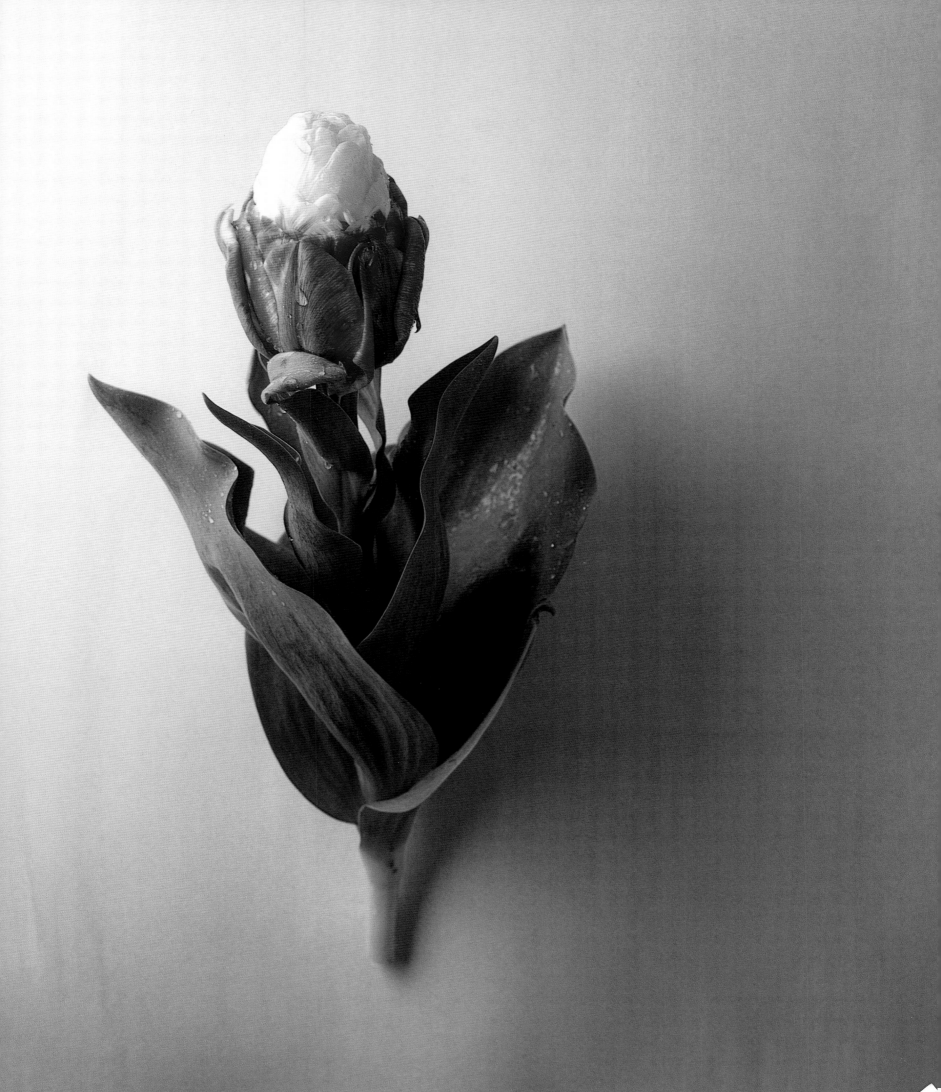

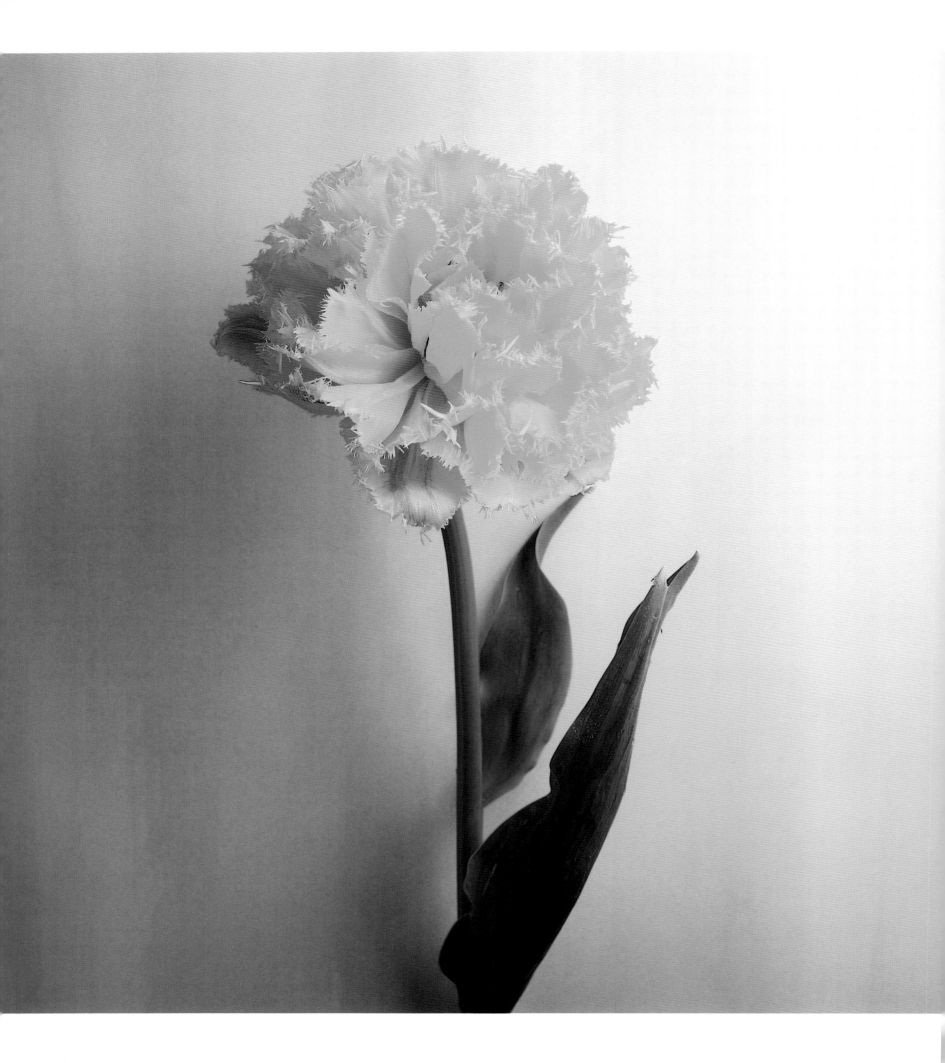

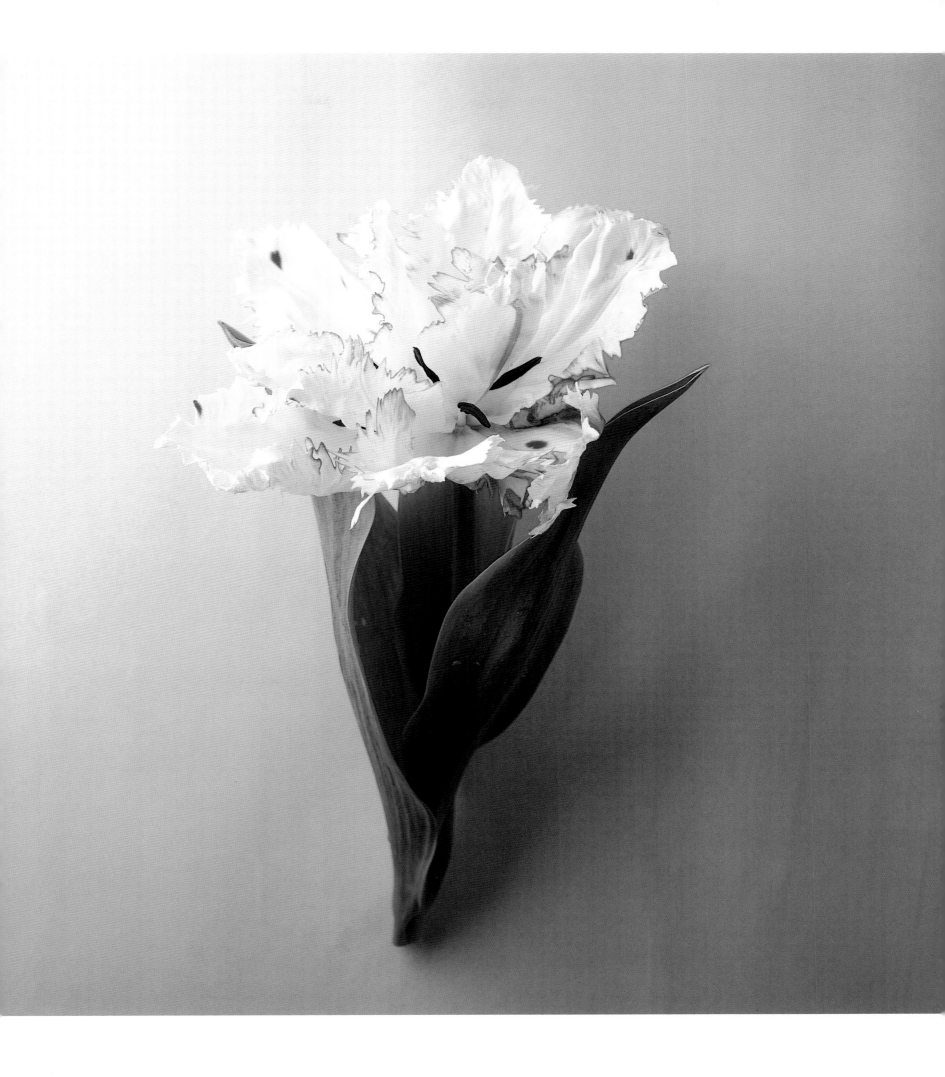

PINK THIEF
Other Tulips
[PLATE 137]

RED THIEF
Other Tulips
[PLATE 136]

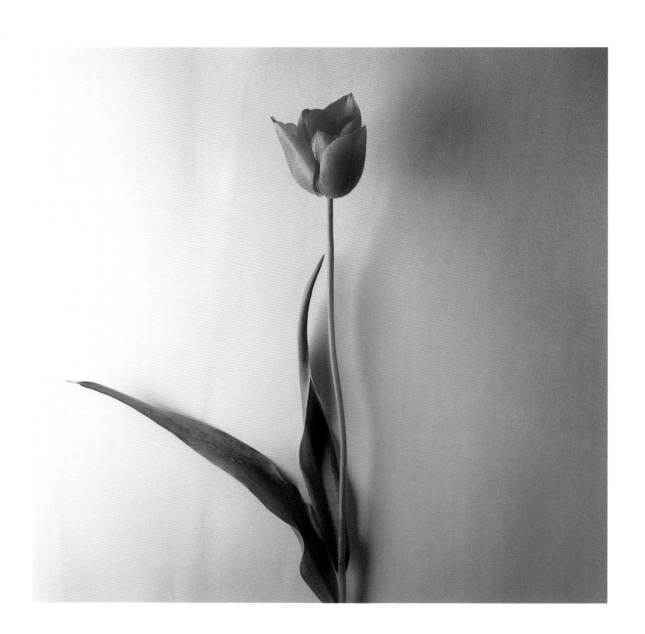

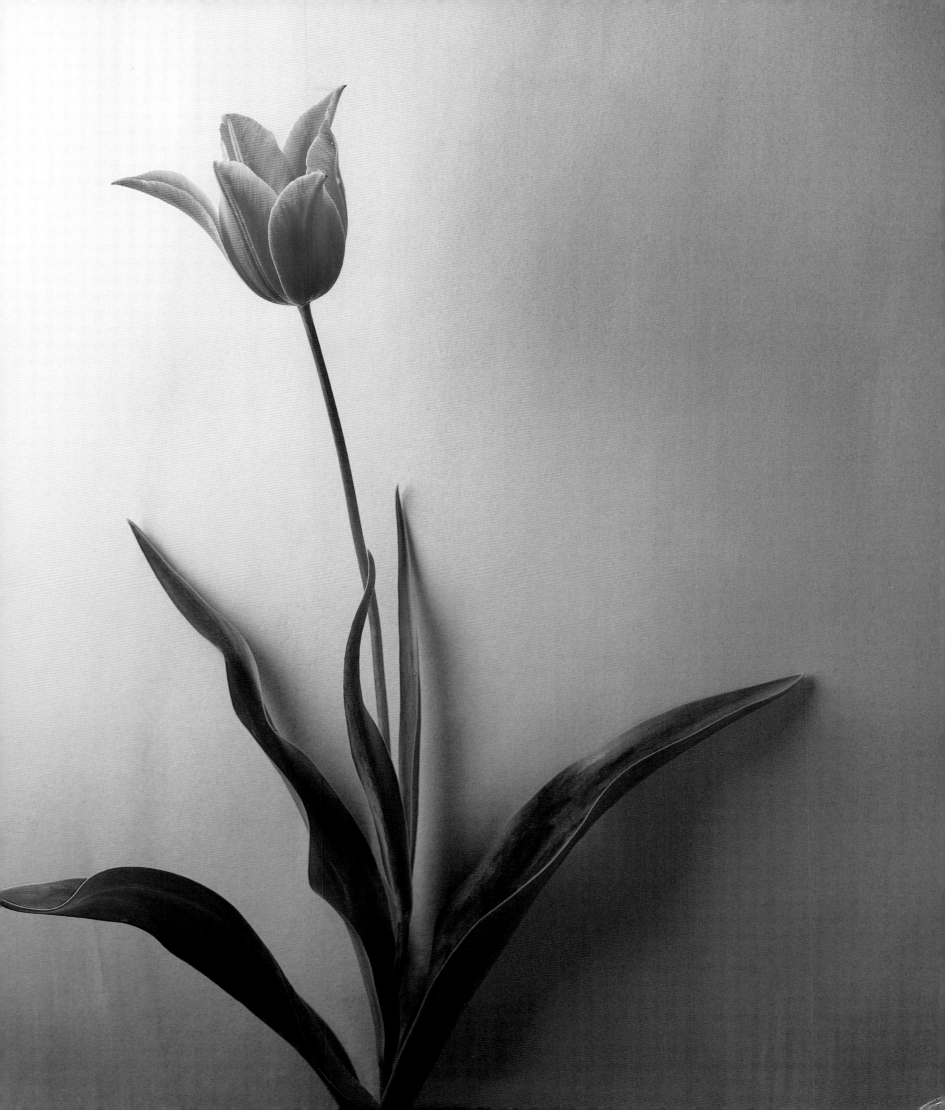

CLASSIFYING TULIPS

THE DESIRE TO CLASSIFY TULIPS was evident well over four hundred years ago, not long after the flower arrived in the Netherlands. Between 1554 and 1562 (the date is uncertain) Ambassador Augier Ghislain de Busbecq, a Flemish diplomat who represented the Habsburg emperors in Constantinople, returned by mail coach from Istanbul to the Low Countries with a handful of tulip bulbs given to him by Sultan Suleiman the Magnificent of Turkey. Busbecq, an enthusiastic gardener, admired the flower called *tulipam* that the Turks had been growing and cultivating since the twelfth century. He was drawn to it in large part because it bloomed when little else did, almost in the middle of winter. The renowned botanist Carolus Clusius made the earliest classification system for tulips in 1573, classifying them as "early," "mid-season," and "late." In 1593, he laid out a new botanic garden in Leiden and planted a great collection of tulips.

By 1636 tulipomania—the most cataclysmic event in the tulip's long and fascinating history, when everyone in Holland including bricklayers, plumbers, and cobblers joined in on the speculative hysteria of tulip futures—had reached its peak, and varieties were being grouped according to their colors. For example, those with violet or lilac nuances on a white ground were called Violetten, varieties with red or rose on a white ground were classified as Roses, and those streaked with red, brown, bronze, pink, or violet on a red, white, or yellow ground were called Bizarres and Bijbloemens.

Tulips weathered the high and inevitable low (tulipomania crashed in 1637 when suppliers outnumbered the demand) of the seventeenth century. Throughout the next hundred years more tulip cultivars were brought on the market and more tulip groups were named—Breeders and English and Dutch Cottage tulips, as well as the beautiful small 'Duc van Tol' tulips.

By the end of the nineteenth century, tulips had gained mass-market appeal and thousands of new cultivars were raised to accommodate the increasing demand for them as bedding plants. In 1886 the firm of E. H. Krelage & Sons of Haarlem introduced a new tulip group: Darwin tulips. Though the Darwins were slightly different from the previous groups of tulips and so warranted their own name, they were, nonetheless, similar enough in form to the Cottage and Breeder tulips that it was growing difficult to keep the divisions clear.

To complicate matters, because there was no official registry of tulips, individual new flowers were being given names that had already been assigned to earlier ones. In 1913, the Council of the Royal Horticultural Society in London appointed a Tulip Nomenclature Committee consisting of British and Dutch specialists to sort out the mounting confusion over nomenclature and divisions. Together they collaborated on the publication of the first classified list of tulips published in 1917. This was a milestone toward the creation of order.

It became apparent just a few years later that yet again another official tulip list was needed to accommodate the Mendel tulips and the Triumph tulips—both came into commerce around 1920–1925. Between that time and 1955, when the Royal General Bulb Growers' Association in Hillegom—Koninklijke Algemeene Vereeniging voor Bloembollencultuur (KAVB)—became the recognized authority on tulip registration, lists were updated and published about every ten years. With the exception of the Triumphs, most of the tulips in these groups have disappeared as a result of their aging stocks and degenerating ability to produce viable offsets or new bulbs. (The life spans of particular tulips are variable; like people, some tulips survive longer than others.) The few remaining tulips still in cultivation from these early groups were added to existing divisions.

TODAY THE SAME general guidelines apply for grouping tulips; that is, they are classified according to their flowering times as well as to the shape or character of their flowers. Tulips are now divided into fifteen groups (in 1958 there were twenty-three divisions). The most recent *Classified List and International Register of Tulip Names* (1996) prepared by the KAVB lists over fifty-six hundred tulips, of which about twenty-six hundred are in cultivation today and readily available. The five hundred tulips chosen for inclusion in *Tulipa* based on their flower color, form, sturdiness, and availability provide a thorough and complete picture of the varieties available today, with tulips included from every group except the Rembrandts, which are no longer grown in Holland. While the Rembrandt tulips are still accorded a place on the *Classified List and International Register of Tulip Names*, these tulips, which were previously called Bizarres and Bijbloemens, are "broken" or virus-infected tulips, obtaining their flamboyant coloring through an infection carried by aphids. Dutch

bulb growers stopped cultivating Rembrandts and today plant health regulations forbid the growing of Rembrandts in Holland.

The tulip groups are organized in *Tulipa* by Early-Flowering, Mid-Season Flowering, and Late-Flowering times:

EARLY-FLOWERING TULIPS
Early-Flowering Species
Kaufmanniana Group
Fosteriana Group
Single Early Group
Double Early Group

MID-SEASON FLOWERING TULIPS
Mid-Season Flowering Species
Darwinhybrid Group
Triumph Group
Greigii Group

LATE-FLOWERING TULIPS
Lily-flowered Group
Parrot Group
Fringed Group
Single Late Group
Double Late Group
Late-Flowering Species
Viridiflora Group

Every tulip listed in these groups falls into one of three broad categories: garden tulips, species tulips, or species-related tulips.

GARDEN TULIPS. The tulips in the Single Early, Double Early, Triumph, Lily-flowered, Parrot, Fringed, Single Late, Double Late, and Viridiflora groups are called garden tulips. Familiar sights in cut-flower markets, public parks, beds, and borders, garden tulips have been cultivated since the twelfth century and bear little or no resemblance to their wild counterparts, from which they originated. Garden tulips are referred to by their registered name in single quotation marks (e.g., 'Ad Rem.')

SPECIES TULIPS. Sometimes called "wild" or "botanical" tulips, species tulips flower throughout the season and are small in stature with open, starlike flowers. Referred to by their botanical name (e.g., *Tulipa humilis*), they are often classified as the group "Other Species." Some species tulips are cultivars and these are referred to by their botan-

ical name followed by their cultivar name in single quotation marks (e.g., *T. humilis* 'Magenta Queen').

SPECIES-RELATED TULIPS. The Kaufmanniana, Fosteriana, Greigii, and Darwinhybrid groups are made up of species-related tulips. Mostly developed in the early part of the twentieth century, these tulips originated from one particular species plant that was hybridized with a garden tulip or another species tulip. Although hybridization has broadened the range of colors and forms in the Kaufmanniana, Fosteriana, and Greigii groups, the characteristics of the species parent are still evident in these tulips. The Darwinhybrids, while also the result of hybridization between a species tulip and a garden tulip, do not show evidence of the wild plant. As is done with garden tulips, they are referred to by their registered name in single quotation marks (e.g., 'Scarlet Baby').

Also included in *Tulipa* are some tulips that are not classified. The New Introductions [PLATES 130–135 & 329] are not a recognized group but are interesting examples of what science can create—one of them looks more like a cabbage than a tulip—and are described to give the entire breadth of tulip possibilities.

The last tulip to mention is the thief [PLATES 136 & 137], the name for an aberration that appears in tulip stocks. For instance, acres planted with a variety such as 'Peach Blossom' will normally look like a sea of rose-colored tulips, but there, suddenly in the middle of it all, will be a red or a pink or a brown tulip. This is called a thief because, in effect, it steals the stock by taking the place of a tulip that should be in the field. Today there are three known thieves, always pink, red, or brownish (in the past there were more) and any one of these may spring up in any of the cultivars. All are late-flowering and produce many offsets, especially the pink thief, which produces the most.

Experienced bulb growers have watched their older stocks produce thieves and decided they must be the result of aging tulips that are simply no longer capable of producing ordinary offsets. Some scientists believe these tulips are old cultivars left in the ground that have mixed with existing stock. Either way, thieves are unwanted in the tulip field and when a grower discovers thieves, he often abandons the aging stocks in favor of fresh, new varieties. Plant health inspectors in Holland make special efforts to reduce thieves through a rigorous inspection program and hope to one day eradicate the problem.

Such is the story of the tulip, and of man's passion to grow ever healthier, more dependable, more beautiful flowers.

The species tulips, also called "wild" or "botanical" tulips, bloom throughout the season beginning with the lovely violet-red-flowered *T. humilis* 'Violacea Black Base,' which appears at the first sign of spring, and ending with a blast of brilliant red color from *T. sprengeri*.

The prolific firm of C. G. van Tubergen of Haarlem brought the first species tulips into Dutch bulb culture around 1870

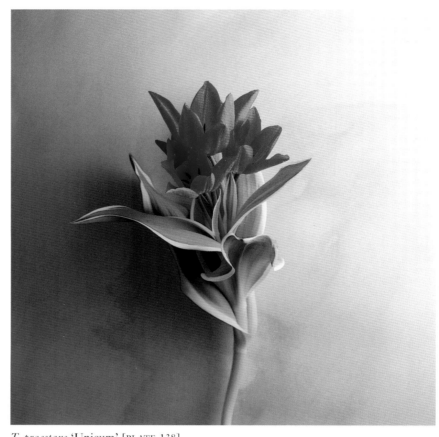

T. praestans 'Unicum' [PLATE 138]

when its plant hunters returned from central Asia with several species tulips they found growing around the Tien Shan mountains and the Pamir and Alai ranges. This central Asia corridor with its steppes, rocky hillsides, and high desert conditions is home to about half of all the species tulips. Other species tulips originate in the areas surrounding the Mediterranean such as Crete and Greece.

While for many years species tulips were of interest only to plant collectors who wanted them for their specialized alpine gardens, they have gained a broader appeal in the last twenty years. Even so, the species tulips are not nearly as popular as garden tulips, which can be used in gardens as well as for the cut-flower market.

Often grouped under the name "Other Species" and referred to by their botanical name (*T. praestans*, for example), the species tulips are

generally small in nature—about 20 centimeters tall—often with small, star-shaped flowers that are either single- or multiheaded. Their leaves are often dramatic: longer than the plant is tall, straplike and narrow, sometimes giving an almost spiderlike appearance to the small plant. Some species tulips have been selected by a grower and given a name, such as *T. praestans* 'Fusilier,' and a few, such as *T. batalinii*, have been hybridized. Except for the garden tulip groups that are made up only of cultivars, these tulips are all species, varieties, and their cultivars in which the wild species is still evident.

As it is important that gardeners understand how the species tulips grow, detailed information is given on each species tulip's bulb and its growing pattern in its description. With the exception of *T. praestans* 'Fusilier' and *T. praestans* 'Unicum,' these species tulips have tiny bulbs. Many species tulips spread by stolons—roots that grow horizontally just underground, giving rise to new plants at the node or apex. Other species tulips spread by seeds. Either way, these tulips are generally tough and hardy, and over years form mature clumps. Their diminutive size makes them ideal for rock gardens or for naturalizing in the wild.

T. aitchisonii

Sir Alfred Daniel Hall described *T. aitchisonii* in 1938. This small yellow flower with a carmine-red blush on the reverse of the outer petals and long leaves is from the mountainous areas of Kashmir and Afghanistan. Sir Alfred named this tulip in honor of James Edward Aitchison, an expert on botanical, medical, and boundary issues who made several expeditions in the latter part of the nineteenth century to Afghanistan on behalf of the British Indian government. Because it has not done well in the European climate, *T. aitchisonii* is grown very sparsely in Holland. The bulbs are small and dark, and difficult to find in the soil. Its height is 15 centimeters. [PLATE 139]

T. clusiana

Originally from Kashmir, northern Afghanistan, Iran, and Iraq, this plant, first described by Augustin Pyramus de Candolle in 1803, is named for the great botanist Carolus Clusius, who in the latter part of the sixteenth century was professor of Botany at Leiden University and one of the first to study bulbs systematically. Nicknamed the "Lady Tulip," *T. clusiana* is a slender plant with a small starlike white flower with carmine-red blotches on the three outer petals, a violet base, and narrow leaves that are undulating and grayish-green. The small, dark, round bulbs with rough skins multiply slowly by offsets as well as by pea-sized stolon bulbs. They will dry out and lose their vigor if they are overfed—the outer shell will split because the

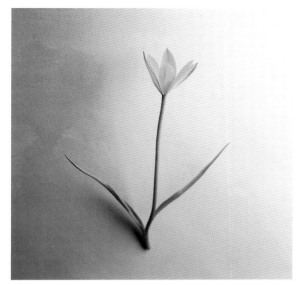

T. aitchisonii [PLATE 139]

inner scales grow at a quicker rate. The stock for *T. clusiana* is uniform and its height is 25 centimeters. [PLATE 5]

T. clusiana Cynthia

A cultivar of *T. clusiana* that was registered by C. G. van Tubergen in 1959, the outer petals of 'Cynthia' are reddish, edged chartreuse-green, and from a distance the flower appears soft orange. Inside it is feathered red on green and the base is purplish. The bulb is the same size as that of *T. clusiana*. 'Cynthia' grows well and is 25 centimeters in height. [PLATE 140]

T. clusiana var. *chrysantha*

Described in 1948 by Sir Alfred Daniel Hall but known before then, this tulip was found in the mountains of northern Afghanistan in the same area where *T. clusiana* was found. It was first known as *T. chrysantha* and later as a variety of *T. clusiana*. A slender variety with small leaves and a flower form that is slightly elongated, its crisply pointed petals are deep yellow with a vast red blush on the exterior, visible when the flower is closed. There is no basal blotch. The bulbs of *T. clusiana* var. *chrysantha* are brown with a rough skin and tufted at the tip. This variety multiplies by offsets and stolons and the stock in Holland shows no variation. Its height is 20 centimeters. [PLATE 3]

T. clusiana var. *chrysantha* Tubergen's Gem

Registered by C. G. van Tubergen in 1969, 'Tubergen's Gem' is a larger version of *T. clusiana* var. *chrysantha*. The outer petals are red and the inner petals are sulfur yellow. This cultivar has a bigger bulb and is more reliable for flowering than *T. clusiana* var. *chrysantha*. It is 25 centimeters tall. [PLATE 141]

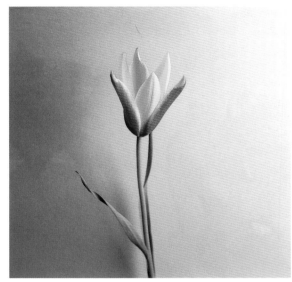

T. clusiana 'Cynthia' [PLATE 140]

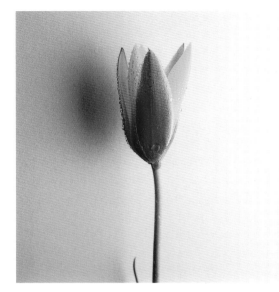

T. clusiana var. *chrysantha* 'Turbergen's Gem' [PLATE 141]

T. humilis

T. humilis was first formally recorded in 1844 by William Herbert but appears much earlier. According to Sir Alfred Daniel Hall in *The Genus Tulipa* (1940), *T. humilis* is referenced in early herbals, indicating that specimens had reached Europe by the seventeenth century. It is native to eastern Turkey, northern Iran, and Kurdistan, where the unique, crocuslike flowers and unusually long leaves can be seen growing on rocky hillsides.

Today *T. humilis* is without question the most popular flower of all the species, but the KAVB in Hillegom is still at work on its correct taxonomic treatment. Until 1996, three similar-looking species plants, *T. humilis*, *pulchella*, and *violacea*, were each considered separate species. Now, although not quite botanically correct, the latter two are treated as cultivars of *T. humilis* (*T. humilis* was chosen because it is the earliest recorded of the three names).

In the nurseries and in the trade, the name *T. humilis* continues to be used to designate the original *T. humilis*, a small plant, about 10 centimeters tall, characterized by its range of colors from white to pale pink and its pointed petals and yellow base. The spidery gray-green leaves are about as long as the plant's stem. The bulbs are generally small, very light brown, and ribbed. [PLATE 1]

T. humilis Group Antalya

This is a group of cultivars raised and registered by Kees Visser in 1987 from the *T. humilis* bulbs he received from the author, Wim Lemmers, who received the bulbs directly from a Turkish dealer in the Antalya region of southern Turkey. Although the bulbs resembled *T. humilis*, the tulips showed a wide variation. Some had flowers that were red or orange or purple; some had long leaves, others short leaves. Many were multiflowered while others were single-flowered. Kees Visser made three selections from this stock and named them 'Lilliput,' 'Pegasus,' and 'Zephyr.' All grow from smooth round bulbs that vary in color from yellowish to brownish.

LILLIPUT

Kees Visser selected and registered 'Lilliput' in 1987. This is a small, multiflowered cultivar with a radiant red color on both the exterior and interior. The leaves are narrow and long and the base is violet. Its height is 10 centimeters. [PLATE 142]

PEGASUS

This multiflowered cultivar, which Visser registered in 1987, is rosy-purple with a yellow-brown base. The leaves are narrow and long and it is 10 centimeters in height.

ZEPHYR

'Zephyr' has several flowers on single stems and is blood-red with a black base. It was raised and registered by Kees Visser in 1987. The leaves are narrow and long and its height is 10 centimeters. [PLATE 8]

T. humilis Alba Coerulea Oculata

Known for more than fifty years in Holland, this startlingly beautiful small white flower with pointed petals and a big blue base, which looks like a big blue eye when the flower is open, was originally described by Edmond Boissier. The leaves are grayish-green and narrow. *T. humilis* 'Alba Coerulea Oculata' is not a very good grower, and while there are several clones, they do not multiply with any regularity, so plants are therefore scarce. The small bulbs have hard skins. Its height is 10 to 12 centimeters. [PLATE 9]

T. humilis Magenta Queen

Registered by W. Kooiman in 1975, 'Magenta Queen' is pinkish-lilac with a fern green flame and a lemon yellow base. The balloonlike flower of 'Magenta Queen' is the largest of the *T. humilis* cultivars. Its rough-skinned bulbs are also the largest of the *T. humilis* group and therefore it does not multiply quickly. 'Magenta Queen' is 15 centimeters in height. [PLATE 143]

T. humilis Violacea Black Base

Nicknamed the "Red Crocus," 'Violacea Black Base' is the most beautiful of the species and the earliest to flower, providing a brilliant purple-red crocuslike flower with a greenish-black basal blotch distinctly margined yellow. The glistening deep green leaves have reddish margins that fade as the plant matures. For many years, this was the only *T. humilis* 'Violacea' on the market, and today it has more acreage than all the other *T. humilis* put together. The bulb is medium-sized with a blackish tunic and a very tough skin. *T. humilis* 'Violacea Black Base' will naturalize well, growing slowly but steadily. Its height is 15 centimeters. [PLATE 6]

T. humilis Violacea Yellow Base

L. Stassen Jr. grew the stock for the cultivars in this group of species tulips, which are characterized by pointed flowers in dark colors—violet-purple to brownish—with a yellow base. They appear to have come from a northern region such as northern Iran and Azerbaijan. The author, Wim Lemmers, purchased the stock from Stassen in 1965 and raised it, then sold it to Kees Visser, who registered several cultivars: 'Eastern Star,' 'Odalisque,' and 'Persian Pearl.' The bulbs for *T. humilis* 'Violacea Yellow Base' and its cultivars are smooth and round, and yellowish to brownish in color. [PLATE 144]

EASTERN STAR

Among the latest to flower of the group, 'Eastern Star' has a starlike flower with a uniform magenta-rose color. The base is canary yellow. It was registered in 1975 by Kees Visser and is 10 centimeters tall.

ODALISQUE

Registered in 1976 by Kees Visser, 'Odalisque' is brownish-dark red with a large buttercup yellow base, and is 10 centimeters in height.

PERSIAN PEARL

Magenta-rose with a greenish tint on the three outer petals, 'Persian Pearl' is a peculiar-looking flower whose green tint stays on the petals as the flower matures. The interior of the flower is purple and the base is buttercup yellow. Registered in 1975 by Kees Visser, 'Persian Pearl' is 10 centimeters tall. [PLATE 145]

T. polychroma

In 1885, Otto Stapf described *T. polychroma*, which has its origins in areas surrounding the Caspian Sea, Iran, western Afghanistan, and Baluchistan, as well as eastern Iran and western Pakistan. Round and balloonlike, the multi-headed flowers, which appear very early in spring, are white with violet on the three outer petals and have a large yellow base. The yellowish-orange bulbs of *T. polychroma* are round and small—about the size of the bulbs of *T. humilis*. They do not multiply by stolons, but *T. polychroma* grows well if not very abundantly. Its height is 10 cen-timeters. [PLATE 146]

T. praestans Fusilier

Imported by C. G. van Tubergen and described by J. M. C.

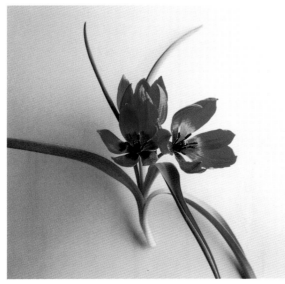

T. humilis 'Lilliput' [PLATE 142]

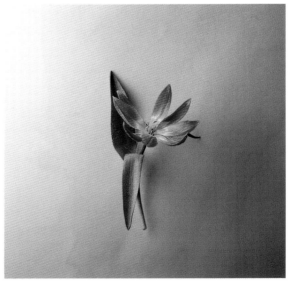

T. humilis 'Magenta Queen' [PLATE 143]

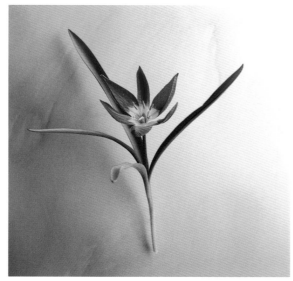

T. humilis 'Violacea Yellow Base' [PLATE 144]

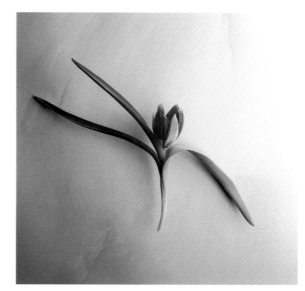

T. humilis 'Persian Pearl' [PLATE 145]

Hoog in 1903, *T. praestans* is native to central Asia, specifically the southern Pamir-Alai area. There are quite a few cultivars of *T. praestans*, some are taller, some smaller, many with varied coloring. 'Fusilier,' a bright orange-scarlet cultivar with a small light-yellow base, registered by J. Roozen, is multiflowering with five to six small cup-shaped flowers, each with purple anthers that show up against the yellow base when the flower is open. Although the date of registration is not known, 'Fusilier' is now something of a classic—it has the most flowers and is the strongest of the cultivars. The bulbs are larger than those of other species tulips, blackish and very tough, with sharp ribs that can irritate hands. 'Fusilier' is 35 centimeters in height and has one sport, 'Unicum.' [PLATE 4]

T. praestans Unicum

Registered by C. A. Verdegaal in 1975, *T. praestans* 'Unicum,' the sport of *T. praestans* 'Fusilier,' has five to six capsicum red flowers each with a small light-yellow base. The variegated leaves have broad silvery white rims and provide beautiful leaf color before and after flowering. Its height is 35 centimeters. The bulbs are similar to *T. praestans* 'Fusilier': larger than those of most species tulips, tough-skinned and dark-colored. [PLATE 138]

T. schrenkii

Initially described by Albrecht Roth in the early 1800s as *T. suaveolens*, this tulip from the shores of the Black Sea, the Caspian Sea, and the Aral Sea in Kasakstan was later recognized as *T. schrenkii* and described by Dr. Eduard August von Regel in 1881. A cup-shaped scarlet flower with pointed petals and a yellow-orange notched rim, *T. schrenkii* looks more like a garden tulip than a species tulip and is very close

in form to a small 'Duc van Tol' tulip. While many colors have been described, only the scarlet is still grown commercially. *T. schrenkii* multiplies slowly by a small bulb. It is 10 centimeters tall. [PLATE 7]

T. turkestanica

T. turkestanica was first described by Dr. Eduard August von Regel in 1875, around the same time that many other species tulips from Turkistan were being discovered. Growing on stony slopes of the eastern Tien Shan mountains, *T. turkestanica* flowers freely and each stem carries one to seven small star-shaped white flowers. The outer petals have a grayish-violet blush on the exterior and the basal blotch, which covers about one third of the petal, is orange-yellow. The leaves are long and narrow. *T. turkestanica* does not look like a traditional tulip and is an extraordinary though not brilliantly colored tulip. A prolific grower and multiplier with a rare characteristic that it shares with a few other species tulips, *T. turkestanica* multiplies both by small offsets along the main bulb *and* by stolons. After growing for one or two years, the small bulbs at the ends of the stolons produce plants that resemble the mother plant perfectly. Spreading can be minimized by planting *T. turkestanica* in a container or a closed area in the garden surrounded by stone or concrete about twenty centimeters deep. *T. turkestanica* will respond well to such containment, particularly if the stone or concrete extends above the soil a few centimeters to retain some of the sun's warmth in the evening. The bulbs are orange-pink, and stock, which used to be variable, is now more uniform. Flower height is 20 to 25 centimeters. [PLATE 2]

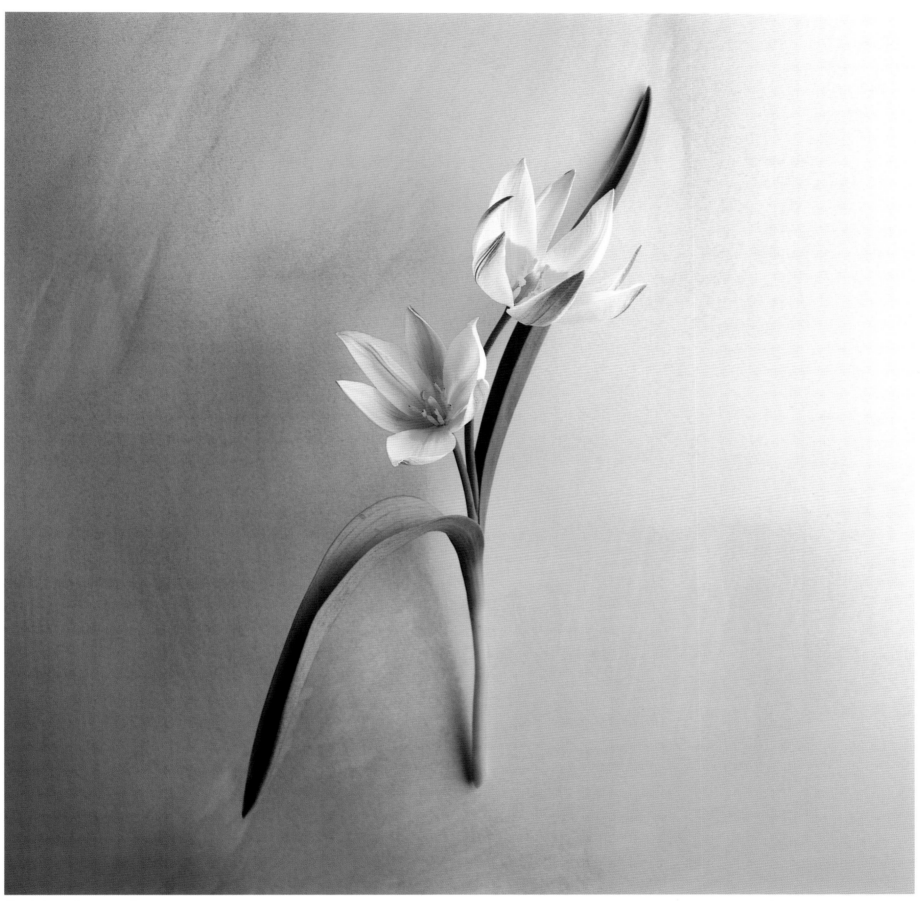

T. polychroma [PLATE 146]

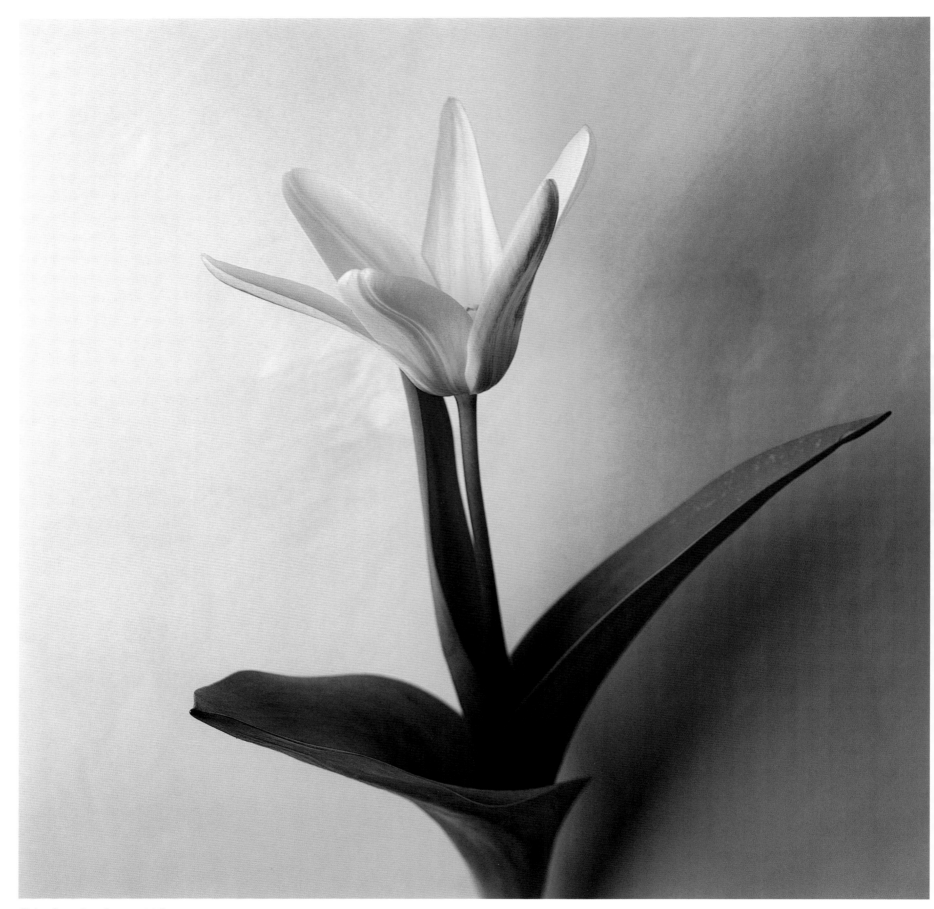

T. kaufmanniana [PLATE 147]

KAUFMANNIANA GROUP

The Kaufmanniana group comprises *T. kaufmanniana* and its cultivars. *T. kaufmanniana* was described by Dr. Eduard August von Regel, curator of the imperial botanical gardens in St. Petersburg, Russia. Dr. von Regel was one of the great plant hunters of the nineteenth century and undertook several expeditions to central Asia with his son, Albert, and other botanists. In 1877, he introduced *T. kaufmanniana* into the horticultural community from plants that he found growing on the Tien Shan mountains of Turkistan near the Chirchik River.

Kaufmannianas are among the first tulips to flower in very early spring, often when there is still snow on the ground. The slender species flower has a short stem, and is either creamy white or yellow with a clear carmine blush on the exterior of the petals, or it is completely red. Hybridization has widened the color range of the Kaufmannianas and their flowering times, but cultivars are still short and slender. Kaufmanniana flowers are sensitive to light, expanding almost immediately in the morning to an open position and becoming a tight cone shape when closed. The six pointed petals open completely horizontally into a flat, star-shaped flower, giving this plant the nickname "Waterlily Tulip."

The leaves—two to four, with the lowest usually at ground level—are often striped or mottled (having broken or interrupted stripes). Mottled leaves is not a characteristic of *T. kaufmanniana*, but often occurs on hybrids because these plants have been cross-pollinated with other tulips. It's possible that some Greigiis, which have mottled leaves, are parents of certain Kaufmanniana hybrids. 'Johann Strauss,' for example, appears to have a Greigii parent, but this has not been confirmed. As a species, *T. kaufmanniana* used to be one of the most variable, but today it is uniform because there is only one form of the species left from which to clone.

What today would be undertaken separately by specialists—growing,

hybridizing, trading, and plant hunting—was all undertaken at the beginning of the century by the Dutch firm of C. G. van Tubergen in Haarlem. The firm and its leading directors for many generations, the Hoog family, sent plant collectors to Turkey and later to central Asia, around the mountains and deserts of Kasakstan, Kirqizii, and the neighboring states, and later still to Bukhara. As a result of their many expeditions, they described more than six species of tulips. (Throughout the twentieth century, C. G. van Tubergen has been the leading firm in growing, hybridizing, and trading many species of bulbs, including narcissus, scilla, gladiolus, anemone, chionodoxa, crocus, muscari, and many others. Clearly, though, it sees its greatest achievement in tulips.)

C. G. van Tubergen introduced most of the first Kaufmanniana selections in the 1920s and 1930s. F. Rijnveld & Sons, a hybridizer in Hillegom, added to their growing numbers in the 1960s. Production of the Kaufmannianas at that time was healthy; perhaps the growers had begun to understand the specific growing needs of these tulips. However, in the last forty years, interest in growing Kaufmannianas has waned due to the greater economic values provided in the forcing market. Kaufmannianas are not used for forcing because their short stems make them impractical as cut flowers. While exquisite in the garden, they simply do not hold the same multipurpose incentive to growers as do the Triumphs.

Another reason we haven't seen many new Kaufmannianas in recent years is that these tulips have not generated many mutations. Of the few sports that have occurred, two were found by the author, Wim Lemmers: 'Little Diamond' and 'Golden Daylight.' Most of the existing cultivars are beginning to show their age, and production of large bulbs, which is necessary for the best performance in the garden, is slowing down.

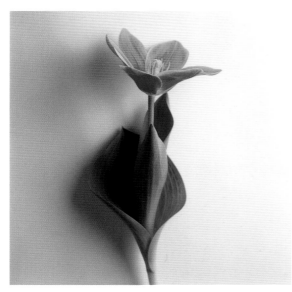

Many of the Kaufmannianas selected by C. G. van Tubergen are named for composers—'Berlioz,' 'Johann Strauss'—and the trend that the firm started was picked up by other Kaufmanniana growers such as J. C. van der Meer, which named 'Franz Lehár' and 'Giuseppi Verdi.'

Kaufmannianas, perhaps the most distinctive group of tulips, are all perfect for the rock garden.

T. kaufmanniana

Described by Dr. Eduard August von Regel in 1877, the only form of the species that is available today is a creamy white flower with bright carmine on the outer petals and a deep golden base. Growers have nicknamed this white-flowering *T. kaufmanniana* "the Type," but it has never been officially registered by this name. Its height is 20 centimeters. [PLATE 147]

ANCILLA

Registered by C. G. van Tubergen in 1955, 'Ancilla' has three soft pink exterior petals and three pure white petals inside with a distinctive red ring in the center. This is the cultivar that best resembles the species. Its stem is very short, the leaves are solid green and ruffled, and its height is 20 centimeters. [PLATE 13]

BERLIOZ

'Berlioz' was registered in 1942 by C. G. van Tubergen and was one of the first Kaufmanniana cultivars to be brought to market. The bright lemon yellow flower has a slightly reddish blush on the exterior of the petals and a golden yellow base. The flower sits on broad and nicely mottled leaves. Quite likely the most beautiful of all the Kaufmannianas, it is 20 centimeters tall.

CORONA

An early C. G. van Tubergen cultivar, registered in 1940, 'Corona' is pale yellow with red coloring on the exterior of the pointed petals. The broad leaves are mottled. At 25 centimeters, 'Corona' is a bit taller than most Kaufmannianas. [PLATE 14]

DAYLIGHT

'Daylight' was registered in 1955 by M. H. M. Thoolen and is red with a black base. The leaves are mottled. It is 25 centimeters in height and has one sport, 'Golden Daylight.'

EARLY HARVEST

'Early Harvest' was registered in 1966 by the firm of F. Rijnveld & Sons, which raised many of the second-generation Kaufmanniana hybrids. Deep orange with a

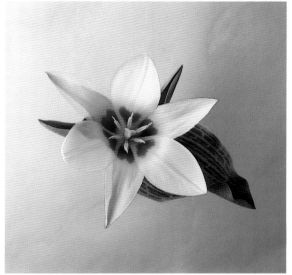

FAIR LADY [PLATE 149]

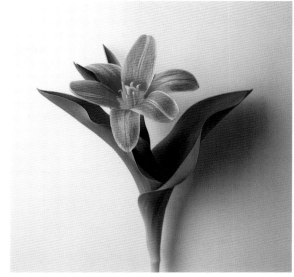

FASHION [PLATE 150]

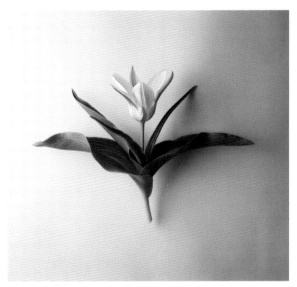

FRANZ LEHÁR [PLATE 151]

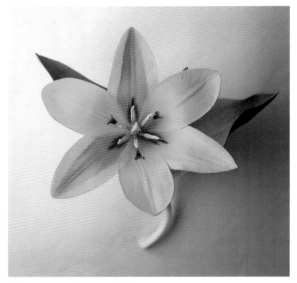

GOUDSTUK [PLATE 152]

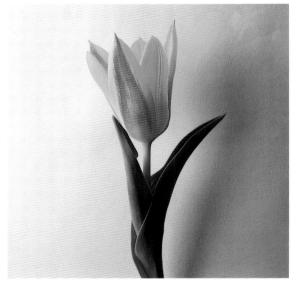

GIUSEPPI VERDI [PLATE 153]

LITTLE DIAMOND [PLATE 154]

slightly lighter color on the edges of the petals and a small yellow base, it flowers very early. 'Early Harvest' has mottled leaves and is 25 centimeters in height.

Bernard Rijnveld played an important role in developing and hybridizing tulip cultivars after World War II. He was a Dutch Jew from Hillegom, a small town in the bulb-growing region of Holland, who survived Germany's occupation of Holland by hiding in a monastery in the neighboring town of Lisse. His firm introduced many of the most significant garden tulips, including a real blue Single Late tulip named 'Blue Hill,' which is now gone. He also developed several long-stemmed late bloomers and tulips for forcing. [PLATE 148]

FAIR LADY
Raised by C. G. van Tubergen, and introduced around 1940, 'Fair Lady' is considered quite old by Kaufmanniana cultivar standards. Both the color and shape of this plant are elegant. The combination of a carmine blush on the outer petals and a creamy ground color contributes to its refined and ladylike appearance. The base is yellow. The leaves are nicely mottled, and it is 25 centimeters tall. [PLATE 149]

FASHION
In 1962, Tenhagen Brothers registered 'Fashion,' a striking tulip with a uniform orange-pink flower and a yellow base. The leaves are a solid green color, not mottled like many Kaufmannianas. Its height is 30 centimeters.

Tenhagen Brothers first acquired the seedling of this cultivar from C. G. van Tubergen, which often sold mixed groups of seedlings to local bulb growers after it extracted the seedlings it wanted. 'Fashion' came out of one of these seedling groups and closely resembles an older C. G. van Tubergen Kaufmanniana, 'Shakespeare.' 'Shakespeare' is a more beautiful flower but 'Fashion' has proven to be a superior grower and has all but replaced 'Shakespeare.' [PLATE 150]

FRANZ LEHÁR
Registered by J. C. van der Meer in 1955, 'Franz Lehár' is sulfur yellow with outer petals blotched red. 'Franz Lehár' has the same coloration as 'Johann Strauss,' which is a smaller Kaufmanniana. The leaves are mottled and it is 30 centimeters tall. [PLATE 151]

GIUSEPPI VERDI
Registered by J. C. van der Meer in 1955, 'Giuseppi Verdi' has carmine petals edged with golden yellow. Its leaves are mottled. This is a robust Kaufmanniana that will continue to grow for several years in the garden. It is 30 centimeters in height. [PLATE 153]

GLÜCK
C. G. van Tubergen registered 'Glück' in 1940. The exterior of the petals carries carmine-red blotches on sulfur yellow grounds and rims. The yellow base has attractive small red blotches on top. The mottled leaves indicate that 'Glück' may be a Kaufmanniana-Greigii hybrid. Its height is 20 centimeters. 'Glück' has one sport, 'Little Diamond.' [PLATE 15]

GOLDEN DAYLIGHT
Among the red flowers of 'Daylight,' the author, Wim Lemmers, discovered one flower that had a partially yellow petal and dug up that bulb. He planted it separately the following year, and five years later he had his first 'Daylight' sport: a brownish-red tulip with yellow margins on the outer petals. Inside, the petals are yellow. The base is black with a red border, and the leaves are heavily mottled. He continued to increase his stock and, in 1988, when he had one hundred kilos (about fifteen years after the initial discovery), he named and registered it 'Golden Daylight.' It is 25 centimeters tall. [PLATE 10]

GOUDSTUK
Registered in 1952 by C. G. van Tubergen, 'Goudstuk' is the largest Kaufmanniana and carries the biggest and one of the prettiest flowers. 'Goudstuk,' which is "gold piece" in Russian, has deep carmine blotches on a golden yellow ground and golden yellow rims on the exterior of the petals. Inside, the color is deep golden yellow. Unfortunately this large Kaufmanniana grows from a big bulb that does not multiply quickly and consequently there is never enough stock to satisfy the demand for 'Goudstuk.' It is 30 centimeters tall. [PLATE 152]

HEART'S DELIGHT
Another C. G. van Tubergen Kaufmanniana, registered in 1952, 'Heart's Delight' is a well-chosen name for this lovely cultivar. This is a carmine-red tulip with pale rose edges that grow paler as it matures, eventually turning to pink. The base is greenish-yellow with a small white edge. Its leaves are mottled and its height is 20 centimeters.

JOHANN STRAUSS
The breeder of 'Johann Strauss' is not known, but is thought to be C. G. van Tubergen—it was introduced before 1938. The exterior of the petals is currant red with sulfur edges; inside, the petals are creamy white and the base is golden yellow. Its leaves are mottled. 'Johann Strauss' has the form of the *T. kaufmanniana* star-shaped flower and the *T. greigii* striped leaves, which may indicate a Kaufmanniana-Greigii crossing. Its height is 20 centimeters.

SCARLET BABY [PLATE 155]

THE FIRST [PLATE 156]

This is not a splashy tulip: Its charms lie in the balanced and proportionate form of the plant and its subtle colors. 'Johann Strauss' is one of the earliest plants to flower and blooms for a long period. It grows very well, is a vigorous plant, and will return year after year with little attention. [PLATE 12]

LITTLE DIAMOND

Wim Lemmers, the author, found and registered 'Little Diamond,' the one sport of 'Glück,' in 1988. The three outer petals are tomato red with golden rims. The inner petals are completely yellow and the basal blotch is speckled bluish-green. The leaves resemble *T. greigii* in their purple stripes. It is 20 centimeters in height. [PLATE 154]

SCARLET BABY

J. C. van der Meer registered 'Scarlet Baby' in 1962, a delightful Kaufmanniana that greatly resembles the form of the species. Geranium red with a yellow base, this small flower has a uniform color—no colored rim—unlike so many of the Kaufmannianas. Quite possibly the shape and color of this cultivar indicate it comes from a form of the wild species tulip *T. kaufmanniana* 'Coccinea.' Its height is 20 centimeters. [PLATE 155]

SHAKESPEARE

One of the oldest C. G. van Tubergen Kaufmannianas, registered in 1942, 'Shakespeare' is an unusual color: The exterior petals carry a combination of carmine-red in a subtle checkered pattern and a salmon-colored edge. The base is golden yellow. The overall flower color is similar to the color of 'Fashion,' but 'Shakespeare' is superior in color. It's easy to see in 'Shakespeare' how the name "Waterlily Tulip" arose from its starlike petals that open out so widely. Its leaves are a uniform green, and it is 25 centimeters in height.

SHOWWINNER

'Showwinner' was raised by F. Rijnveld & Sons and was considered, upon its registration in 1966, to be one of Rijnveld's best cultivars. The exteriors of the petals are a gorgeous deep cardinal red and the base is a buttercup yellow. Leaves are mottled and thick and wide. It is 25 centimeters tall. [PLATE 11]

STRESA

'Stresa' was registered by C. G. van Tubergen in 1942 and today is the best known of all the Kaufmanniana cultivars. The flower has currant red blotches on the exterior of the petals, a yellow ground color, and yellow edges. The yellow base has bloodred blotches. Its leaves are mottled and 'Stresa' is 25 centimeters tall. [PLATE 16]

THE FIRST

Registered by F. Roozen in 1940, 'The First' has a carmine-red exterior color and white edges. Inside, the flower is ivory white. The base is yellow. 'The First' is an appropriate name for this Kaufmanniana cultivar that is the first to appear early in the spring, when it is still very cold. While 'The First' greatly resembles the species *T. kaufmanniana* in its shape and color patterns, the red in 'The First' is slightly darker than that in the species. The leaves are not mottled and it stands 20 centimeters tall. [PLATE 156]

YELLOW PURISSIMA [PLATE 157]

FOSTERIANA GROUP

The first specimens of *T. fosteriana* arrived in Holland around 1906, a few years after Joseph Haberhauer discovered the species in the lower Himalayas, between the Caspian Sea and the Pamir Valley of Bukhara (now called the independent republics of Tajikistan and Uzbekistan). The original species varied in heights from ten to fifty centimeters, with very broad leaves that were either shiny and green or fleecy and gray-green. The base of the flower was black or yellow. To the Dutch growers, the most astonishing aspect of *T. fosteriana* was the vivid scarlet color on long flowers with broad petals. This was a striking, very brilliant red that had never been seen in any other tulip. Mr. Haberhauer, traveling in central Asia on behalf of the C. G. van Tubergen firm, sent a package of *T. fosteriana* to J. M. C. Hoog, the director of C. G. van Tubergen, who shared the package with his colleagues and other bulb growers, and very soon the bulbs spread into the Dutch bulb culture.

Throughout the 1940s and until about 1970, Dutch growers selected new varieties and hybridized *T. fosteriana* with other species tulips and garden tulips in order to introduce a range of colors into the group. Many of the Fosteriana hybrids came from the firm of Hybrida, which crossed *T. fosteriana* with *T. kaufmanniana* to produce tulips with ivory to yellow to orange-yellow background colors and a red blush on the outside. When *T. fosteriana* was crossed with certain Single Early tulips, the results were the closest to creating a tulip with the original form and flowering time of the *T. fosteriana* but in an array of beautiful colors.

Unfortunately, the Dutch bulb industry has not hybridized Fosterianas for the last thirty years because its focus has been on creating the more lucrative forcing tulips. This group may well vanish in the next decade or so. Most of the Fosteriana hybrids are sterile and since they are now quite old, the bulbs are no longer as vigorous and productive as they once were.

The only way to restore the Fosteriana group now would be to replicate the crosses. But hybridizers would be hindered by two problems: One is that the parentage for the crosses is unknown due to poor record-keeping, and the other is that many parents are now out of cultivation.

However uncertain the future of the Fosterianas may appear, these tulips have played an enormous role in breeding. The Fosteriana's usefulness as a hybridizing plant is unequaled among tulips. By crossing a Fosteriana with a Darwin tulip, an entire group of tulips was created: the Darwinhybrids.

The tulips in the Fosteriana group are early flowering with medium to long stems, and leaves that are sometimes mottled or striped. They are all suitable for the garden, and some are used for forcing.

CANDELA

'Candela' was registered by K. van Egmond & Sons in 1961. It is a large oblong flower with striking black anthers standing out against a uniform soft golden yellow ground. This hybrid, a cross between the fiery red Fosteriana 'Madame Lefeber' and an orange Single Early tulip 'Thomas Moore' (long out of cultivation), stands 35 centimeters tall.

CONCERTO

Raised by Hybrida around 1950, 'Concerto' appears to be a cross between *T. fosteriana* and *T. kaufmanniana*. The *T. fosteriana* influence can be seen in the flower's form and height. Its flower colors—ivory white with a black base, edged yellow—and the bluish-green leaves indicate a *T. kaufmanniana* parentage. While 'Concerto' is not the most spectacular color, it grows well and is a good contribution to a garden collection of Fosterianas, where its subtle colors provide a foil for some of the brighter tulips. Its height is 30 centimeters. [PLATE 158]

EASTER PARADE

Hybrida registered 'Easter Parade' in the late 1940s or early 1950s. This is a long yellow flower with a red blush on the exterior of the petals and a blackish-brown base, broadly edged in red. It also has a delicate bulb that needs too much special care—and so 'Easter Parade' is nearly out of cultivation. It is 40 centimeters in height and has one sport, 'Hit Parade.'

HIT PARADE

Found and registered by the author, Wim Lemmers, in 1979, 'Hit Parade' is a sport of 'Easter Parade.' It has similar colors to the mother plant, but here the yellow ground and red flame on the petals carry deeper tones.

'Hit Parade' is a beautiful flower and is 40 centimeters tall. [PLATE 159]

JUAN

C. G. van Tubergen registered 'Juan' in 1961. The exterior of the flower is a deep orange, as is the inside. The base, which is very wide, is yellow. The leaves are broadly striped reddish-brown. A striking plant that looks like a Fosteriana-Greigii cross, it grows well and its height is 45 centimeters. [PLATE 19]

MADAME LEFEBER
Red Emperor

'Madame Lefeber' was registered by D. W. Lefeber & Company around 1931. Since its introduction, this Fosteriana, which is fiery red with a black base edged with yellow, has been one of the most desirable tulips in cultivation. Used extensively in the development of the Darwinhybrids, this vigorous grower multiplies freely, with a height of 40 centimeters.

'Madame Lefeber' has another name, 'Red Emperor'—the result of two growers introducing the same plant at almost the same time. D. W. Lefeber wanted to name the plant after his wife, Mrs. Lefeber, while the C. G. van Tubergen firm, which actually imported the species into Holland, wanted to call it 'Red Emperor' (a fitting name considering its splendid oriental red color). The rules of nomenclature are very straightforward, however: Mr. Lefeber got to the registration office first. [PLATE 17]

ORANGE EMPEROR

Registered in 1962 by K. van Egmond & Sons, 'Orange Emperor' is a carrot orange flower with a base that is deep green, edged buttercup yellow. Occasionally, the larger bulbs will produce a multiheaded plant. Its parents are the Fosteriana 'Madame Lefeber' and an orange Single Early tulip, 'Fred Moore,' which is no longer in cultivation. 'Orange Emperor' is sometimes used for forcing and its height is 40 centimeters. [PLATE 22]

PURISSIMA

Registered by C. G. van Tubergen in 1943, 'Purissima' is a hybrid whose wide petals beautifully illustrate the form of *T. fosteriana*. White with a yellow base and grayish leaves, it is, in fact, the only pure white Fosteriana. 'Purissima's white color probably comes from a Single Early parent, which would also explain this tulip's fragrance. This very sturdy plant grows well, in part because the bulb has a very good skin. 'Purissima,' sometimes used for forcing, is 45 centimeters tall. It has two sports, 'Purissima King' and 'Yellow Purissima.' [PLATE 20]

PURISSIMA KING

Registered in 1994 by Van der Salm, 'Purissima King' is a sport of 'Purissima.' A red flower with a canary yellow base, its height is 45 centimeters.

ROBASSA

Registered by H. Vreeburg & Sons in 1981, 'Robassa' is vermilion with a bluish-black base, edged yellow. 'Robassa' is a sport of the vermilion Fosteriana 'Red Bird,' a tulip still in cultivation and often mistaken for 'Madame Lefeber,' which it greatly resembles. 'Robassa' has broad creamy yellow streaks on and near the rims of the leaves. It is 30 centimeters in height. [PLATE 18]

SPRING PEARL

In 1955, Rijnveld & Sons registered 'Spring Pearl,' an appropriate name for this pearl gray flower. The petals are edged vermilion and the base is yellow; the height is 40 centimeters.

SUMMIT

Registered by K. van Egmond & Sons in 1962, 'Summit' is mimosa yellow on the exterior of the petals with a deeper buttercup yellow on the interior. It is 40 centimeters tall.

SWEETHEART

In 1976, J. C. Nieuwenhuis registered this lemon yellow tulip with a broad white edge on the petals. 'Sweetheart' is a sport of an unnamed Fosteriana that was intermingled with 'Purissima' stock. Flowering later than 'Purissima,' it is also slightly shorter at 40 centimeters.

SYLVIA VAN LENNEP

'Sylvia van Lennep' was registered by Hybrida in 1965. The flower is deep pink; the base is yellowish black, edged yellow. Its height is 35 centimeters. [PLATE 21]

YELLOW PURISSIMA

Registered in 1980 by J. N. M. van Eeden, 'Yellow Purissima,' a 'Purissima' sport, is entirely yellow: lemon yellow with a bright canary yellow edge. Sometimes used for forcing, its height is 45 centimeters. [PLATE 157]

ZOMBIE

Hybrida raised 'Zombie' and registered it in the 1940s or 1950s—the date is uncertain. The exterior petals are creamy yellow with a carmine-rose blush. Inside, the petals are flushed rose. The base is black, edged red. In addition to this striking color combination, 'Zombie' has an excellent Fosteriana form and grows well. Its height is 35 centimeters. [PLATE 160]

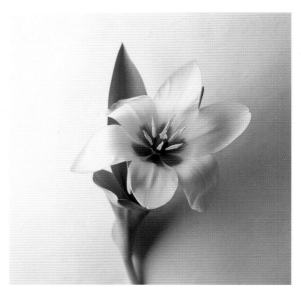

CONCERTO [PLATE 158]

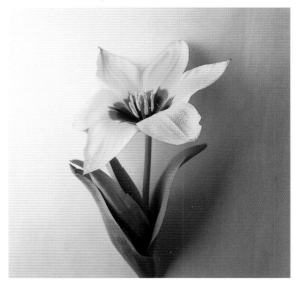

HIT PARADE [PLATE 159]

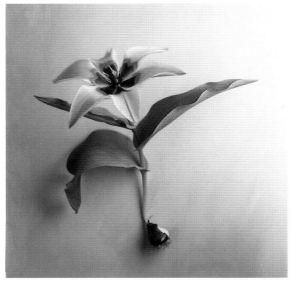

ZOMBIE [PLATE 160]

SINGLE EARLY GROUP

Though Single Early tulips have been around for a long time, it was not until the early part of the nineteenth century when the Dutch began exporting large quantities of uniform stocks of bulbs that the demand for these good forcing varieties became great. The bulb industry in Holland responded to the need for more tulips, and nurseries sprang up around the city gardens of Haarlem and in the newer bulb-growing fields around Hillegom and Lisse. At that time, the Single Early tulips were the best forcing tulips and the cut-flower market was quickly becoming the most important customer for the bulb growers.

The Single Early group includes tulips still in cultivation from two dying breeds: The Mendels and 'Duc van Tol' hybrids. 'Duc van Tol' tulips were grown between 1722 and 1920. Like many Single Early tulips, they are short and early flowering, so the few that remain were incorporat-

ed into the Single Early tulip group in 1969. Many beautiful Single Early tulips, such as 'Ruby Red,' are 'Duc van Tol' hybrids.

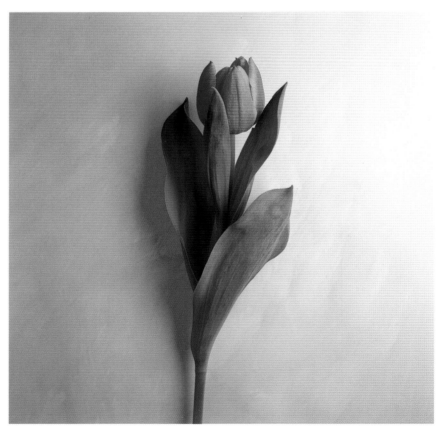

CHRISTMAS DREAM [PLATE 161]

The Mendels are another aging breed that have become part of the Single Early group. The Mendel tulips were produced by E. H. Krelage of Haarlem in the 1920s through crosses between 'Duc van Tol' and the then new Darwin tulips (a group of tulips no longer

warranting its own class; not to be confused with today's Darwinhybrids). Around the turn of the century, Krelage developed a breeding program to accommodate the demand from the foreign market for large quantities of uniform garden tulips that could be used as bedding plants, and also satisfy the demand for forced tulips that could be brought on the market from Christmas to Easter. John Dix, the firm's hybridizer, crossed 'Duc van Tols,' which were short and very early flowering, with Darwins, which were mostly tall and late-flowering, and created Mendels: tall-stemmed varieties that were mostly early flowering. He called the hybrids Mendels in honor of Gregor Mendel, the Austrian monk and pioneer of modern hybridizing.

Though the Mendels quickly became the dominant forcing tulip, they had inherited a weak stem and a small flower. In addition, although they produced several seedlings, the color range of the new seedlings was limited. By 1981, the Mendels had lost importance as other, better forcers were introduced and the few varieties still in cultivation were added to the Single Early group. (Some were also folded into the Triumph group.)

The Single Early tulips are a relatively small group of tulips blooming in early spring, mostly on short stems. Single-flowered, with cup-shaped flowers and buds that are slender and pointed, the Single Early tulips are still valuable forcing tulips, and many of them are available around the Christmas holidays. Some of the older cultivars such as 'Apricot Beauty,' 'Generaal de Wet,' and 'Prins Carnaval' are fragrant. All are wonderful in gardens. Many are used for forcing.

APRICOT BEAUTY
A tulip that has been in cultivation since 1953 when it was registered by C. Vlugt van Kimmenade, 'Apricot Beauty' is a fragrant, soft, very feminine, salmon rose tulip. This is a valuable tulip for the forcing market because it can be forced in time for the Christmas holidays. With a height of 45 centimeters, 'Apricot Beauty' is a lovely tulip and also has a beautiful sport, 'Bestseller.' [PLATE 27]

BESTSELLER
Registered by C. Vlugt van Kimmenade in 1959, 'Bestseller,' a sport of 'Apricot Beauty,' has a unique bright coppery orange flower. Good for forcing, it is 45 centimeters tall.

BRILLIANT STAR
Brilliant Star Maxima
'Brilliant Star' was registered in 1906. 'Brilliant Star Maxima' was at first recognized in 1930 as a larger form of 'Brilliant Star' but is now considered a synonym. The exte-

rior petals are flamed cardinal red with a small bloodred edge; inside, the petals are bloodred. Its black base with a yellow rim might indicate that one of this tulip's parents is *T. agenensis*. While its raiser is unknown, 'Brilliant Star's earliest champion was Maarten Kamp, a Dutch bulb grower from Lisse. Kamp lived alone in a tiny room adjacent to a bulb shed and raised so much stock of 'Brilliant Star' that he became known as the "Star King." 'Brilliant Star' has a nickname, too, the "Christmas Tulip," because it is available as a forced tulip at Christmas and is often used to great effect as a holiday decoration. Its height is 30 centimeters. 'Joffre' and 'Sint Maarten' are two of 'Brilliant Star's best sports. [PLATE 23]

BURNING LOVE
Registered in 1981 by H. G. Huyg, 'Burning Love' is light red with a small bloodred edge on the exterior of the petals. Inside, the petals are tomato red and the base is buttercup yellow. Mr. Huyg, a raiser who concentrated on producing early forcing varieties, created in 'Burning Love' one of the very earliest forcing tulips. Its height is 45 centimeters.

CHRISTMAS DREAM
A sport of 'Christmas Marvel,' 'Christmas Dream' was registered in 1973 by L. J. C. Schoorl, the grandson of the raiser of 'Christmas Marvel.' 'Christmas Dream' is a softer shade of red than 'Christmas Marvel' and the inside of the flower is a soft carmine-rose. The large white base has yellow basal blotches. This tulip is good for forcing and its height is 35 centimeters. [PLATE 161]

CHRISTMAS MARVEL
Registered in 1965 by L. Schoorl, 'Christmas Marvel' is a deep cherry color and a hybrid of two early forcing varieties. One parent is 'First Rate,' a red Mendel tulip no longer in cultivation, and 'Demeter,' a plum purple Triumph tulip. 'Christmas Marvel' is one of the most popular forced varieties for cut flowers around the Christmas holidays. An excellent tulip in the garden as well, it is 35 centimeters tall. Four of the best of its sports are 'Christmas Dream,' 'Merry Christmas,' 'White Marvel,' and 'Queen of Marvel,' a Double Early tulip. [PLATE 24]

FLAIR
Raised and registered by Jacobus van den Berg in 1978, 'Flair' is a splashy tulip: buttercup yellow with an irregular pattern of feathered Dutch vermilion on the exterior of the petals. The pattern will vary from plant to plant; some are redder or more yellow. The anthers are a pretty canary yellow showing up against the broad blue-black base. 'Flair' is 35 centimeters tall. [PLATE 26]

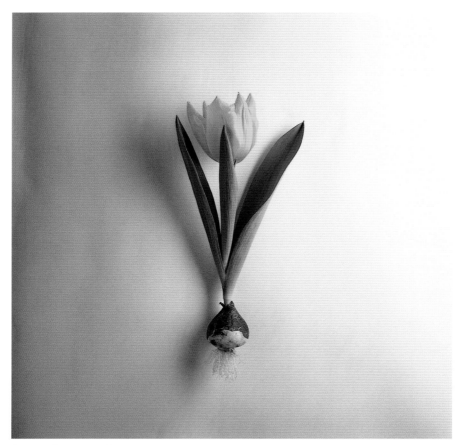

Joffre [plate 162]

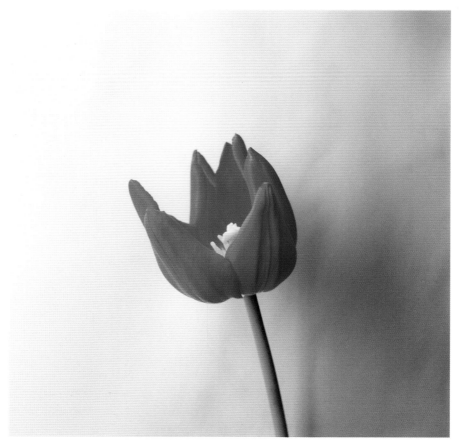

Merry Christmas [plate 163]

GENERAAL DE WET

De Wet, General de Wet

First registered in 1904, 'Generaal de Wet,' named for the South Afrikaner general who served in the Boer War, is one of the oldest Single Early tulips. The cup-shaped flowers are very soft orange with finely textured, almost imperceptible orange spots. 'Generaal de Wet' was the first orange sport of 'Prince of Austria,' an orange-scarlet tulip dating back to 1860. Stronger orange tulips have superseded 'Generaal de Wet.' It is a fragrant flower 40 centimeters in height.

JOFFRE

'Joffre,' a sport of 'Brilliant Star,' is a yellow flower laced with red nuances. It was registered in 1931 and its raiser is unknown. An early forcing variety and very often seen around Christmas, 'Joffre' is only 12 centimeters tall. [PLATE 162]

KEIZERSKROON

Grand Duc

'Keizerskroon,' Dutch for "Emperor's Crown," is one of the oldest varieties, dating back to 1750. Combining the subtle Old World color combination of a deep red flame and a yellow ground and base, 'Keizerskroon' at 35 centimeters tall is an excellent garden tulip. 'Rex,' a Parrot tulip, is its only sport. [PLATE 25]

MERRY CHRISTMAS

Th. & W. B. Reus registered 'Merry Christmas' in 1972. A sport of 'Christmas Marvel' with a bright cherry red flower, 'Merry Christmas' has a large yellowish-white base with a small purple edge. Suitable for forcing, its height is 35 centimeters. [PLATE 163]

MICKEY MOUSE

'Mickey Mouse' was registered in 1960 by E. Kooi. Its petals are flamed bloodred on a yellow ground. A slender plant with a somewhat smaller flower than most Single Early tulips, 'Mickey Mouse' is suitable for forcing. It is 35 centimeters in height.

PRINS CARNAVAL

Prince Carnival

'Prins Carnaval' was first registered in 1930 and its raiser is unknown. Like 'Generaal de Wet,' this is a sport of the old orange-scarlet tulip 'Prince of Austria' and it is fragrant. Its flower color resembles 'Mickey Mouse' with red stripes on a yellow ground. Now often superseded by other plants of the same color, such as 'Mickey Mouse,' because its aging stock is beginning to degenerate and lose

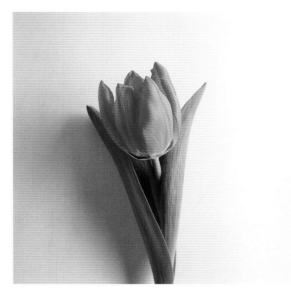

SINT MAARTEN [PLATE 164]

strength, 'Prins Carnaval' is not used as frequently as it was in the past. Its height is 40 centimeters.

RUBY RED

Registered by B. P. Heemskerk in 1944, 'Ruby Red' is a bright glowing red hybrid, a cross between 'Duc van Tol,' which was small and very early flowering, and 'William Pitt,' one of the oldest Darwins, tall and red. It has a broad star-shaped green base on a yellow ground. 'Ruby Red' was originally classified in the Mendel group—it is one of the last of the Mendel tulips—and was later reclassified as a Single Early tulip when the Mendel tulips were folded into the Single Early group. 'Ruby Red' is taller than 'Duc van Tol' but shorter than its Darwin parent, illustrating beautifully the concept behind the creation of the Mendel tulips, which was to produce plants with just this size and bearing. Still used for very early forcing, it is usually available in November and December. Its height is 40 centimeters.

SINT MAARTEN

Registered by P. C. de Geus in 1983, 'Sint Maarten' is a sport of 'Brilliant Star.' It is nasturtium orange and its petals are flamed brick red—one of the rare orange-colored Single Early tulips. De Geus named this tulip for Saint Martin, who is celebrated at Christmas in a popular children's festival that takes place in the northern part of the Netherlands. Available as a forced tulip as early as Christmas, 'Sint Maarten' is 30 centimeters tall. [PLATE 164]

WHITE MARVEL

Not yet registered, the name 'White Marvel' is reserved for the white sport of 'Christmas Marvel' that has been found by several growers in Holland. Good for forcing, it is 35 centimeters tall.

DOUBLE EARLY GROUP

The Double Early tulips, brimming with petals and flowering early in the season, were first mentioned around 1613 when they were called *"Monstre double"* tulips. In the past, these mutations of single tulips with several times the number of petals often carried flowers too heavy for their stems, and the added weight caused the flowers to topple easily in the wind or after a rain. Dutch breeders have concentrated on improving and strengthening the stems of the Double Early tulips, and today there are tulips with stems that can carry the flower perfectly under all weather circumstances.

Historically, the most important Double Early tulip is 'Murillo,' which has had over 140 named sports since it was first introduced in 1860 by Gerard Leembruggen. Today, twenty-two sports are still in cultivation and their range of colors is astounding: from pure whites and pale pinks to reds, yellows, oranges, and purples. Many have contrasting colors on the rims. Some of the 'Murillo' sports are bright and lively, others are softer and more subdued. They are characterized by very pointed petals and leaves that also point and curl.

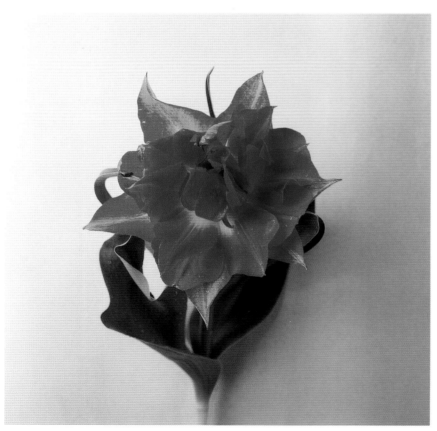

Goya [Plate 165]

The family of Gerard Leembruggen from Leiden, so influential in producing the 'Murillos,' also contributed to the expansion of the bulb business in Holland by creating land suitable for tulip growing. Around 1833,

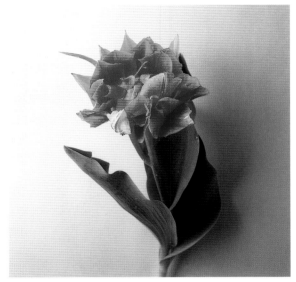

ANTHONY EDEN [PLATE 166]

the Leembruggens bought a large tract of land in an area to the north of Leiden, between Lisse and Hillegom, which at the time consisted of swamps, dunes, and peaty boggy land, with occasional streams that flowed into a nearby lake. It was uninhabited and considered too poor to farm. The wealthy Leembruggens funded the draining, grew enormous quantities of 'Murillos' in the fields, and sold the stock in a green auction (a sale that takes place in the tulip fields) in 1860. This area now forms the eastern border of what is now referred to as Holland's bulb district, or "Bloembollenstreek."

Today the Double Early tulips account for nearly 12 percent of all tulips grown in Holland. About 1 percent of that acreage is devoted to growing 'Murillo' and its sports and half of that 1 percent is acreage for growing its most popular sport, 'Peach Blossom.' The Double Early tulip 'Monte Carlo,' raised by Anton Nijssen, and its sports have replaced the 'Murillo' group in popularity. 'Monte Carlo' and its sports make up the largest acreage in Holland and are greatly valued in the forcing market.

There is great variation among the Double Early tulips, some of which are very small and low-growing, such as 'Yellow Baby,' which is only fifteen centimeters tall, and others that are at least twice that height. Petal shapes vary, too—from the pointed petals of 'Murillo' and its sports to others that are rounded. Some of the Double Early tulips such as 'Monte Carlo' and its sports are also fragrant. All are great in gardens and many are used for forcing.

ANTHONY EDEN

Registered by J. de Groot Moes in 1956, 'Anthony Eden' is apricot orange and golden yellow. This is a sport of 'Maréchal Niel,' another sport of 'Murillo.' 'Anthony Eden' is suitable for forcing, with a height of 25 centimeters. [PLATE 166]

ARIE ALKEMADE'S MEMORY

Registered in 1959 by C. P. Alkemade, 'Arie Alkemade's Memory' is a splendid glowing vermilion color. The firm of Alkemade raised many of the Double Early tulips after World War II. Eventually named after one of the firm's founders, for many years this tulip was known only as Number 44. Now widely available, 'Arie Alkemade's Memory' is one of the few Double Early tulips left from a group that was grown to replace the very popular 'Murillos.' Unfortunately, the bulbs were susceptible to a fusarium disease, and most in the group have not survived well. Suitable for forcing, it is 35 centimeters tall. [PLATE 31]

CARDINAL MINDSZENTY

Van Reisen & Sons registered 'Cardinal Mindszenty' in 1949. It is a large pure white flower and is a sport of 'Madame Testout,' which itself is a sport of 'Murillo.' Suitable for forcing, it is 25 centimeters in height.

CARLTON

'Carlton,' registered by C. P. Alkemade in 1950, is even older than 'Arie Alkemade's Memory' and is a deeper, darker red. One of the earliest Double Early tulips, it is still one of the best—it grows well and is resistant to a bulb disease that causes some Double Early tulips to die. Found suitable for forcing, 'Carlton' is one of the taller Double Early tulips, with its height of 40 centimeters. [PLATE 167]

DAVID TENIERS

'David Teniers' was registered by P. Bakker in 1960 and is a violet-purple flower. A sport of 'Murillo,' it is one of the

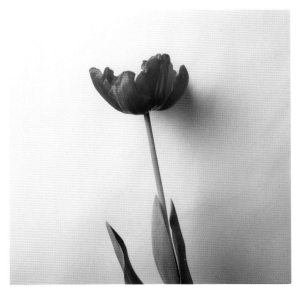

CARLTON [PLATE 167]

darkest, representing one side of the enormous breadth of the 'Murillo' color spectrum. Suitable for forcing, it is 25 centimeters in height. [PLATE 28]

DOUBLE PRICE

'Double Price' was raised by H. van Dam and registered by Hybris in 1992 and has a round violet-purple flower. The exterior of the petals carry a lilac-purple edge. Good for forcing, it has a height of 35 centimeters.

ESKILSTUNA

Registered by A. Langedijk in 1977, 'Eskilstuna' is a sport of 'Stockholm.' It resembles a 'Murillo' tulip but its petals are rounder and the flower is fuller. The flower color is aureolin. 'Eskilstuna,' like 'Stockholm,' is named for a Swedish city. Good for forcing, it is 30 centimeters in height. [PLATE 168]

GOYA

P. Bakker registered 'Goya' in 1933. It is salmon, scarlet, and yellow, which blend together on the petals to give it the appearance of an orange tulip. 'Goya' is a sport of 'Oranje Nassau,' another 'Murillo' sport. Good for forcing, this beautiful tulip is 25 centimeters tall. [PLATE 165]

MARÉCHAL NIEL

The raiser of 'Maréchal Niel,' a 'Murillo' sport, is unknown; it was first registered in 1930. It is yellow flushed with orange on the petals, and is suitable for forcing. Its height is 25 centimeters. 'Maréchal Niel' has several sports, including 'Anthony Eden.' [PLATE 170]

MARQUETTE

A sport of 'Murillo,' 'Marquette' is red and the petals are edged yellow. It was registered in 1914 and its raiser is unknown. Suitable for forcing, it is 25 centimeters tall. [PLATE 169]

MONSELLA

Registered by Bakker Brothers in 1981, 'Monsella,' a sport of 'Monte Carlo,' is light canary yellow with a bloodred flame on the exterior of the petals and sulfur yellow with the same bloodred flame on the interior. The flame is variable and occasionally appears as a single red stripe. As is the case with 'Monte Carlo,' the feathering on the petals varies: On some, the red feathering will appear as just one stripe and on others it will appear as multiple stripes. 'Monsella' is fragrant and suitable for forcing. It is 30 centimeters tall. [PLATE 33]

MONTE CARLO

Anton Nijssen & Sons registered 'Monte Carlo' in 1955. 'Monte Carlo' is a light yellow-colored flower, occasionally with very slight red feathering. An extremely popular cut flower, this is probably the most widely grown bulb for forcing in the industry. Fragrant, with a height of 30 centimeters, 'Monte Carlo' has one sport, 'Monsella.' [PLATE 32]

MONTREAUX

Registered by Hybris in 1990, 'Montreaux' resembles another Double Early tulip named 'Verona' and could be a sister seedling. 'Montreaux' is pale yellow, and as the flower matures, it develops a red glow on the petals. The base is yellow. This sturdy, very beautiful, and fragrant tulip is suitable for forcing. It is 45 centimeters in height.

MURILLO

'Murillo' is one of the oldest tulips still in cultivation, dating back to 1860, when it was introduced by Gerard

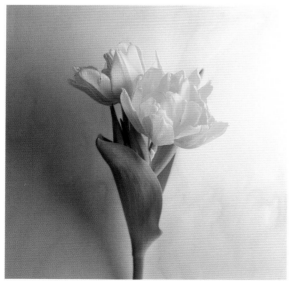

ESKILSTUNA [PLATE 168]

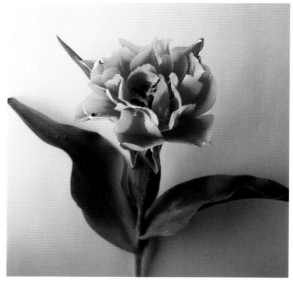

MARQUETTE [PLATE 169]

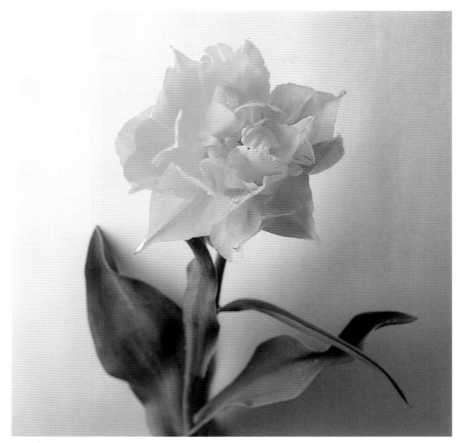

Maréchal Niel [plate 170]

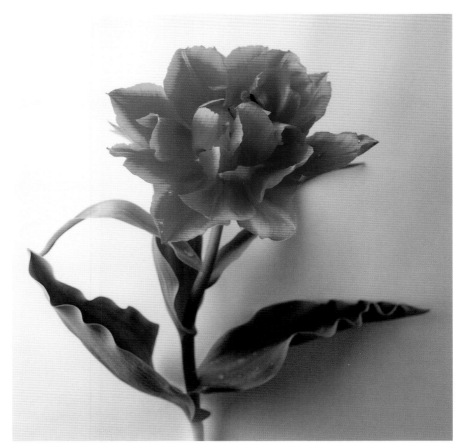

Oranje Nassau [plate 171]

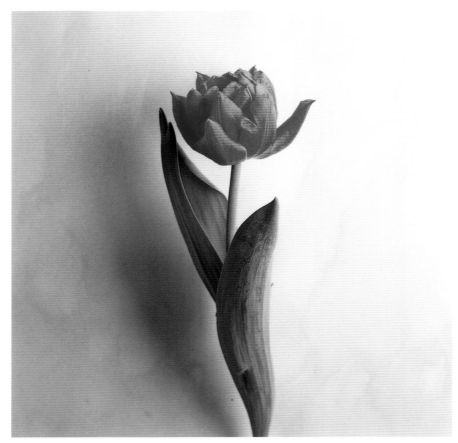

QUEEN OF MARVEL [PLATE 172]

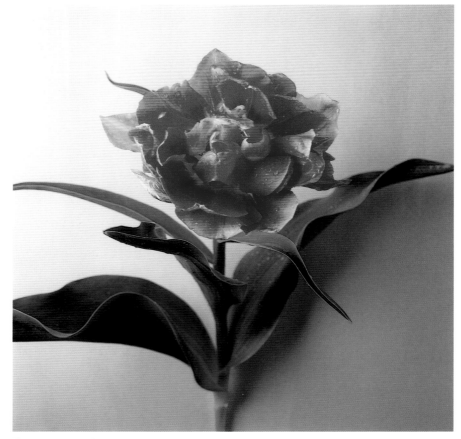

TRIUMPHATOR [PLATE 173]

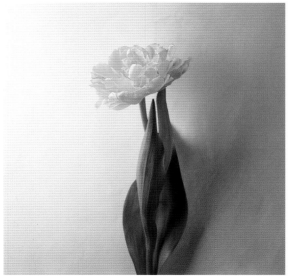

VERONA [PLATE 174]

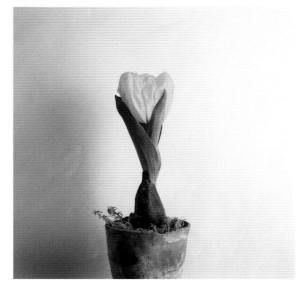

YELLOW BABY [PLATE 175]

Leembruggen. It is white, flushed pink on its petals, and fragrant. Good for forcing, it is 25 centimeters tall. 'Murillo' has more sports than any other tulip. The best include 'Anthony Eden,' 'Cardinal Mindszenty,' 'David Teniers,' 'Goya,' 'Maréchal Niel,' 'Marquette,' 'Oranje Nassau,' 'Peach Blossom,' and 'Triumphator.' [PLATE 29]

ORANJE NASSAU
'Oranje Nassau' was introduced before 1912 but not registered until 1930, when it was given its name. No raiser is known. 'Oranje Nassau' is an early 'Murillo' sport with a dramatic flower color: bloodred and flushed fiery red on the exterior of the petals. It continues to do well in cultivation. Suitable for forcing, it is 25 centimeters tall. [PLATE 171]

PEACH BLOSSOM
One of the first and still most popular 'Murillo' sports, 'Peach Blossom' was introduced in 1890. It carries a deeper rose color and has greater stamina than the mother tulip. Suitable for forcing, it is 25 centimeters in height.

QUEEN OF MARVEL
C. J. Dekker registered 'Queen of Marvel' in 1982. It is a sport of the Single Early tulip 'Christmas Marvel.' The exterior petals are flamed chrysanthemum red with rose-feathered edges and the inner petals carry a cherry red color. Good for forcing, it is 35 centimeters tall. [PLATE 172]

STOCKHOLM
'Stockholm,' registered by Anton Nijssen & Sons in 1952, is scarlet with a yellow base. Its petals are rounder than 'Murillo' petals. Good for forcing, it is 30 centimeters tall and has a wonderful sport in 'Eskilstuna.' [PLATE 30]

SVEN DAHLMAN
Raised and registered in 1964 by P. Nijssen & Sons, 'Sven Dahlman' is an unusual pale purple flower and the outer petals are flamed with ivory white, sometimes topped with green. 'Sven Dahlman' has an elegant round shape, and is suitable for forcing. Its height is 30 centimeters.

TRIUMPHATOR
The raiser of 'Triumphator,' a 'Murillo' sport, is unknown but the tulip was registered in 1919. This is a rosy, dusky pink flower suitable for forcing. Its height is 25 centimeters. [PLATE 173]

VERONA
Raised by M. Boots and registered by Hybris in 1991, 'Verona' is an unusual pale yellow flower with a sulfur yellow flame on the exterior of the petals. Inside, the petals are primrose yellow with an ivory white mid-vein. Its flower shape is slightly more elongated than most Double Early tulips. The fragrant 'Verona' may eventually prove as enduring as the Murillos; its stock is growing fast because it tends to grow better than the older Double Early tulips. Taller-stemmed than most Double Early, 'Verona' is often used for forcing and is 40 centimeters tall. [PLATE 174]

YELLOW BABY
Registered by J. F. van den Berg & Sons in 1971, this flower is aureolin with pale yellow anthers. 'Yellow Baby' is a peculiar Double Early: It has the diminutive stature of a 'Duc van Tol' tulip, which may be one of its parents. Its height is 15 centimeters. [PLATE 175]

T. albertii

Dr. Eduard August von Regel first wrote about *T. albertii* in 1877 and named this strong dark red-flowered plant to honor his son, Albert von Regel, a physician in eastern Turkistan and avid plant collector who was said to have roamed far and wide seeking new species. It is found in the Tien Shan mountains of central Asia. *T. albertii* is variable in the wild but not so in Holland, where it is grown from a clone and its square-shaped single flower is always a deep red. The leaves are narrow and curl slightly, and the bulb is almost as big as a garden tulip's bulb. Its height is 30 centimeters. [PLATE 176]

T. aucheriana

Described by John Gilbert Baker in 1883, *T. aucheriana* is found in the north and middle of Iran. This is a very small plant—only 5 to 8 centimeters in height—with narrow, glossy leaves and a pink-and-cream-colored starlike flower that darkens in color as the plant matures. A uniform species distinguishable by its small bulbs, *T. aucheriana* can be difficult to grow as the bulbs often disappear for no apparent reason. [PLATE 38]

T. ferganica

Described by Aleksei Vvedensky in 1935, *T. ferganica* was discovered in central Asia, specifically in the Fergana Valley in the Pamir and Alai mountains of Uzbekistan. Its star-shaped flowers, usually two per plant, are yellow with a crimson-orange blush on the exterior of the petals and its lance-shaped leaves are fleecy. *T. ferganica* is grown from a small stock in Holland and its bulbs have a rough leathery skin. Its height is 30 centimeters. [PLATE 34]

T. kolpakowskiana

T. kolpakowskiana, first described in 1877 by Dr. Eduard August von Regel, was found in the Tien Shan mountains of central Asia. Yellow with red streaks on the outer petals, *T. kolpakowskiana* appears as all-yellow when the flower is young and open. As the plant matures, the red color emerges on the interior of the petals. Sometimes there are two flowers to a stem, and the attractive, very long leaves, two to four per plant, are silvery green and strongly curled along the rims. In the wild, the color range for *T. kolpakowskiana* is wide—orange, red, and all-yellow forms—but the only form grown in Holland is the one described here. The purple-brown bulbs with tough skins multiply well and there is reasonable stock in Holland. It is 20 centimeters in height. [PLATE 35]

T. sylvestris

T. sylvestris, nicknamed the "Wood Tulip," was first described in 1753 by Carl Linnaeus. Found in Asia Minor, northwest Iran, and Europe, *T. sylvestris* is naturalized even in Holland, where it is found in the meadows between Enkhuizen and Bovenkarspel. Stems often carry two sweet-scented flowers that are yellow with pointed petals and have a red blush on the outside. Its leaves, two or three per plant, are long and bluish-green. Like those of late-flowering *T. saxatilis*, the flowers of *T. sylvestris* are very shy and need a warm place under a south-facing wall or stones around the plants to maintain the heat of the sun into the cool of the night. *T. sylvestris* needs a good baking in the sun in order to produce strong bulbs for the next year's flowers. It is stoloniferous and often spreads without flowering if plants do not receive the growing conditions they require. Only the big bulbs will produce flowers. *T. sylvestris* is 30 centimeters tall. [PLATE 37]

T. wilsoniana

Found in the mountains of central Asia in the area formerly known as Turkmenistan, *T. wilsoniana* was first described by J. M. C. Hoog in 1902. The rounded petals, each with a small, pointed tip, are deep bloodred, the exterior ones tinged purple on the outside. The base is black. Although this is not a plant that flowers abundantly, the single-stemmed flowers are very pretty. A plant has about five leaves, undulated, with narrow red margins. The brownish-colored bulbs have tough skins. There is plenty of good stock in Holland for *T. wilsoniana*. It is relatively short at 15 centimeters. [PLATE 36]

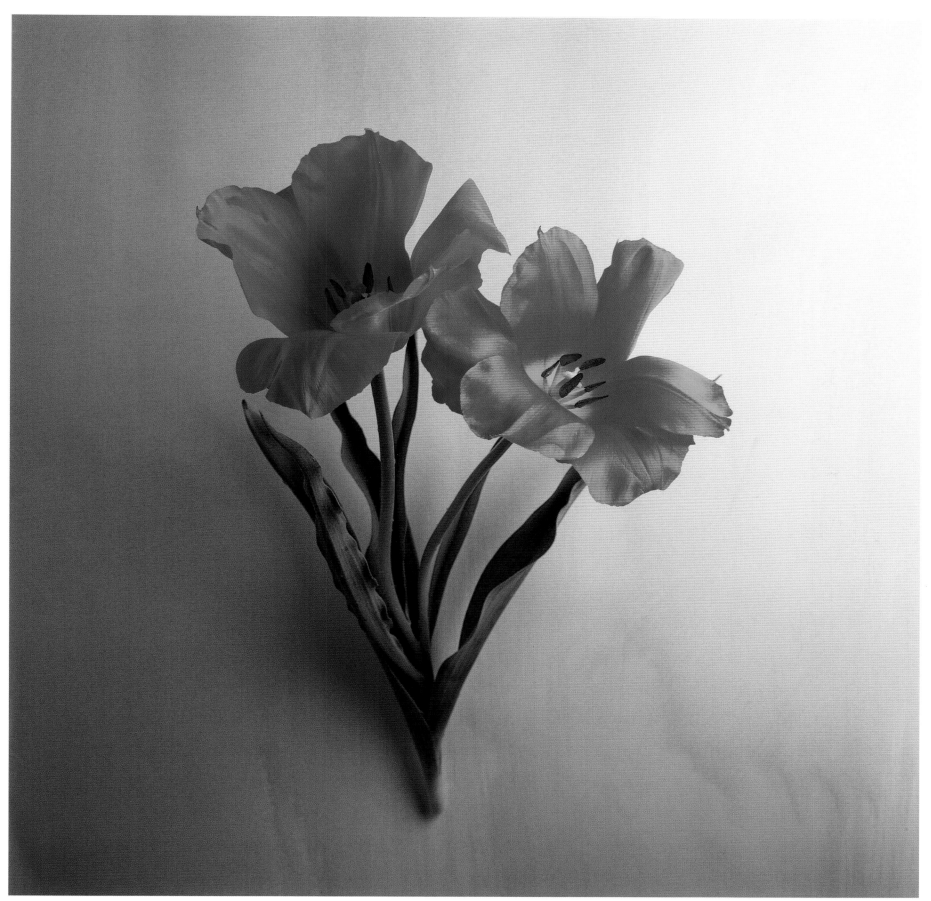

T. albertii [PLATE 176]

DARWINHYBRID GROUP

The Darwinhybrid group came about in the 1940s as a result of the hybridization of the Fosterianas and the then very popular Darwin tulips (a group that no longer exists today). The birth of the Darwinhybrids signaled a new and exciting period in the Dutch tulip industry. The Darwinhybrids brought the splendid satin red shades of the Fosteriana 'Madame Lefeber' to the sturdy, well-proportioned Darwin flower on a tall, strong stem.

Dirk Lefeber is the Dutch bulb grower who first saw the potential in crossing the Fosterianas with the Darwin tulips and is credited with creating so many of these beautiful hybrids. One of the founders of the famous Keukenhof Gardens in Lisse, Lefeber was independently wealthy and was able to devote himself to creating Darwinhybrids. He made hundreds of crosses, and one of those crosses produced 364 seedlings. This was a cross between a Fosteriana cultivar he had named 'Madame Lefeber' and a Darwin. In 1945, Mr. Lefeber enlisted the services of two other Dutch bulb growers, Arie Overdevest and Piet de Groot, to explore the possibilities of these 364 seedlings. It was decided they would register just ten of the seedlings and destroy the rest. This was a very clever marketing plan designed to bring out only as many new tulips as Lefeber thought the market could bear. With the introduction of these ten seedlings, all proudly carrying such World War II commemorative names as 'Parade,' 'Dover,' 'General Eisenhower,' and 'Franklin D. Roosevelt,' these Darwinhybrids established that indeed a bright new future existed for the world and for the Dutch bulb culture. About this time another hybridizer, Hybrida, introduced more colors into the new Darwinhybrid group with the pink 'Tender Beauty' and orange 'Oranjezon.' These were exciting contributions, and for many years following World War II, these tulips were enormously popular.

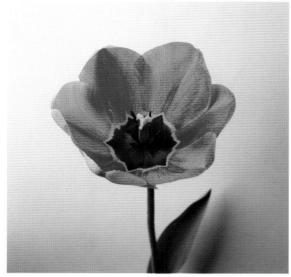

APELDOORN'S ELITE [PLATE 177]

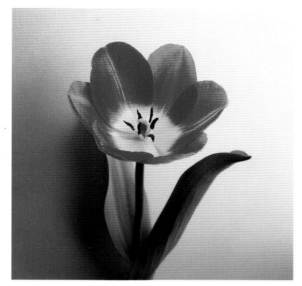

BIG CHIEF [PLATE 178]

It was soon discovered the new Darwinhybrids had one drawback: They could not be forced as successfully as other garden tulips. The newly created group of Triumph tulips, which were excellent forcers, began to take the place of many Darwinhybrids. However, improved growing methods and chilling techniques in greenhouses has made forcing tulips easier, and many of the Darwinhybrids are now used for this purpose.

Today the Darwinhybrids are considered one of the tulip industry's most important innovations and are the second most widely grown tulip in Holland (after the Triumphs). The primary use for the Darwinhybrids is the garden. They flower mid-season and make excellent fresh cut flowers because of their long sturdy stems and large beautiful flowers. Some are also used for forcing.

AD REM
Registered by Konijnenburg & Mark in 1960, 'Ad Rem' is an orange-scarlet flower edged yellow on the petals with a black base. The parents of 'Ad Rem' are 'Princeps,' a red Fosteriana, and 'Denbola,' a red Triumph tulip edged white. Larger than most Darwinhybrids and requiring a bit more space in the garden, this is a good forcing variety and a terrific garden tulip. The bulb is vigorous and will produce flowers for several years. Its height is 60 centimeters. [PLATE 39]

APELDOORN
Registered by D. W. Lefeber in 1951, 'Apeldoorn' is cherry red and huge. The base is black, edged yellow. In an article about his Darwinhybrids in *The 1960 Tulip and Daffodil Yearbook,* Lefeber wrote that 'Apeldoorn' is the result of a Darwin-Fosteriana cross. He was no more specific than this because he did not want his cross repli-

cated. It had been assumed that the Fosteriana he used was his own 'Madame Lefeber' but the Darwin parent is unknown. In the early 1970s, the Institute for Horticultural Breeding in Holland (the full Dutch name is Instituut voor de veredeling van Tuinbouw producten—known as IVT) created a study group devoted to learning the parents of 'Apeldoorn.' The author, Wim Lemmers, participated in the study group and advised IVT to try the Darwin tulip 'Madame Curie,' also a Lefeber tulip. This cross was successful, producing two seedlings that looked like 'Apeldoorn': 'Lefeber's Memory' and 'Come-Back.' 'Apeldoorn,' which is used for forcing, is 55 centimeters tall.

'Apeldoorn' has many sports, and sports of sports. The sturdiest and most widely grown are 'Apeldoorn's Elite,' 'Bienvenue,' 'Blushing Apeldoorn,' 'Golden Apeldoorn,' and 'Hans Mayer.' [PLATE 44]

APELDOORN'S ELITE
Registered by J. S. Verdegaal in 1968, 'Apeldoorn's Elite' is the best of the orange 'Apeldoorn' sports. The rims of the petals are a slightly lighter orange color and the base of the flower is black, edged yellow. 'Bienvenue' is one of its sports. 'Adeldoorn's Elite' is 55 centimeters tall. [PLATE 177]

BIENVENUE
In 1984, H. Roozen registered 'Bienvenue,' which is yellow with a red flame on the exterior of the petals as well as the interior. The base is black. A sport of 'Apeldoorn's Elite,' it is used for forcing and it is 55 centimeters tall.

BIG CHIEF
Registered in 1959 by A. Frijlink & Sons, 'Big Chief' has a balloonlike flower with petals that are rose pink on the

exterior, edged orange-red. Inside, the petals are flamed with cream and the base is canary yellow. The peculiar but very attractive color is especially vivid when the plant is young. A very sturdy plant, 'Big Chief' is one of the older and taller Darwinhybrids, a little taller than 'Pink Impression.' Its height is 60 centimeters. [PLATE 178]

BLUSHING APELDOORN
'Blushing Apeldoorn,' registered by J. Balder in 1989, is a sport of another 'Apeldoorn' sport 'Beauty of Apeldoorn,' which is gone already. This is a colorful lemon yellow tulip with a rich orange rim. Inside, the color is yellow with an orange feather and the base is black. It is 55 centimeters in height. [PLATE 179]

BURNING HEART
Registered by J. N. M. van Eeden in 1991, 'Burning Heart' is a sport of 'Ivory Floradale.' On the outer petals there is a single bloodred stripe and on the inside a broader tomato red flame. The base is sulfur yellow. Its height is 55 centimeters. [PLATE 43]

COME-BACK
This sister seedling of 'Lefeber's Memory' was raised by IVT and registered in 1984 by H. Roozen, who bought it as a seedling and named it. Darkish-red, with a black base, edged yellow, and suitable for forcing, it is 50 centimeters tall. [PLATE 180]

DAYDREAM
Found and registered by J. N. M. van Eeden in 1980, 'Daydream,' a sport of 'Yellow Dover,' is spotted orange on a yellow ground, with its petals carrying a slightly lighter yellow on the rims. Its height is 55 centimeters.

DIPLOMATE
'Diplomate' was registered by D. W. Lefeber in 1950, and while it may have come from the same two parents used to create 'Apeldoorn,' this plant is shorter and sturdier with a deeper red flower and a greenish-yellow base. It flowers a bit later than the other Darwinhybrids and is 50 centimeters in height.

ELIZABETH ARDEN
'Elizabeth Arden' was registered by W. E. De Mol and A. H. Nieuwenhuis in 1942. The flower is dark salmon pink, its petals flushed violet. The base is white with yellow blotches. 'Elizabeth Arden' has a large, well-formed flower that is characteristic of the Darwinhybrids. It is 55 centimeters tall. [PLATE 181]

FORGOTTEN DREAMS
Konijnenburg & Mark registered 'Forgotten Dreams' in 1968. Its parents are 'Denbola,' a deep red Triumph with a white rim, and a Greigii, though it looks like it was crossed with a Fosteriana because the flower is so large. Its very big rose-colored flower with narrow yellow edges of the petals make this a wonderfully attractive Darwinhybrid. The base is bronze-green. Unfortunately, there is not much stock left. Its height is 55 centimeters.

GOLDEN APELDOORN
Registered before 1965 by C. Gorter and A. Overdevest, 'Golden Apeldoorn,' a sport of 'Apeldoorn,' is the most popular Darwinhybrid. A more robust plant than 'Apeldoorn,' it is golden yellow with a black base and has no red streaks in it. 'Golden Apeldoorn,' which is suitable for forcing, has several sports, one of which is 'Hans Mayer.' Its height is 55 centimeters. [PLATE 45]

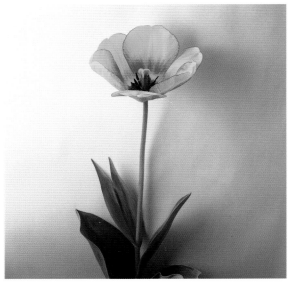

BLUSHING APELDOORN [PLATE 179]

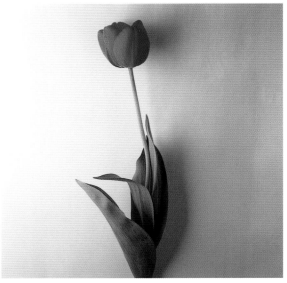

COME-BACK [PLATE 180]

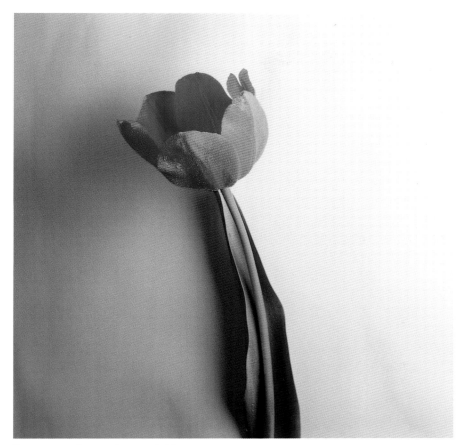

ELIZABETH ARDEN [PLATE 181]

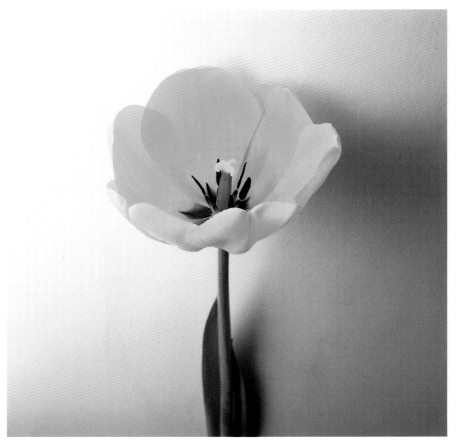

GOLDEN PARADE [PLATE 182]

GOLDEN PARADE

Found and registered by A. Overdevest in 1963, 'Golden Parade' is a sturdy buttercup yellow Darwinhybrid with a black base. Much used in the cut-flower industry, the fresh flowers are picked from the fields in April. A sport of 'Parade,' it is 60 centimeters tall. [PLATE 182]

GORDON COOPER

'Gordon Cooper' is from Konijnenburg & Mark (after World War II, the largest Dutch firm growing, exporting, and hybridizing bulbs including tulips, gladioli, and narcissus), which registered it in 1963. This is the tallest Darwinhybrid—its parents are 'Charwenka,' a salmon red Darwin, and the Fosteriana 'Madame Lefeber'—with flowers that are round and not too big. The petals are carmine-rose, edged signal red, and the base is black edged yellow. 'Gordon Cooper' flowers later than most Darwinhybrids and does better than other Darwinhybrids in warm climates. Its height is 60 centimeters. [PLATE 183]

GUDOSHNIK

'Gudoshnik' was registered by D. W. Lefeber & Company in 1952. 'Gudoshnik' is yellow, its petals spotted and streaked with red. The red pattern in the petals can be variable. Its base is black. It is 60 centimeters in height.

HANS MAYER

A sport of 'Golden Apeldoorn' found and registered by C. Gorter in 1972, 'Hans Mayer' was the first yellow Darwinhybrid with a red flame on the petals. The vermilion flame appears more on the inside of the petals than the outside. It has a smallish deep brown base. Its height is 55 centimeters. [PLATE 184]

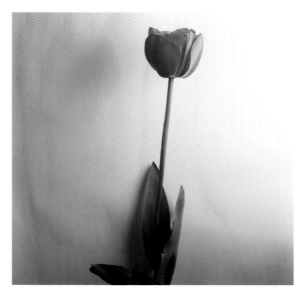

GORDON COOPER [PLATE 183]

HOLLANDS GLORIE

'Hollands Glorie' was found and registered by D. W. Lefeber & Company in 1942 and is a cross between 'Bartigon,' an old red Darwin tulip, and the Fosteriana 'Madame Lefeber.' It is a dark poppy red color that deepens as the flower matures. The base is greenish-black. The long, wide petals of 'Hollands Glorie' indicate a strong Fosteriana influence. One of the biggest flowers of all tulips, and 60 centimeters tall, it is very popular. [PLATE 42]

IVORY FLORADALE

Registered by Doornbosch Brothers in 1965, 'Ivory Floradale' is ivory yellow, slightly spotted carmine-red on the exterior of the petals. Inside, the color is creamy yellow and the base is blotched green. A tall plant with a very large egg-shaped flower, this was the first whitish Darwinhybrid found. A sport of the red-colored 'Floradale,' it has a sport, 'Burning Heart.' Its height is 60 centimeters.

JULIETTE

'Juliette' was registered in 1985 by Q. van den Berg & Sons. A sport of 'Golden Oxford,' which is a sport of 'Oxford,' it is golden yellow with a red flame on the petals. 'Juliette' is 55 centimeters tall.

OLLIOULES

Registered by Van Zanten Brothers in 1988, 'Ollioules' is named for the town in the south of France that is the center of the French flower industry. The pale, light pink flower blends and fades into white on the edges of the exterior petals, and there is a little red in the color as well as a tint of light green. The base is canary yellow. This unusual-colored flower is 55 centimeters tall.

OLYMPIC FLAME

'Olympic Flame,' registered by A. Verschoor Jr. in 1971, is a sport of 'Olympic Gold,' which is itself a sport of 'Lefeber's Favourite.' Although 'Lefeber's Favourite' did not grow well, its beauty lives on in this, one of the most attractive Darwinhybrids. 'Olympic Flame' has a perfect, rounded form, a yellow flower with a red flame, and is 55 centimeters tall.

ORANJEZON

Hybrida registered 'Oranjezon' in 1947. A bright, pure orange Darwinhybrid, this is one of the few truly orange tulips. Its parents are the fragrant Single Early tulip 'Generaal de Wet' and a Greigii. The Greigii influence is evidenced in the leaves that are mottled when the plant is young. The flowers are beautiful and perfectly round. Suitable for forcing, it is 50 centimeters in height. [PLATE 46]

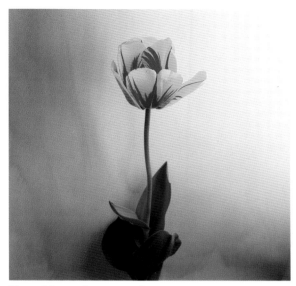

HANS MAYER [PLATE 184]

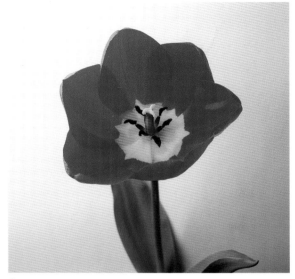

OXFORD [PLATE 185]

OXFORD

'Oxford' was registered by D. W. Lefeber & Company in 1945, one of the ten selected from his large batch of seedlings. This scarlet tulip with a sulfur yellow base is one of the most beautiful Darwinhybrids. It has several sports, some of which also have sports. One of the prettiest is 'Juliette,' which is a sport of 'Golden Oxford.' 'Oxford' is suitable for forcing and its height is 55 centimeters. [PLATE 185]

PARADE

Registered by D. W. Lefeber & Company in 1951, 'Parade' is a red flower with a showy black base, edged with yellow. It continues to be a sturdy plant after nearly fifty years and has produced many sports, one of which is 'Golden Parade.' 'Parade' is 60 centimeters tall.

PINK IMPRESSION

'Pink Impression,' raised by IVT and registered in 1979 by J. W. A. van der Wereld, was the first true pink Darwinhybrid. Its base is black with a small yellow edge. Its parents are 'Eurovisie,' a red Triumph tulip, and the Fosteriana 'Madame Lefeber.' 'Pink Impression' performs well in warm climates and is a good multiplier. It has two good sports, 'Red Impression' and 'Apricot Impression.' Its height is 55 centimeters. [PLATE 40]

TENDER BEAUTY

Registered by Hybrida in the 1940s, 'Tender Beauty' appears to be the result of a cross between a Fosteriana and 'Pink Beauty,' a Single Early tulip, although no record of its parents has been published. The flower is white with a broad pink edge. Its pink color does not fade as it matures, which can happen in other tulips, and the white flame stays white. However, the bulb is large and is sometimes prone to rot, so for this reason the Triumph tulip 'Judith Leyster' has somewhat superseded 'Tender Beauty.' It is 50 centimeters in height. [PLATE 41]

WORLD'S FAVOURITE

Raised by IVT and registered by World Flower in 1992, 'World's Favourite' is a red flower with a brilliant yellow edge on the pointed petals. A very good multiplier and a fast grower as well, it has a longer stem that keeps the flowers upright. 'World's Favourite' is 45 centimeters tall.

YELLOW DOVER

'Yellow Dover' was registered by A. Overdevest in 1963. A buttercup yellow sport of red 'Dover,' which is not nearly as widely grown as its many sports, 'Yellow Dover' has a black base. Its height, the same as that of its sport 'Daydream,' is 55 centimeters.

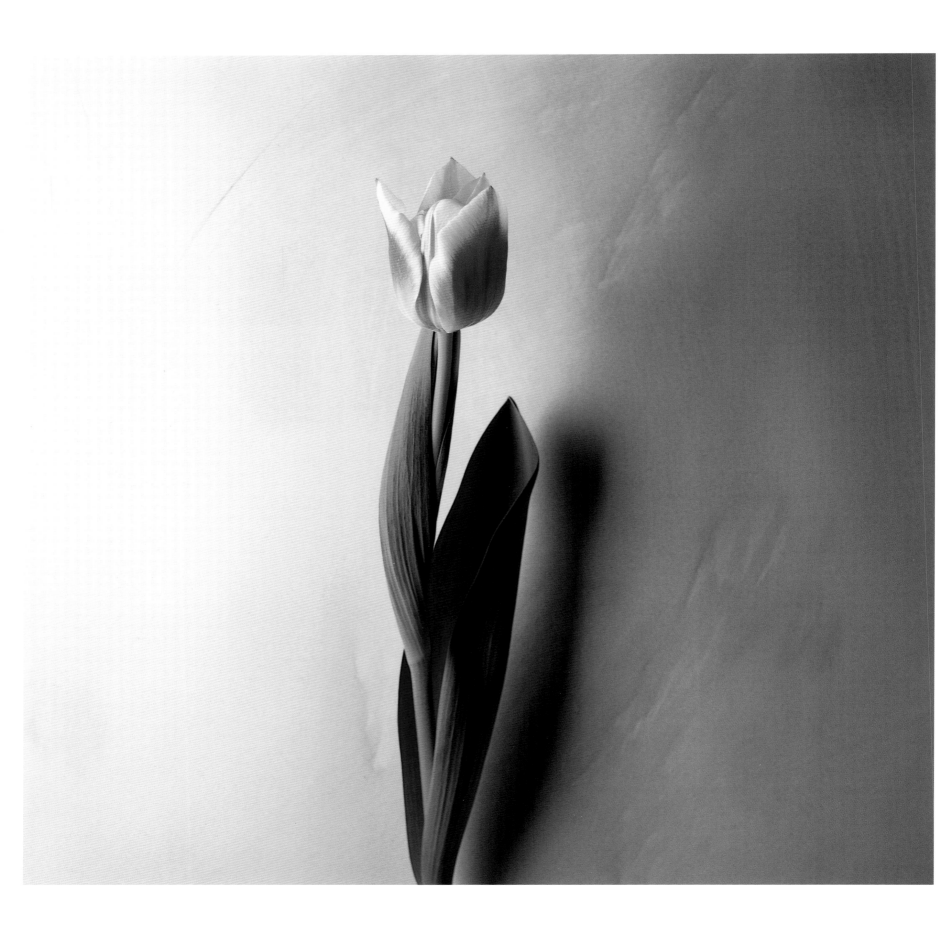

Anna José [plate 186]

TRIUMPH GROUP

Around the turn of the century, Zocher & Company of Haarlem sought to develop a breeding program to accommodate the demand from the foreign market for large quantities of uniform garden tulips that could be used as bedding plants, as well as the demand for forced tulips that could be brought on the market from Christmas to spring. Zocher's hybridizer, J. J. Kerbert, was well known in the trade and crossed early-flowering tulips with mid- and late-flowering tulips to produce strong-stemmed, large tulips in an astonishing range of colors. Most important, Kerbert's tulips showed the early forcing capacity customers wanted. Zocher sold the Kerbert seedlings to Klaas Zandbergen from Rijnsburg in 1930, who selected, named, and sold the new tulips—dubbing them Triumphators, as they were stronger-stemmed, bigger, and bolder than any existing tulips. The name Triumph stuck.

Also at the turn of the century another grower, E. H. Krelage, also of Haarlem, was working toward the same goal. Though Krelage came up with the Mendel tulips that seemed to fit the bill, the Mendels proved to have weak stems. Today Mendels have all but disappeared and the few left have been combined into the Triumph and Single Early groups.

Kerbert continued hybridizing Triumphs and established a large-scale hybridizing business with Willem van Waveren of Hillegom. But the expense of running an enormous operation proved too great and Kerbert and Van Waveren sold their stock to Gerbrand Kieft from Schoorl, who, with his company, Hybrida, selected and named more Triumphs. The second generation of Triumphs was an even greater success than the first as many were perfected for forcing. Though Kerbert was a shy man who never came to the fore to claim the honor of creating the Triumphs, he will nonetheless long be remembered, for the Triumph group is sure to exist well into the future.

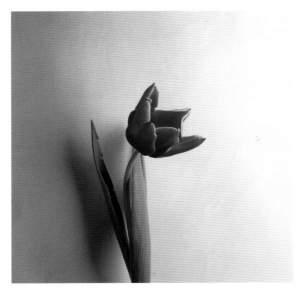

ABRA [PLATE 187]

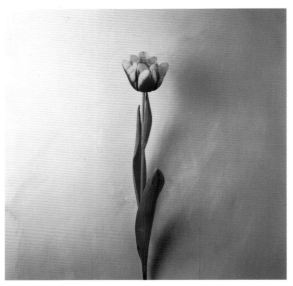

ABU HASSAN [PLATE 188]

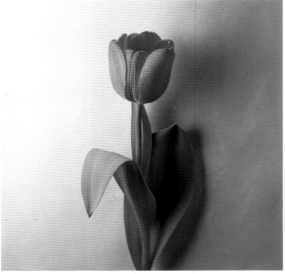

ANNIE SCHILDER [PLATE 189]

The Triumphs flower mostly in mid-season and most have conical, single flowers on sturdy stems. Resistant to bad weather, wind, and rain, with fairly short stems, the Triumphs today are by far the most popular group of tulips, and claim 45 percent of the total acreage of tulips in Holland. Almost all of the Triumphs are good forcers. New forcing varieties in better colors and with sturdier flowers are constantly coming on the market. All the Triumphs, with their perfectly symmetrical flowers and upright carriage, add a touch of elegance to any garden.

ABRA
Registered by Hybrida in 1959, 'Abra' is a mahogany flower whose petals are edged with bright yellow. Suitable for early forcing and a familiar sight at flower markets, 'Abra' is 40 centimeters tall. [PLATE 187]

ABU HASSAN
Raised by J. F. van den Berg & Sons and registered by C. Roet & Sons in 1976, 'Abu Hassan' is a very popular forcing variety. A glowing cardinal red flower with buttercup yellow edges on the petals, its base is primose yellow and it is 50 centimeters in height. [PLATE 188]

AFRICAN QUEEN
'African Queen' was registered by J. Ligthart in 1983 and is deep purple with a yellowish-white rim. The base is primrose yellow. 'African Queen' has a beautiful dark flower with an unusual, long top part of the stem. Its height is 55 centimeters. [PLATE 47]

AMBASSADOR
In 1979, Bito registered 'Ambassador,' a scarlet Triumph with a cherry red flame on the petals and a light yellow base. The flower is big, and in the United States it is used mostly for containers. It is 40 centimeters tall.

ANNA JOSÉ
Registered in 1977 by P. J. Nijssen, 'Anna José' is a small and delicate soft pink flower; the petals are edged white. The base is yellow. Suitable for forcing, it is 50 centimeters tall. [PLATE 186]

ANNIE SCHILDER
Raised by Kees Visser and registered by J. Ligthart in 1982, 'Annie Schilder' is a deep orange flower with lighter orange edges on the petals. The base is lemon yellow. Annie Schilder was a very popular female folk singer in the 1980s from the Dutch village of Volendam, a small fishing port on the Zuiderzee. 'Annie Schilder' is one of the few orange Triumph tulips. Its height is 45 centimeters. [PLATE 189]

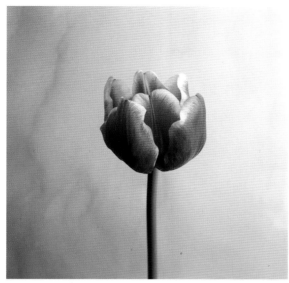

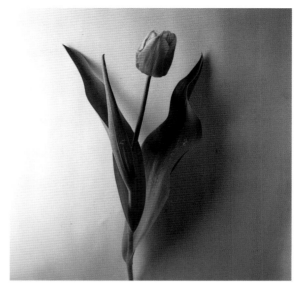

ARABIAN MYSTERY

In 1953, P. Hopman & Sons registered 'Arabian Mystery,' which has a fresh purple flower with pure white edges on the petals that are clearly visible. The contrast is beautiful. Excellent for forcing, 'Arabian Mystery' is 40 centimeters tall. [PLATE 190]

ARIE HOEK

Registered by Konijnenburg & Mark in 1977, 'Arie Hoek' is named for the firm's most important hybridizer. Arie Hoek, a resident of Noordwijk, was, in fact, one of the best hybridizers in the Dutch bulb business. A prominent tulip in the forcing trade, 'Arie Hoek' is a strong and sturdy deep red tulip with a bronze-green base. Its height is 55 centimeters. [PLATE 57]

ATTILA

'Attila' was raised and registered by G. van der Mey's Sons in 1945, and its velvety purple flower has a beautifully rounded form. The base is greenish-white. A great winner in flower shows and competitions since its introduction over fifty years ago, 'Attila' is at the end of its life. Fortunately, though, it has many nice sports, one of which is 'Attila's Elite.' Suitable for forcing, 'Attila' is 50 centimeters tall. [PLATE 62]

ATTILA'S ELITE

Attila's Graffiti

Registered by J. Balder in 1985, 'Attila's Elite' is a beautiful velvety sport of 'Attila.' Dark red with a base that is purplish with white blotches, it has another name, 'Attila's Graffiti,' which came about when the sport was mistakenly registered under a different name. 'Attila's Elite,' suitable for forcing, is 50 centimeters in height.

BARCELONA

'Barcelona' was registered in 1989 by Hybris and is a light purple flower with small magenta edges on the petals. The base is green surrounded by ivory white. Slightly pinker than 'Attila,' 'Barcelona' will take the place of 'Attila' as the older flower dies out. Suitable for forcing, it is 60 centimeters tall.

BARONESSE

In 1981, J. F. van den Berg & Sons registered 'Baronesse,' which is a pale pink flower—slightly on the magenta side—with soft pink edges on the petals. The white base has blue and yellow basal blotches. One of the latest-flowering Triumphs, 'Baronesse' is used for forcing and stands 55 centimeters tall. [PLATE 64]

BASTOGNE

'Bastogne,' registered by Koedijk & Sons in 1980, is blood-red with a lighter red on the edges of the petals. The base is yellow with bronze-green basal blotches. A tall Triumph frequently used in forcing, it is 60 centimeters in height.

BELCANTO

'Belcanto' was raised and registered by J. F. van den Berg & Sons in 1965 and is glowing red and feathered. The petals have yellow edges and the base is yellow. A slender plant with early forcing qualities, it is 50 centimeters in height. [PLATE 191]

BELINDA REUS

Vertuco raised and J. W. Reus registered 'Belinda Reus' in 1992. A tall, sturdy plant with a square form to its light yellow flower, it has primrose yellow margins on the petals. This is a relatively new variety and has yet to

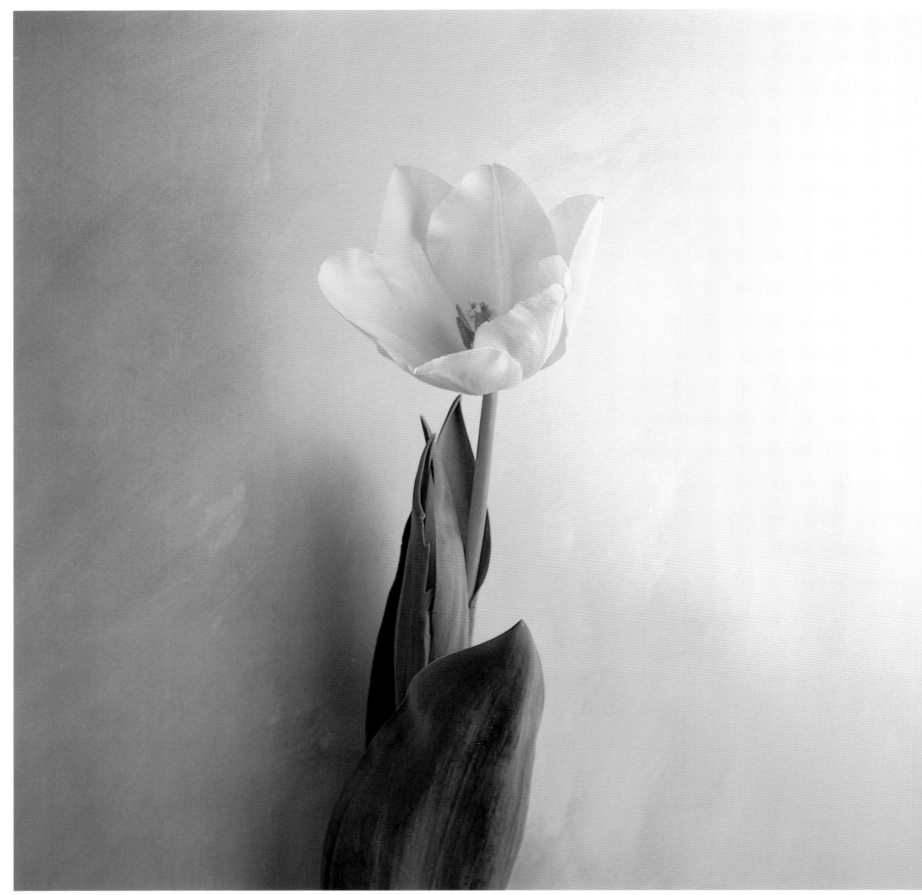

BELINDA REUS [PLATE 192]

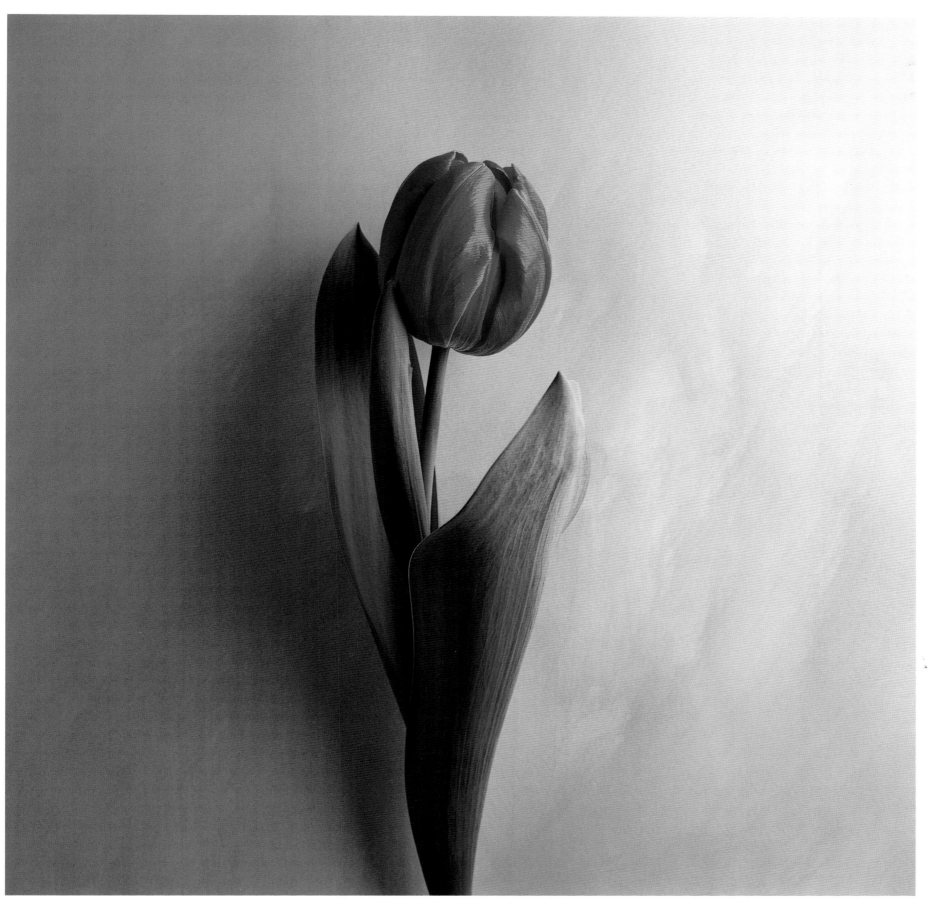

BLUE RIBBON [PLATE 193]

prove its durability. Used for forcing, it is 50 centimeters in height. [PLATE 192]

BELLONA
Registered by H. de Graaff & Sons in 1944, 'Bellona' has a round, balloonlike, pure golden yellow flower which is fragrant. It has a few sports, one of which is 'Striped Bellona.' Suitable for forcing, 'Bellona' is 50 centimeters tall.

BEN VAN ZANTEN
'Ben van Zanten,' a beautiful, solid cherry red flower, was registered by Van Zanten Brothers in 1967. Its base is brown-black, edged yellow. It is named for one of the directors of that firm, which for over one hundred years was one of the largest Dutch exporters of bulbs including alstromerias, chrysanthemums, and carnations. 'Ben van Zanten' is a good very early forcing variety and stands 50 centimeters tall. [PLATE 194]

BLENDA
In 1947, L. A. Hoek registered 'Blenda,' which has an egg-shaped dark rose flower and a large white base. A forcing variety, it also has a beautiful white sport, 'Inzell.' 'Blenda's height is 45 centimeters. [PLATE 65]

BLUE RIBBON
'Blue Ribbon' was raised by M. H. Immerzeel and registered by T. Langeveld in 1981 and is lilac-purple with an almost round form to its large flower. It is only 35 centimeters in height. [PLATE 193]

BRIGITTA
P. Nijssen registered 'Brigitta' in 1978. A golden-yellow flower with petals that are feathered dark red and edged canary yellow, 'Brigitta' is a very early forcing variety, available around Christmas. Its height is 50 centimeters. [PLATE 195]

CALGARY
Raised by Vertuco and registered by Veul Brothers in 1995, 'Calgary' is an ivory white flower with a large yellow flame on the outer petals. As the flower matures, the flame fades and the flower becomes ivory white. Its square, very sturdy flower is long-lasting and sits on a short stem. Its height is 20 centimeters. [PLATE 196]

CANDLELIGHT
'Candlelight,' which is cardinal red with broad primrose yellow edges on the petals, was registered by J. Jongejan & Sons in 1982. Its base is sulfur yellow. A sport of 'Lucky Strike,' it is suitable for forcing and is 55 centimeters tall.

CAPRI
'Capri,' raised by F. C. Bik and registered in 1974 by Jacobus Tol, is a short-stemmed, slender plant with a small cardinal red flower and lighter red edges on the petals. Used for forcing in the mid-season to late period, it is 40 centimeters tall. [PLATE 197]

CARAVELLE
Konijnenburg & Mark registered 'Caravelle' in 1981. It is a big, broad plant with a dark, glowing ruby red rounded flower that has darker edges and a black base. The splendid dark tones of 'Caravelle' make it a dramatic tulip. Frequently used for forcing, it has a height of 55 centimeters. [PLATE 198]

CAROLA
'Carola' was registered in 1986 by Vertuco and is a square, nicely formed rose-red flower with a chartreuse-green base. Good for forcing, it is 45 centimeters. [PLATE 199]

CASSINI
Registered in 1944 by Segers Brothers, 'Cassini' is a brownish-red flower. One of the few forcing tulips Segers Brothers raised, 'Cassini' was frequently used and mass-produced up until recently, but its stock is beginning to age and consequently the acreage is dropping dramatically. Fortunately, it has a brightly colored sport, 'Orange Cassini.' It is 45 centimeters in height.

CHARLES
C. P. Alkemade registered 'Charles' in 1954. A large scarlet flower with a yellow base, it is suitable for forcing and stands 40 centimeters tall.

CHARMEUR
'Charmeur,' registered in 1992 by J. A. Borst & Sons, is vermilion with large ivory white edges on the petals. It is a brightly colored flower with beautifully variegated leaves that have pale yellow rims. Suitable for forcing, it is 45 centimeters tall.

CHEERS
'Cheers,' raised by Robta and registered by J. J. Buis & Corggo in 1990, is a very strong, square primrose yellow flower with a sulfur yellow rim. The yellow color deepens toward the middle of the flower. Used for forcing, 'Cheers' is 40 centimeters in height. [PLATE 200]

CHIEFTAIN
Van Zanten Brothers registered 'Chieftain' in 1990. Its longish cardinal red flower is edged ivory white.

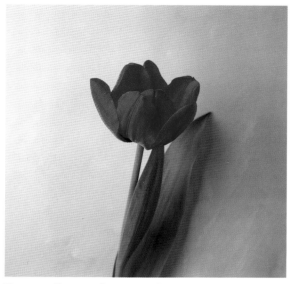

BEN VAN ZANTEN [PLATE 194]

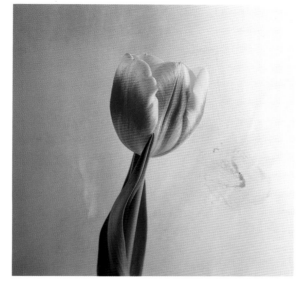

BRIGITTA [PLATE 195]

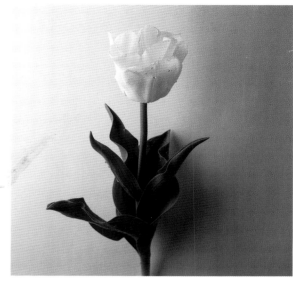

CALGARY [PLATE 196]

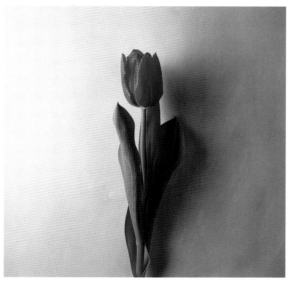

CAPRI [PLATE 197]

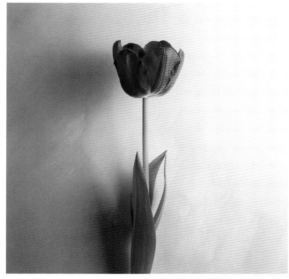

CARAVELLE [PLATE 198]

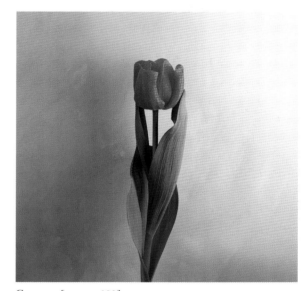

CAROLA [PLATE 199]

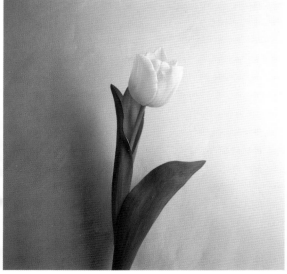

CHEERS [PLATE 200]

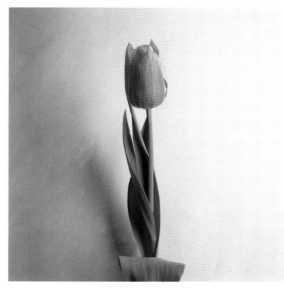

CONCOURS [PLATE 201]

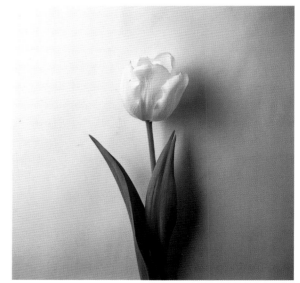

COQUETTE [PLATE 202]

'Chieftain,' a slender plant suitable for forcing, is 45 centimeters tall.

CONCOURS

In 1988, Van Zanten Brothers registered 'Concours,' which is one of the smallest Triumphs. A very slender plant with a pointed slender flower, 'Concours' is lilac-purple and the outer petals are edged dark pink, making an unusual color combination. Inside, the flower is lilac-purple and the base is primrose yellow. With its very pointed flower tips, 'Concours' almost looks like a Lily-flowered tulip in its form. Used for forcing, it is 40 centimeters tall. [PLATE 201]

COQUETTE

'Coquette' was registered by Konijnenburg & Mark in 1973 and has an egg-shaped creamy white flower with a canary yellow base. It is an early forcing variety, often used around the holidays, and is 45 centimeters tall. [PLATE 202]

COULEUR CARDINAL

An old tulip that is now classified as a Triumph, 'Couleur Cardinal' was first mentioned in 1845 and its raiser is unknown. Scarlet on the interior with a plum color on the exterior of the petals, this tulip was under-valued for many years, credited only for flowering after the Single Early and before the Single Late tulips. 'Couleur Cardinal' has persevered for over 150 years and is appreciated today for its historical importance as well as its pretty purple color. Frequently used for forcing, 'Couleur Cardinal' has three sports, 'Arma,' a Fringed tulip, 'Prinses Irene,' a Triumph, and 'Rococo,' a Parrot. Its height is 35 centimeters.

CREAM PERFECTION

'Cream Perfection,' registered in 1988 by J. Broersen, is a small primrose yellow flower with a sulfur yellow flame on the petals. A very slender plant that forces quickly, it is 45 centimeters tall. [PLATE 203]

DEBUTANTE

Raised by IVT and registered by H. Roozen in 1984, 'Debutante' is cherry red with a narrow white edge on the petals and a yellow-and-white base. A cross between the Triumph 'Preludium' and another Triumph 'Lustige Witwe,' 'Debutante' is a slender plant with a strong stem much used for forcing throughout the season. Its height is 50 centimeters.

DOLLY DOTS

In 1981, Reus Brothers registered 'Dolly Dots,' a rose-red sport of 'Mirjoran' with a big broad yellow edge on the petals. The base is buttercup yellow with a narrow purple edge. Named for the band Dolly Dots, a Dutch version of the Spice Girls that was very popular in Holland in the late 1980s, it is 45 centimeters tall and suitable for forcing.

DON QUICHOTTE

'Don Quichotte' is an older variety, registered by Konijnenburg & Mark in 1952. Its egg-shaped flower is a brightly colored Tyrian rose. 'Don Quichotte' has a long vase life, making it a popular cut flower. Used for forcing, its height is 50 centimeters. [PLATE 205]

DREAMING MAID

Registered by J. J. Kerbert in 1934, 'Dreaming Maid' is a violet flower with a broad and clearly visible white edge on

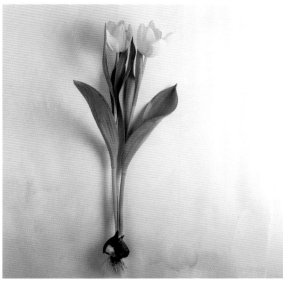

CREAM PERFECTION [PLATE 203]

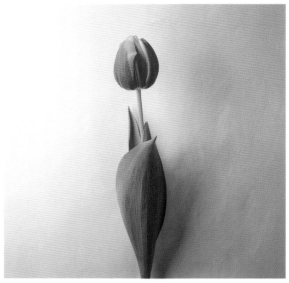

ETUDE [PLATE 204]

the petals and a whitish base. One of the most frequently used tulips for forcing, 'Dreaming Maid' has become somewhat of a classic in the cut-flower market. Its height is 55 centimeters. [PLATE 63]

EARLY GLORY
H. G. Huyg, raisers of many early forcing varieties, registered 'Early Glory' in 1981. A dark pink flower that appears earlier than most Triumphs, 'Early Glory' has an ivory white base with a yellow center. It is 45 centimeters tall and used for forcing. [PLATE 206]

ETUDE
Registered by Van den Berg & Sons in 1977, 'Etude,' a round, bright red flower with a broad yellow rim and a yellow base, is a good late forcing variety. A tulip with excellent form, its height is 40 centimeters. [PLATE 204]

FIRE QUEEN
Registered by A. L. van Bentgem & Sons in 1981, 'Fire Queen' is a sport of 'Prinses Irene.' Its unusual reddish-lanceolate petals are similar to those of a Parrot tulip but without the fringe or curl. The base is lemon yellow and the leaves are variegated. 'Fire Queen' is used for forcing and it is 35 centimeters in height.

FIRST LADY
'First Lady' was registered in 1951 by Hybrida. Reddish-violet, flushed purple on the petals, it has a big flower. Though it can be forced, the plant has many leaves, making 'First Lady' less desirable for this purpose. Its height is 55 centimeters. [PLATE 207]

FORTISSIMO
Raised by P. Voorn and registered by M. Boots in 1991, 'Fortissimo' is aureolin, flamed buttercup yellow; inside, the color is also buttercup. Often used as a forcing variety for early flowers, it stands 45 centimeters tall. [PLATE 208]

FRANÇOISE
'Françoise' was raised by IVT and registered by G. W. van Went & Sons in 1981. This big creamy white flower with a sulfur yellow flame is a cross between 'Mrs. John T. Scheepers,' a yellow Single Late tulip, and 'Tender Beauty,' a rosy-red Darwinhybrid. 'Françoise' has a long flower form and is taller than most Triumphs, with a height of 60 centimeters. [PLATE 48]

FRISO
'Friso,' registered by Van Zanten Brothers in 1988, is a deep bloodred. The large base is primrose yellow with a bluish-green blotch. Used for forcing, it is 45 centimeters in height. [PLATE 209]

GANDER
In 1952, Segers Brothers registered 'Gander,' which is a bright magenta flower and an early forcing variety. It has several sports, including 'Gander's Ouverture' and 'Gander's Rhapsody.' Its height is 60 centimeters.

GANDER'S OUVERTURE
Registered in 1986 by J. Molenaar, 'Gander's Ouverture' is creamy white with an ivory white edge; it is used for forcing and is 60 centimeters tall.

GANDER'S RHAPSODY
Jacobus Tol registered 'Gander's Rhapsody' in 1970. It is spotted red, with the red intensifying as the flower matures. The base is yellow with a small purple edge. It is used for forcing, and its height is 60 centimeters. [PLATE 210]

GARDEN PARTY
Registered in 1944 by P. Hopman & Sons, 'Garden Party' is white, edged glowing carmine on the petals, with a white base. It is 40 centimeters tall. [PLATE 211]

GAVOTA
'Gavota,' raised by Vaclavik and registered by Cebeco in 1995, is maroon with a yellow rim extending over one half of the petals and has a yellow base. It is a pointed flower whose yellow margin fades away to a whitish color as the flower matures. 'Gavota' was bred in Czechoslovakia and brought to Holland after the Soviet Union opened up in the late 1980s. Used for forcing, it is 45 centimeters in height. [PLATE 59]

GOLDEN FICTION
Registered by J. H. Clement in 1980, 'Golden Fiction' is deep red, and the petals are edged with pale yellow. The slightly star-shaped base is primrose yellow. A midsized flower and sport of 'Lucky Strike,' 'Golden Fiction' has a broader yellow rim than its mother plant. A forcing tulip, it is 55 centimeters tall. [PLATE 212]

GOLDEN MELODY
P. Hermans registered 'Golden Melody' in 1961. A slender buttercup yellow flower that is used for forcing, its height is 55 centimeters.

GOLDEN MIRJORAN
'Golden Mirjoran,' found and registered by Jacobus Tol in

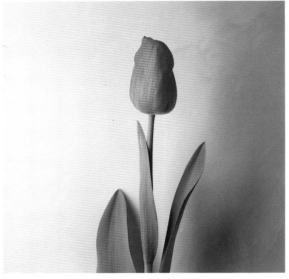

Don Quichotte [plate 205]

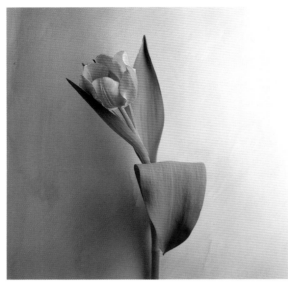

Early Glory [plate 206]

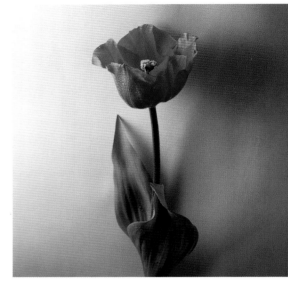

First Lady [plate 207]

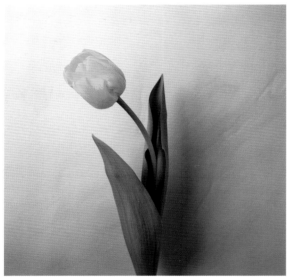

Fortissimo [plate 208]

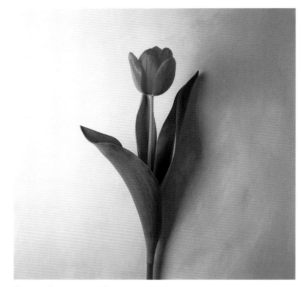

Friso [plate 209]

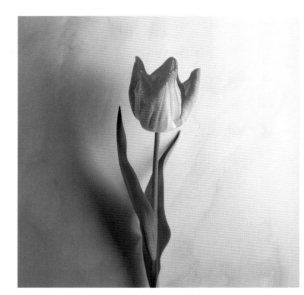

Gander's Rhapsody [plate 210]

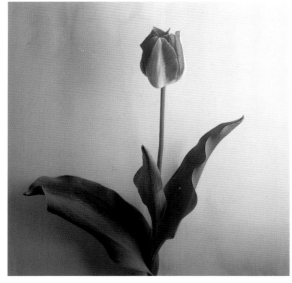

Garden Party [plate 211]

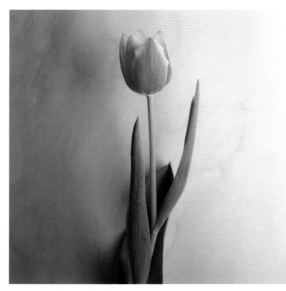

Golden Fiction [plate 212]

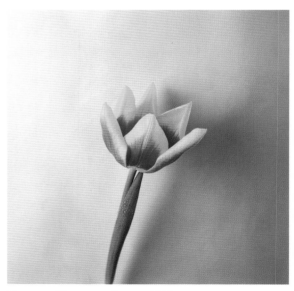

Golden Mirjoran [plate 213]

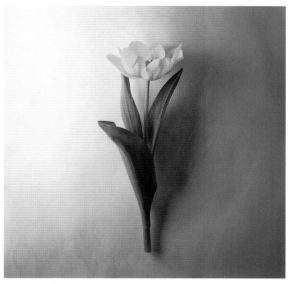

GOLDEN PRESENT [PLATE 214]

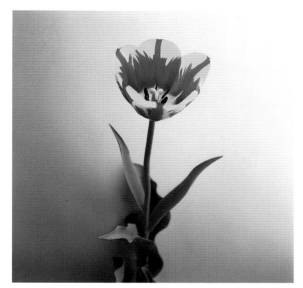

HELMAR [PLATE 215]

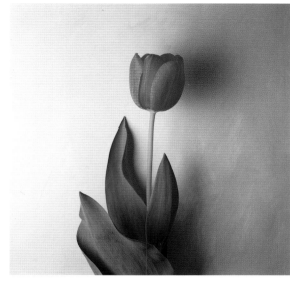

HOLLANDIA [PLATE 216]

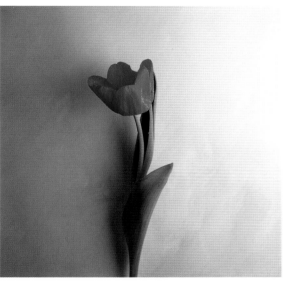

ILE DE FRANCE [PLATE 217]

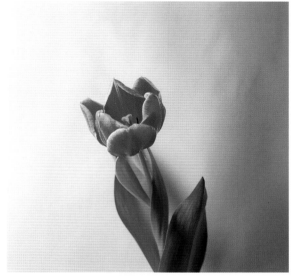

INVASION [PLATE 218]

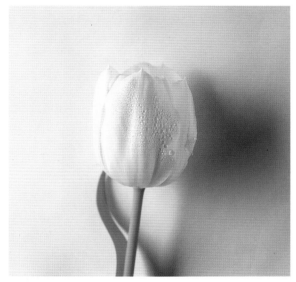

INZELL [PLATE 219]

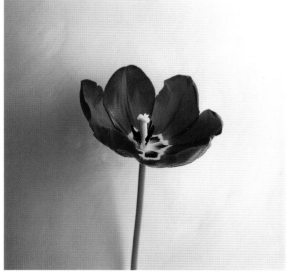

JAN REUS [PLATE 220]

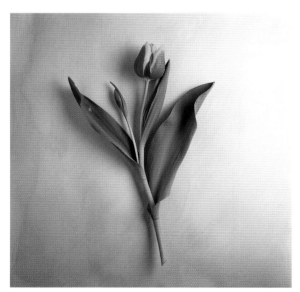

KEES NELIS [PLATE 221]

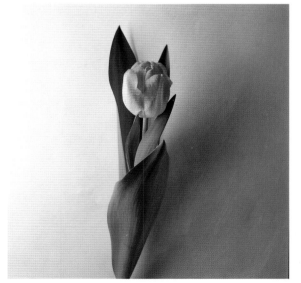

LABYRINTH [PLATE 222]

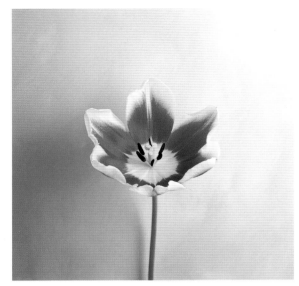

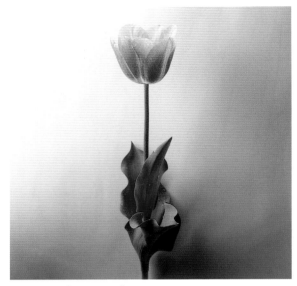

LEEN VAN DER MARK [PLATE 223]　　　LIBRETTO [PLATE 224]

1964, is carmine-red and the petals have broad creamy white edges. This sport of 'Mirjoran' has a slender flower and is a good forcing variety. Its height is 45 centimeters. [PLATE 213]

GOLDEN PRESENT
Registered by J. A. Borst in 1989, 'Golden Present' is mimosa yellow, edged canary yellow on the petals. A sport of 'Yellow Present,' it shares the pointed petal form of its mother plant. Its height is 35 centimeters. [PLATE 214]

HANNA GLAWARI
A sport of 'Lustige Witwe,' 'Hanna Glawari' was registered by Mrs. J. Zwaan-Bakker in 1972. This cherry red flower with a white base is 40 centimeters in height. It has one sport, 'Burning Desire,' and is used for forcing.

HAPPY FAMILY
H. G. M. Huyg registered 'Happy Family' in 1985. 'Happy Family,' which is rosy-purple with a narrow pinkish-white edge, represents a successful attempt to produce a multi-flowered plant (with two to three flowers) that is early flowering. The base is creamy yellow. Suitable for forcing, it is 50 centimeters in height. [PLATE 67]

HAPPY GENERATION
Registered by de Vries & Sons in 1988, 'Happy Generation,' a sport of the Adorno sport 'Ida,' is a splashy tulip: ivory white, flamed red on the petals with a light golden yellow base. The leaves have white margins. It is 50 centimeters tall. [PLATE 51]

HELMAR
Raised by D. & A. Noort Brothers and registered by P. Kortekaas in 1986, 'Helmar' is a sport of 'Yellow Mask.' The exterior is flamed ruby red on a primrose yellow ground and inside the color is even more vibrant and brilliant. The base is lemon yellow. Its height is 55 centimeters. [PLATE 215]

HERMITAGE
In 1986, J. de Wit & Sons registered 'Hermitage,' a sport of 'Prinses Irene' that is a deeper color than its mother plant. The petals are red with mandarin red edges, flamed pale orange. The base is canary yellow and fades into the red. Used for forcing, it is 35 centimeters in height.

HIBERNIA
'Hibernia,' registered by Jacobus Tol Jr. in 1946, has a big sturdy white flower on a broad-leaved plant. 'Hibernia' is 45 centimeters tall.

HIGH SOCIETY
Jacobus Tol registered 'High Society' in 1958. It is orange-red, edged orange, and stands 45 centimeters tall.

HOLLANDIA
In 1988, Van Zanten Brothers registered 'Hollandia,' a bloodred flower with a cardinal red flame on the petals and a yellow-green base. It is used for forcing, and its height is 40 centimeters. [PLATE 216]

ILE DE FRANCE
Registered by Blom & Padding in 1968, 'Ile de France' is cardinal red on the exterior of the petals and bloodred on the interior. The base is dark bronze-green with a narrow yellowish edge. Used for forcing, it is 50 centimeters tall. [PLATE 217]

INVASION

'Invasion,' registered by Hybrida in 1944, has an orange-red flower with petals that are edged cream. 'Invasion' is a short plant, only 40 centimeters tall, and is suitable for forcing. [PLATE 218]

INZELL

N. Koster & Sons registered 'Inzell' in 1969. An ivory white sport of 'Blenda,' it is one of the prettiest white Triumphs with a large and well-formed flower. Suitable for forcing, it is 45 centimeters in height. [PLATE 219]

JAN REUS

'Jan Reus,' raised by Hybris and registered by Reus Brothers in 1986, is a slender plant with a rounded dark crimson flower. It was named for Jan Reus, a pioneer bulb grower in the clay area in the north of Holland, and also director of local auctions in the Netherlands. A good forcing variety valued for its unusual color, 'Jan Reus' is used frequently in mixed bouquets. Its height is 50 centimeters. [PLATE 220]

JIMMY

In 1962, J. van Hoorn & Co. registered 'Jimmy,' a carmine-rose flower with orange edges and a lemon yellow base. Suitable for forcing, it stands 35 centimeters tall.

JUDITH LEYSTER

'Judith Leyster,' raised by IVT and registered by G. H. van Went & Sons in 1980, is a cross between 'Mrs. John T. Scheepers,' a yellow Single Late tulip, and 'Tender Beauty,' a rosy-red Darwinhybrid. Named for the seventeenth-century Dutch painter, 'Judith Leyster' is a longish flower with a red rim, which spreads over the whole of the flower as it matures. The ground color is creamy white. A long-lasting flower and a very good multiplier, 'Judith Leyster' is tall at 55 centimeters.

KAISERIN MARIA THERESIA

Raised by D. van Buggenum and registered by P. Hopman & Sons in 1982, 'Kaiserin Maria Theresia' is a dark pink flower with a yellowish white base. When forced, it is a lighter pink color. The height of this sport of 'Gander' is 60 centimeters.

KEES NELIS

Registered by 't Mannetje in 1951, 'Kees Nelis' is blood-red, edged orange-yellow on the petals with a yellow base. Named for a Dutch bulb exporter, 'Kees Nelis' opens very quickly to reveal a red interior as vibrant as the exterior. Popular for forcing, as a cut flower this tulip has been enjoyed by millions. 'Kees Nelis' has recently produced a sport, 'Bright Parrot,' which will be registered soon. 'Kees Nelis' is 45 centimeters in height. [PLATE 221]

LABYRINTH

J. F. van den Berg & Sons registered 'Labyrinth' in 1990. A primrose yellow flower flamed with red and ivory white on the petals, giving it pinkish-rose tones overall, it is square in form. Often used for forcing, it is 35 centimeters tall. [PLATE 222]

LEEN VAN DER MARK

'Leen van der Mark,' registered by Konijnenburg & Mark in 1968, is cardinal red, and the petals are edged with white. Initially the white rim is yellowish, becoming whiter as the plant matures. The base is ivory white, spotted pale yellow. One of Konijnenburg & Mark's best Triumphs, 'Leen van der Mark,' is a great forcing tulip that can be

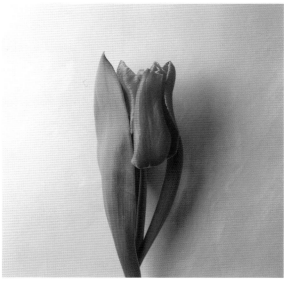

LILO PINK [PLATE 225]

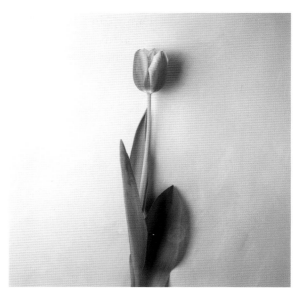

LUCKY STRIKE [PLATE 226]

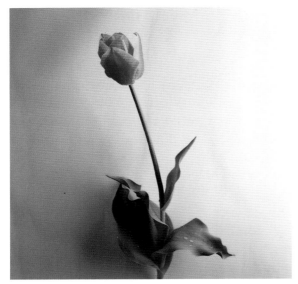

MADAME DE LA MAR [PLATE 227]

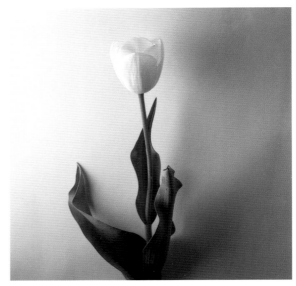

MAGIC MOUNTAIN [PLATE 228]

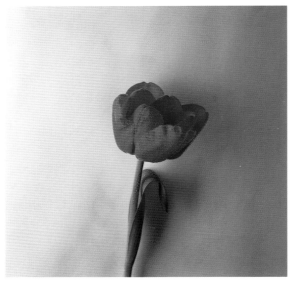

MARTINE BIJL [PLATE 229]

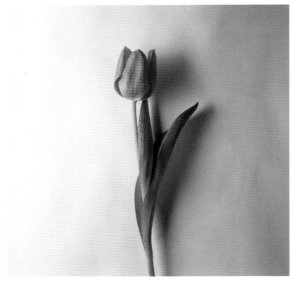

MARY HOUSLEY [PLATE 230]

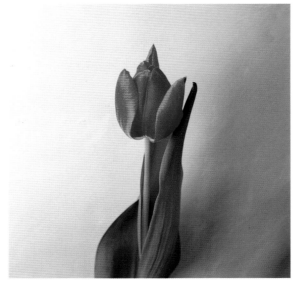

MISS HOLLAND [PLATE 231]

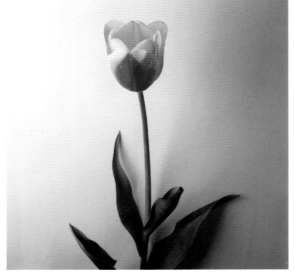

MONTE ROSA [PLATE 232]

used throughout the forcing season. Its height is 45 centimeters. [PLATE 223]

LEO VISSER

Raised by P. J. Nijssen and registered by M. Boots in 1992, 'Leo Visser' is a slender plant with a pointed flower that is soft red with a white rim on the petals. The base is ivory white with a central chartreuse-green blotch. Used for forcing, 'Leo Visser' is new and still under trial for large usage. Its height is 50 centimeters.

LIBRETTO

'Libretto,' registered by Van Kooten in 1964, has a white ground, cardinal red flame and spots on the petals, and a primrose yellow base. A sport of 'Prominence,' it is used for forcing and is 40 centimeters tall. [PLATE 224]

LILO PINK

Raised by IVT and registered by J. A. Borst & Sons in 1992, 'Lilo Pink' has a very large reddish-pink flower with a light yellow base. A broad-leaved plant whose parents are 'Danseuse,' a purple Triumph no longer in cultivation, and the Lily-flowered tulip 'White Triumphator'—both slender plants—'Lilo Pink' is unlike either. Its height is 40 centimeters. [PLATE 225]

LOS ANGELES

J. F. van den Berg & Sons registered 'Los Angeles' in 1965. A slender plant with a red flower, edged yellow, and a yellow base, 'Los Angeles' is a good forcing tulip. It is one of the many good Triumphs of this color raised by van den Berg. Its height is 45 centimeters.

LUCKY STRIKE

'Lucky Strike' is an older variety, registered by P. & J. W. Mantel in 1954. Deep red, with pale yellow edges on the petals, it is suitable for forcing and has two sports: 'Candlelight' and 'Golden Fiction.' 'Lucky Strike' is 55 centimeters tall. [PLATE 226]

LUSTIGE WITWE
Merry Widow

In 1942, van der Meys Sons registered 'Lustige Witwe,' which is deep red with a pure white edge extending over about one half of the flower. The base is white, too. One of the oldest Triumphs, 'Lustige Witwe' continues to be one of the top ten tulips grown in Holland. It has many sports, including two Parrot sports, 'Destiny' and 'Frederica,' and many Triumph sports, including 'Hanna Glawari,' 'Success,' and 'Zarewitch.' Suitable for forcing, 'Lustige Witwe' is 40 centimeters tall. [PLATE 56]

MADAME DE LA MAR

P. J. Nijssen registered 'Madame de la Mar' in 1975. This rosy-red flower with a phlox pink edge on the petals was named in honor of the wife of a former secretary of the KAVB who served the growers' association for many years. 'Madame de la Mar' flowers late in the season and is 40 centimeters tall. [PLATE 227]

MADURODAM

'Madurodam,' registered in 1983 by J. F. van den Berg & Sons, is deep yellow with a lemon yellow base. Used for forcing, it is 35 centimeters tall.

MAGIC MOUNTAIN

De Geus-Vriend registered 'Magic Mountain' in 1993. This new, very good ivory white tulip has a canary yellow base and is 45 centimeters in height. [PLATE 228]

MAKASSAR

Registered by De Mol & Nieuwenhuis in 1942, 'Makassar' has a deep yellow flower. This sturdy plant is used for forcing. An older variety but still going strong, it is 45 centimeters in height.

MAKE-UP

Jacobus Tol registered 'Make-Up' in 1969; it was raised by F. C. Bik. It is creamy white with a spotted red margin on the top of the petals that spreads over the flower as it matures. The base is blue. A beautiful tulip, 'Make-Up' is 55 centimeters tall.

MARGOT FONTAINE

'Margot Fontaine,' raised by 't Mannetje and registered in 1962 by Leo Bisschops, has a large cardinal red flower, edged light yellow, and broad leaves. 'Margot Fontaine' is 40 centimeters tall.

MARTINE BIJL

P. J. Nijssen registered 'Martine Bijl' in 1975. Glowing bloodred with a lemon yellow base, it was named for a Dutch entertainer and comedienne. 'Martine Bijl,' a very beautiful red color, is good for forcing. Its height is 50 centimeters. [PLATE 229]

MARY HOUSLEY

'Mary Housley,' a stately apricot orange tulip with good form and an unusual color, was registered in 1955 by Zandvoort, an independent raiser from Noordwijk known for his seedlings. In the 1950s, pretty orange Triumphs were difficult to find; 'Mary Housley' was one of the rare ones and continues to be one of the

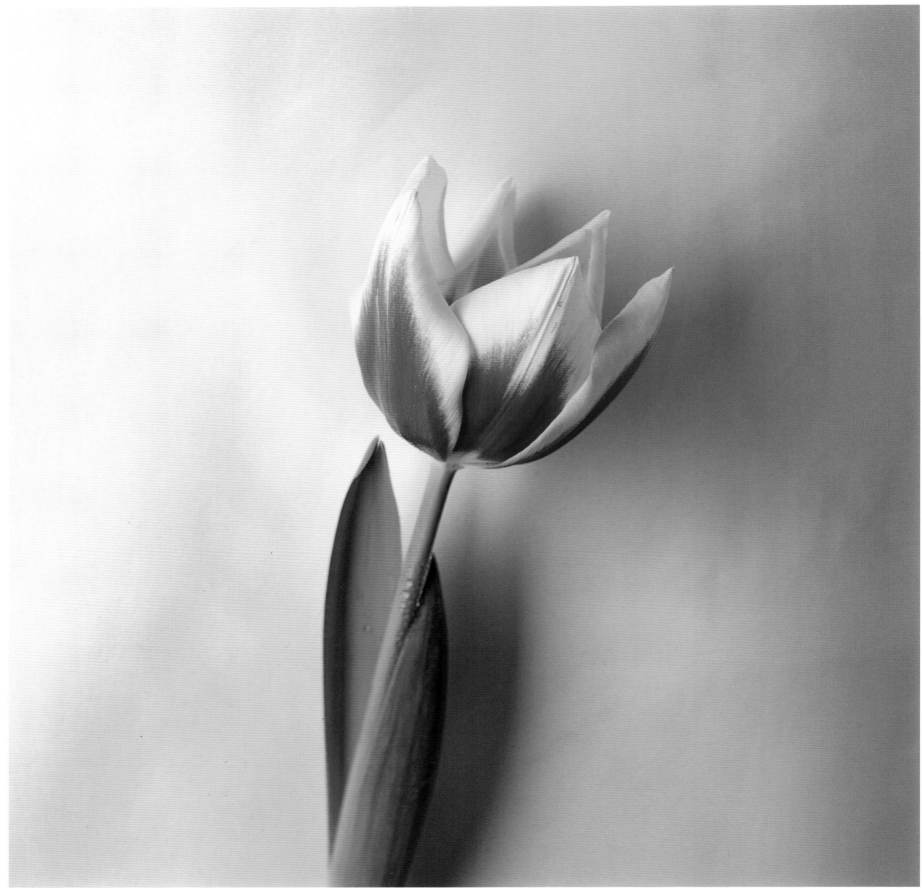

MIRJORAN [PLATE 233]

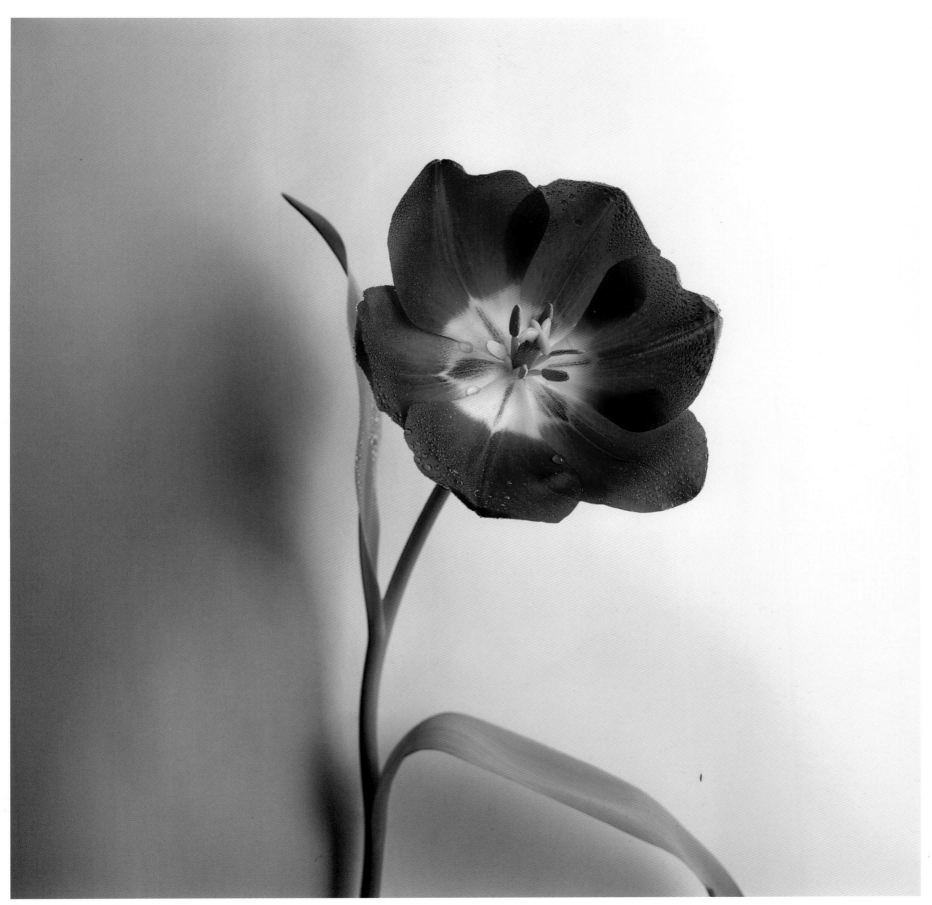

NEGRITA [PLATE 234]

best. Used for forcing, it has a height of 45 centimeters. [PLATE 230]

MEISSNER PORZELLAN

Registered by Konijnenburg & Mark in 1952, 'Meissner Porzellan' is a white flower with a prominent rose rim. A sturdy tulip that is often used for forcing, 'Meissner Porzellan' is 55 centimeters tall.

MERAPI

Blom & Padding registered 'Merapi' in 1981. Bloodred, with a darker bloodred flame on the petals and a light yellow base, this is a nice plant. Used for forcing, it is 45 centimeters in height.

MINERVA

In 1969, J. F. van den Berg & Sons registered 'Minerva,' which is carmine-red with a small white rim and a soft yellow base. An unusual color, it is good for forcing. 'Minerva' is 45 centimeters tall.

MIRJORAN

'Mirjoran,' registered by Hybrida in 1944, is carmine-red with a broad, creamy white edge on the petals. A forcing tulip, it has two sports: 'Dolly Dots' and 'Golden Mirjoran.' 'Mirjoran' stands 45 centimeters tall. [PLATE 233]

MISS HOLLAND

F. C. Bik raised and Jacobus Tol registered 'Miss Holland' in 1973. The large, broad flower is glowing bloodred with a cardinal red flame on the petals and a yellow base. The flower tapers to a point. Because the plant is leafier than most, it requires a bit more space in the garden. Suitable for forcing, 'Miss Holland' is tall at 55 centimeters. [PLATE 231]

MONTE ROSA

Registered by P. C. de Geus in 1984, 'Monte Rosa' is flamed carmine-rose on its outer petals and rosy white on its inner petal, with a primrose yellow base. Used for forcing, it is tall at 60 centimeters. [PLATE 232]

MONTEVIDEO

J. F. van den Berg registered 'Montevideo' in 1951. Soft yellow, flamed orange and rose on the exterior of the petals, inside, the colors are lighter and even softer. 'Montevideo' opens quickly and develops its color as it matures. Suitable for forcing, 'Montevideo' is 35 centimeters. [PLATE 60]

NEGRITA

F. C. Bik raised and Jacobus Tol registered 'Negrita,' which has a dark purple uniform color. Used mostly for early forcing, 'Negrita' is 45 centimeters in height. [PLATE 234]

NEW DESIGN

'New Design' is pale pink with a white lower half that grows pinker as the flower develops. It has variegated leaves with pinkish-white margins that become whiter as the plant matures. It was registered in 1974 by Jacobus Tol. (Tol, a bulb grower from Sint Pancras who was one of the most knowledgeable forcers in the industry, developed many sports and later hybridized new varieties with F. C. Bik. Together they formed a firm called Bito.) Suitable for forcing, 'New Design' is 50 centimeters tall. [PLATE 55]

OHARA

From Vertuco-Van Lierop and not yet KAVB-registered, 'Ohara' is light yellow on both the interior and exterior of

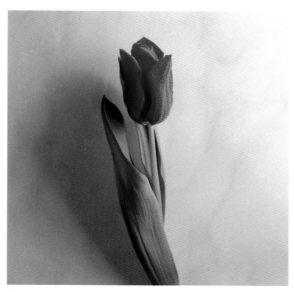

OSCAR [PLATE 235]

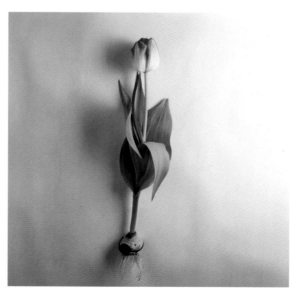

PAGE POLKA [PLATE 236]

the petals. A sturdy plant that can be used for forcing, its height is 20 centimeters.

ORANGE BOUQUET

'Orange Bouquet,' registered by Konijnenburg & Mark in 1964, is a bright red multiheaded tulip with a yellow base. It is rumored to have *T. praestans* as one of its parents but that has never been confirmed and the chromosomal make-up of 'Orange Bouquet' makes it improbable. A very nice, sturdy plant, 'Orange Bouquet' is 50 centimeters tall. [PLATE 58]

ORANGE CASSINI

Registered by J. van den Berg & Sons in 1981, 'Orange Cassini' is red, and the petals are flamed delft rose on the exterior. The lemon yellow base is edged bronze-green. Used for forcing, it stands at 45 centimeters.

ORANGE MONARCH

Raised by G. Lamboo and registered by Eggink Brothers in 1962, 'Orange Monarch' is a square-shaped orange flower with a lighter orange edge and an orange-yellow base. Frequently used for forcing, 'Orange Monarch' is also a sturdy garden tulip. It is 45 centimeters tall.

ORLEANS

'Orleans,' raised by IVT and registered by G. H. van Went & Sons in 1981, has a large ivory flower with a small yellow flame on its petals. As it matures the yellow flame fades and the petals become pure white. A cross between the yellow Single Late tulip 'Mrs. John T. Scheepers' and the rosy-red Darwinhybrid 'Tender Beauty,' 'Orleans' has the typical elongated flower shape of 'Mrs. John T. Scheepers.' Its height is 60 centimeters.

OSCAR

'Oscar,' raised by F. C. Bik and registered by Jacobus Tol in 1975, is dull cardinal red on the exterior of the petals and glowing bloodred on the inside. It has a yellow base and its height is 40 centimeters. [PLATE 235]

PAGE POLKA

In 1969, Konijnenburg & Mark registered 'Page Polka,' which has a small pink flower with a broad white edge on the petals and a white base. 'Page Polka' is a slender plant, suitable for forcing. It is 40 centimeters tall. [PLATE 236]

PALESTRINA

Registered in 1944 by Captein Brothers, 'Palestrina' is green and salmon pink on the exterior of the petals; the interior is bright salmon pink. A cross between the light red Single Late 'Mayflower' (a former Cottage tulip) and the orange Single Early 'Generaal de Wet,' the plant is aging, but its unusual color keeps it in demand. It is 40 centimeters in height.

PASSIONALE

'Passionale,' registered by L. J. C. Schoorl in 1983, with its lilac-purple coloring on the exterior of the petals and beet-root purple interior, is one of the best of a range of purples Schoorl has produced. The flower is square-shaped and has a height of 40 centimeters. [PLATE 237]

PEER GYNT

In 1973, Konijnenburg & Mark registered 'Peer Gynt,' an elegant and soft pink-rose flower that is slightly darker at the bottom than it is toward the top. The base is white with yellow spots. A great winner at flower shows and often used for forcing, 'Peer Gynt,' at 50 centimeters, has excellent form. [PLATE 49]

PEERLESS PINK

'Peerless Pink,' registered in 1930 by H. Carlee, is an old cultivar with a large soft satin pink flower. This broad-leaved plant often used for late forcing is still going strong. Its height is 45 centimeters.

PRIMAVERA

Konijnenburg & Mark registered 'Primavera' in 1969. The flower is rosy-red with a green-yellow base. A sturdy plant used for forcing, it has one sport, 'Primavista,' and is 60 centimeters in height.

PRIMAVISTA

Shining cardinal red, 'Primavista' was registered by P. Swier & Sons in 1994 and is a better, more desirable color than its mother plant, 'Primavera.' Indeed, 'Primavista' will replace 'Primavera' in the future. Its base is yellow with a little green. Used for forcing, it is 60 centimeters tall.

PRINCESS VICTORIA

J. F. van den Berg & Sons registered 'Princess Victoria' in 1979. The flower is carmine-red with a broad white edge on the exterior of the petals; inside, the white becomes feathered and blends beautifully into the red. The base is yellowish-white. Occasionally, a large bulb will produce a plant with two flowers. 'Princess Victoria,' a large plant with a good stature and strong leaves, 50 centimeters tall, is frequently a show tulip, and is used for late forcing. [PLATE 54]

PRINSES IRENE

'Prinses Irene,' registered by Van Reisen & Sons in 1949, is an orange flower with a purple flame. Beautiful, with a unique warm color, 'Prinses Irene' has many sports, including 'Fire Queen,' 'Hermitage,' 'Orange Princess,' and 'Prinses Margriet.' A large bulb will produce a plant with two flowers. Used for forcing, it stands 35 centimeters tall. [PLATE 61]

PROFESSOR PENN

'Professor Penn' was registered by Hybris in 1991. This cardinal red Triumph with bright, broad white margins on the petals was named for a popular Dutch economics professor and television commentator. 'Professor Penn,' a relatively new Triumph, is 40 centimeters in height. [PLATE 238]

PROMINENCE

Registered by P. van Kooten in 1943, 'Prominence' is one of several seedlings produced by crossing 'William Pitt,' an old red Darwin much used in hybridization, and 'Couleur Cardinal,' a red Triumph. Not surprisingly, 'Prominence' is red, too, with a black base edged white. At first, the tulip was not considered promising because the red was too dark. Growers soon began to see it as a "workhorse": It was indefatigable and could be forced throughout the whole season. 'Prominence,' with its beautiful egg-shaped flower, has proven to be a valuable Triumph, and at one time its growing acreage in Holland was 450 hectares. Today it is grown on 181 hectares, still a considerable area. Greatly used for forcing, 'Prominence' is 40 centimeters tall. Other excellent red Triumphs such as 'Arie Hoek' and 'Bastogne' will replace 'Prominence' as it dies out.

'Prominence' has several sports, including 'Red Nova,' a Double Late tulip, the Parrots 'Libretto Parrot' and 'Topparrot,' and 'Libretto,' 'Romance,' 'Wibo,' 'Winterberg,' 'Yellow Star,' and 'Zamire,' all Triumphs. [PLATE 53]

PURPLE FLAG

L. J. C. Schoorl registered 'Purple Flag' in 1983. 'Purple Flag' is a square, oversized Tyrian purple flower, which is beetroot purple inside, with a canary yellow base. Used for forcing, it is 45 centimeters tall.

PURPLE PRINCE

In 1987, L. J. C. Schoorl registered 'Purple Prince,' a rounded mallow purple flower with a dullish lilac flame on its petals. Inside, the color is beetroot purple and the star-shaped base is yellow. A good forcer, its height is 35 centimeters.

PURPLE WORLD

IVT raised and, in 1992, World Flower registered 'Purple World,' which has a large, broad magnolia purple flower with a lighter edge and an ivory white base. 'Purple World,' a cross between the red Single Early tulip 'Christmas Marvel' and an unknown species tulip, is a strong plant, 40 centimeters tall, good for forcing.

RED PRESENT

Hybrida registered 'Red Present' in 1953. A deep cardinal red flower on a short stem, it is a sport of 'Yellow Present.' 'Red Present' has slightly pointed petal tips like the mother plant. 'Red Present' is a very sturdy tulip, 35 centimeters tall. [PLATE 239]

RIVIERA

'Riviera,' registered in 1986 by J. & P. Snoek, has a square form to the flower, which is reddish-orange. Inside the color is bloodred with a yellow base. Used occasionally for forcing, it is 55 centimeters in height.

ROMANCE

Registered by Koning Brothers in 1978, 'Romance,' a sport of 'Prominence,' is ivory white on the exterior with a yellow flame and light rose-colored spots. When forced, however, 'Romance' is completely white; the warmth after the cooling period causes the color to lighten. It is 40 centimeters in height and used for forcing.

ROSALIE

'Rosalie' was registered by G. Groot-Vriend in 1986 and is soft phlox pink on a lighter rose ground with a yellow base. A slender plant, 55 centimeters tall, 'Rosalie' is mostly used for forcing and is particularly nice in gardens.

ROSARIO

Registered by P. Nijssen & Sons in 1957, 'Rosario' is a carmine-rose flower with a large white base visible from the outside. The most beautiful pink-and-white tulip, 'Rosario,' 50 centimeters in height, is a tall, stately, exceptional show flower that has always performed well. While acreage devoted to growing 'Rosario' is beginning to decline, it will probably last at least another ten years. 'Rosario' is used for forcing. [PLATE 240]

ROSY WINGS

'Rosy Wings,' registered in 1944 by C. G. van Tubergen, has a small, pure pink flower with long petals and a white base. A good multiplier that works well in gardens, 'Rosy Wings' is showing signs of aging and may not be around much longer. Its height is 60 centimeters.

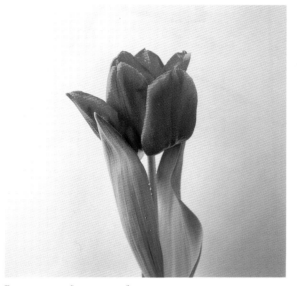

PASSIONALE [PLATE 237]

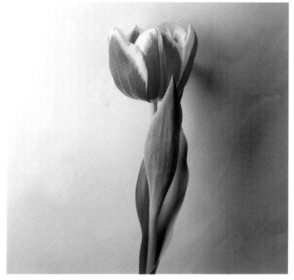

PROFESSOR PENN [PLATE 238]

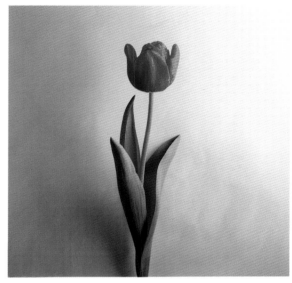

RED PRESENT [PLATE 239]

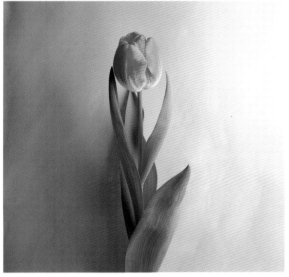

ROSARIO [PLATE 240]

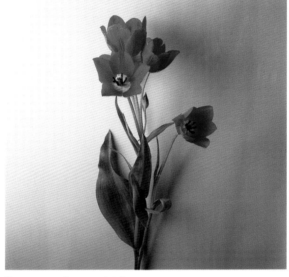

ROULETTE [PLATE 241]

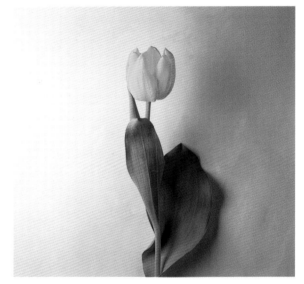

SALLY [PLATE 242]

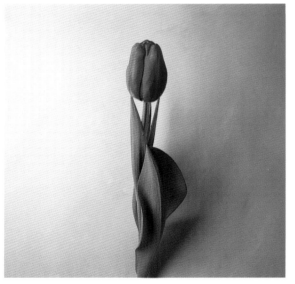

SAMSON [PLATE 243]

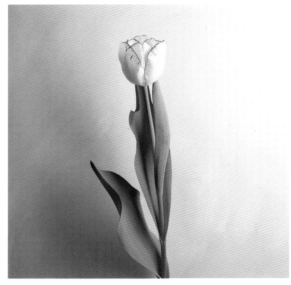

SHIRLEY [PLATE 244]

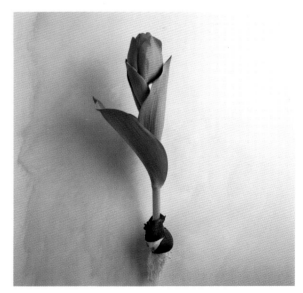

SPRYING [PLATE 245]

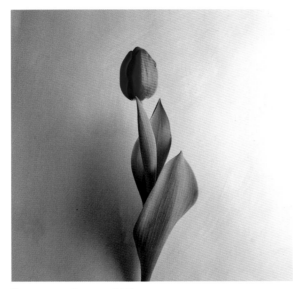

SUPERSTAR [PLATE 246]

ROULETTE

In 1988, Van Zanten Brothers registered 'Roulette,' an early-flowering Triumph that is bloodred and multi-flowered with a primrose yellow base. Its height is 45 centimeters. [PLATE 241]

SALLY

Registered by N. P. & M. J. Boon in 1991, 'Sally' is all canary yellow and is used for forcing. It is 45 centimeters tall. [PLATE 242]

SAMSON

'Samson' was raised by P. J. Nijssen & Sons and registered by J. A. Borst in 1982 and has one of the largest flowers, carmine-red, edged bloodred. The base is black, edged yellow. A very strong plant with an impressive oval-shaped show flower, 'Samson' is used for forcing. It is 55 centimeters in height. [PLATE 243]

SCALA

J. F. van den Berg & Sons registered 'Scala' in 1964. The color of the flower is a mixture of pink, orange, and red; the base is a pale yellow. A good forcing variety, 'Scala' is 55 centimeters tall.

SEVILLA

In 1991, Hybris registered 'Sevilla,' a bowl-shaped China rose flower that becomes redder as the flower opens. The base is greenish-white. One of the most promising red tulips for forcing, 'Sevilla' is still relatively new. It is 55 centimeters in height. [PLATE 50]

SHIRLEY

Raised by F. C. Bik and registered by Jacobus Tol in 1968,

'Shirley' is ivory white with a small purple edge on the petals. The white base is spotted pale purple. It is a good forcing variety, and is 50 centimeters in height. [PLATE 244]

SILENTIA

'Silentia,' raised in 1977 by Jacobus Tol and registered by Th. van der Gulik, is ivory white with a light yellow base. A strong plant, 50 centimeters tall, with a very attractive flower, 'Silentia' is used for forcing.

SILVER DOLLAR

Raised by IVT and registered by H. Van Dam, 'Silver Dollar' is flamed light yellow on an ivory white ground. As the flower matures, it becomes a luminous creamy white. It is a slender plant, often used for early forcing, and is a good multiplier. Its height is 55 centimeters.

SINT PANCRAS

'Sint Pancras,' registered in 1955 by J. F. van den Berg, is a fragrant, lemon yellow Triumph, sometimes multiheaded. Suitable for forcing, 'Sint Pancras' is 35 centimeters tall.

SNOW LADY

Ropta raised and Armapool registered 'Snow Lady' in 1992. The large ivory white flower sits on a sturdy plant. The Ropta Nursery in Metslawier is an independent hybridization station owned by potato growers who attempted to enter the tulip business. When this venture did not succeed, they sold many of their seedlings to a group of growers called Armapool. 'Snow Lady,' grown from one of these seedlings, is 45 centimeters tall, and though new, is very promising for forcing.

SNOWSTAR

'Snowstar,' registered by 't Mannetje in 1955, is pure white. One of the first white Triumphs, 'Snowstar' has a tapering small flower and is often multistemmed. This is a beautiful white Triumph but it has already been super-seded by 'Inzell,' another white Triumph with a larger, fuller flower. Often used for early forcing, 'Snowstar' is 45 centimeters in height.

SPALDING

Registered by P. Nijssen & Sons in 1959, 'Spalding' is soft pink with a white base. A sturdy plant, 45 centimeters tall, and frequently used for forcing, 'Spalding' is named for the city in Lincolnshire that is the center of the UK bulb-growing region.

SPRYNG

'Spryng,' raised by IVT and registered by Vertuco in 1985,

has a beautiful large glowing red flower with a brighter red edge on the petals. The base is black with gray blotches on a yellow ground. 'Spryng' has unusual color and a height of 35 centimeters. [PLATE 245]

STABILITY

Doornbosch Brothers registered 'Stability' in 1981. Dark purple with a white base, this is a sturdy, late-flowering Triumph. It is 35 centimeters tall.

STARGAZER

'Stargazer' was registered in 1991 by Hybris and has a large shiny cardinal red flower with a broad white rim on the petals. The base is primrose yellow. Presently under trials for forcing, it is 45 centimeters in height.

STRIPED BELLONA

A. Berbee and others registered 'Striped Bellona' in 1973. A sport of 'Bellona,' it is deep yellow with an irregular flamed pattern on its petals. The base is buttercup yellow. It is fragrant, 50 centimeters tall, and suitable for forcing.

STRONG GOLD

'Strong Gold,' raised by J. F. van den Berg & Sons and registered by J. A. Borst & Son in 1989, is deep yellow. One of the parents of this rather new tulip is the beautiful yellow Triumph 'Yokohama.' 'Strong Gold' has a long vase life and looks to have a bright future as a forcing tulip. It is 40 centimeters in height. [PLATE 52]

SUCCESS

K. C. Vooren & Sons raised and P. Verdegaal and Sons registered 'Success' in 1971. The lilac-purple flower with a white edge on the petals is a sport of the red-and-white Triumph 'Lustige Witwe.' 'Success,' used for forcing, is 40 centimeters tall.

SUNLIFE

Registered in 1975 by J. F. van den Berg & Sons, 'Sunlife' is rose-red with a small yellow rim on the exterior of the petals. The color on the inside is a deeper bloodred feathered on a yellow ground. The base is yellow with a purple-black margin. A slender tulip used for early forcing, 'Sunlife' is 45 centimeters in height.

SUPERSTAR

'Superstar,' registered by J. de Wit & Sons in 1986, is currant red with a bluish-black base, edged white. A cross between 'Prominence,' a red Triumph, and 'Avanti,' a lighter red Single Late, 'Superstar' was bred specifically to produce a forcing tulip. With a slightly egg-shaped flower similar to its parent 'Prominence,' 'Superstar' is 45 centimeters tall. [PLATE 246]

TED TURNER

A. Nijssen & Sons raised and Vertuco registered 'Ted Turner' in 1995. It is light yellow on the exterior of the petals; inside, the color is deeper. A sturdy plant, it has a height of 30 centimeters. [PLATE 247]

TOSCA

'Tosca' was raised by J. F. van den Berg & Sons and registered in 1980 by G. P. Bos and is cardinal red on a yellow ground. One of the many red-yellow forcing tulips from van den Berg, 'Tosca' is a slender plant, 50 centimeters tall.

TRANSAVIA

Raised by Vertuco and registered in 1988 by H. van Dam,

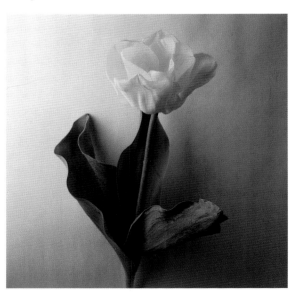

TED TURNER [PLATE 247]

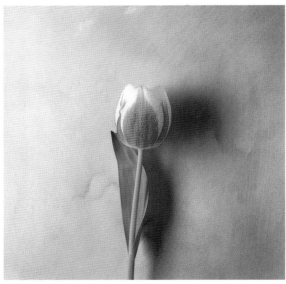

VALENTINE [PLATE 248]

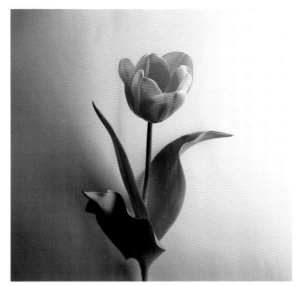

VARINAS [PLATE 249]

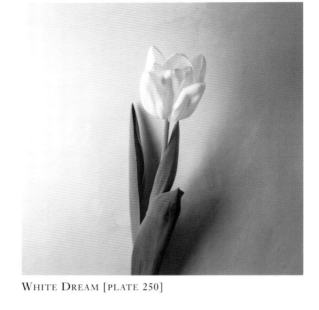

WHITE DREAM [PLATE 250]

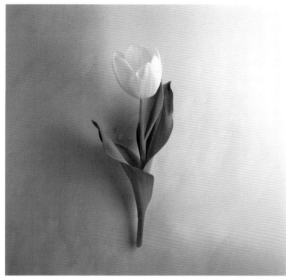

WINTERBERG [PLATE 251]

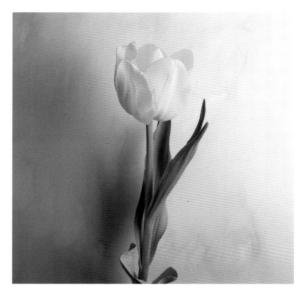

YELLOW PRESENT [PLATE 252]

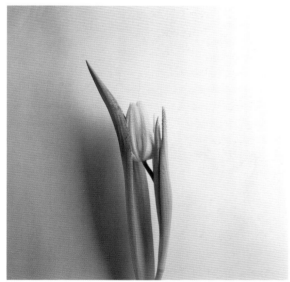

YOKOHAMA [PLATE 253]

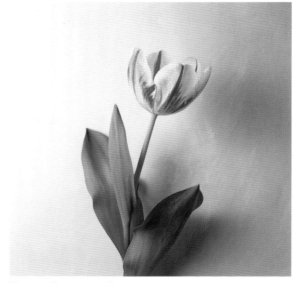

ZAMIRE [PLATE 254]

'Transavia' has a well-proportioned all-yellow flower and a height of 55 centimeters. It is very good for forcing.

VALENTINE

F. C. Bik raised and Jacobus Tol registered 'Valentine' in 1970. Its Tyrian purple color blends and feathers into the white edge on the petals, giving 'Valentine' an unusual color. The base is canary yellow. A broad plant with many leaves, it is 45 centimeters tall. [PLATE 248]

VARINAS

'Varinas,' registered in 1944 by G. van Steyn & Sons, has a lilac-pink, egg-shaped flower with silvery-white edges on the petals. This is a sturdy plant, 40 centimeters tall. [PLATE 249]

WALTER SCHEEL

Raised by IVT and registered by T. Timmerman in 1978, 'Walter Scheel' has a small, soft yellow flower and is 50 centimeters tall. It is a good forcing tulip.

WASHINGTON

J. Ligthart found and registered 'Washington' in 1981. A golden yellow sport of 'Golden Melody,' it has a bloodred flame in the middle of the petals. Like 'Golden Melody,' 'Washington' is a good forcing variety. It has an elongated egg-shaped flower and is 55 centimeters in height.

WHITE DREAM

Raised by J. F. van den Berg & Sons and registered by J. A. Borst & Sons in 1972, 'White Dream' is an ivory white flower with a height of 50 centimeters. It is used for forcing. [PLATE 250]

WHITE IDEAL

Hybris registered 'White Ideal' in 1988. The large bowl-shaped ivory white flower has a primrose yellow glow and a yellow base. 'White Ideal,' used for forcing, is 40 centimeters tall. [PLATE 66]

WIBO

One of the many sports of 'Prominence,' 'Wibo' was registered in 1986 by J. de Wit & Sons. Primrose yellow with a purple-red flame, 'Wibo' is a good forcer and is 40 centimeters in height.

WINTERBERG

'Winterberg' was registered by A. W. Bos in 1985 and is the whitest sport of 'Prominence,' a dark red Triumph. When forced, 'Winterberg' looks like another whitish sport of 'Prominence,' 'Romance.' In the garden, 'Winterberg' is

flamed primrose yellow on a yellowish-white ground. Its height is 40 centimeters. [PLATE 251]

WONDERFUL

F. C. Bik raised and Jacobus Tol registered 'Wonderful' in 1972. It has a large glowing rosy-red flower. Suitable for forcing, 'Wonderful' is 35 centimeters tall.

YELLOW FLIGHT

Hybris raised and M. Boots registered 'Yellow Flight' in 1994. A beautiful all-yellow tulip, the plant and flower are both sturdy. Presently undergoing forcing trials, this new Triumph is 35 centimeters in height.

YELLOW MASK

'Yellow Mask,' registered by Konijnenburg & Mark in 1964, is yellow-tinged purple on the exterior of the petals and buttercup yellow on the interior, and is 55 centimeters tall. It has one sport, 'Helmar.'

YELLOW PRESENT

Registered by Hybrida in 1953, 'Yellow Present' has a creamy yellow flower with petal tips that are slightly pointed. It has two sports, 'Golden Present' and 'Red Present,' both of which share this flower form. 'Yellow Present' is used entirely for containers and exclusively in the United States. Its height is 35 centimeters. [PLATE 252]

YELLOW STAR

'Yellow Star' was registered by J. de Wit & Sons in 1985. A sport of 'Prominence,' 'Yellow Star' is mostly yellow with barely perceptible red spots on the interior of the petals. Suitable for forcing, its height is 40 centimeters.

YOKOHAMA

'Yokohama,' registered by J. F. van den Berg in 1961, is a deep yellow flower with pointed and curled petals. Mostly used for forcing but equally lovely in gardens, 'Yokohama' is 35 centimeters tall. [PLATE 253]

ZAMIRE

Not yet registered, this dark red sport of 'Prominence' has a creamy white edge and a height of 40 centimeters. 'Zamire' is a good forcing variety. [PLATE 254]

ZAREWITCH

Straathof registered 'Zarewitch' in 1969. Cardinal red with petals edged primrose yellow, 'Zarewitch' has a yellow-white base. It is a sport of 'Lustige Witwe,' and is a good tulip for forcing. It is 40 centimeters tall.

GREIGII GROUP

T. greigii originally came from Turkistan and was named and described in 1873 by Dr. Eduard August von Regel of St. Petersberg. Though the plants that Dr. Regel described were variable because of the fact that they multiplied by seed, they shared a very distinct characteristic in the markings of their leaves, which were striped, dotted, or mottled with purple. The broad leaves were often strongly undulated and were spread on the ground. The large flower on a short or a tall stem came in many colors: orange-red, red, yellow with red blushes. Some were even cream-colored. The shape of the flower was usually square, though sometimes it was rectangular. Even the number of petals varied: Usually each flower had six petals, but occasionally some of the bigger bulbs produced flowers with eight petals. While some classification "purists" found it troublesome to group both six- and eight-petaled flowers in the same species, eventually there was agreement that both types did indeed belong together.

Although the firm of C. G. van Tubergen in Haarlem received the first samples of *T. greigii* from Turkistan in 1873 and began hybridizing, it was not until 1950 that C. G. van Tubergen began to register its hybrids. By then it was clear that the hybrids were becoming more important than the original species.

Because they have been bred with a variety of garden and other species tulips, the Greigii hybrids offer a wider range of colors. One of the most interesting hybridizing programs was Dirk Lefeber's. At first, Lefeber crossed *T. greigii* with the taller species plants to produce his crosses. While the results were beautiful and colorful hybrids, unfortunately many of them had papery tunics on the bulbs, which proved a disadvantage because the bulbs lacked adequate protection. Eventually Lefeber abandoned this program. It was when he crossed the Darwin tulip 'City of Haarlem' (now out of cultivation) with *T. greigii* that he produced his best Greigii hybrids:

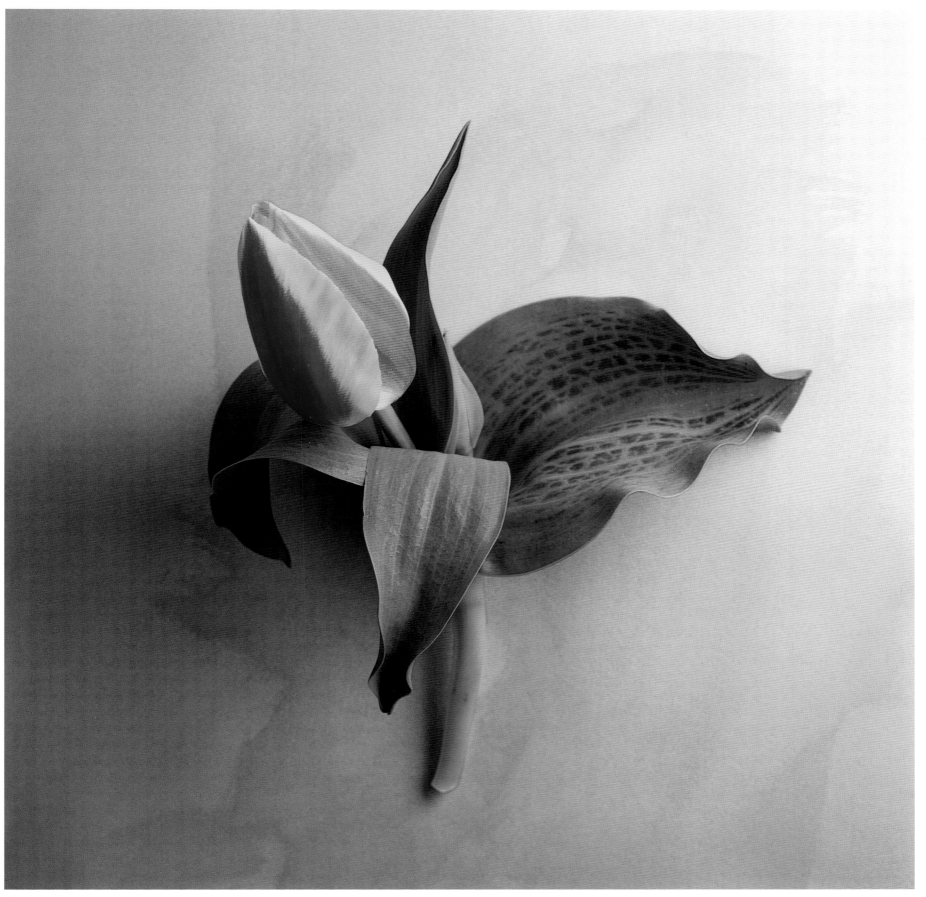

Carioca [plate 255]

four tall, late-flowering tulips with strong stems and heavily mottled leaves. They are the red-colored 'Bokhara'; 'Margaret Herbst,' which is also red and the best of all; 'Oriental Splendour,' and 'Smyrna,' both of which are red with yellow rims. Yet another spectacular Lefeber cross is 'Temple of Beauty,' which he produced through crossing the species with the Lily-flowered tulip 'Mariette.' 'Temple of Beauty' is a long, slender flower on a very tall stem. Its form resembles neither a Greigii nor a Lily-flowered tulip and has been classified into the Single Late group.

The firm of Hybrid also created many Greigii hybrids, using mostly Fosterianas and Single Early tulips in its crosses. C. & A. van Bentam, J. H. Rijkelijkhuizen, Bito, and IVT have all produced a few worthy hybrids.

There is no evidence that any of the commercially grown Greigiis today is the original species; they are all hybrids within the species or hybrids produced by crosses with other tulip species and with garden varieties.

The Greigiis flower mid-season and are all suitable for the rock garden.

ALI BABA
Registered by Hybrida in 1955, 'Ali Baba' has soft, rosy-red petals on the outside, which are a deeper scarlet on the inside. This is a slender plant, and at 30 centimeters a little taller than the average Greigii. The base of 'Ali Baba' is yellow with red blotches. The leaves are mottled. Overall, it is one of the most elegant Greigiis.

When it was first introduced, growers thought 'Ali Baba' might prove superior to 'Red Riding Hood,' a very beautiful carmine-red Greigii that had come to notice just two years earlier. Unfortunately, 'Ali Baba' does not multiply as quickly as 'Red Riding Hood,' and consequently has never surpassed it.

ANNIE SALOMONS
'Annie Salomons,' registered by Belle & Teeuwens in 1962, is a Greigii hybrid that resembles the species with its big and bright vermilion flower. The color is the same on the interior and the exterior of the petals. The base is deep brown, spotted with yellow, and the leaves are mottled. Its height is 25 centimeters.

Fons Belle, whose nursery, Belle & Teeuwens, in Lisse, was one of the original ten founders of Keukenhof Gardens, the famous tulip preserve in Lisse. For more than thirty-five years, Belle continued his association with the park as a member of the board of directors and as an exhibitor at the annual spring tulip shows. Around 1980, Belle retired and the author, Wim Lemmers, took his place in the garden as an exhibitor. [PLATE 256]

ANTONI VAN LEEUWENHOEK
In 1960, L. Strassen Jr. registered 'Antoni van Leeuwenhoek,' a carmine-rose tulip with a bright sulfur yellow edge and a black base, 35 centimeters tall. Strassen was a bulb trader who probably did not raise this Greigii but brought it to market by purchasing the seedling stock. 'Antoni van Leeuwenhoek' is named for the Dutch scientist who invented the microscope. [PLATE 257]

BELLA VISTA
'Bella Vista,' registered by A. Verschoor Jr. in 1972, a very pretty sport of 'Zampa,' is yellow with a red flame on the exterior of the petals. Inside, the flower is yellow with a bronze-green basal blotch. The leaves have attractive purple mottling and spread themselves on the ground. Its height is 30 centimeters. [PLATE 71]

BUTTERCUP
'Buttercup' was registered by J. B. Roozen in 1955. The exterior petals have carmine blotches and yellow edges. Inside the flower, the color is a deep golden yellow. The base is also yellow, with red blotches, and the leaves are mottled. 'Buttercup' is 25 centimeters tall. [PLATE 258]

CALIFORNIAN SUN
Registered by J. Prins & Sons in 1988, 'Californian Sun' is canary yellow with a large scarlet flame from the base to the top of the petals. It is a sport of 'Plaisir,' found by several growers including the author, Wim Lemmers. 'Californian Sun' is 25 centimeters in height.

CAPE COD
'Cape Cod,' raised and registered by Hybrida in 1955, is apricot with yellow-orange edges on the exterior of the petals. Inside, the color is bronze-yellow with a broad apricot streak, and the base is black with red blotches. The leaves are mottled. Its height is 30 centimeters.

Kees Lemmers, the author's father, grew this variety before it was registered, at which time it was designated only by a number. The elder Lemmers had seen the bulbs at a nursery and purchased "two rows," an amount equal to about fifteen plants. A few years later, the plant was registered and named 'Cape Cod.' It grew well and the Lemmers nursery built up a large stock. [PLATE 78]

CAPTEIN'S FAVOURITE
'Captein's Favourite' was registered by Captein Brothers in 1971 and is a glowing tomato red flower with a black base. The leaves are mottled and its height is 35 centimeters.

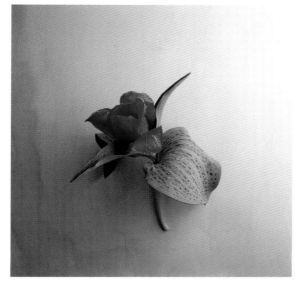

ANNIE SALOMONS [PLATE 256]

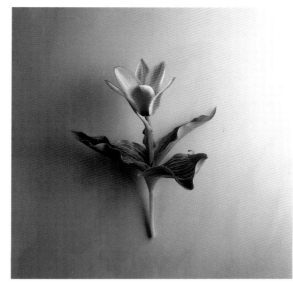

ANTONI VAN LEEUWENHOEK [PLATE 257]

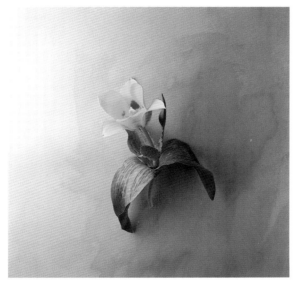

BUTTERCUP [PLATE 258]

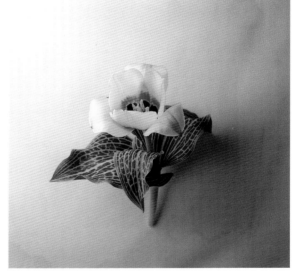

DONNA BELLA [PLATE 259]

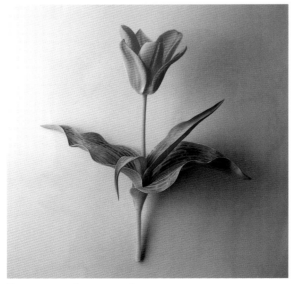

DREAMBOAT [PLATE 260]

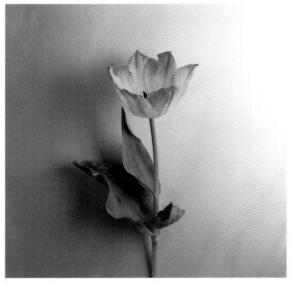

EASTER SURPRISE [PLATE 261]

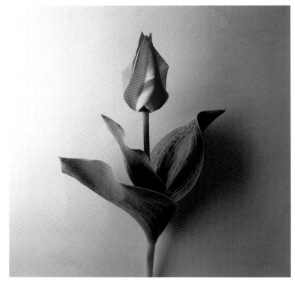

ENGADIN [PLATE 262]

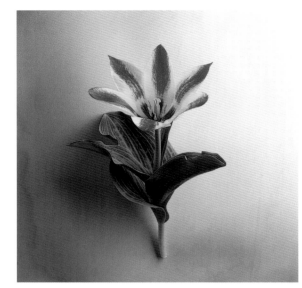

GOLDEN DAY [PLATE 263]

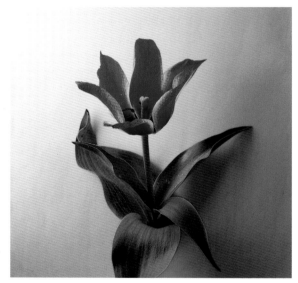

JOCKEY CAP [PLATE 264]

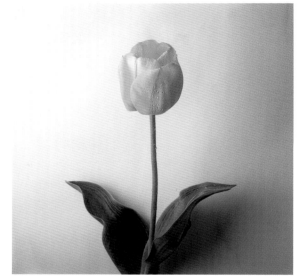

LEMON GIANT [PLATE 265]

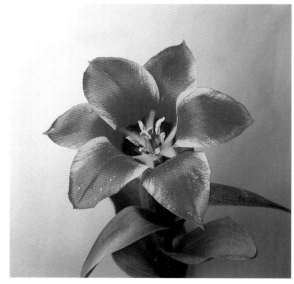

LOVELY SURPRISE [PLATE 266]

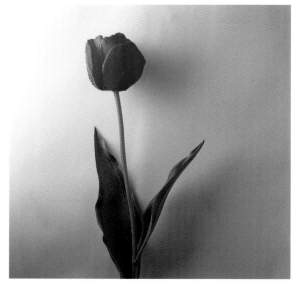

MARGARET HERBST [PLATE 267]

CARIOCA

Raised and registered by Hybrida in 1960, 'Carioca' has beautiful porcelain rose petals with soft buttercup yellow edges on the outside of the petals. Inside, the petals are yellow and the base is deep brown, edged red. This is one of the most beautiful and unusual Greigiis, slightly bigger than most, with a large and peculiar egg-shaped flower. The bulb, also large, does not multiply quickly. The leaves are mottled. It is 35 centimeters in height. [PLATE 255]

CHINA LADY

'China Lady,' registered by Hybrida in 1953, is one of the best of the "whitish" Greigiis. Quite possibly its white color comes from a creamy white *T. greigii* parent. It has three exterior white petals with large carmine-rose blushes, and the base is edged in red. The interior is ivory white and grows whiter as the flower matures. It has a big dark brown basal blotch. Thirty centimeters tall, 'China Lady' has a large flower and a sturdy stem, with heavily mottled leaves that appear to be purple. 'China Lady' comes from a big bulb, and consequently stock increases slowly. [PLATE 68]

COMPOSTELLA

Raised and registered by Hybrida in 1955, 'Compostella' is an apricot flower with yellow edges on the petals. The base is black with a red blotch and its leaves are mottled. 'Compostella' resembles 'Cape Cod' but has a bigger, squarer flower on a shorter stem. Though 'Compostella' is more impressive, 'Cape Cod' comes from a smaller bulb and therefore multiplies more quickly. 'Compostella's height is 25 centimeters.

CORSAGE

One of the most beautiful Greigiis, 'Corsage' was registered by Hybrida in 1960. The petals are feathered and spotted porcelain rose with yellow edges, giving the flower a richly textured salmon color. The base is bronze and the flower shape is square. In addition to its beauty, 'Corsage' has the advantage of growing from big round bulbs, which is not typical of Greigiis, and may indicate one of the parents is a garden tulip. The only flaw 'Corsage' has is its weak stem. The leaves are heavily mottled and it is 30 centimeters in height. [PLATE 73]

CZAAR PETER

'Czaar Peter' has a large flower with claret red petals on a whitish ground. The basal blotch is grayish-green. Its leaves are mottled and it is 25 centimeters tall. 'Czaar Peter' was registered in 1982 by J. F. Verwer, who had been an employee of the Captein Brothers' nursery, which did a great deal of hybridizing and breeding.

DONNA BELLA

'Donna Bella' was registered by Hybrida in 1955. The exterior petals are carmine with creamy white edges that grow whiter as the flower matures. Inside, the color is creamy yellow and the base is black with scarlet blotches. The flowers are slender with eight petals, an occasional characteristic of the Greigiis. 'Donna Bella'—"Beautiful Lady"—is indeed beautiful and, though slightly larger, closely resembles 'China Lady.' 'Donna Bella' has mottled leaves and a height of 30 centimeters. [PLATE 259]

DREAMBOAT

In 1953, Hybrida registered 'Dreamboat,' which is an amber yellow flower with a red tinge on the petals. The base is greenish-bronze with red blotches. The flower has a rectangular shape, and the leaves are mottled. The plant's height is 25 centimeters. 'Dreamboat' seems a well-chosen name for this nearly perfect Greigii. [PLATE 260]

EASTER SURPRISE

Hybrida registered 'Easter Surprise' in 1965. It is a sport of 'Tango' that looks like a Rembrandt (a tulip whose colorful streaking is the result of a virus). 'Easter Surprise' is deep lemon yellow, becoming orange at the tops of the petals. The base is bronze-green. Its height is 40 centimeters. [PLATE 261]

ENGADIN

Raised and registered by Hybrida in 1955, 'Engadin' is named for the mountain area in Switzerland near Austria. The 'Engadin' flower is the deepest red and yellow of the Greigiis. The bloodred stripes and yellow edges on the exterior of the petals are striking and dramatic, as is the golden yellow interior. A plant that multiplies slowly, it is 35 centimeters tall. [PLATE 262]

GOLDEN DAY

'Golden Day,' another Hybrida hybrid, was registered in 1955. It has a lemon yellow flower, tinged with red. Its leaves are mottled and its height is 30 centimeters. [PLATE 263]

GOLDEN TANGO

J. N. M. van Eeden registered 'Golden Tango' in 1982. Like 'Easter Surprise,' this sport of 'Tango' also resembles a Rembrandt tulip with its canary yellow coloring and the slightly visible green-and-red-tinted flame on the outside of each petal. Inside, the flower is yellow with a

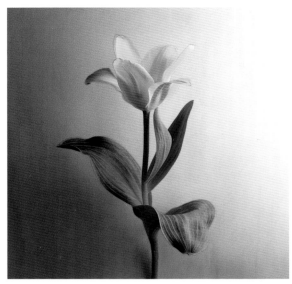

MISKODEED [PLATE 268]

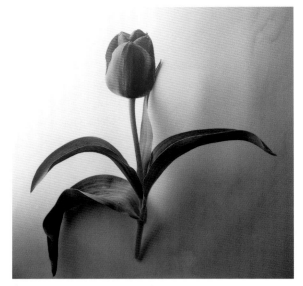

ORANGE ELITE [PLATE 269]

bronze-black, star-shaped base. Its height is 40 centimeters. [PLATE 70]

JOCKEY CAP

Registered by Hybrida in 1959, 'Jockey Cap' has a brightly colored deep carmine flower and petals edged creamy white. The base is black, edged yellow, and the leaves are mottled. With a longer stem than most Greigiis, 'Jockey Cap' is 25 centimeters tall. [PLATE 264]

LEMON GIANT

W. A. M. Pennings registered 'Lemon Giant' in 1989. An all-yellow sport of 'Margaret Herbst,' it has mottled leaves and its height is 50 centimeters. [PLATE 265]

LONGFELLOW

Registered by Hybrida in 1960, 'Longfellow' is vermilion with lighter vermilion-colored stripes on the petals. The base is black. All the flower petals are pointed. It would appear from its height, 50 centimeters tall, and mottled leaves that 'Longfellow' is a cross between a Greigii tulip and a Fosteriana. [PLATE 75]

LOVELY SURPRISE

'Lovely Surprise,' registered by D. W. Lefeber in 1965, is a red flower with lemon yellow edges. The leaves are mottled. A sturdy, very strong hybrid and a beautiful plant, 'Lovely Surprise' is the result of crossing two Greigiis, which its grower considered ideal. A cross such as this produces a plant that resembles the species but has the vigor of a hybrid. The only disadvantage to 'Lovely Surprise' is the papery skin on its bulb, which does not provide adequate protection; consequently the bulb is easily damaged and bruised. At 50 centi-

meters in height, this is one of the tallest Greigii tulips. [PLATE 266]

MARGARET HERBST

Royal Splendour

'Margaret Herbst' was registered by D. W. Lefeber in 1949. This very beautiful vermilion hybrid is the result of a cross between two very different tulips, a Greigii and a Darwin (Darwin tulips no longer exist as a separate division). 'Margaret Herbst,' a sister seedling of 'Oriental Splendour,' a red-and-yellow Greigii, is a strong tulip, flowering a little later than other Greigiis. The leaves are beautifully mottled and it is 50 centimeters in height. It has a couple of sports, one of the prettiest being 'Lemon Giant.' [PLATE 267]

MISKODEED

'Miskodeed' was registered by Hybrida in 1955. The exterior flower color is apricot rose and the interior is a rare color combination of lemon yellow with a base that is golden yellow with red blotches. The broad leaves with purple stripes are quite handsome. The combination of a softly colored flower and misty, striped leaves is quite the opposite of most of the Greigiis, which tend to have splashy colors. 'Miskodeed,' 30 centimeters tall, multiplies well. [PLATE 268]

ORANGE ELITE

'Orange Elite,' registered by Hybrida in 1952, is apricot rose, edged orange on the outside. Inside, the flower is orange with a deep green base, edged yellow. Resembling 'Corsage,' but with more orange, 'Orange Elite' has a dominating flower that stands above the uppermost leaves, which are nicely mottled. Its height is 35 centimeters. [PLATE 269]

ORANGE TORONTO

Registered by W. A. M. Pennings in 1987, this multiheaded sport of 'Toronto' is marigold orange and, like its mother plant, has slightly mottled leaves. It is 35 centimeters tall.

ORIENTAL BEAUTY

'Oriental Beauty' was registered by Hybrida in 1952 and is completely red. One of Hybrida's first hybrids, it continues to be as popular today as it was in the 1950s. The exterior of the flower is carmine-red, while the interior is a slightly more orange-red. The base is deep brown and the leaves are mottled. Its height is 50 centimeters. [PLATE 270]

ORIENTAL SPLENDOUR

Raised and registered in 1961, 'Oriental Splendour' is one of Dr. Lefeber's celebrated crosses between a Greigii species tulip and 'City of Haarlem,' a Darwin tulip no longer in cultivation. It is carmine-red, edged lemon yellow on the exterior of the petals, and inside the color is yellow with a dark green base. 'Oriental Splendour' created a sensation when it was first introduced: It is beautiful and, at 50 centimeters, very tall for a Greigii hybrid. [PLATE 76]

PERLINA

Registered by Hybrida in 1960, 'Perlina' has a porcelain rose flower with a lemon yellow base. It is one of the few Greigiis with this unusual soft coloring. The leaves are mottled and it is 25 centimeters in height. [PLATE 77]

PINOCCHIO

The firm of Bito registered 'Pinocchio' in 1980. The flower, red with an ivory white edge, is more slender and smaller than other Greigiis, and the overall size of the plant is smaller, too. The base is yellow and the leaves are mottled. 'Pinocchio' is 25 centimeters tall.

PLAISIR

Registered by Hybrida in 1953, 'Plaisir' is carmine-red on the outside and vermilion inside, and the petals are edged sulfur yellow. The base is bronzy-green, and the leaves are heavily mottled. 'Plaisir' is 25 centimeters in height. It has one sport, 'Californian Sun.' [PLATE 74]

QUEBEC

'Quebec' was registered by P. & M. van der Poal in 1991. This scarlet sport of 'Toronto' with rather broad chartreuse-green margins on the petals is, like 'Toronto,' multiheaded. 'Quebec' has a buttercup yellow base and its broad leaves are mottled slightly. Its height is 35 centimeters.

QUEEN INGRID

'Queen Ingrid' was registered by Hybrida in 1955 and is carmine-red, edged yellow on the petals. There are red blotches on the interior and the base is black. Its flowers are more pointed than those of other Greigiis and show a nice form. Its height is 35 centimeters.

RED REFLECTION

'Red Reflection' is a Hybrida cross, registered in 1955. Its parents are 'Duc van Tol' and *T. greigii*. ('Tango' is another Greigii from the same cross and looks much like this tulip.) 'Red Reflection' is a dramatic Greigii, with a deep scarlet flower and a black base. The leaves are mottled and it is 40 centimeters tall.

When it was first introduced and exhibited, 'Red Reflection' won many flower contests. Many of the bulb growers in Holland grew it solely for its value as a show

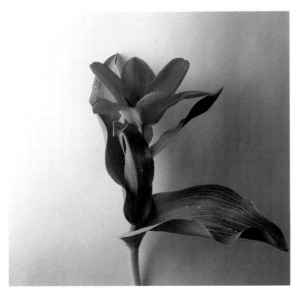

ORIENTAL BEAUTY [PLATE 270]

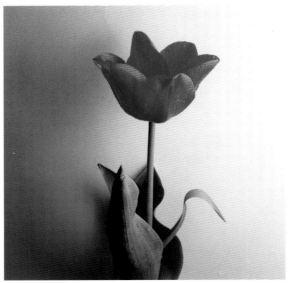

RED REFLECTION [PLATE 271]

flower. 'Red Reflection' was considered the best of a series of about four registered red Greigii hybrids, but like the other hybrids from the crossings of two diverse groups, 'Red Reflection' has proven sterile. Only a very small stock for this plant is left. [PLATE 271]

RED RIDING HOOD
Roodkapje
Registered by Hybrida in 1953, 'Red Riding Hood' is carmine-red with a black base. It is one of the very prettiest Greigiis and is probably as popular today as it was when first introduced. The flower, while not large, is perfectly square. The beautiful leaves, mottled reddish-purple, are heavier and have more ornamental mottling than on any other Greigii. 'Red Riding Hood' is short at 20 centimeters. [PLATE 69]

ROCKERY MASTER
Registered by Hybrida in 1952, 'Rockery Master' is an early Hybrida with an exterior and interior color of pale salmon rose on the petals. The leaves are nicely mottled. Twenty centimeters tall, 'Rockery Master,' as its name suggests, is perfect for rock gardens.

SOMBRERO
'Sombrero,' registered by Uitenbooggard & Sons in 1962, is a red flower with a buttercup yellow base. The leaves are mottled and the height is 35 centimeters.

SPARKLING FIRE
Registered by Hybrida in 1955, 'Sparkling Fire' is an appropriate name for this vermilion red flower with a yellow base. With its red-and-yellow coloring and rectangular flower shape, 'Sparkling Fire' actually looks like the flame of a candle. This is the biggest flower of the rectangular-shaped Greigiis and the leaves are nicely mottled. Its height is 30 centimeters. [PLATE 272]

SUN DANCE
'Sun Dance' was registered by Hybrida in 1962. The exterior is vermilion red, edged saffron yellow. The inside colors are similarly red with yellow at the edges of the petals. 'Sun Dance,' 30 centimeters tall, looks somewhat like 'Engadin,' but with softer and less dramatic coloring. [PLATE 273]

SWEET LADY
Registered by J. C. van der Meer in 1955, 'Sweet Lady' is a soft peach blossom color. The base is bronzy-green, tinged yellow. The solidly square shape of the flower is further enhanced by its beautifully mottled leaves. It has a sturdy stem and a height of 30 centimeters. [PLATE 274]

TANGO
'Tango' is yet another hybrid from Hybrida—this one registered in 1952. As with 'Red Reflection,' its parentage is 'Duc van Tol' and *T. greigii*. 'Tango' is orange-scarlet inside and out, and the black base has yellow blotches. It is 40 centimeters tall. 'Tango' is not widely grown in Holland, and its stock is low, but it does have two exceptional sports: 'Easter Surprise' and 'Golden Tango.' [PLATE 275]

TORONTO
Registered by Uitenbooggard & Sons in 1963, 'Toronto' is a vermilion flower with bronzy-green blotches on a buttercup yellow base. 'Toronto' is an unusual Greigii because it is multiheaded. The leaves are slightly mottled and it is 35 centimeters in height. 'Toronto,' a very good grower, has two excellent sports: 'Orange Toronto' and 'Quebec.' [PLATE 72]

UNITED STATES
'United States' was registered by D. W. Lefeber in 1974. The exterior petals are scarlet-flamed on a fire red ground, with buttercup-yellow feathered edges. Inside, the color is fire red with yellow toward the edges, with black basal blotches. The leaves are slightly mottled and it stands 45 centimeters tall.

ZAMPA
'Zampa,' raised and registered by Hybrida in 1952, is a soft primrose yellow with a reddish blush on the petals. The base is bronze and green and the leaves are heavily mottled. Its height is 30 centimeters. 'Zampa' has two sports, 'Bella Vista' and 'Zampa Rose.' [PLATE 276]

ZAMPA ROSE
Not yet registered, 'Zampa Rose' is the provisional name for this pink flower with a red flame on the petals raised by W. A. M. Pennings. Its height is 30 centimeters. [PLATE 277]

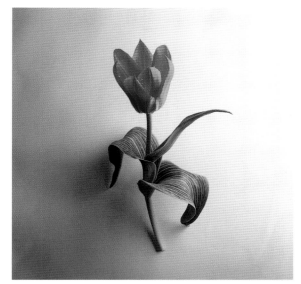

SPARKLING FIRE [PLATE 272]

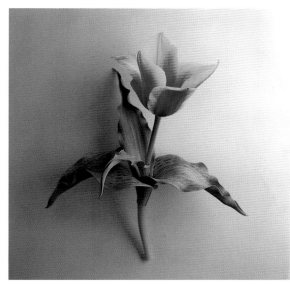

SUN DANCE [PLATE 273]

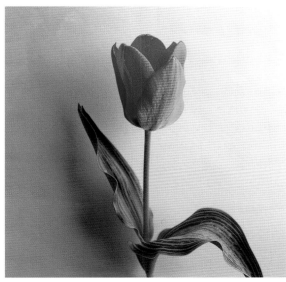

SWEET LADY [PLATE 274]

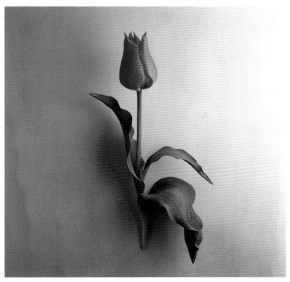

TANGO [PLATE 275]

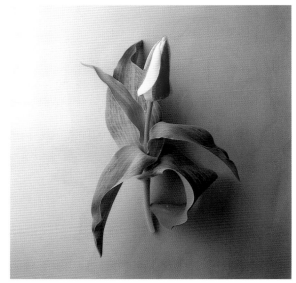

ZAMPA [PLATE 276]

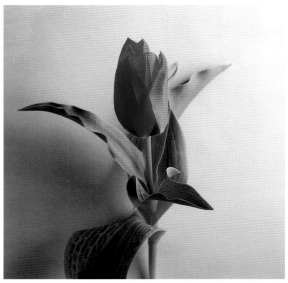

ZAMPA ROSE [PLATE 277]

LILY-FLOWERED GROUP

Lily-flowering tulips are probably the most graceful of all the tulips. The long and narrow flowers are completely unlike the usual bowl or egg-shaped form of most tulips, and instead of blunt petal tips, those of the Lily-flowered tulips are pointed, bending outward in a reflexed fashion. In full sun, the reflexed petals will open up completely, flattening out to resemble the petals of a lily flower. Old Turkish tiles depict the ideal form of the tulip in the Ottoman gardens of the sixteenth and seventeenth centuries, a form strikingly similar to the Lily-flowered tulips.

While no particular species is involved in creating today's Lily-flowered tulips, there are several old reflexed tulips such as *T. fulgens* that were probably used as parents many years ago. Yet another parent is *T. retroflexa*, which hybridizers often used at the turn of the century. More recently, hybridizers relied on *T. acuminata*. However, today's Lily-flowered tulips, such as the elegant 'Mariette,' 'White Triumphator,' and the best of the Nieuwenhuis Nursery tulips, have such exquisite forms that hybridizers no longer look to crosses with reflexed species tulips to create Lily-flowered tulips. The offspring of any such crosses simply would not meet the high standard set by the modern Lily-flowered tulips.

In the first half of the century, Nieuwenhuis

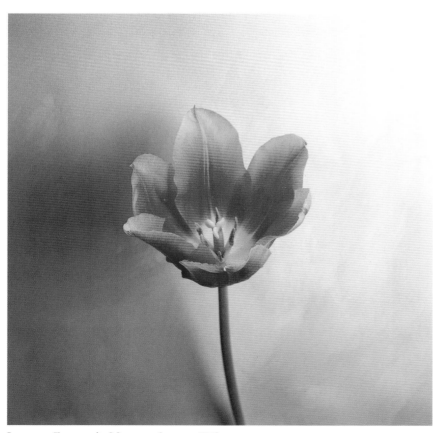

JAN VAN ZANTEN'S MEMORY [PLATE 278]

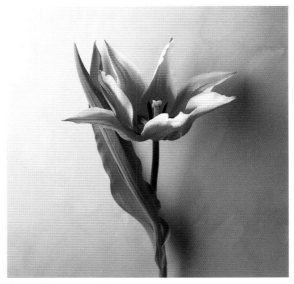

AKITA [PLATE 279]

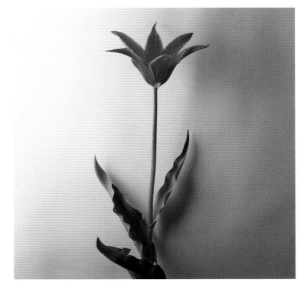

ALADDIN [PLATE 280]

Brothers of Lisse, one of the largest nurseries, exporters, and hybridizers in Holland, developed some of the most exquisite Lily-flowered tulips, including 'West Point,' 'Queen of Sheba,' 'Maytime,' and 'Aladdin.' In the 1930s and 1940s the Nieuwenhuis Brothers worked with Dr. W. E. de Mol, a scientist whose innovative techniques involved the use of X rays to bring about mutations from tulips. When Nieuwenhuis Brothers created 'Ballade,' it created the Lily-flowering tulip that has the best possible form and is a good forcer.

Eye-catching and elegant, Lily-flowered tulips flower from mid-season to late spring. They come in a variety of colors and have varying lengths of stems. While some are fragrant and some are good forcers, all are perfect for the garden.

AKITA

Raised by P. J. Nijssen and registered by M. Boots in 1992, 'Akita' is one of the newer Lily-flowered tulips. The exterior color of the flower is a beautiful chrysanthemum red and the rims of the petals carry a broad band of ivory white. The stem and leaves are a fern green color; the flower is set just slightly above the leaves. 'Akita' can be forced and, in fact, was raised by Nijssen with the goal of creating a forcible Lily-flowered tulip. Plants generally grow to 50 centimeters, but are shorter when forced. [PLATE 279]

ALADDIN

Registered by Dr. W. E. de Mol & A. H. Nieuwenhuis in 1942, 'Aladdin,' as its name may imply, has an exotic Arabian quality in its scarlet ground color and yellow-edged petals. This is a Lily-flowered tulip that looks a lot like 'Queen of Sheba' but is smaller. It is 55 centimeters tall and is suitable for forcing. [PLATE 280]

BALLADE

'Ballade,' registered by W. E. de Mol & A. H. Nieuwenhuis in 1953, has an unusual reddish-magenta flower with broad white edges. The base is white with yellow blotches. The petal tips are less reflexed and wider than most Lily-flowered tulips. Because there are not many good Lily-flowered tulips for forcing, 'Ballade' is often used for this purpose, making it very popular as a cut flower. Its height is 55 centimeters.

'Ballade' has produced some beautiful sports, many more than have yet been named. A few good sports that will be introduced in coming years are 'Je t'aime' (also called 'Ballade Orange'), which is orange with lemon yellow margins, and 'Sonnet' [PLATE 281] (also called 'Ballade Dream'), which is a deep purple-red with a canary yellow base. Yet another sport is 'Ballade White.' [PLATE 83]

BALLERINA

Raised by J. F. van den Berg & Sons and registered in 1980 by J. A. Borst, this is an all-orange tulip with a lighter yellow rim and feathering on the exterior of the petals. The base is star-shaped, buttercup yellow. 'Ballerina' is the only orange Lily-flowered tulip and bears a striking resemblance in its unusual color to the Single Early tulip 'Prince of Austria,' which may indicate one of its parents. 'Ballerina' also is fragrant like 'Prince of Austria.' It has a more slender form and flowers a little earlier than other Lily-flowered tulips. Considered the best forcer of this group and beautiful in the garden, too, 'Ballerina' is 55 centimeters in height. [PLATE 80]

CHINA PINK

Dr. W. E. de Mol & A. H. Nieuwenhuis registered 'China Pink' in 1944. A small pink Lily-flowered tulip with a

lighter pink rim and a white base, it demonstrates splendidly the open form of Lily-flowered tulips. Its height is 45 centimeters. [PLATE 81]

DOCTOR WISSE DEKKER

'Doctor Wisse Dekker,' registered by Hybris in 1987, is a bloodred flower, edged white, with a broad white base. It is 45 centimeters tall.

DYANITO

Registered by D. van Buggenum in 1949, 'Dyanito' has a tall stem, a bright red pointed flower, and a yellow base. For many years, Van Buggenum had a very good relationship with Segers Brothers and trialed and registered several tulips grown from its seedlings. 'Dyanito' is probably one of the Segers seedlings. Van Buggenum was knowledgeable in tulip-forcing practices for the cut-flower market, but unfortunately 'Dyanito' is not a forcible tulip. At 55 centimeters, it is tall enough but lacks the leaf mass and body. This is a slender plant that should be mass-planted to give a good impression.

ELEGANT LADY

Nieuwenhuis Brothers registered 'Elegant Lady' in 1953. This is a creamy yellow flower, edged violet-red. It is 60 centimeters in height. [PLATE 282]

JACQUELINE

Registered by Segers Brothers in 1958, 'Jacqueline' is deep rose with a yellow base. Segers first became well known for its breeding activities with the Single Late group, particularly for 'Renown,' and for the development of the Fringed tulips that were originally part of the Single Late group. With great successes in these tulip groups, Segers Brothers sought to improve tulips in the Lily-flowered group. 'Jacqueline' is one of the last it registered. It is a tall (65 centimeters), robust plant with a nice color and average Lily-flowered form.

JAN VAN ZANTEN'S MEMORY

Registered by Van Zanten Brothers in 1966, this is a tall, slender plant with a deep pink flower whose very pointed petals are lighter at the edges. The base is white. 'Jan van Zanten's Memory' is named in honor of a member of the Van Zanten family. It is not the most reflexed of the Lily-flowered tulips but the flower is beautiful. 'Jan van Zanten's Memory' is 55 centimeters tall. [PLATE 278]

LILAC TIME

Registered by Dr. W. E. de Mol & A. H. Nieuwenhuis in 1943, 'Lilac Time' is a single color, violet-purple, which is a unique color among the Lily-flowered tulips. It was created by de Mol and Nieuwenhuis to satisfy the demand for a wider color spectrum of tulips. While 'Lilac Time' is not a big flower, it does have good form. Its height is 45 centimeters.

MARIETTE

Registered by Segers Brothers in 1942, 'Mariette' is deep satin pink with a white base. 'Mariette,' the result of crossing 'Bartigon,' a red Darwin tulip (no longer in cultivation), and *T. retroflexa*, is beautiful and holds a great place among the Lily-flowered tulips. 'Mariette' is tall, 55 centimeters. Three of its best sports are 'Marilyn,' 'Marjolein,' and 'Mona Lisa,' all of which have excellent form.

MARILYN

Registered by C. N. Verbruggen in 1976, 'Marilyn' is a

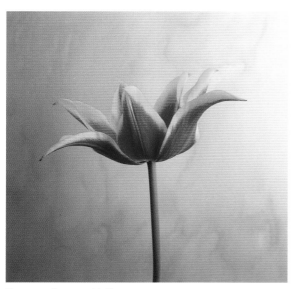

SONNET [PLATE 281]

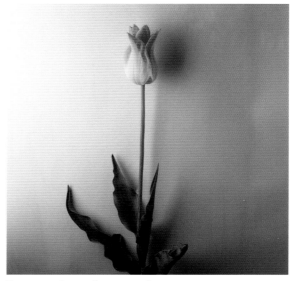

ELEGANT LADY [PLATE 282]

white sport of 'Mariette' with a red flame on each of its petals. The base is white and its height is 55 centimeters. [PLATE 85]

MARJOLEIN

A sport of 'Mariette' registered by P. Visser in 1962, 'Marjolein' has an exterior color of orange and carmine-rose and a pepper red inside. The base is yellow. It is 55 centimeters tall.

MAYTIME

Registered by Dr. W. E. de Mol & A. H. Nieuwenhuis in 1942, 'Maytime' is a reddish-violet flower. The yellow base has a narrow white edge. 'Maytime' has a very good form and is 50 centimeters in height. [PLATE 86]

MONA LISA

C. N. Verbruggen registered 'Mona Lisa' in 1988, a soft yellow sport of 'Marilyn' with a narrow, rich red flame on its petals. A flower with an elegant color combination, 'Mona Lisa' stands 55 centimeters tall.

MOONSHINE

'Moonshine', raised by Hybris and registered by P. S. A. van Geest in 1987, is a delightful light yellow tulip of medium height. Used for forcing, it is 50 centimeters in height.

QUEEN OF SHEBA

Raised and registered by Dr. W. E. de Mol and A. H. Nieuwenhuis in 1968, 'Queen of Sheba' has the exotic color combination of glowing brownish-red and orange-edged petals. 'Queen of Sheba' has a good shape and its reflexed petals are a fine example of the best Lily-flowered form. This is a colorful, robust plant, excellent for the garden. 'Queen of Sheba' is tall at 60 centimeters. [PLATE 84]

RED SHINE

Hybrida registered 'Red Shine' in 1955. This is a deep red tulip with a good, sharp color. Strong and elegant, 'Red Shine' flowers a little later than the others in this group. The firm of Hybrida is better known for its Triumph and Greigii tulips, but 'Red Shine' is certainly a great accomplishment. 'Red Shine' is 55 centimeters tall.

SAPPORO

'Sapporo' was raised by P. J. Nijssen and registered by M. Boots in 1992. The flower begins yellow and lightens to white as it matures. 'Sapporo' is a sister seedling of 'Très Chic' and has a very similar shape and color. It was raised in order to create a forcible tulip and today has about twice

the growing acreage of 'Très Chic.' Certainly the future will show which of the two tulips will prove the better forcer. It is 45 centimeters in height.

TRÈS CHIC

Raised by Hybris and registered in 1992 by H. van Dam, 'Très Chic' is a creamy white tulip with a greenish-white glow on the mid-vein of the petals. 'Très Chic' has an excellent Lily-flowered form and a beautiful flower. It also has a rather short stem and is very leafy, making it seem even shorter than its 45 centimeters. Like its sister seedling, 'Sapporo,' 'Très Chic' was created to be forced.

WEST POINT

Dr. W. E. de Mol and A. H. Nieuwenhuis registered 'West Point' in 1943. Primrose yellow and fragrant, single-colored 'West Point' is one of the finest examples of a Lily-flowered tulip. The reflexed petals are pronounced and will open out completely in warm weather. The leaves are quite long. Its height is 50 centimeters. [PLATE 79]

WHITE ELEGANCE

'White Elegance,' raised by De Geus-Vriend and registered in 1993, is one of the newest Lily-flowered tulips. The flower is ivory white and the stems are an interesting lettuce green. There used to be many more white Lily-flowered tulips, but today, with little emphasis on growing those tulips that are not reliable forcers, hybridizers are not creating many new white Lily-flowered tulips. 'White Elegance' is 35 centimeters tall. [PLATE 82]

WHITE TRIUMPHATOR

In 1942, C. G. van Tubergen registered 'White Triumphator,' a pure white, shining, beautiful flower. This is one of the Lily-flowered tulips with the best form; it is also strong and tall at 60 centimeters.

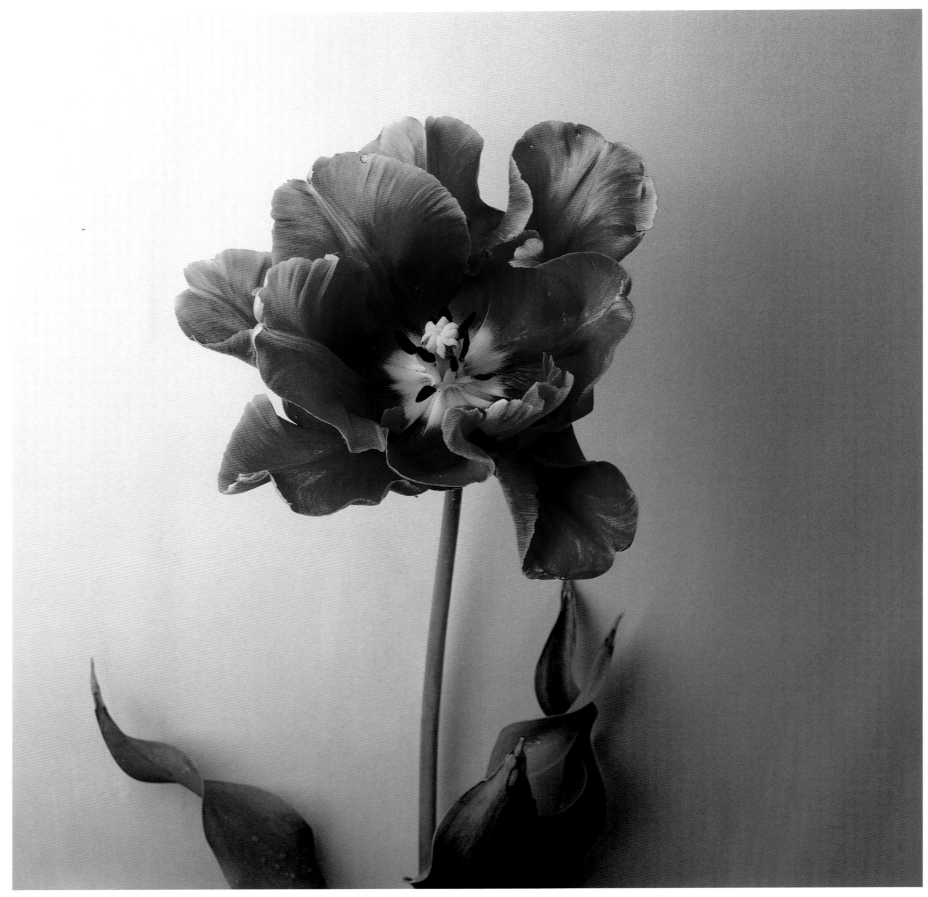

BLUE PARROT [PLATE 283]

Parrot Group

Parrot tulips were first mentioned around 1660. These natural mutations, which the French originally named '*Monstreuses*,' are large single flowers with laciniate, curled, and twisted petals, often sumptuously flamed and feathered. In the past, the enlarged flower was usually too heavy for its stem, so Parrot tulips were planted in baskets where they could hang languorously over the edges. Today's Parrot tulips have decidedly stronger stems that hold up the flowers better.

Parrots are mutations of ordinary tulips—even the species-related tulips in the Kaufmanniana and Greigii groups produce Parrots. The demand for the Parrots' wild, ruffled petals is great, and while growers have worked hard to develop techniques to encourage new mutations, the task has not proved easy. One method is to employ radiation techniques on the bulbs to artificially stimulate mutation; a few new Parrots have been developed using this method. One noted scientist who worked with Dutch bulb growers in the 1930s and 1940s toward this goal was Dr. Willem E. de Mol of Amsterdam.

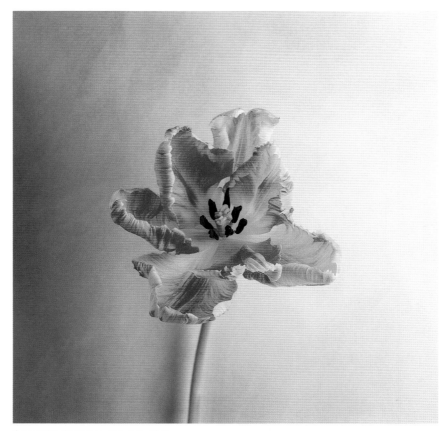

APRICOT PARROT [PLATE 284]

Dr. de Mol developed 'Estella Rijnveld' by bombarding its mother bulb, 'Red Champion' (another Parrot tulip), with X rays in order to produce a mutation. The grower, Segers Brothers, named the Parrot sport 'Estella Rijnveld' after

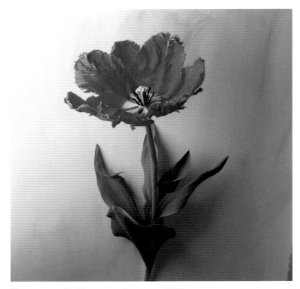

DOORMAN'S RECORD [PLATE 285]

de Mol's wife. (Dr. de Mol also worked extensively with Nieuwenhuis Brothers of Lisse to create new Lily-flowered tulips, and succeeded beautifully with 'Ballade.') Another Parrot, 'Salmon Parrot,' was developed through a radiation process called "Röntgen rays," similar to X rays. Röntgen rays were used to create 'Salmon Parrot' by stimulating the mother plant, 'Karel Doorman,' to produce a sport.

Another method of creating Parrots is hybridizing. Hybridizing has run into problems, though, because the Parrot form has not been adaptable. The first and only genetic Parrot was created in 1975 by IVT when it crossed the red-and-white Single Late tulip 'Cordell Hull' with itself and created 'Amethyst.' Hybridizing on the whole has proved unsuccessful for the Parrots, and growers today, such as the forward-thinking Vertuco, are experimenting with new ways to create Parrots.

Most Parrot tulips are late-flowering and they vary in height. All Parrots are suitable for the garden. They are difficult tulips to force, but those that can be used in forcing are always in great demand.

APRICOT PARROT

In 1961, H. G. Huyg registered 'Apricot Parrot,' a pale apricot yellow sport of 'Karel Doorman' with shades of white and pink throughout. Like the other 'Karel Doorman' sports, the flower on 'Apricot Parrot' is unusually large. Good for forcing, it is 50 centimeters in height. [PLATE 284]

BIRD OF PARADISE

'Bird of Paradise' was raised by J. Valkering and registered in 1962 by J. de Goede Valkering. A sport of the mahogany red Triumph tulip 'Bandoeng,' this is a colorful Parrot, cardinal red, edged orange on the exterior of the petals and red with orange feathering on the interior. The base is bright yellow and its height is 40 centimeters. [PLATE 90]

BLACK PARROT

'Black Parrot' was registered in 1937 by C. Keur & Sons. A sport of 'Philippe de Comines,' a beautiful maroon, nearly black Single Late tulip, 'Black Parrot' is deep purple on the outside and blackish-purple on the inside. This very dark, almost black tulip is even darker than the Single Late tulip 'Queen of Night' and is one of the most gorgeous of all the Parrots. An older tulip, 'Black Parrot' is difficult to grow—even for professionals—and may not be around for much longer for this reason. The ruffled flower, which is not overly large, sits on a strong stem. 'Black Parrot' is 50 centimeters tall. [PLATE 91]

BLUE PARROT

'Blue Parrot' was registered by John F. Dix in 1935. An older variety that is still going strong, 'Blue Parrot' is the only violet Parrot in cultivation today. Its large, bright violet flower looks almost blue. A sport of a wonderful old lilac Darwin tulip, 'Blue Amiable,' now classified as a Single Late, 'Blue Parrot' is 55 centimeters tall. [PLATE 283]

DESTINY

Registered in 1980 by Mrs. C. Burger, 'Destiny,' a sport of 'Lustige Witwe,' has a carmine-rose flower with a white rim and white base. Its stem has a difficult time holding the large flower upright. Only very skilled forcers have been successful with forcing 'Destiny.' Its height is 40 centimeters.

DOORMAN'S RECORD

Registered in 1975 by A. Bakkum and others, 'Doorman's Record,' a sport of 'Karel Doorman,' is bloodred, flamed carmine-rose with a tiny orange-yellow edge on the petals. The base is canary yellow. It is suitable for forcing and is 50 centimeters in height. [PLATE 285]

ERNA LINDGREEN

'Erna Lindgreen' was found and registered by a Swedish forcer, Albert Lindgreen, in 1951. It is bright red and suitable for forcing. Its height is 50 centimeters. [PLATE 286]

ESTELLA RIJNVELD

Registered by Segers Brothers in 1954, 'Estella Rijnveld' is a white flower, streaked and flamed deep red on the petals. Named for the wife of the scientist who created this tulip by stimulating the mother bulb, 'Red Champion,' with radiation in order to produce a sport, 'Estella Rijnveld' has a strong stem and is very colorful. Used for

late-season forcing, it is not an easy tulip to force, but the color and form are a welcome addition to the cut-flower market. Its height is 50 centimeters. [PLATE 88]

FANTASY

'Fantasy' is one of the oldest Parrots, registered in 1910. Its raiser is unknown. Salmon pink with green stripes and feathers on the outer petals, 'Fantasy' is a sport of 'Clara Butt,' a salmon pink Darwin (now part of the Single Late group). One of the first Parrot tulips to mutate from a Darwin (this group is no longer a separate division), with the characteristically strong Darwin stem, 'Fantasy' set the standard when it first came out and is still one of the best. A beautiful tulip, it is 55 centimeters tall.

FLAMING PARROT

P. Heemskerk raised and C. A. Verdegaal registered 'Flaming Parrot' in 1968. Its petals are flamed red on a yellow ground. The yellow turns to white as the flower matures. The base is primrose yellow. 'Flaming Parrot' resembles a broken or virus-infected tulip (a Rembrandt tulip), but fortunately 'Flaming Parrot' is healthy. Nevertheless, because it has the Rembrandt color pattern, 'Flaming Parrot' is carefully monitored for viruses by the plant health inspectors in Holland. 'Flaming Parrot,' with a very strong stem that holds its large flower well, is becoming a classic. It is 70 centimeters in height. [PLATE 87]

GLASNOST

Registered by W. Van Lierop & Sons in 1990, 'Glasnost' is red with a broad yellow edge on the petals. One of the latest sports of 'Karel Doorman,' its curled petals have the broadest and most attractive Parrot fringe. 'Glasnost,' suitable for forcing, is 50 centimeters tall.

GREEN WAVE

J. J. Rozenbroek registered 'Green Wave' in 1984. A sport of the Viridiflora tulip 'Groenland,' its petals have a green flame and a soft mauve rim. The base is white. Very attractive with its unusual color combination, 'Green Wave' has a large flower on a strong stem. It is 50 centimeters in height. [PLATE 94]

HOLLAND HAPPENING

'Holland Happening,' a sport of the Darwinhybrid 'Apeldoorn,' was registered by Jan van Bentem in 1986. It is scarlet with a pattern of green flames that blend into the scarlet at the tips of the petals. 'Holland Happening,' 50 centimeters tall, has a very large flower on a stem that is barely strong enough to carry it; therefore it needs a sheltered position in the garden out of the wind.

JAMES V. FORRESTAL

An early sport of 'Karel Doorman,' this orange-red flower, edged yellow, was found and registered by John B. Meskers & Sons in 1955. Suitable for forcing, it is 55 centimeters.

KAREL DOORMAN

John B. Meskers & Sons registered 'Karel Doorman' in 1946. A sport of the Triumph tulip 'Alberio,' which is no longer in cultivation, 'Karel Doorman' is cherry red, edged yellow. It is named for an admiral of the Dutch fleet who in 1940 fought the Japanese fleet near the coast of Java for Indonesia, then called the Dutch Indies. (The Dutch were defeated and Doorman died there.) Mid-season flowering, unlike most Parrots, 'Karel Doorman' needs a bit more space in the garden because of its large flower. Also suitable for forcing, 'Karel Doorman' has many sports, including 'Apricot Parrot,' 'Doorman's Record,' 'Glasnost,'

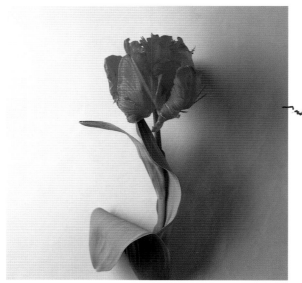

ERNA LINDGREEN [PLATE 286]

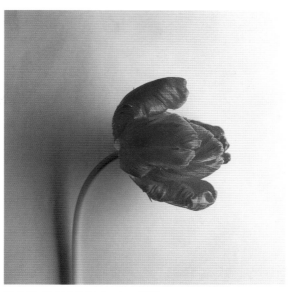

KAREL DOORMAN [PLATE 287]

'James V. Forrestal,' and 'Onedin,' all of which are similar in color but differ in the size of the fringe. The newer sports have the broader and more attractive fringes; 'Glasnost,' which came out in 1990, has the best fringe. 'Karel Doorman' is 50 centimeters tall. [PLATE 287]

LIBRETTO PARROT

'Libretto Parrot' was registered in 1993 by W. J. Kok & Sons. A sport of the Triumph tulip, 'Libretto,' with variable cream and pink coloring mixed with green that fades as the plant matures, 'Libretto Parrot' is a good forcing tulip with a strong stem. Its height is 40 centimeters. [PLATE 89]

ONEDIN

Registered by C. Adrichem in 1980, 'Onedin' has a pinkish flower with a canary yellow base. Its leaves are edged with a lighter color. While 'Onedin,' a sport of 'Karel Doorman,' is not a traditionally beautiful Parrot, the effect of the whole plant is quite striking. It is good for forcing and is 50 centimeters tall.

ORANGE FAVOURITE

K. C. Vooren & Sons registered 'Orange Favourite' in 1930. An older orange Parrot with green blotches and a yellow base, it is a fragrant flower. One of the best then and now, 'Orange Favourite' is beginning to show signs of aging and probably will not be around much longer. It will be greatly missed. With a reasonably good stem, its height is 50 centimeters.

ORANGERIE

'Orangerie' was registered by J. J. Rozenbroek in 1990. A recently named sport of 'Red Devil,' which is a sport of 'Karel Doorman,' 'Orangerie' is a large orange and yellow flower with a brown-red edge on the petals. Inside, the edge is a brighter red and the yellow base is spotted deep gray-blue. 'Orangerie,' fairly close in color to another Parrot tulip, 'Professor Röntgen,' is 55 centimeters in height. [PLATE 288]

PROFESSOR RÖNTGEN

Registered by C. A. Verdegaal in 1978, 'Professor Röntgen' has a beautiful large flower flamed lemon yellow on a rose-scarlet feathered ground and green basal blotches on a yellow ground. 'Professor Röntgen,' a sport of 'Salmon Parrot,' is named for the scientist who developed the radiation technique known as "Röntgen rays." Popular for forcing because of its unique color, it is 50 centimeters tall. "Röntgen rays" were used to create the mother plant, 'Salmon Parrot,' by stimulating the bulb of its mother plant, 'Karel Doorman,' with radiation to produce a mutation. [PLATE 289]

RAI

Burger & Blank registered 'Rai' in 1986. A Parrot sport of the Triumph 'Frederica,' which is a sport of 'Lustige Witwe,' it has a very pretty mixture of pinkish colors on the inside and outside of the petals. The base is yellowish-white. 'Rai' does not have a very strong stem, but its unusual coloring makes it very attractive. Its height is 35 centimeters.

RED CHAMPION

The first sport of 'Bartigon,' an old red Darwin tulip no longer in cultivation, 'Red Champion,' registered in 1930 by H. M. Ruysenaars, is bloodred. 'Red Champion' has several sports, including 'Estella Rijnveld.' It is 50 centimeters tall.

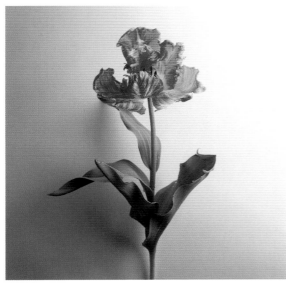

ORANGERIE [PLATE 288]

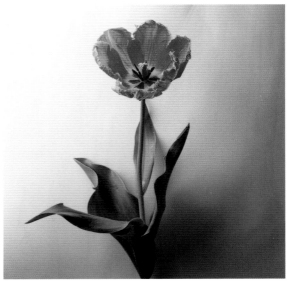

PROFESSOR RÖNTGEN [PLATE 289]

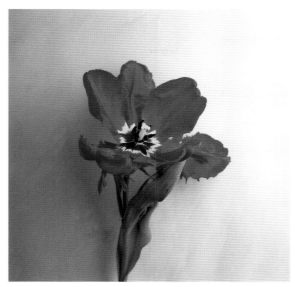

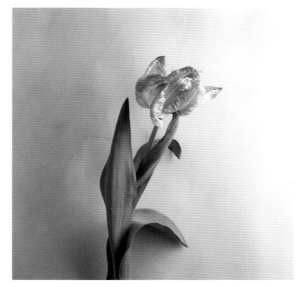

TOPPARROT [PLATE 290]

WEBER'S PARROT [PLATE 291]

RED PARROT

'Red Parrot' was registered in 1940 by J. C. Evers and has a raspberry red flower with exquisite Parrot form and a sturdy stem. 'Red Parrot' is still going strong nearly sixty years after it was first introduced. A lovely tall tulip, it is 70 centimeters in height.

ROCOCO

'Rococo' was registered in 1942 by H. Slegtkamp & Company. A sport of the Triumph tulip 'Couleur Cardinal,' it is a simple red Parrot with a striking red fringe and excellent form. It takes up about one third of all the acreage for Parrot tulips in Holland. Used for forcing throughout the season, this beautiful tulip is short-stemmed and, unlike most Parrots, flowers mid-season. Its height is 35 centimeters. [PLATE 93]

TEXAS FLAME

A sport of 'Texas Gold,' another Parrot tulip, 'Texas Flame' was found and registered by J. J. de Wit in 1958. A large and colorful flower with a carmine-red flame on a buttercup yel-low ground, 'Texas Flame' is very late flowering. Although it does not have a very strong stem, it is an attractive addi-tion to gardens. It is 45 centimeters in height. [PLATE 92]

TOPPARROT

Registered by Triflor in 1992, 'Topparrot' is a sport of 'Prominence,' a dark red Triumph popular for forcing. 'Topparrot' is also deep red, with a primrose yellow base, and though relatively new has the potential to become a mass-produced forcing tulip—the large flower is carried on a strong stem and it is easy to force. In gardens, it flowers mid-season, unlike other Parrots. Its height is 40 centimeters. [PLATE 290]

WEBER'S PARROT

'Weber's Parrot,' found and registered by Van Graven Brothers in 1968, has a large ivory white flower with rosy-purple coloring extending to the edges of the petals. A sport of an old Mendel tulip, 'Weber,' this is one of the very few Parrot sports of a Mendel and it is questionable whether it will prove durable. With a slender stem that is not very strong, 'Weber's Parrot' is nevertheless used for forcing because of its exceptional color. Also striking in gardens, it is 40 centimeters tall. [PLATE 291]

WHITE PARROT

Found and registered by Valkering & Sons in 1943, 'White Parrot' has a pure white flower and for many years was the *only* white Parrot. A beautiful tulip, it has broad leaves and is 40 centimeters tall.

FRINGED GROUP

The Fringed tulips are a group of tulips with crisply cut, short, and spiky fringes on the edges of their petals. Similar to Parrot tulips but less pleated and frilly, the Fringed tulips became recognized as their own group in 1981. They began to show up about fifty-five years earlier when 'Sundew' appeared in 1925 as a Fringed sport of 'Orion,' a scarlet Darwin. The second Fringed tulip occurred a few years later, in 1930, a sport of a very old Double Early tulip called 'Titian,' which was red with beautiful golden yellow margins. This sport, 'Fringed Beauty,' is still very much in demand today. It has a golden yellow fringe along the edges, accentuating the red in the flower color, and is typical of those Fringed tulips whose crystalline edges contrast with the flower color. Next came 'Sothis,' a richer and deeper red mutation of 'Sundew.' Both have long since disappeared; nevertheless, along with 'Fringed Beauty' they helped establish the market for tulips with these unusual fringes on the tepals, and Dutch bulb growers set about looking for sports.

While the Fringed tulips originated as sports, it was quickly discovered they could also be created through hybridizing. Two hybridizers from Lisse, Segers Brothers and Nieuwenhuis Brothers, created the majority of Fringed tulips. First they began to cross Single Late tulips with Fringed tulips. Their goal—to create Fringed tulips that could be forced—was finally achieved through crosses with Triumph tulips. When Segers Brothers closed its business in 1975, its stock and seedlings went to a grower in Noordwijkerhout, W. A. M. Pennings, which has built up a large domestic trade.

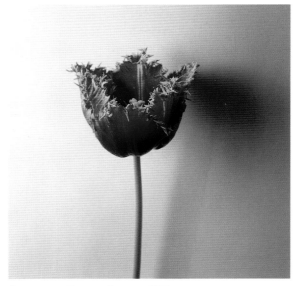

AMERICAN EAGLE [PLATE 292]

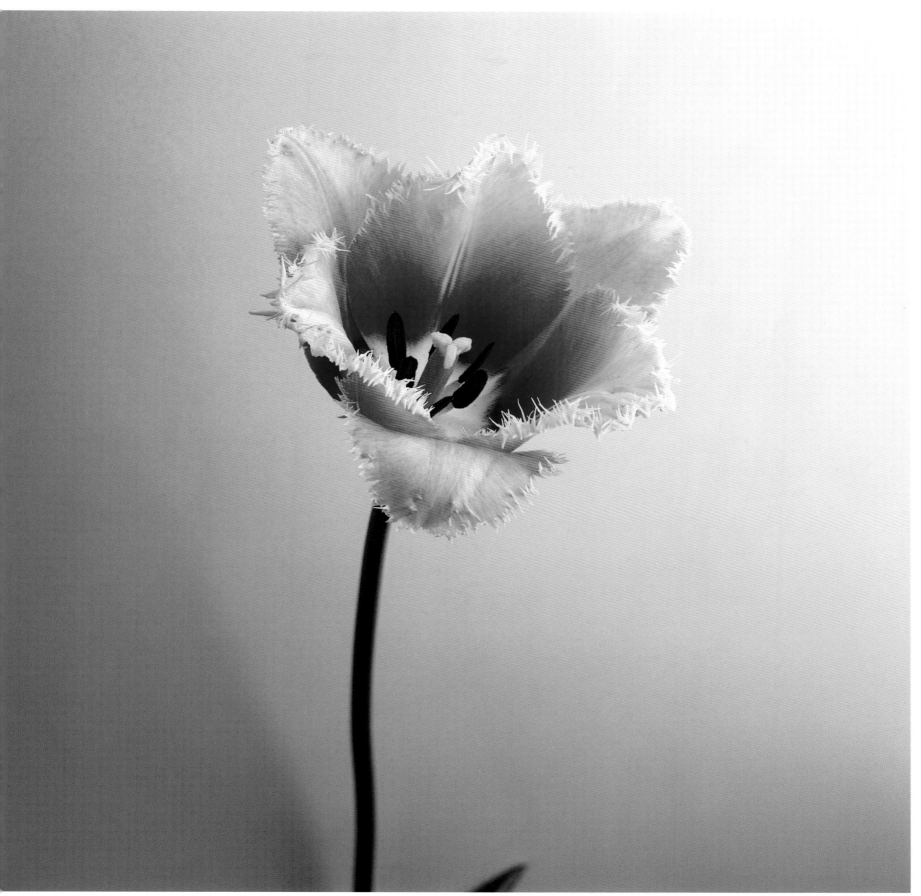

Canova [plate 293]

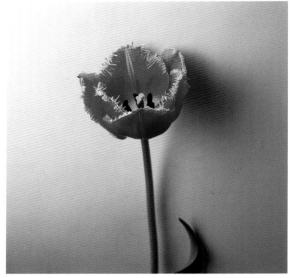

Bellflower [PLATE 294]

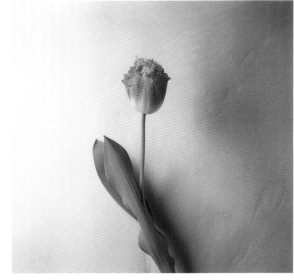

Fancy Frills [PLATE 295]

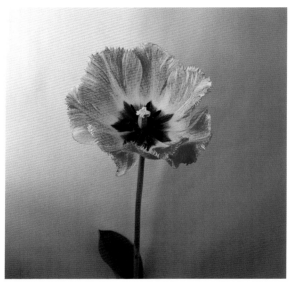

Fringed Gudoshnik [PLATE 296]

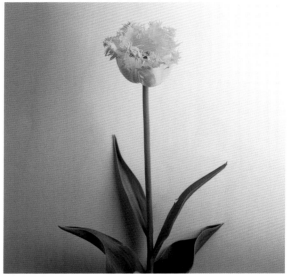

Hamilton [PLATE 297]

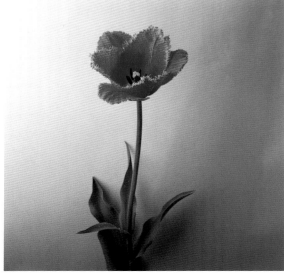

Heidrun Harden [PLATE 298]

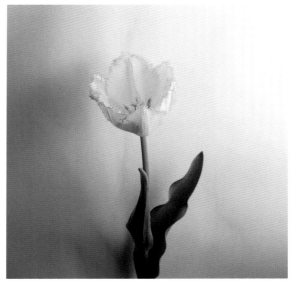

Laverock [PLATE 299]

Mutations continue to occur, producing more Fringed tulips. Even the newer Darwinhybrids, which have been around since only the 1940s, are producing Fringed sports. 'Apeldoorn,' for instance, has several very attractive Fringed sports. Most of the tulips in the Fringed group flower late, although some, such as the Fringed Darwinhybrid mutations, flower earlier, and their heights range from 25 to 70 centimeters. All are great in gardens. Only some are suitable for forcing.

ALEPPO

Registered by Segers Brothers in 1969, 'Aleppo' is red with a broad apricot-colored rim and an excellent fringe. The base is bright yellow. 'Aleppo' is a robust plant and is 50 centimeters tall. [PLATE 96]

AMERICAN EAGLE

'American Eagle,' registered by J. N. M. van Eeden in 1987, is still considered rather new. It is reddish-violet, with petals flamed an unusual violet-purple color, and the base is yellow on a purple ground. This is a large flower with an attractive fringe. Its height is 55 centimeters. [PLATE 292]

ARMA

Registered by Knijn Brothers in 1962, 'Arma' is cardinal red with fringed edges that sometimes carry a tinge of yellow. The flower, which is egg-shaped, opens very slowly. A sport of the scarlet Triumph tulip 'Couleur Cardinal,' 'Arma' has been a popular Fringed tulip for many years and continues to be grown in large quantities in Holland, ensuring the stock's stability. Suitable for forcing, it is 35 centimeters in height. [PLATE 99]

BELLFLOWER

Segers Brothers registered 'Bellflower' in 1970. This Fringed tulip is a deep rose with a distinctive crystalline fringe. The base is white, tinged blue, and the anthers are yellow. 'Bellflower's petals are very rounded and quite beautiful. This is a tall plant at 60 centimeters. [PLATE 294]

BURGUNDY LACE

'Burgundy Lace' was registered by Segers Brothers in 1961. A Fringed tulip with a uniform color—bright claret wine red—'Burgundy Lace' was much in demand in the 1970s and 1980s and was the leading tulip in production. Today the multicolored Fringed tulips are more popular than those with uniform color, and 'Burgundy Lace,' while still in cultivation, is not as widely grown. The very last of the Fringed tulips to flower, 'Burgundy Lace' is a tall plant at 70 centimeters. [PLATE 98]

CANOVA

In 1971, Segers Brothers raised and registered 'Canova.' The flower is violet and the fringe on the petals is white, an attractive combination. 'Canova' is strong and tall, with a height of 60 centimeters. [PLATE 293]

CRYSTAL BEAUTY

P. van Dijk & Sons registered 'Crystal Beauty' in 1982. 'Crystal Beauty,' a sport of the cherry red Darwinhybrid 'Apeldoorn,' is claret rose with a fringe on the petals that is reddish-orange. 'Crystal Beauty' and 'Fringed Apeldoorn,' another 'Apeldoorn' sport, look very similar, but 'Crystal Beauty,' which was found eleven years later, has the better-developed fringe of the two: It is broader and more visible. The height is 55 centimeters.

FANCY FRILLS

Segers Brothers raised 'Fancy Frills' and W. A. M. Pennings registered it in 1972. A pink flower with a broad white rim and a large white base, its fringe is well developed. Often used for forcing, it is 45 centimeters tall. [PLATE 295]

FRINGED APELDOORN

Registered by Looyestein & Sons in 1971, 'Fringed Apeldoorn' is a sport of the Darwinhybrid 'Apeldoorn.' It has the same uniform coloring as 'Apeldoorn'—cherry red—but with a fringe. Its height is 55 centimeters.

FRINGED BEAUTY

'Fringed Beauty' was introduced in 1930; its raiser is unknown. A sport of 'Titian,' an old Double Early tulip that was vermilion with golden yellow margins, 'Fringed Beauty' has the same wonderful color combination with a good fringe. After nearly 70 years, 'Fringed Beauty' is still in cultivation, but the stock is showing signs of degeneration. It is shorter than most of the other Fringed tulips—only 25 centimeters in height. [PLATE 100]

FRINGED GOLDEN APELDOORN

Registered by C. & W. Nijssen in 1982, 'Fringed Golden Apeldoorn' is a sport of 'Golden Apeldoorn.' Like 'Golden Apeldoorn,' it is a golden yellow color with a black star-shaped base. Its height is 55 centimeters.

FRINGED GUDOSHNIK

This is a new Fringed tulip, found in 1995 and not yet in commerce or registered. 'Fringed Gudoshnik' is a sport of that strangely colored Darwinhybrid, 'Gudoshnik': The flower is yellow, its petals spotted and streaked with red. The base is black. 'Fringed Gudoshnik' is a tall plant, 60 centimeters, with a big flower. [PLATE 296]

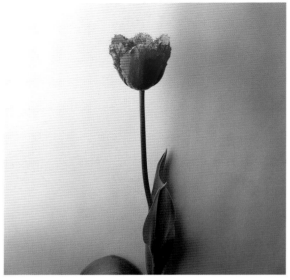

MAX DURAND [PLATE 300]

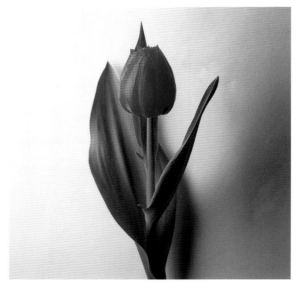

RED WING [PLATE 301]

FRINGED SOLSTICE

Registered by W. Philipsen in 1989, 'Fringed Solstice' is a sport of 'Fringed Apeldoorn.' It has a lemon yellow flower with darker margins on the petals and a bloodred flame that is sometimes feathered. In some instances, the flame covers the entire petal. It is 55 centimeters in height.

HAMILTON

'Hamilton' was registered by Segers Brothers in 1974. It is buttercup yellow with a particularly attractive fringe of the same color. For a while 'Hamilton' was used for forcing, but it proved too difficult because of a virus to which the plant was susceptible. It is 65 centimeters tall. [PLATE 297]

HEIDRUN HARDEN

Segers Brothers registered 'Heidrun Harden' in 1970. A crimson tulip with a reddish-colored fringe, 'Heidrun Harden' flowers a little later than most Fringed tulips. The base is white, edged blue. Its height is 55 centimeters. [PLATE 298]

LAVEROCK

'Laverock,' registered in 1970 by Segers Brothers, has a bright yellow flower and a particularly well-developed fringe that is darker yellow. Somewhat leafier than most Fringed tulips, 'Laverock,' 55 centimeters tall, will require a little more space in the garden. [PLATE 299]

MADISON GARDEN

'Madison Garden' was raised by Segers Brothers and registered by W. A. M. Pennings in 1986. Carmine-red with a very good yellow-pinkish rim, 'Madison Garden' is medium height, 50 centimeters, with a very large flower that necessitates a bit more space in the garden. The base

is yellowish-white. Strong and sturdy, 'Madison Garden' is suitable for forcing. [PLATE 95]

MAJA

Registered by Segers Brothers in 1968, 'Maja' is pale yellow with a lighter yellow color on the edges. The base is bronze-yellow. It flowers a little later than the other Fringed tulips, and because it is a big plant, 'Maja' needs some extra space in the garden. This tall, robust plant is 65 centimeters in height. [PLATE 97]

MAX DURAND

'Max Durand' was registered by Segers Brothers in 1972. The flower color is violet-purple with a lighter violet rim and fringe. The base is white. 'Max Durand' is a stately tulip, 50 centimeters tall, that stands well in the garden. [PLATE 300]

RED WING

'Red Wing' was registered by Segers Brothers in 1972 and is glowing cardinal red with a lighter red fringe. The base is black with a yellow edge. Despite the initial optimism that 'Red Wing' could satisfy the demand for a good forcible Fringed tulip, its heavy leaves proved too weak. Still a great garden tulip, 'Red Wing' is 50 centimeters in height. [PLATE 301]

SWAN WINGS

Raised by Segers Brothers and registered in 1959, 'Swan Wings' is one of the few white Fringed tulips. A pure white flower with a fine fringe, its black anthers stand out when the flower is open. 'Swan Wings' has survived a long time in cultivation. Its height is 55 centimeters. [PLATE 302]

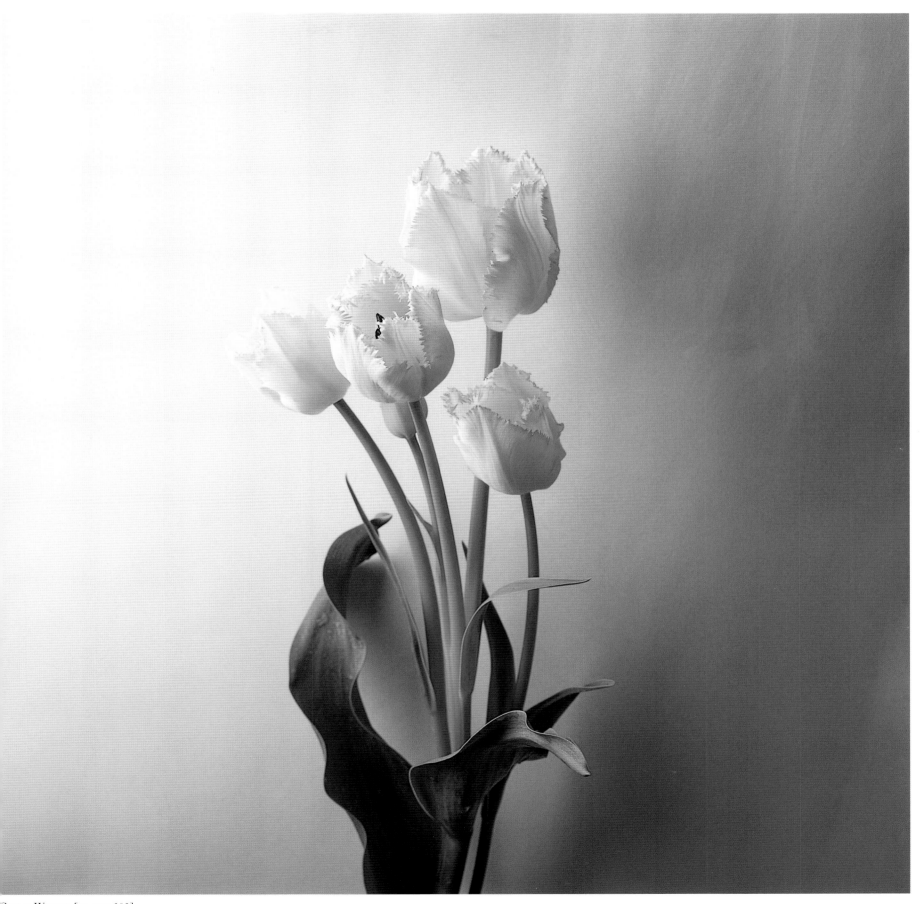

Swan Wings [plate 302]

SINGLE LATE GROUP

The Single Late tulip group is a mixture of old tulip divisions and newer developed strains. Today the group consists mostly of tulips grown from 'Mrs. John T. Scheepers' seedlings and sports of 'Temple of Beauty.' Sometimes called "the dustbin of classification," the Single Late group is where the old divisions such as the English and Dutch Cottage tulips, Darwins, and Breeder tulips have been collected. It is a variable group of flowers with a range of single- and multiheaded late flowers that are mostly long-stemmed. The main shared qualities are the single form of the flowers and late-flowering time. The total tulip acreage in Holland for growing the Single Late tulips is about 4 percent.

Some Single Late tulips are sports of the wonderful old Darwin tulip 'Bartigon'—and sports of sports of 'Bartigon.' At one time there were thirty-one 'Bartigon' sports in cultivation; in 1971 there were twenty-five; in 1981 there were fifteen. Today there are only a handful. 'Bartigon' and its sports were valuable forcing tulips, with large flowers on very sturdy stems. However, their decline in tulip acreage is due in large part to the rise in the 1950s of the Triumph tulips, which took their place in the forcing market. Triumphs are less expensive to produce since they require less time in the hothouse. The Single Late

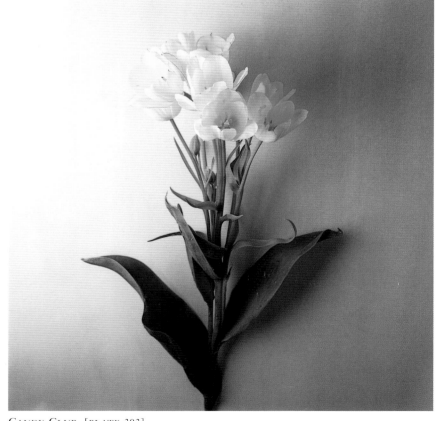

CANDY CLUB [PLATE 303]

forcing tulips generally required about four weeks in the hothouse, but most of the Triumphs only need half that time to flower.

Quite a few Dutch bulb growers grew 'Bartigon' and found and raised its sports, including the authors' grandfather, Willem Lemmers. Another finder was Piet Bakker Jr. from Enkhuizen, whose nickname was "Tulpenpiet" ("Tulip Pete"). A tulip grower who pioneered bulb growing in the clay area in the north of Holland near the former Zuiderzee around 1910, Piet Bakker became a legend among bulb growers. He never failed to make the long trip each Monday to the tulip exchange in Haarlem. It was said that Tulpenpiet would do anything to get to the exchange and did not mind the road conditions in the winter, which in those days were treacherous, or the traffic police, who often issued him speeding tickets.

All the tulips in the Single Late group are good in gardens and some are also used for forcing.

ATLANTIS
In 1981, J. Ligthart registered 'Atlantis,' a unique amethyst-violet tulip with a broad white edge that was raised by J. F. van den Berg & Sons. The round-shaped flower sits on a sturdy stem. 'Atlantis,' used for forcing, is 40 centimeters in height.

AVIGNON
Found and registered by W. Dekker in 1966, 'Avignon' is orange with pink shades and its base is yellow with a greenish edge. A sport of 'Renown,' a rosy-red Single Late tulip, it is 65 centimeters tall.

BIG SMILE
Raised by IVT and registered by W. Van Lierop & Sons in 1990, 'Big Smile' has a large oval-shaped flower that starts out lemon yellow, then matures into a deeper yellow. A cross between 'Mrs. John T. Scheepers,' another Single Late tulip, and the species tulip *T. eichleri* 'Excelsa,' with a height of 60 centimeters, this is an excellent garden tulip. [PLATE 106]

BLACK DIAMOND
Registered by Rijnveld & Sons in 1962, 'Black Diamond' is reddish-brown, growing darker at the edges of the petals. Its height is 70 centimeters.

BLUSHING BEAUTY
'Blushing Beauty,' registered in 1983 by D. W. Lefeber & Company, is flamed red on apricot-orange on the exterior of the petals and a rosy-white feathered flame on the inside, giving this tulip with a blushing color a well-chosen name.

The base is yellow. A sport of 'Temple of Beauty,' 'Blushing Beauty' has an elongated flower that lasts a very long time and its height is 75 centimeters. [PLATE 103]

BROADWAY
'Broadway,' raised by J. F. van den Berg & Sons and registered by P. C. de Geus in 1985, is flamed ruby red with a white rim on the exterior of the petals and feathered red on interior with a narrower white edge. A broad flower, suitable for forcing, it is 40 centimeters tall.

CANDY CLUB
Registered by H. G. Huyg & Sons in 1993, 'Candy Club' is multiheaded. Its white petals have violet bands on the rims that grow larger as the flowers mature. The leaves have a pale green edge. Its height is 50 centimeters. [PLATE 303]

CARAVELLE
In 1981, Konijnenburg & Mark registered 'Caravelle,' a well-proportioned, glowing ruby red flower with a darker red rim and black base. 'Caravelle' is a sturdy plant with many leaves, 55 centimeters tall. Beautiful in gardens, it will need a little more space. 'Caravelle' is also suitable for forcing.

CASHMIR
Registered by Segers Brothers in 1969, 'Cashmir' is a bright red flower that has a yellow base with a narrow green edge. The longish flower form and long stem reflect its 'Mrs. John T. Scheepers' parentage. A very pretty tall tulip, 'Cashmir' is 70 centimeters in height.

COLOUR SPECTACLE
Kees Visser registered 'Colour Spectacle' in 1990. A multiheaded yellow sport of 'Georgette' with deep red flames on the petals and a yellow base, it is 50 centimeters in height. [PLATE 305]

CORDELL HULL
A sport of 'Bartigon,' raised and registered by Piet Bakker in 1933, 'Cordell Hull' is a striking combination: white with a red flame on each petal. Good for forcing, it has a strong stem and is 55 centimeters tall. [PLATE 110]

CRI DE COEUR
In 1973, P. C. de Geus and A. Moras registered 'Cri de Coeur,' a primrose yellow sport of 'Renown' with a cherry red flame on the petals and a yellow base. The yellow in 'Cri de Coeur' comes from the parent of 'Renown,' 'Mrs. John T. Scheepers,' which is also yellow. 'Cri de Coeur' is 65 centimeters in height.

CUM LAUDE

'Cum Laude,' registered by J. J. Grullemans & Sons in 1944, is a dark violet color that almost looks blue and has a white base. Originally a Darwin, 'Cum Laude' became a Single Late tulip after the Darwins were reclassified. A strong tulip, it is 60 centimeters tall. [PLATE 306]

DELMONTE

J. F. van den Berg & Sons registered 'Delmonte' in 1978. The exterior is a rosy-purple color, the interior a lighter rosy-purple, and the base is yellow. Suitable for forcing, Delmonte is 45 centimeters in height. [PLATE 307]

DILLENBURG

'Dillenburg,' raised by C. G. van Tubergen, has no known registration date but it did receive an award from the KAVB in 1930. A terra-cotta orange tulip that is fragrant, 'Dillenburg,' a former Dutch Breeder tulip, became one of the first orange Single Lates when Dutch Breeders were reclassified. A gorgeous tulip, it is 60 centimeters tall. [PLATE 308]

DORDOGNE

'Dordogne,' a sport of 'Menton,' was registered by W. Dekker & Sons in 1991. A dark rose flower with red and orange colors blended in, 'Dordogne' has a yellow base with green stripes. It stands 65 centimeters tall.

DREAMLAND

Registered by H. G. Huyg in 1969, 'Dreamland' is a cross between 'Her Grace,' a former Mendel tulip (now a Triumph), and 'Elisabeth Evers,' a Triumph, both of which are white and pink. 'Dreamland' is rosy-red white with a broad edge and white base. One of the best, most robust garden tulips available today, 'Dreamland' has a sturdy flower that holds its color very well. Its height is 60 centimeters. [PLATE 109]

ESTHER

C. J. Keppel registered 'Esther' in 1967. The flower is fuchsia pink with a lighter edge on the outsides of the petals and the base is blue. Suitable for forcing, 'Esther,' 50 centimeters tall, is one of the most popular tulips in Japan. [PLATE 304]

GEORGETTE

'Georgette,' registered in 1952 by Hybrida, is yellow with a red edge on the petals that intensifies into a deeper red as the flower matures. A multiheaded tulip, 'Georgette' provides long-lasting color as new flowers emerge. In the past, the few late-flowering cultivars with multiheaded flowers such as 'Georgette' were classified into the Cottage division, which now no longer exists. Very late flowering, with pointed flowers on long and slender stems, 'Georgette,' with a height of 50 centimeters, is perfect in gardens. 'Georgette' has three sports: 'Colour Spectacle,' 'Lucette,' and 'Red Georgette.' [PLATE 108]

HOCUS POCUS

D. W. Lefeber registered 'Hocus Pocus' in 1983. It is sulfur yellow with an irregular darker yellow flame on the petals that becomes pink at the tips; the colors inside are brighter yellow. A sport of 'Temple of Beauty,' 'Hocus Pocus' has similar spotted leaves that appear when the plant is young, then disappear as the flower matures. Its height is 70 centimeters. [PLATE 317]

KINGSBLOOD

'Kingsblood,' registered by Konijnenburg & Mark in 1952, is cherry red; the petals are edged scarlet. Its parents are a carmine Triumph 'Korneforos' and 'Mrs. John T. Scheepers.' It is 60 centimeters tall.

LA COURTINE

W. Dekker & Son registered 'La Courtine,' a sport of 'Renown,' in 1988. The flower is yellow with a lighter yellow color extending midway over the petals, which have bloodred mid-veins. The red is more pronounced on the interior of the flower. Its height is 65 centimeters.

LUCETTE

Registered in 1990 by Kees Visser, 'Lucette' is a yellow sport of 'Georgette' with some red spots on the exterior of the petals. Multiheaded like 'Georgette,' it is 50 centimeters in height. [PLATE 318]

MAGIER

In 1951, Hybrida raised and registered 'Magier,' which is white with a small violet-blue rim. As the flower matures, the violet-blue color spreads into the whole of the flower, leaving a bit of white on the base. 'Magier,' which is Dutch for "magician," is an appropriate name for this seemingly magical flower that right before our eyes turns from white to violet-blue. Long-lasting, 'Magier' is 60 centimeters tall.

MAUREEN

Registered in 1950 by Segers Brothers, 'Maureen' is a marble white seedling of 'Mrs. John T. Scheepers.' The influence of 'Mrs. John T. Scheepers' can be seen in 'Maureen's long flower and tall stature. At 70 centimeters, it is one of the tallest tulips. 'Maureen' is one of several Single Late tulips whose stock is initially grown in Holland, then

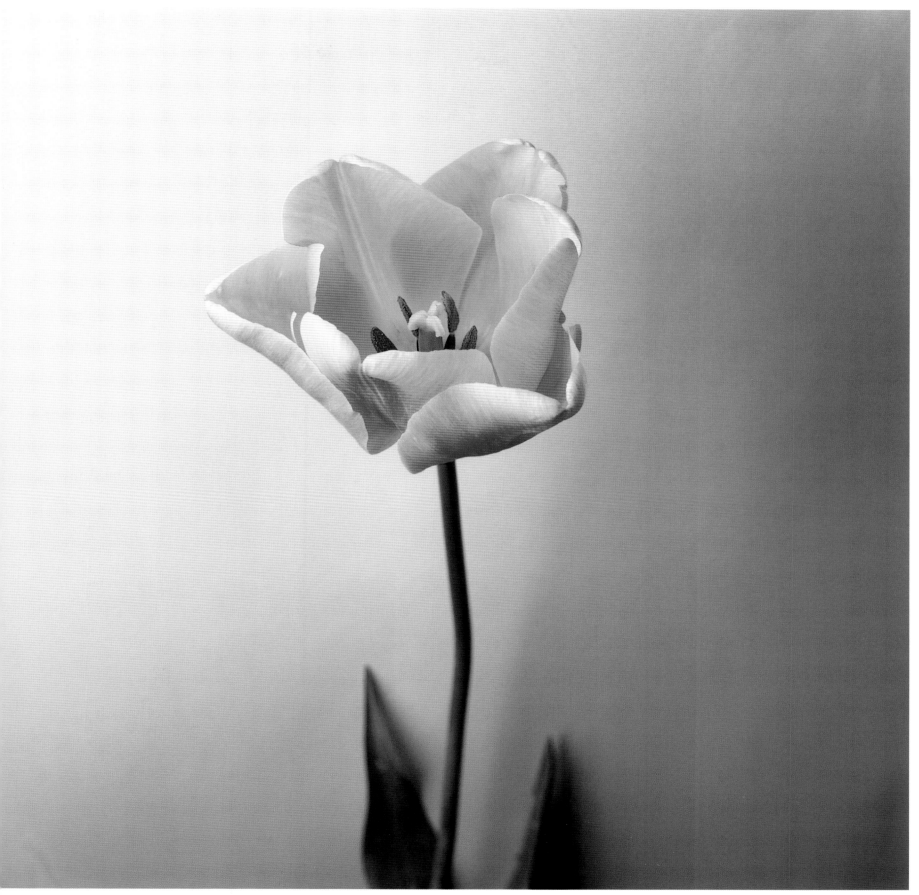

ESTHER [PLATE 304]

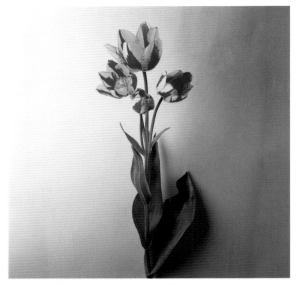

Colour Spectacle [plate 305]

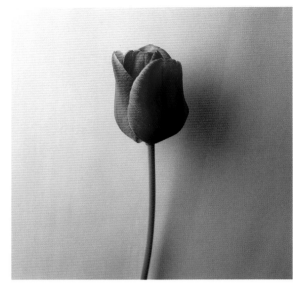

Cum Laude [plate 306]

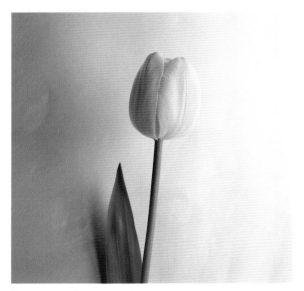

Delmonte [plate 307]

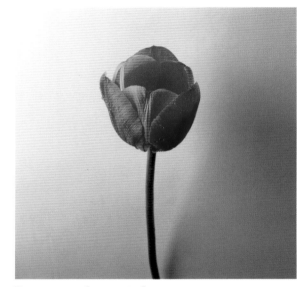

Dillenburg [plate 308]

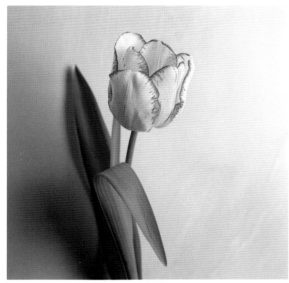

Montgomery [plate 309]

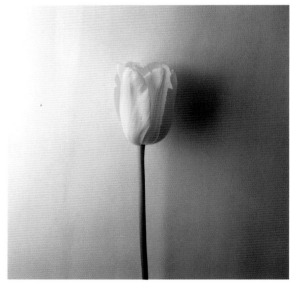

Mrs. John T. Scheepers [plate 310]

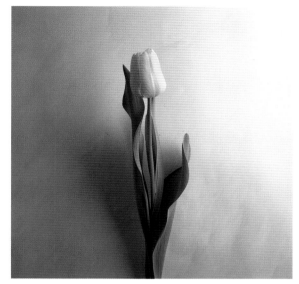

PINK DIAMOND [PLATE 311]

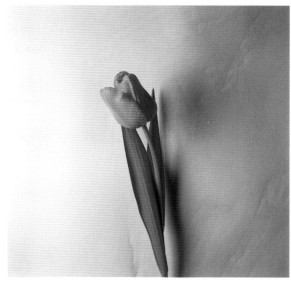

QUEEN OF BARTIGONS [PLATE 312]

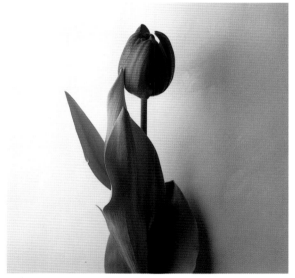

RECREADO [PLATE 313]

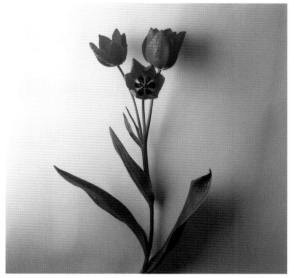

RED GEORGETTE [PLATE 314]

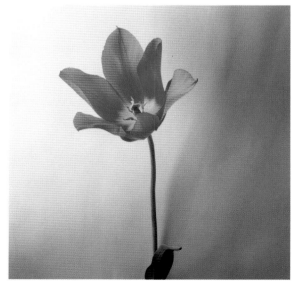

TEMPLE OF BEAUTY [PLATE 315]

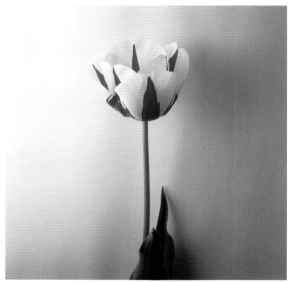

WORLD'S EXPRESSION [PLATE 316]

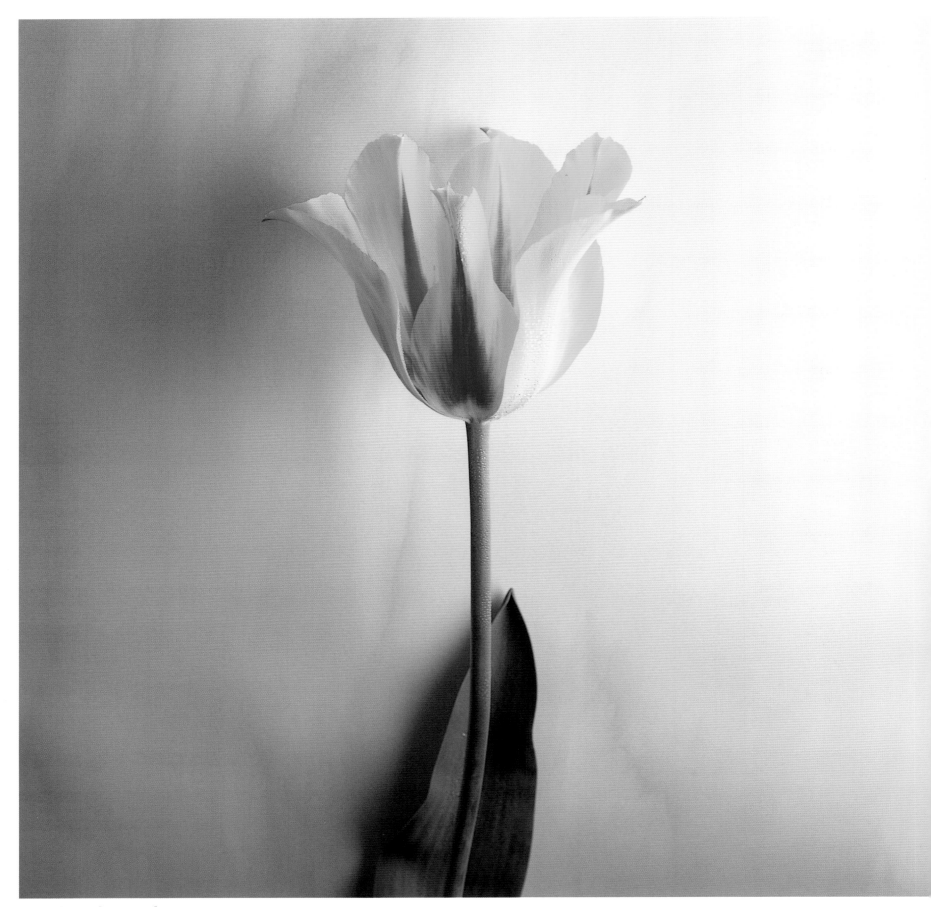

Hocus Pocus [plate 317]

exported to fields in the south of France, where the bulbs are planted and flowers are harvested the following spring. In this warmer climate, flowers appear about two weeks earlier than those grown in Holland. In order to keep the bulbs producing, a leaf is left on the plants and the bulbs are left in the ground. Each year, plants will produce flowers a little earlier in the spring until the bulbs eventually die out, usually after about three years. Most of the flowers are sold in Paris markets early in spring.

MENTON
Found by W. Dekker & Son in 1971, 'Menton' is a lighter pink color than the rosy-red 'Renown,' of which it is a sport, and also has some orange in its color. Its height is 65 centimeters. [PLATE 102]

MONTGOMERY
Registered by E. J. van der Zaal in 1954, 'Montgomery' is a sport of 'Cordell Hull.' The flower is white with a spotted red rim that grows wider as the flower matures. 'Montgomery,' suitable for forcing, is 55 centimeters tall. [PLATE 309]

MRS. JOHN T. SCHEEPERS
The year of introduction is unknown for 'Mrs. John T. Scheepers,' but this outstanding all-yellow tulip is large—the flower is nearly twice the length of most tulips. It received an Award of Merit in 1930 and a First Class Certificate in 1931 from the KAVB. The broad leaves and size of this plant, 60 centimeters tall, require that it be allowed a little more space in the garden. 'Mrs. John T. Scheepers' has been used extensively in breeding and has produced many seedlings. Three outstanding tulips grown from seedlings are 'Kingsblood,' which is red, 'Maureen,' which is white, and 'Renown' which is pink. There are several others but 'Renown' is the most successful of the 'Mrs. John T. Scheepers' seedlings because it has produced many sports in a wide range of colors. [PLATE 310]

PERESTROYKA
'Perestroyka,' a sport of 'Temple of Beauty,' was found by D. W. Lefeber & Company in 1990 and sold in a green auction when Lefeber closed his nursery. W. Van Lierop & Sons bought and registered it with a name to commemorate the collapse of the Communist regime in Russia. 'Perestroyka' is a soft mixture of colors: The exterior is scarlet with orange margins and a red flame and the interior is orange with a narrow red flame. The base is yellow. Like its mother plant, 'Temple of Beauty,' 'Perestroyka' has spots on its leaves, which disappear as the flower matures. One of the tallest Single Late tulips, 'Perestroyka' is 75 centimeters in height.

PHILIPPE DE COMINES
A very old Single Late tulip, 'Philippe de Comines' was registered in 1891 by E. H. Krelage and has a particularly beautiful small maroon, almost black flower. A slender plant, it is 55 centimeters in height.

PICTURE
'Picture,' raised and registered by G. Baltus in 1949, is a lilac-rose flower. Its form is distinct, resembling an ornamental urn with its curled edges. 'Picture' may be the first of many other tulips with this unusual shape, as it has recently produced two sports: one a darker rose color and the other white, both of which will be registered in the near future. 'Blenda,' a Triumph, has a similar form to its flower and has also recently produced sports that will soon come on the market. It is possible that these are the first tulips in what may be, in years to come, an entirely new tulip group. 'Picture' is 60 centimeters tall. [PLATE 107]

PINK DIAMOND
Registered in 1976 by C. N. Verbruggen, 'Pink Diamond' has a very soft pink flower with a lighter pink on the outsides of the petals. Inside, the flower is pink and the base is gray-yellow. Suitable for forcing, it is 50 centimeters in height. 'Pink Diamond' is one of the most popular tulips in Japan. [PLATE 311]

PINK JEWEL
'Pink Jewel,' registered in 1980 by J. J. Duif, is very light pink with a white flame on the petals and a white base. The pink color inside is a deeper pink. A sport of 'Queen of Bartigons,' and suitable for forcing, it is 55 centimeters tall. [PLATE 105]

QUEEN OF BARTIGONS
In 1944, Piet Bakker registered 'Queen of Bartigons,' a salmon pink sport of 'Bartigon' that is the most beautiful of all the pink tulips. Its white base is edged blue. Suitable for forcing, it is 55 centimeters. [PLATE 312]

QUEEN OF NIGHT
'Queen of Night,' a deep velvety maroon tulip whose year of introduction is not known, won an Award of Merit in 1944 from the KAVB. Its raiser, J. J. Grullemans & Sons of Lisse, was a bulb grower and exporter from 1839 to 1965 that grew many late-flowering tulips for its own trade. 'Queen of Night' was one of the first nearly black tulips to come on the market for forcing and today continues to hold a valuable place. A very beautiful tulip, it is 60 centimeters in height. [PLATE 104]

RECREADO

In 1979, Kees Visser registered 'Recreado,' a dark purple tulip with a violet flame. The color inside is glistening purple. 'Recreado' has an egg-shaped flower and a sturdy stem. Suitable for forcing, it is 50 centimeters in height. [PLATE 313]

RED GEORGETTE

Registered in 1983 by Kees Visser, 'Red Georgette' is an all-red sport of 'Georgette.' It is multiheaded and 50 centimeters tall. [PLATE 314]

RENOWN

'Renown,' a 'Mrs. John T. Scheepers' seedling, was registered in 1949 by Segers Brothers. It is rosy-red, edged a paler rose, and the base is yellow. Its height is 65 centimeters. 'Renown' has an enormous flower that grows from an exceptionally large bulb. It has produced several sports, including 'Avignon,' 'Cri de Coeur,' 'La Courtine,' and 'Menton.'

ROSA LISTO

Raised by Segers Brothers and registered by C. W. van der Salm & Sons in 1986, 'Rosa Listo' is flamed rosy-red on the exterior of the petals. Inside, the color is a softer rose with a carmine-tinted edge on the petals and a white base. Its height is 50 centimeters. When the firm of Segers Brothers in Lisse closed its nursery business in 1975, it sold its bulbs to other bulb growers out of its fields in a green auction. Van der Salm, from Breezand, came to the Segers bulb fields to purchase hyacinths and dug up the bulbs himself. He planted his new bulbs and discovered the following year when they came up that, among his hyacinth seedlings, he also had tulip seedlings. He selected one of the seedlings, named it 'Rosa Listo,' and gave credit to Segers Brothers for raising it by registering it in both his and Segers Brothers' names.

SORBET

Registered by J. J. Eyken in 1959, 'Sorbet' is flamed carmine-red on a white ground. 'Sorbet' is a sharp, two-colored flower—the recipient of many garden awards. The base is creamy white. Its height is 60 centimeters. [PLATE 101]

SWEET HARMONY

J. B. Roozen registered 'Sweet Harmony' in 1944. Light yellow, edged white, its rich and creamy color can best be described by the nickname Dutch bulb growers have given it: "Advocaat met slagroom," which translates as "Eggnog with cream." A sturdy plant, 'Sweet Harmony' is aging now but still wonderful. It is 55 centimeters in height.

TEMPLE OF BEAUTY

Registered by D. W. Lefeber & Company in 1959, salmon rose 'Temple of Beauty' is the result of a cross between 'Mariette,' a Lily-flowered tulip, and an unknown Greigii. With pointed petals that resemble those of its Lily-flowered parent, 'Temple of Beauty's slightly mottled leaves reflect its Greigii influence. As the plant matures, the leaves lose their markings and become all-green. Its height is 75 centimeters. 'Temple of Beauty' has a long-lasting vase life and is often used as a cut flower, picked from fields late in the spring. There are many sports, including 'Blushing Beauty,' 'Hocus Pocus,' 'Perestroyka,' and 'Temple's Favourite.' [PLATE 315]

TEMPLE'S FAVOURITE

'Temple's Favourite' was registered by D. W. Lefeber & Company in 1984 and is a deeper rose color than its mother plant, 'Temple of Beauty,' which is salmon rose. 'Temple's Favourite' also has a reddish edge and a yellow base. Like 'Temple of Beauty,' 'Temple's Favourite' has leaves with markings that gradually disappear as the plant matures. At 75 centimeters, it is very tall.

TOYOTA

Raised by IVT and registered by Captein Brothers and Van Til Hartman in 1984, 'Toyota' is the result of a cross between 'Duc de Berlin,' a red-and-yellow Single Early tulip from 1860, and 'Mrs. John T. Scheepers.' 'Toyota' is white with a deep red flame and scarlet-edged petals. The base is yellow. 'Toyota' has suffered because of its name, which it was given as a promotion by the Toyota car company and has proven to be off-putting to buyers in the American market. Its height is 65 centimeters.

VLAMMENSPEL

Fireside

'Vlammenspel,' registered in 1941 by P. Groot, is yellow with a bloodred flame on the petals. Very late flowering, 'Vlammenspel' is 50 centimeters in height.

WORLD'S EXPRESSION

In 1993 Worldson Bulbs registered 'World's Expression,' a square and sturdy yellow flower with bright red feathering on the petals. One of the most long-lasting tulips, 'World's Expression' flowers a little later than most Single Late tulips. It is very beautiful and is 60 centimeters tall. [PLATE 316]

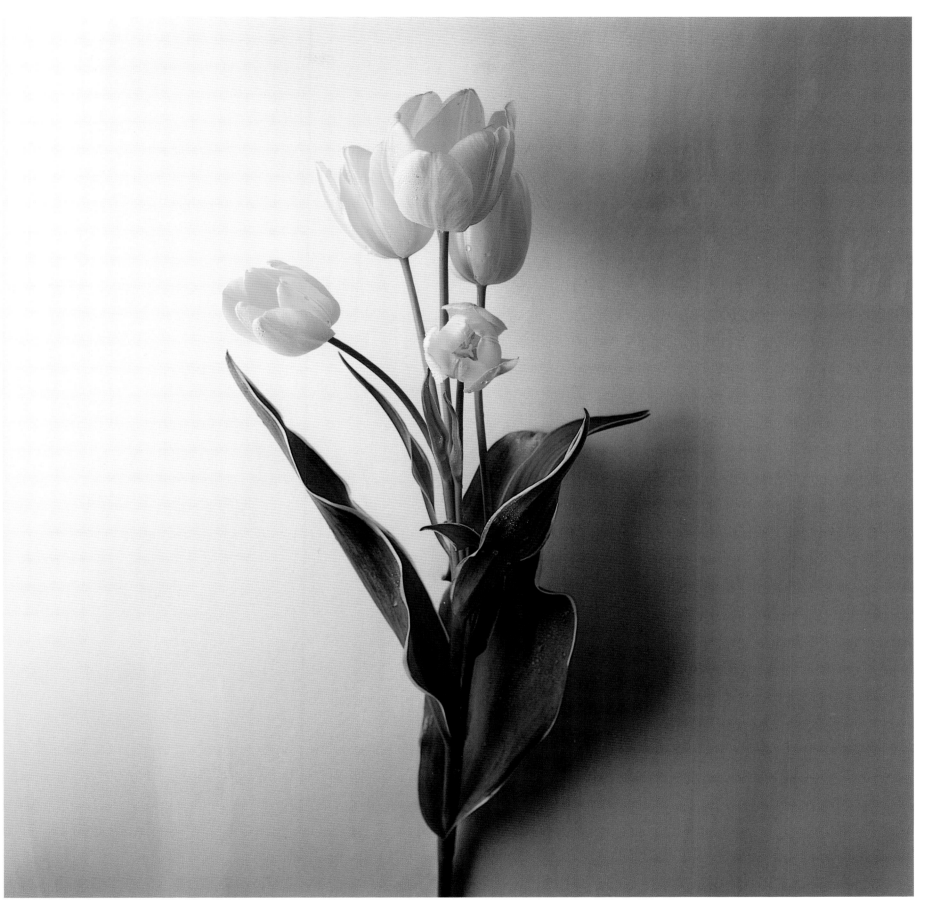

LUCETTE [PLATE 318]

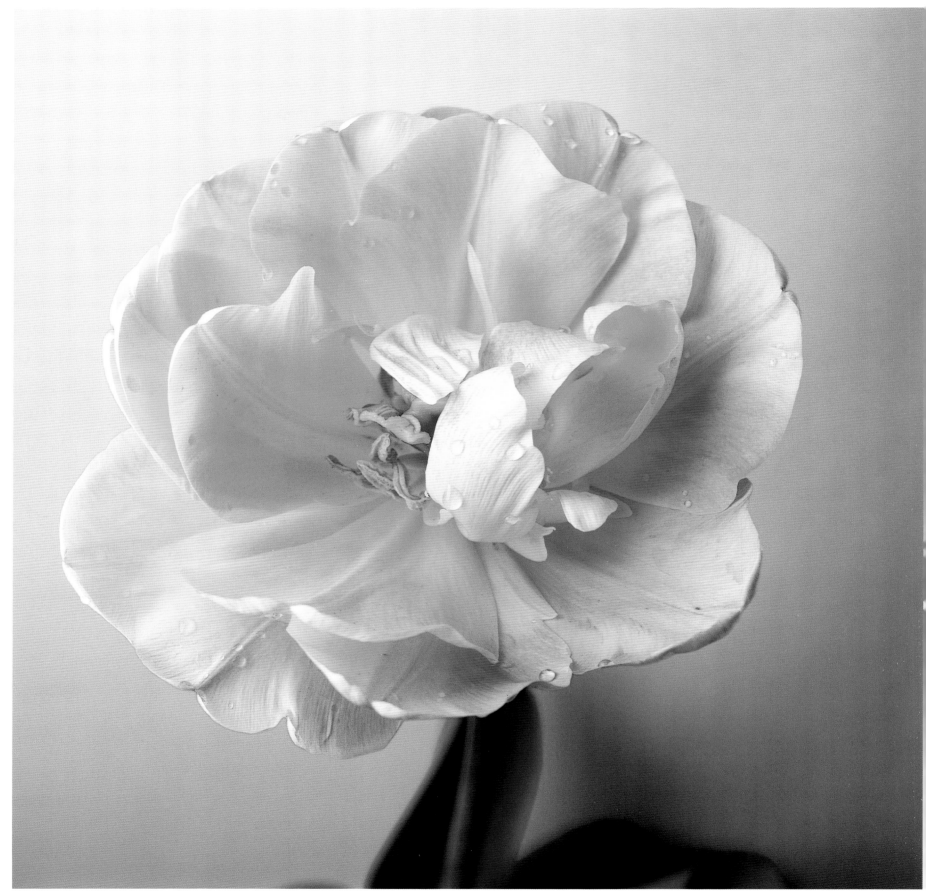

CREME UPSTAR [PLATE 319]

DOUBLE LATE GROUP

The Double Late tulips, also called peony-flowered tulips, are characterized by large heads of flowers bursting with petals. Though these very old tulips have been around for several centuries—the Double Lates were particularly fashionable in the mid-seventeenth century—the group has been sadly susceptible to the dictates of fashion. Throughout much of the twentieth century, critics of the Double Lates have judged these tulips rococo and unrefined, seeing their flower heads as untidy messes of petals.

However, in spite of their critics, the Double Late tulips have enjoyed a revival due to the perseverance of a few Dutch bulb growers who continued to grow and improve the group. After hybridizing them with Triumphs for the last seventy years and enriching the stems—in the past, the Double Lates' heavy flowers were too weighty for their stems, particularly in wet and windy weather—they are stronger today and less likely to bend under the weight. With longer stems than those of the Double Early and the Single Early tulips, the strength and durability of the Double Late stem is all the more important. The Double Lates are now grown more widely than ever and the group boasts a nice range of colors.

Some of the best Double Lates were raised by Jan J. Kerbert and released by Gerbrand Kieft of Schoorl, a small village about fifty kilometers north of Haarlem. Mr. Kieft bought out the entire stock of seedlings for Double Late, Triumph, Greigii, and Fosteriana tulips from Kerbert and his partner, Willem van Waveren, when they liquidated an enormous hybridizing operation called Winterrust in Hillegom. In the 1940s Kieft founded Hybrida, a consortium of growers, and continued to select, name, and distribute all these tulip groups. However, the market for Double Late tulips had diminished greatly at that time and become unprofitable, so Hybrida sold its stock of Double Lates in the 1950s to Leen van Staalduinen Jr., an independent bulb trader from the village of

's-Gravenzande near The Hague. Van Staalduinen subsequently sold the stock to other growers.

As double tulips were out of fashion at the time, all but a few of the early Kieft Double Late tulips disappeared from cultivation. 'Maywonder' is one that survives, and another is 'Gerbrand Kieft'—one of the group's most enduring flowers named for one of the group's earliest champions. While Kieft eventually sold out all his stocks to other bulb growers, he was responsible for preserving tulips that would have otherwise been lost. It is through Kieft's efforts that many of the best hybrids are here today. Double Lates are *all* attractive in gardens. Many are also used for forcing.

ALLEGRETTO
In 1963, J. F. van den Berg & Sons registered 'Allegretto,' which is red with yellow-edged petals. A brightly colored flower on a sturdy plant, 'Allegretto' is suitable for mid-season forcing. Its height is 35 centimeters.

ANGELIQUE
'Angelique,' raised and registered by D. W. Lefeber & Company in 1959, is a wonderful pale pink flower with lighter shades on the edges of the petals. The base is small and white. Used for mid-season and late-season forcing, 'Angelique' is particularly robust in warmer-climate gardens. It is 40 centimeters in height.

BLACK HERO
In 1984, J. Beerepoot registered 'Black Hero,' a dark, almost black double sport of 'Queen of Night,' a Single Late tulip. A wonderful and unusual tulip, 'Black Hero' is 60 centimeters in height.

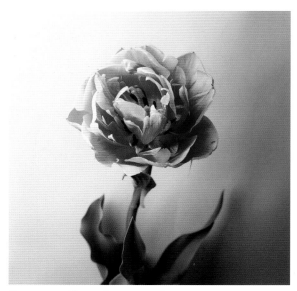

GERBRAND KIEFT [PLATE 320]

BONANZA
Registered in 1943, 'Bonanza' is carmine-red, edged yellow on the petals. An older, medium-sized round double flower, 'Bonanza' has a strong stem and is suitable for forcing. It is very pretty and is 40 centimeters tall.

CARNAVAL DE NICE
C. G. van Tubergen registered 'Carnaval de Nice' in 1953. The petals are white feathered with red. The white rims on the leaves are quite eye-catching. Suitable for forcing, it is 50 centimeters tall. [PLATE 111]

CASABLANCA
Raised and registered by J. F. van den Berg & Sons in 1981, 'Casablanca' begins creamy yellow and becomes white as the flower opens. Its base is yellow. Its long and slender stem is just strong enough to hold the heavy flower. 'Casablanca' is suitable for forcing and is 55 centimeters in height. [PLATE 112]

CREME UPSTAR
'Creme Upstar,' registered by J. F. van den Berg & Sons in 1982, is warm ivory white with a broad rosy-purple band on the margins of the petals. A sport of 'Upstar' and very distinctive, 'Creme Upstar' is suitable for forcing. Its height is 35 centimeters. [PLATE 319]

DALADIER
Zocher & Company registered 'Daladier' in 1951. Crimson-carmine with a white base, it has a nice round flower. 'Daladier' is greatly valued in the fresh cut-flower market because it is one of the easiest tulips to pick from the field; its stem snaps neatly in two. Very late flowering, 'Daladier' is 50 centimeters tall.

GERBRAND KIEFT
Glowing purple-red with petals edged in white, 'Gerbrand Kieft' is from Hybrida, which raised and registered it in 1951. This beautiful double flower, named for one of the owners of Hybrida, is a strong forcing tulip. Its height is 45 centimeters. [PLATE 320]

MAYWONDER
In 1951, Hybrida registered 'Maywonder,' which has a large, beautiful rose-colored double flower with a white base and a sturdy stem. A very durable tulip, 'Maywonder,' 50 centimeters tall, will survive in all kinds of weather.

MIRANDA
Raised by J. A. van Gent & Sons and registered by C. A. Verdegaal in 1981, 'Miranda' has a very large and full

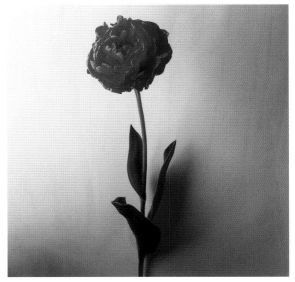

MIRANDA [PLATE 321]

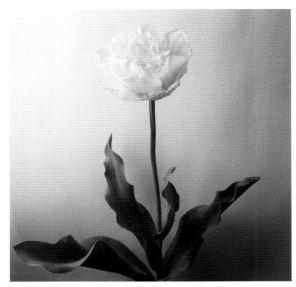

MOUNT TACOMA [PLATE 322]

double flower, flamed a dull red on Dutch vermilion ground. A sport of 'Apeldoorn's Favourite,' a semi-double Darwinhybrid, 'Miranda' is a much improved Double Late, but its stem is not strong enough to carry the large flower and sometimes the 55-centimeter-tall plant is unable to stay upright. [PLATE 321]

MOUNT TACOMA

'Mount Tacoma,' raised by Polman Mooy and registered around 1912, is one of the oldest Double Late tulips still in cultivation and its acreage in Holland continues to grow. With a good form to the white flower and a strong stem, 'Mount Tacoma' is one of the best garden tulips. Its height is 45 centimeters. [PLATE 322]

ORANGE PRINCESS

'Orange Princess,' an orange sport of the Triumph 'Prinses Irene,' was found in several places and registered jointly by two growers who found it, C. V. Zonneveld & Sons and W. B. and Th. Reus in 1983. 'Orange Princess' is packed with petals and the strong stem is capable of carrying the added weight. A beautiful tulip, 'Orange Princess' stands 30 centimeters tall. It has a red sport, 'Red Princess.'

RED NOVA

Registered jointly by Reus and S. Bakker in 1989, this sport of 'Prominence' is one of the few dark red Double Lates. 'Red Nova' is a round flower with a glowing blood-red rim on the petals. Frequently used for forcing, 'Red Nova' is valued for its rare dark red double flower. Its height is 40 centimeters. [PLATE 114]

RED PRINCESS

'Red Princess,' registered by C. V. Zonneveld & Sons in

1990, is bloodred with a deep cardinal red flame. The red in 'Red Princess,' a sport of the orange 'Orange Princess,' can be traced to previous generations: 'Red Princess' inherits its color from 'Couleur Cardinal,' a scarlet Triumph that created 'Prinses Irene,' an orange sport, which in turn created 'Orange Princess.' Dutch bulb growers call this process whereby a tulip inherits its color from a tulip several generations earlier "backsporting." 'Red Princess' has a beautiful color and is 35 centimeters tall.

UNCLE TOM

Registered in 1935 by Zocher & Company, 'Uncle Tom' has a large maroon-red flower on a strong stem. The deepest red color of the Double Lates, 'Uncle Tom' is an older variety that recently has been used as a forcing tulip because the revival of interest in doubles has increased demand. Its height is 45 centimeters.

UPSTAR

Raised by J. F. van den Berg & Sons and registered by J. A. Borst in 1982, 'Upstar' is ivory white with a broad rosy-purple band on the edges of the petals. The small fragrant flower—which is not a very full double flower—sits on a medium-sized stem. It is used in the forcing market and has a beautiful sport in 'Creme Upstar.' 'Upstar' is 45 centimeters in height.

WIROSA

'Wirosa' was raised and registered by P. and J. W. Mantel in 1949. The wine red flower with a creamy white edge on its petals has a short and strong stem. A recent increase in the popularity of Double Late tulips has contributed to a kind of revival for this once-declining tulip. 'Wirosa's height is 35 centimeters. [PLATE 113]

T. acuminata

T. acuminata was first described by Martin Vahl in 1813, but tulips such as these with elongated flowers and reflexed and pointed petals were known long before then. Depicted on Turkish tiles dating back to the seventeenth century and grown in gardens since at least then, *T. acuminata* is known only in cultivation. It is not known where it originated. The narrow petals are yellow with variable scarlet streaks and the leaves are long, undulated, and gray-green. Sometimes called the "Horned Tulip" (or *T. cornuta*) because of its pointed petals, *T. acuminata* stock in Holland is diminishing. The bulbs are small and its height is 50 centimeters. [PLATE 125]

T. bakeri

Described by Sir Alfred Daniel Hall in 1938, *T. bakeri* is a rather small plant from Crete with a yellow base and dull mauve-colored petals that are round, tapering at the tips. The broad and glossy leaves are longer than the plant is tall. *T. bakeri* is a smaller and darker-colored relative of *T. saxatilis*. In order to produce healthy bulbs and flowers, these native Mediterranean plants require warm growing conditions. In colder climates, the bulbs of *T. bakeri* will multiply slowly if planted by a warm and sunny south-facing wall. It is quite short with a height of 10 centimeters. [PLATE 324]

T. bakeri Lilac Wonder

A cultivar of *T. bakeri* registered in 1971 by Kees Visser, 'Lilac Wonder' is light purple on the exterior; inside, the petals are an even lighter purple and the large round base is lemon yellow. It is 15 centimeters tall. Visser received his bulbs from Gerard Hageman of Hillegom and was able to raise a stock of *T. bakeri* 'Lilac Wonder' from the first bulbs he received. This cultivar closely resembles *T. saxatilis*, which led many Dutch growers to favor the name *T. saxatilis* 'Lilac Wonder.' Because *T. bakeri* 'Lilac Wonder' has the same chromosomal makeup as *T. bakeri*, the registration committee of the KAVB decided its appropriate taxon would be *T. bakeri*. There is a large stock of *T. bakeri* 'Lilac Wonder' in Holland. [PLATE 123]

T. batalinii

T. batalinii was described by Dr. Eduard August von Regel in 1889. Found in the Pamir and Alai mountains of central Asia, this is an all-yellow flower with a light bronze base. *T. batalinii* is short—only 10 centimeters in height—and consequently many of its narrow grayish leaves spread loosely on the ground around the plant. Thought to be an albino form of *T. linifolia*, which is red, this species plant has produced several beautiful hybrids. It is not known who raised the hybrids; recently it is thought the hybrids were produced in Ireland by Hogg & Robertson. (No records are available.) The bulbs are pea-sized with rough skin. In crosses between *T. batalinii* and *T. linifolia*, the hybrids are taller and have larger flowers than either parent.

T. batalinii Apricot Jewel

Registered by G. H. Hageman & Sons in 1961, 'Apricot Jewel' is a hybrid whose parents are *T. batalinii* and *T. linifolia*. The flower is orange-red on the exterior with a golden yellow interior. 'Apricot Jewel' has gray-green leaves and a height of 15 centimeters.

T. batalinii Bright Gem

Registered by Jan Roes in 1952, *T. batalinii* 'Bright Gem' has a sulfur yellow flower, flushed with orange and a brown base. Its leaves are grayish-green. A sturdy plant and long-lasting, it is 15 centimeters in height. *T. batalinii* 'Bright Gem' could in fact be the same tulip as *T. batalinii* 'Sunrise,' which received an Award of Merit from The Royal Horticultural Society in 1901 (years before this tulip was registered). A hybrid whose parents are *T. batalinii* and *T. linifolia*, *T. batalinii* 'Bright Gem' is one of several such crosses and is the most beautiful. [PLATE 120]

T. batalinii Bronze Charm

In 1952, C. G. van Tubergen registered *T. batalinii* 'Bronze Charm,' which is yellow with attractive bronze feathering on the petals and grayish-green leaves. *T. batalinii* 'Bronze Charm' is a hybrid whose parents are *T. batalinii* and *T. linifolia*. Its height is 15 centimeters.

T. batalinii Red Gem

G. H. Hageman & Sons raised and W. P. van Eeden registered *T. batalinii* 'Red Gem' in 1985. The flower is vermilion with a pink glow on the exterior of the petals and scarlet with pale yellow veins on the interior. The base is black with pale yellow veins. Its leaves are grayish-green. *T. batalinii* 'Red Gem' is a hybrid whose parents are *T. batalinii* and *T. linifolia* and it is 15 centimeters in height.

T. batalinii Yellow Jewel

T. batalinii 'Yellow Jewel,' registered by G. H. Hageman

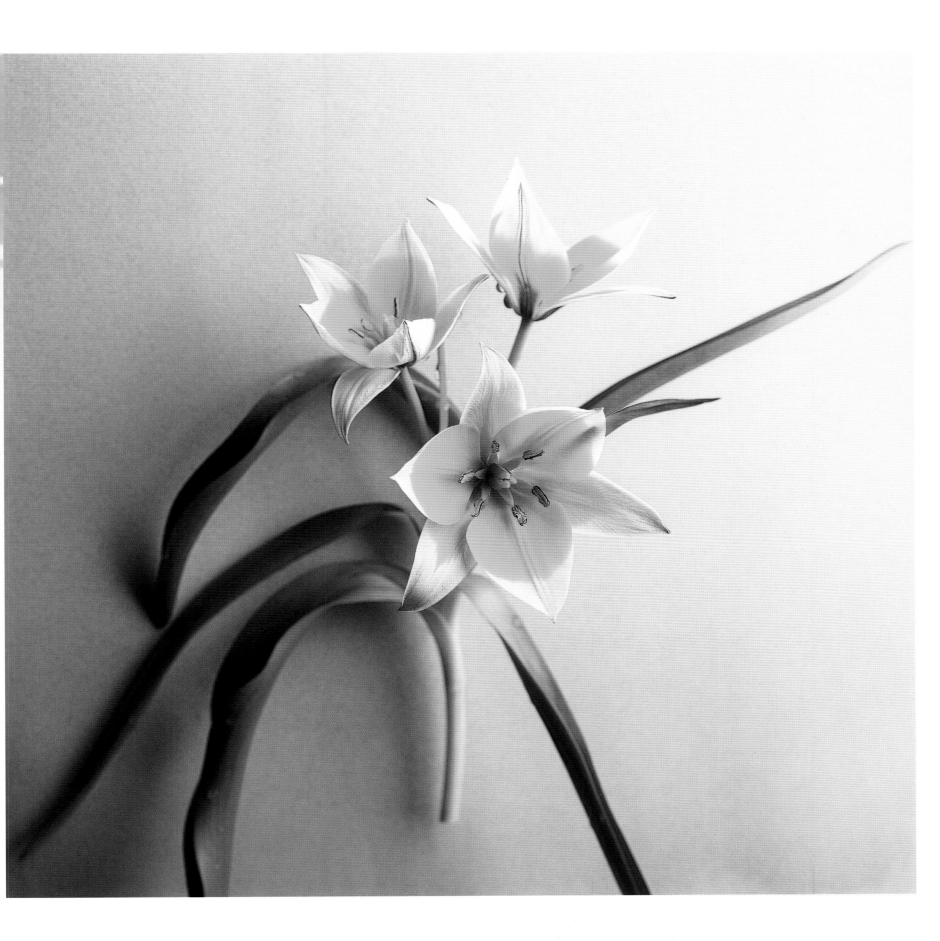

T. tarda [PLATE 323]

& Sons in 1961, is a yellow flower, tinged rose, with a greenish-yellow base and grayish-green leaves. A hybrid whose parents are *T. batalinii* and *T. linifolia*, its height is 15 centimeters.

T. didieri

T. didieri was found in the Savoy Alps in the region of the Franco-Italian border and described by Claude Jordan in 1846. In cultivation for a long time, *T. didieri* has a small currant red flower on a slender stem and resembles a garden tulip. *T. didieri* is considered one of the "Neo-tulipae," a term used to designate tulips that are neither genuine wild species tulips nor "escaped" garden species that have multiplied; it is possible *T. didieri* is a little of both. The bulbs look like garden tulip bulbs, only smaller. There is little stock of *T. didieri* in Holland and it is aging. It is 40 centimeters tall. [PLATE 118]

T. hageri Splendens

Registered by C. G. van Tubergen in 1945, *T. hageri* 'Splendens' is multiheaded with three to five coppery bronze-colored flowers, each with a colorless blush on the outside of the petals. *T. hageri* was first described in 1874 by Theodor Heinrich Hermann von Heldreich. The flowers of *T. hageri* 'Splendens' are long-lasting and have a nice form, with petals that are broad in the middle, tapering at the tips and bottom. Occasionally, plants produce a single flower. The leaves are an attractive dark green. The brownish-colored, smooth-skinned bulb does not produce stolons. Its height is 20 centimeters. [PLATE 121]

T. linifolia

Dr. Eduard August von Regel described *T. linifolia* in 1884. The species originates in the Pamir and Alai mountains of Afghanistan and Iran and the name refers to the narrow leaves that are folded down the center with red margins. *T. linifolia* is tiny—only 10 centimeters tall—with brilliant red flowers that are starlike when open, revealing the black base. The dark brown, rough-skinned bulbs are about the size of peas. In the past, stock was grown from several clones in Holland that differed in bulb size and multiplication rate, but today growers are working with a more homogeneous stock. [PLATE 117]

T. marjolettii

In 1894, Eugène Pierre Perrier de la Bâthie and André Songeon first described *T. marjolettii* which, like *T. didieri*, is a Neo-tulipae from the Savoy Alps and not considered a true wild species plant. Creamy white with broad, red streaks that run on the bottom outside and middle of the petals, *T. marjolettii* has the same stature as *T. didieri* and

is also 40 centimeters tall. Most of its hybirds and sports have disappeared, and today there is very little stock of *T. marjolettii* and its cultivars in Holland. It is worth keeping stocks of species tulips such as *T. marjolettii* and *T. didieri* alive for the future, if only to examine the plants and come to a better understanding of the Neo-tulipae ancestry. [PLATE 119]

T. orphanidea

Found in Greece in 1862 and described by Pierre Edmond Boissier, *T. orphanidea* is a variable species in the wild, with flowers either single or multiheaded and colors ranging from orange to dull red. The base is a darker color, nearly brown. The narrow leaves are characteristically longer than the plant is tall. The thick, smooth-skinned bulbs are slightly larger than peas. The cultivated stocks in Holland produce a lighter-colored flower. Because it does not grow well in Holland, *T. orphanidea* has little stock. It is 20 centimeters in height. [PLATE 115]

T. orphanidea Flava

Registered by J. M. C. Hoog in 1960, *T. orphanidea* 'Flava' was grown in Holland long before then. The plant generally has two small pale yellow flowers with pointed petals rimmed in red and a bronze base. The base has brown blotches. At 30 centimeters, *T. orphanidea* 'Flava,' also from Greece, is taller and grows better than *T. orphanidea*. [PLATE 116]

T. saxatilis

Described by Franz Wilhelm Sieber and Curt Polycarp Joachim Sprengel in 1825, *T. saxatilis* is found almost exclusively in Crete. The pointed petals are pale lilac and the base of this medium-sized plant is yellow. Like *T. bakeri*, it is a very shy flowering plant and needs the same warm growing conditions to which it is accustomed in order to flower. If grown in a colder climate, *T. saxatilis* needs to be under a south-facing wall or surrounded by slates or stones that will absorb the heat of the day and hold it throughout the chilly night. *T. saxatilis* will need to receive plenty of heat all summer in order to produce strong bulbs for the following year's flowers. This plant also has the habit of making stolons, but only the big bulbs will produce flowers. Its height is 20 centimeters.

T. sprengeri

T. sprengeri is the very last species tulip to bloom, and its brilliant red flowers provide a dazzling end to the tulip season. Found near Amasya in the province of Pontus in northern Turkey near the Black Sea, *T. sprengeri* was described by John Gilbert Baker in 1894 and named for the

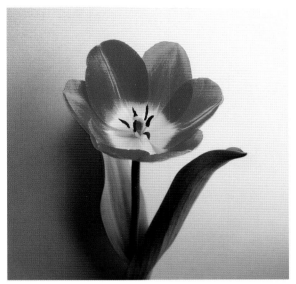

T. bakeri [PLATE 324]

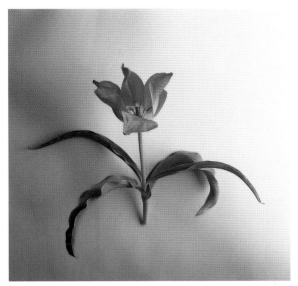

T. vvedenskyi [PLATE 325]

botanist Curt Polycarp Joachim Sprengel. When the flower opens in the sun, its golden yellow anthers and bronze base show up beautifully against the bright scarlet red petals. The leaves are a glossy green and its height is 40 centimeters. *T. sprengeri* does not produce any offsets but does produce seeds very abundantly; when the seeds are allowed to germinate naturally, small bulbs appear that can be harvested after a couple of years. [PLATE 129]

T. tarda

Described in 1933 by Otto Stapf, *T. tarda* was found in the Tien Shan mountains of central Asia. This multiheaded plant has small, star-shaped fragrant flowers that are white with large bright yellow bases. The outer petals are brownish-purple and the bright green leaves are closely set on the stem forming a rosette. *T. tarda* is a very popular species tulip grown from round, yellow-orange bulbs. Hardy and long-lasting, it is 10 centimeters in height. [PLATE 323]

T. urumiensis

This tulip from Lake Rezaiyeh in the north of Iran was first described in 1932 by Otto Stapf and later introduced by C. G. van Tubergen. Multiflowered with about four to eight flowers tapering at the tips, each flower is clear yellow and the backs of the outer petals are flushed with red and olive. The base is dark yellow. The leaves are glossy and its orange-yellow bulb is larger than that of most species bulbs. *T. urumiensis* grows well and multiplies well, too, producing many bulbs. Its height is 10 centimeters. [PLATE 124]

T. vvedenskyi

Found in the western Tien Shan mountains of central Asia and named for Aleksei Vvedensky, a Russian botanist and taxonomist, *T. vvedenskyi* was described by another Russian botanist, Zinaida Petrovna Botschantzeva, author of *Tulips*, a valuable guide to the tulips native to the central Asian republics. In the 1950s *T. vvedenskyi* came into commerce in Holland and good stock is still available. The big, bold, square-shaped flowers are light scarlet to orange with a yellow or brownish base with a yellow margin. The leaves are sometimes mottled. The large, light-colored bulbs are rough-skinned. It is 25 centimeters tall. [PLATE 325]

T. vvedenskyi **Tangerine Beauty**

In 1980, Kees Visser selected the most beautiful *T. vvedenskyi* cultivar and registered it 'Tangerine Beauty,' which is bright fire red with an orange flame on the petals. The basal blotch is lemon yellow. The big bulbs form droppers (smaller bulbs) often descending more than two feet deep, making them very difficult to find. Good stock is available in Holland. It is 25 centimeters tall.

T. whittallii

Described by Sir Alfred Daniel Hall in 1929, *T. whittallii* is named for Edward Whittall, who discovered this tulip in Smyrna, in western Turkey. The long-lasting flower is bright orange initially, growing darker into a burnt orange as the flower matures. The backs of the outer segments are tinted green and buff. The base is round and bronzy-black margined with a lighter color. A species tulip that multiplies by offsets and stolon bulbs, the bulb for *T. whittallii* is characterized by a smooth dark orange-brown skin. There is only one clone in Holland so stock is small. Its height is 30 centimeters. [PLATE 122]

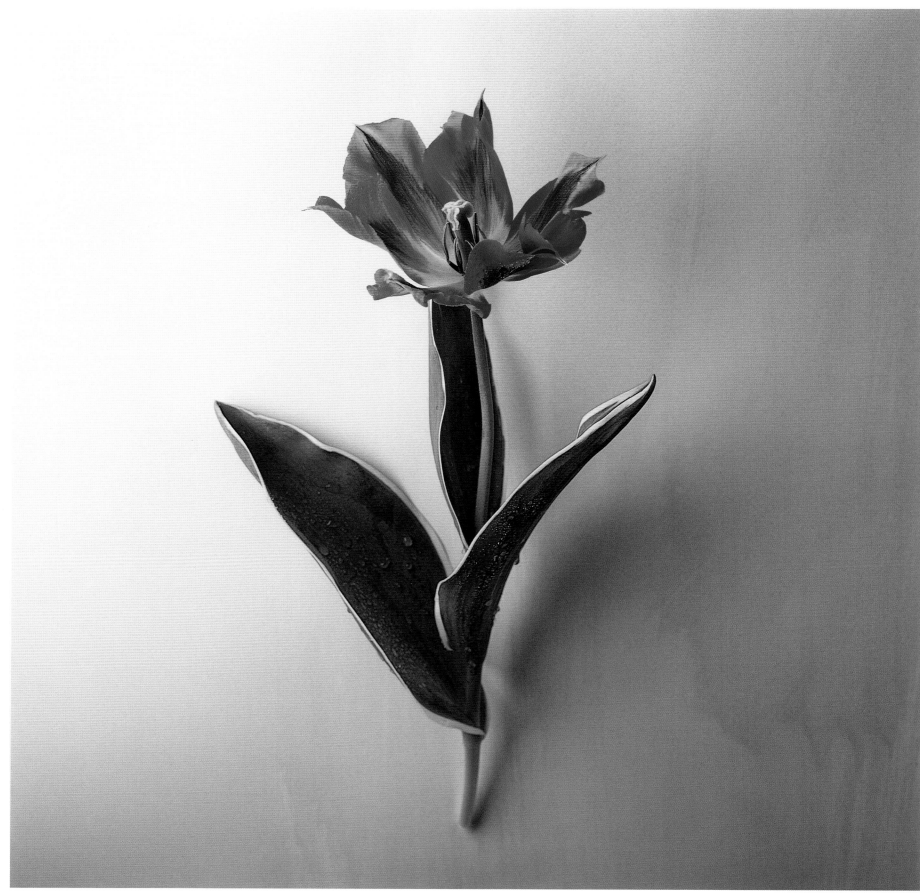

ESPERANTO [PLATE 326]

VIRIDIFLORA GROUP

The Viridifloras are a group of tulips that have partly greenish petals; the green appears as a flame running from the base of the flower through each petal to its tip. The name "viridiflora" derives from the Latin: *viridi*, "green," *flora*, "flower." While there have always been a few tulips with this unusual coloring—'Groene Ridder' ("Green Knight"), one of the earliest, was first recorded in 1700—it was only recently, in 1987, that the Viridiflora cultivars became a group large enough to warrant its own class. Before becoming a recognized group, the Viridifloras were included in the Single Late tulip group because they share the same late-flowering time.

There are basically two different types of Viridifloras. One is composed of 'Artist' and its many, many sports, which are short-stemmed, about 30 centimeters tall. The other is the Viridifloras not related to 'Artist,' which are tall. 'Groenland,' the tallest Viridiflora at 55 centimeters, is almost twice the height of 'Artist.'

The success of the Viridifloras, and in particular 'Artist,' is due in great part to the hybridizing efforts of Captein Brothers of Breezand. The Captein brothers, Adriaan and Jan, were originally cattle farmers whose interest in growing and hybridizing bulbs eventually led them to give up farming and create one of the most successful nurseries in Holland. They worked with tulips, narcissus, and other flowering bulbs. In 1944, Adriaan Captein raised a very popular Triumph called 'Palestrina' by crossing the Single Early 'Generaal de Wet' and the Single Late 'Mayflower.' From the same cross a few years later, Captein produced 'Artist,' a Viridiflora that has practically created its own subdivision with all its sports.

During the 1950s, the Viridifloras were so fashionable and in such demand that the rage for new varieties of 'Artist' took the form of a twentieth-century tulipomania. 'Hollywood,' a deeper-colored sport of 'Artist,' was sold for close to £500 per kilo planting stock, considered at

that time an extravagant price to pay. Captein Brothers' hybridizing efforts were also successful with Triumphs and Greigiis; in the early 1970s they made several successful crosses in the Greigii group, including 'Authority,' 'Captein's Favorite,' and 'March of Time.'

The most recent development in Viridifloras came a few years ago when a completely green tulip was developed. Its production, however, was very slow, and the raiser, J. F. van den Berg & Sons, was not able to create enough stock for the market. The firm of J. F. van den Berg & Sons also raised 'Groenland,' an exceptional Viridiflora tulip.

All the Viridifloras are perfect for the garden. 'Artist' and its mutations have the perfect stature for garden plants: a thick broad leaf at the bottom, a sturdy stem, and a big flower. The Viridifloras are not used for forcing.

ARTIST

'Artist' was registered by Captein Brothers in 1947 and is the result of a cross between the orange Single Early tulip, 'Generaal De Wet,' and 'Mayflower,' a red Single Late tulip raised by C. G. van Tubergen. 'Artist' has a salmon pink flower with a broad green flame visible on the interior and the exterior of the petals. At 30 centimeters, it is a shorter plant than either of its parents. 'Artist' is sturdy, with a large long-lasting flower.

'Artist' has produced many sports, and many of those sports have produced still more sports, including 'China Town,' 'Esperanto,' 'Golden Artist,' 'Green River,' 'Hollywood,' and 'Hollywood Star.' [PLATE 126]

CHINA TOWN

'China Town,' a relatively new sport of a sport of 'Artist' called 'Golden Artist,' was raised and registered by Captein Brothers in 1988. It has a phlox pink ground with a moss green flame on the petals. The leaves are variegated with whitish margins. And although 'Esperanto,' another sport, also has whitish margins, the pattern and coloring on edged-white 'China Town's leaves are more beautiful. Its height is 30 centimeters. [PLATE 128]

ESPERANTO

Registered in 1968 by J. Pranger, 'Esperanto' is a sport of 'Hollywood,' another 'Artist' sport. 'Esperanto' is soft rose with a green flame on the petals. The leaves have distinct white rims. It is 30 centimeters tall. [PLATE 326]

EYE CATCHER

Registered by Konijnenburg & Mark in 1968, 'Eye Catcher' is a brick red flower with a narrow green flame. The flower is a little more slender than the other Viridifloras and it is a bit taller at 55 centimeters. Its slightly reflexed petals make it look somewhat like a Lily-flowered tulip. Konijnenburg & Mark registered many Viridifloras, and 'Eye Catcher,' because of its brightly contrasting color combination, is one of the best. [PLATE 127]

GOLDEN ARTIST

Raised and registered by Captein Brothers in 1959, this sport of 'Artist' is golden orange with attractive broad green stripes running up the petals. It is 30 centimeters in height. [PLATE 327]

GREEN RIVER

Registered by C. Nielen & Son in 1993, 'Green River' is a sport of 'Artist.' The variegated leaves are a darker green than the fern green flame in the flower. The edges of the leaves are lemon yellow. Its height is 30 centimeters.

GROENLAND

Greenland

Registered by the firm of J. F. van den Berg & Sons in 1955, 'Groenland' is soft rose with petals flamed green: a beautiful color combination. This is the largest Viridiflora, with a strong stem. The Van den Berg firm worked extensively with the Viridifloras, and 'Groenland' is certainly one of its greatest successes. There is a new Parrot sport of 'Groenland' named 'Green Wave' that has the same soft pink-and-green coloring. 'Groenland's height is 55 centimeters.

HOLLYWOOD

'Hollywood' was one of the first 'Artist' sports, registered in 1956 by Captein Brothers. It is a bright red color on green and is 30 centimeters tall.

HOLLYWOOD STAR

Registered by C. Nielen & Son in 1987, 'Hollywood Star' is a sport of 'Hollywood.' Its color is a deeper red than that of 'Hollywood' and the flame is moss green. The leaves are variegated with pale yellow margins. Its height is 30 centimeters. [PLATE 328]

SPRING GREEN

Registered in 1969 by P. Liefting, 'Spring Green' is an outstanding example of the beauty of the Viridiflora group. It is ivory white with green feathering. This is a strong, medium-sized plant whose height is 50 centimeters.

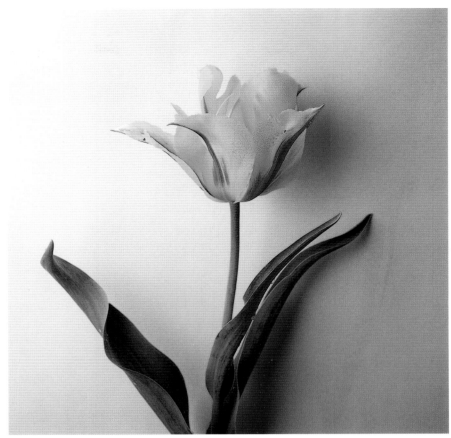

GOLDEN ARTIST [PLATE 327]

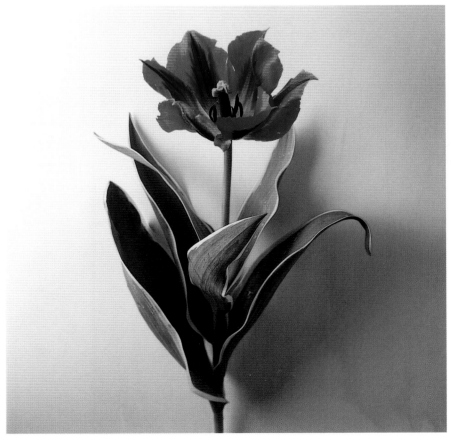

HOLLYWOOD STAR [PLATE 328]

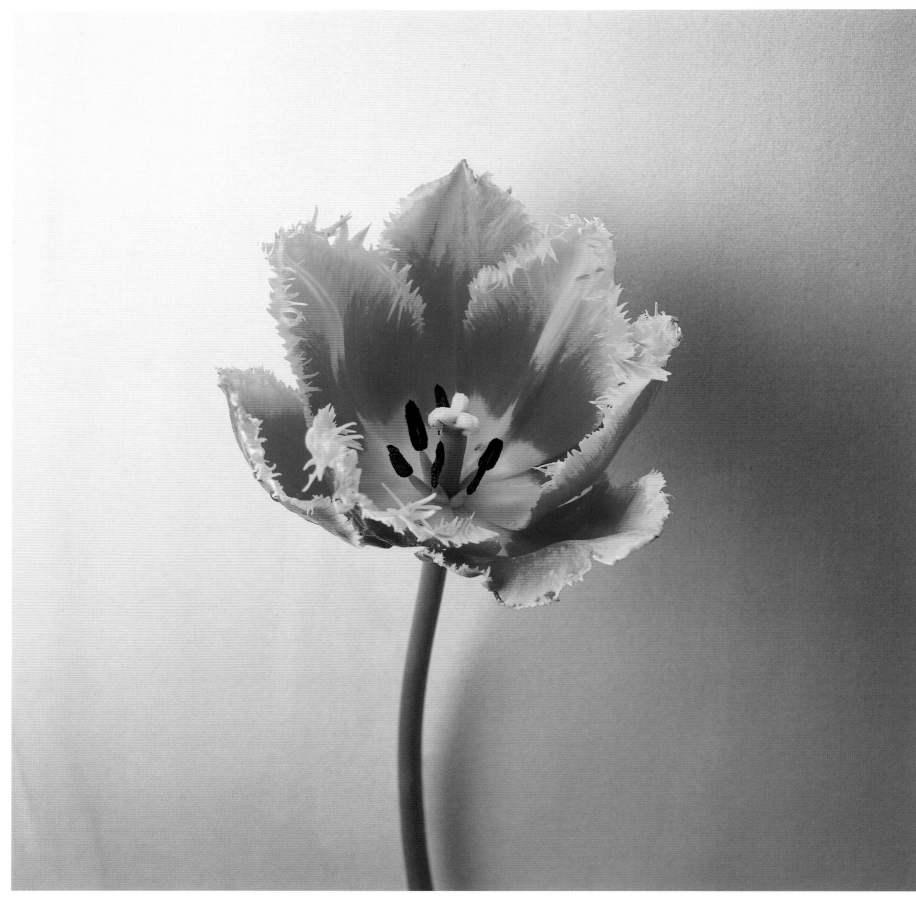

FRINGED TULIP: NEW INTRODUCTION [PLATE 329]

New Introductions

Some of the new experimental tulips photographed for this book were shown in recent years in Dutch flower shows, and, as might be expected, the comments from viewers were mixed. Produced by the hybridizer Vertuco, they are the result of imaginative and innovative breeding programs. One peculiar tulip, 'Ice Cream' [PLATE 133], is a pink flower tulip whose thick mass of white petals protruding from the base resembles the leaves of a cabbage plant. 'Ice Cream' is 40 centimeters in height. Another experimental tulip is 'Cummings' [PLATE 131], a new, heavily fringed tulip, 50 centimeters tall, that is purple with a white rim on the edges of the petals. The fringe is so extreme, it resembles sharks' teeth.

At the end of the day, hybridizers must ask whether the market *wants* a tulip that looks like a cabbage and whether they want to continue their breeding programs to create tulips no one may want to grow. Certainly it is a gamble, and the future for these tulips is entirely unpredictable. Who knows what forms will be desirable in twenty or forty years? There is no limit to the kinds of colors and forms new tulips may take. The only limiting factors are time and money.

MUTATION-RELATED TULIPS

NEW TULIP CULTIVARS COME ABOUT in one of two ways: hybridization or mutation. While hybridization involves crossing two genetically diverse plants to produce an offspring, mutation is spontaneous: A gene in one cell mutates, then develops and divides, causing visible changes in the plant. The most common mutation produces a flower of another color, but it can also create a different form—a Single Early tulip may mutate into a Parrot tulip, for example. These new plants, called "sports," may give rise to even more mutations. The following list describes the relationships between mother plant, sport, and sport of sports. The sports of sports are indented and *their* sports are indented further.

MOTHER PLANT SPORTS

Kaufmanniana Tulips

| 'Daylight' | 'Golden Daylight' |
| 'Glück' | 'Little Diamond' |

Fosteriana Tulips

'Easter Parade'	'Hit Parade'
'Purissima'	'Purissima King'
	'Yellow Purissima'

Single Early Tulips

'Apricot Beauty'	'Bestseller'
'Brilliant Star'	'Joffre'
	'Sint Maarten'
'Christmas Marvel'	'Christmas Dream'
	'Merry Christmas'
	'Queen of Marvel' (Double Early)
	'White Marvel'
'Keizerskroon'	'Rex' (Parrot)

Double Early Tulips

'Monte Carlo'	'Monsella'
'Murillo'	'David Teniers'
	'Madame Testout'
	'Cardinal Mindszenty'
	'Maréchal Niel'
	'Anthony Eden'
	'Marquette'

MOTHER PLANT SPORTS

	'Oranje Naussau'
	'Goya'
	'Peach Blossom'
	'Triumphator'
'Stockholm'	'Eskilstuna'

Darwinhybrid Tulips

'Apeldoorn'	'Apeldoorn's Elite'
	'Bienvenue'
	'Apeldoorn's Favourite'
	'Miranda' (Double Late)
	'Beauty of Apeldoorn'
	'Blushing Apeldoorn'
	'Crystal Beauty' (Fringed)
	'Fringed Apeldoorn' (Fringed)
	'Fringed Solstice' (Fringed)
	'Fringed Golden Apeldoorn' (Fringed)
	'Golden Apeldoorn'
	'Hans Mayer'
	'Holland Happening' (Parrot)
'Dover'	'Yellow Dover'
	'Daydream'
'Floradale'	'Ivory Floradale'
	'Burning Heart'
'Pink Impression'	'Apricot Impression'
	'Red Impression'

Triumph Tulips

'Adorno'*	'Ida'
	'Happy Generation'
'Attila'	'Attila's Elite'
'Bandoeng'	'Bird of Paradise' (Parrot)
'Blenda'	'Inzell'
'Cassini'	'Orange Cassini'
'Couleur Cardinal'	'Arma' (Fringed)
	'Prinses Irene'
	'Hermitage'
	'Orange Princess' (Double Late)
	'Red Princess' (Double Late)
	'Rococo' (Parrot)
'Gander'	'Gander's Ouverture'
	'Gander's Rhapsody'
	'Kaiserin Maria Theresia'
'Lucky Strike'	'Candlelight'
	'Golden Fiction'

MOTHER PLANT SPORTS

Mother Plant	Sports
'Lustige Witwe'	'Destiny' (Parrot)
	'Frederica'
	'Rai' (Parrot)
	'Hanna Glawari'
	'Burning Desire'
	'Success'
	'Zarewitch'
'Mirjoran'	'Dolly Dots'
	'Golden Mirjoran'
'Prominence'	'Libretto'
	'Libretto Parrot' (Parrot)
	'Red Nova' (Double Late)
	'Romance'
	'Topparrot' (Parrot)
	'Wibo'
	'Winterberg'
	'Yellow Star'
	'Zamire'
'Yellow Present'	'Golden Present'
	'Red Present'

Greigii Group

Mother Plant	Sports
'Plaisir'	'Californian Sun'
'Tango'	'Easter Surprise'
	'Golden Tango'
'Toronto'	'Orange Toronto'
	'Quebec'
'Zampa'	'Bella Vista'
	'Zampa Rose'

Lily-flowered Tulips

Mother Plant	Sports
'Ballade'	'Ballade White'
	'Je t'aime'
	'Sonnet'
'Mariette'	'Marilyn'
	'Mona Lisa'
	'Marjolein'

Parrot Group

Mother Plant	Sports
'Alberio'* (Triumph)	'Karel Doorman'
	'Apricot Parrot'
	'Doorman's Record'
	'Glasnost'

MOTHER PLANT SPORTS

'James V. Forrestal'
'Onedin'
'Red Devil'
'Orangerie'
'Salmon Parrot'
'Professor Röntgen'

Single Late Group

'Bartigon'* 'Cordell Hull'
'Montgomery'
'Pink Attraction'
'Queen of Bartigons'
'Pink Jewel'
'Red Champion' (Parrot)
'Estella Rijnveld' (Parrot)

'Georgette' 'Coulour Spectacle'
'Lucette'
'Red Georgette'

'Philippe de Comines' 'Black Parrot' (Parrot)
'Queen of Night' 'Black Hero' (Double Late)
'Renown' 'Avignon'
'Cri de Coeur'
'La Courtine'
'Menton'

'Temple of Beauty' 'Blushing Beauty'
'Hocus Pocus'
'Perestroyka'
'Temple's Favourite'

Double Late Group

'Upstar' 'Creme Upstar'

Viridiflora Group

'Artist' 'Golden Artist'
'China Town'
'Green River'
'Hollywood'
'Esperanto'
'Hollywood Star'

'Groenland' 'Green Wave' (Parrot)

Other Species

T. praestans 'Fusilier' *T. praestans* 'Unicum'

*No longer in cultivation

LIST OF 500 TULIPS

THIS LIST OF FIVE HUNDRED TULIPS is organized according to flowering time—early- to mid-season to late-flowering. The tulips are arranged alphabetically within their cultivar and species groups. Each entry includes the page number on which the tulip is described along with its color plate number.

EARLY FLOWERING

EARLY-FLOWERING SPECIES

T. aitchisonii, page 189, PLATE 139
T. clusiana, page 189, PLATE 5
T. clusiana 'Cynthia,' *page 189,* PLATE 140
T. clusiana var. *chrysantha, page 189,* PLATE 3
T. clusiana var. *chrysantha*
 'Tubergen's Gem,' *page 189,* PLATE 141
T. humilis, page 190, PLATE 1
T. humilis 'Lilliput,' *page 190,* PLATE 142
T. humilis 'Pegasus,' *page 190*
T. humilis 'Zephyr,' *page 190,* PLATE 8
T. humilis 'Alba Coerulea Oculata,' *page 190,* PLATE 9
T. humilis 'Magenta Queen,' *page 191,* PLATE 143
T. humilis 'Violacea Black Base,' *page 191,* PLATE 6
T. humilis 'Violacea Yellow Base,' *page 191,* PLATE 144
T. humilis 'Eastern Star,' *page 191*
T. humilis 'Odalisque,' *page 191*
T. humilis 'Persian Pearl,' *page 191,* PLATE 145
T. polychroma, page 191, PLATE 146
T. praestans 'Fusilier,' *pages 191–92,* PLATE 4
T. praestans 'Unicum,' *page 192,* PLATE 138
T. schrenkii, page 192, PLATE 7
T. turkestanica, page 192, PLATE 2

KAUFMANNIANA GROUP

'Ancilla,' *page 196,* PLATE 13
'Berlioz,' *page 196*
'Corona,' *page 196,* PLATE 14
'Daylight,' *page 196*
'Early Harvest,' *pages 196–97,* PLATE 148
'Fair Lady,' *page 198,* PLATE 149
'Fashion,' *page 198,* PLATE 150
'Franz Lehár,' *page 198,* PLATE 151
'Giuseppi Verdi,' *page 198,* PLATE 153
'Glück,' *page 198,* PLATE 15

'Golden Daylight,' *page 198,* PLATE 10
'Goudstuk,' *page 198,* PLATE 152
'Heart's Delight,' *page 198*
'Johann Straus,' *pages 198–99,* PLATE 12
'Little Diamond,' *page 199,* PLATE 154
'Scarlet Baby,' *page 199,* PLATE 155
'Shakespeare,' *page 199*
'Showwinner,' *page 199,* PLATE 11
'Stresa,' *page 199,* PLATE 16
'The First,' *page 199,* PLATE 156
T. kaufmanniana, page 196, PLATE 147

FOSTERIANA GROUP

'Candela,' *page 202*
'Concerto,' *page 202,* PLATE 158
'Easter Parade,' *page 202*
'Hit Parade,' *page 202,* PLATE 159
'Juan,' *page 202,* PLATE 19
'Madame Lefeber,' *page 202,* PLATE 17
'Orange Emperor,' *page 202,* PLATE 22
'Purissima,' *page 202,* PLATE 20
'Purissima King,' *page 202*
'Robassa,' *pages 202–3,* PLATE 18
'Spring Pearl,' *page 203*
'Summit,' *page 203*
'Sweetheart,' *page 203*
'Sylvia van Lennep,' *page 203,* PLATE 21
'Yellow Purissima,' *page 203,* PLATE 157
'Zombie,' *page 203,* PLATE 160

SINGLE EARLY GROUP

'Apricot Beauty,' *page 205,* PLATE 27
'Bestseller,' *page 205*
'Brilliant Star,' *page 205,* PLATE 23
'Burning Love,' *page 205*
'Christmas Dream,' *page 205,* PLATE 161
'Christmas Marvel,' *page 205,* PLATE 24

'Flair,' *page 205*, PLATE 26
'Generaal de Wet,' *page 207*
'Joffre,' *page 207*, PLATE 162
'Keizerskroon,' *page 207*, PLATE 25
'Merry Christmas,' *page 207*, PLATE 163
'Mickey Mouse,' *page 207*
'Prins Carnaval,' *page 207*
'Ruby Red,' *page 207*
'Sint Maarten,' *page 207*, PLATE 164
'White Marvel,' *page 207*

DOUBLE EARLY GROUP
'Anthony Eden,' *page 209*, PLATE 166
'Arie Alkemade's Memory,' *page 209*, PLATE 31
'Cardinal Mindszenty,' *page 209*
'Carlton,' *page 209*, PLATE 167
'David Teniers,' *pages 209–10*, PLATE 28
'Double Price,' *page 210*
'Eskilstuna,' *page 210*, PLATE 168
'Goya,' *page 210*, PLATE 165
'Maréchal Niel,' *page 210*, PLATE 170
'Marquette,' *page 210*, PLATE 169
'Monsella,' *page 210*, PLATE 33
'Monte Carlo,' *page 210*, PLATE 32
'Montreaux,' *page 210*
'Murillo,' *pages 210, 213*, PLATE 29
'Oranje Nassau,' *page 213*, PLATE 171
'Peach Blossom,' *page 213*
'Queen of Marvel,' *page 213*, PLATE 172
'Stockholm,' *page 213*, PLATE 30
'Sven Dahlman,' *page 213*
'Triumphator,' *page 213*, PLATE 173
'Verona,' *page 213*, PLATE 174
'Yellow Baby,' *page 213*, PLATE 175

MID-SEASON FLOWERING

MID-SEASON FLOWERING SPECIES
T. albertii, *page 214*, PLATE 176
T. aucheriana, *page 214*, PLATE 38
T. ferganica, *page 214*, PLATE 34
T. kolpakowskiana, *page 214*, PLATE 35
T. sylvestris, *page 214*, PLATE 37
T. wilsoniana, *page 214*, PLATE 36

DARWINHYBRID GROUP
'Ad Rem,' *page 217*, PLATE 39
'Apeldoorn,' *page 217*, PLATE 44
'Apeldoorn's Elite,' *page 217*, PLATE 177
'Bienvenue,' *page 217*

'Big Chief,' *pages 217–18*, PLATE 178
'Blushing Apeldoorn,' *page 218*, PLATE 179
'Burning Heart,' *page 218*, PLATE 43
'Come-Back,' *page 218*, PLATE 180
'Daydream,' *page 218*
'Diplomate,' *page 218*
'Elizabeth Arden,' *page 218*, PLATE 181
'Forgotten Dreams,' *page 218*
'Golden Apeldoorn,' *page 218*, PLATE 45
'Golden Parade,' *pages 218, 220*, PLATE 182
'Gordon Cooper,' *page 220*, PLATE 183
'Gudoshnik,' *page 220*
'Hans Mayer,' *page 220*, PLATE 184
'Hollands Glorie,' *page 220*, PLATE 42
'Ivory Floradale,' *page 220*
'Juliette,' *page 220*
'Ollioules,' *page 220*
'Olympic Flame,' *page 220*
'Oranjezon,' *page 220*, PLATE 46
'Oxford,' *page 221*, PLATE 185
'Parade,' *page 221*
'Pink Impression,' *page 221*, PLATE 40
'Tender Beauty,' *page 221*, PLATE 41
'World's Favourite,' *page 221*
'Yellow Dover,' *page 221*

TRIUMPH GROUP
'Abra,' *page 224*, PLATE 187
'Abu Hassan,' *page 224*, PLATE 188
'African Queen,' *page 224*, PLATE 47
'Ambassador,' *page 224*
'Anna José,' *page 224*, PLATE 186
'Annie Schilder,' *page 224*, PLATE 189
'Arabian Mystery,' *page 225*, PLATE 190
'Arie Hoek,' *page 225*, PLATE 57
'Attila,' *page 225*, PLATE 62
'Attila's Elite,' *page 225*
'Barcelona,' *page 225*
'Baronesse,' *page 225*, PLATE 64
'Bastogne,' *page 225*
'Belcanto,' *page 225*, PLATE 191
'Belinda Reus,' *pages 225, 228*, PLATE 192
'Bellona,' *page 228*
'Ben van Zanten,' *page 228*, PLATE 194
'Blenda,' *page 228*, PLATE 65
'Blue Ribbon,' *page 228*, PLATE 193
'Brigitta,' *page 228*, PLATE 195
'Calgary,' *page 228*, PLATE 196
'Candlelight,' *page 228*
'Capri,' *page 228*, PLATE 197
'Caravelle,' *page 228*, PLATE 198

'Carola,' *page 228*, PLATE 199

'Cassini,' *page 228*

'Charles,' *page 228*

'Charmeur,' *page 228*

'Cheers,' *page 228*, PLATE 200

'Chieftain,' *pages 228, 230*

'Concours,' *page 230*, PLATE 201

'Coquette,' *page 230*, PLATE 202

'Couleur Cardinal,' *page 230*

'Cream Perfection,' *page 230*, PLATE 203

'Debutante,' *page 230*

'Dolly Dots,' *page 230*

'Don Quichotte,' *page 230*, PLATE 205

'Dreaming Maid,' *pages 230–31*, PLATE 63

'Early Glory,' *page 231*, PLATE 206

'Etude,' *page 231*, PLATE 204

'Fire Queen,' *page 231*

'First Lady,' *page 231*, PLATE 207

'Fortissimo,' *page 231*, PLATE 208

'Françoise,' *page 231*, PLATE 48

'Friso,' *page 231*, PLATE 209

'Gander,' *page 231*

'Gander's Ouverture,' *page 231*

'Gander's Rhapsody,' *page 231*, PLATE 210

'Garden Party,' *page 231*, PLATE 211

'Gavota,' *page 231*, PLATE 59

'Golden Fiction,' *page 231*, PLATE 212

'Golden Melody,' *page 231*

'Golden Mirjoran,' *page 231*, PLATE 213

'Golden Present,' *page 234*, PLATE 214

'Hanna Glawari,' *page 234*

'Happy Family,' *page 234*, PLATE 67

'Happy Generation,' *page 234*, PLATE 51

'Helmar,' *page 234*, PLATE 215

'Hermitage,' *page 234*

'Hibernia,' *page 234*

'High Society,' *page 234*

'Hollandia,' *page 234*, PLATE 216

'Ile de France,' *page 234*, PLATE 217

'Invasion,' *page 234*, PLATE 218

'Inzell,' *page 235*, PLATE 219

'Jan Reus,' *page 235*, PLATE 220

'Jimmy,' *page 235*

'Judith Leyster,' *page 235*

'Kaiserin Maria Theresia,' *page 235*

'Kees Nelis,' *page 235*, PLATE 221

'Labyrinth,' *page 235*, PLATE 222

'Leen van der Mark,' *page 235*, PLATE 223

'Leo Visser,' *pages 235, 237*

'Libretto,' *page 237*, PLATE 224

'Lilo Pink,' *page 237*, PLATE 225

'Los Angeles,' *page 237*

'Lucky Strike,' *page 237*, PLATE 226

'Lustige Witwe,' *page 237*, PLATE 56

'Madame de la Mar,' *page 237*, PLATE 227

'Madurodam,' *page 237*

'Magic Mountain,' *page 237*, PLATE 228

'Makassar,' *page 237*

'Make-up,' *page 237*

'Margot Fontaine,' *page 237*

'Martine Bijl,' *page 237*, PLATE 229

'Mary Housley,' *page 237*, PLATE 230

'Meissner Porzellan,' *pages 237, 240*

'Merapi,' *page 240*

'Minerva,' *page 240*

'Mirjoran,' *page 240*, PLATE 233

'Miss Holland,' *page 240*, PLATE 231

'Monte Rosa,' *page 240*, PLATE 232

'Montevideo,' *page 240*, PLATE 60

'Negrita,' *page 240*, PLATE 234

'New Design,' *page 240*, PLATE 55

'Ohara,' *page 240*

'Orange Bouquet,' *pages 240–41*, PLATE 58

'Orange Cassini,' *page 241*

'Orange Monarch,' *page 241*

'Orleans,' *page 241*

'Oscar,' *page 241*, PLATE 235

'Page Polka,' *page 241*, PLATE 236

'Palestrina,' *page 241*

'Passionale,' *page 241*, PLATE 237

'Peer Gynt,' *page 241*, PLATE 49

'Peerless Pink,' *page 241*

'Primavera,' *page 241*

'Primavista,' *page 241*

'Princess Victoria,' *page 241*, PLATE 54

'Prinses Irene,' *pages 241–42*, PLATE 61

'Professor Penn,' *page 242*, PLATE 238

'Prominence,' *page 242*, PLATE 53

'Purple Flag,' *page 242*

'Purple Prince,' *page 242*

'Purple World,' *page 242*

'Red Present,' *page 242*, PLATE 239

'Riviera,' *page 242*

'Romance,' *page 242*

'Rosalie,' *page 242*

'Rosario,' *page 242*, PLATE 240

'Rosy Wings,' *page 242*

'Roulette,' *pages 242, 244*, PLATE 241

'Sally,' *page 244*, PLATE 242

'Samson,' *page 244*, PLATE 243

'Scala,' *page 244*

'Sevilla,' *page 244*, PLATE 50

'Shirley,' *page 244*, PLATE 244
'Silentia,' *page 244*
'Silver Dollar,' *page 244*
'Sint Pancras,' *page 244*
'Snow Lady,' *page 244*
'Snowstar,' *page 244*
'Spalding,' *page 244*
'Spryng,' *page 244*, PLATE 245
'Stability,' *page 245*
'Stargazer,' *page 245*
'Striped Bellona,' *page 245*
'Strong Gold,' *page 245*, PLATE 52
'Success,' *page 245*
'Sunlife,' *page 245*
'Superstar,' *page 245*, PLATE 246
'Ted Turner,' *page 245*, PLATE 247
'Tosca,' *page 245*
'Transavia,' *page 245*
'Valentine,' *pages 245, 247*, PLATE 248
'Varinas,' *page 247*, PLATE 249
'Walter Scheel,' *page 247*
'Washington,' *page 247*
'White Dream,' *page 247*, PLATE 250
'White Ideal,' *page 247*, PLATE 66
'Wibo,' *page 247*
'Winterberg,' *page 247*, PLATE 251
'Wonderful,' *page 247*
'Yellow Flight,' *page 247*
'Yellow Mask,' *page 247*
'Yellow Present,' *page 247*, PLATE 252
'Yellow Star,' *page 247*
'Yokohama,' *page 247*, PLATE 253
'Zamire,' *page 247*, PLATE 254
'Zarewitch,' *page 247*

GREIGII GROUP
'Ali Baba,' *page 250*
'Annie Salomons,' *page 250*, PLATE 256
'Antoni van Leeuwenhoek,' *page 250*, PLATE 257
'Bella Vista,' *page 250*, PLATE 71
'Buttercup,' *page 250*, PLATE 258
'Californian Sun,' *page 250*
'Cape Cod,' *page 250*, PLATE 78
'Captein's Favourite,' *page 250*
'Carioca,' *pages 250, 253*, PLATE 255
'China Lady,' *page 253*, PLATE 68
'Compostella,' *page 253*
'Corsage,' *page 253*, PLATE 73
'Czaar Peter,' *page 253*
'Donna Bella,' *page 253*, PLATE 259
'Dreamboat,' *page 253*, PLATE 260

'Easter Surprise,' *page 253*, PLATE 261
'Engadin,' *page 253*, PLATE 262
'Golden Day,' *page 253*, PLATE 263
'Golden Tango,' *page 253*, PLATE 70
'Jockey Cap,' *page 254*, PLATE 264
'Lemon Giant,' *page 254*, PLATE 265
'Longfellow,' *page 254*, PLATE 75
'Lovely Surprise,' *page 254*, PLATE 266
'Margaret Herbst,' *page 254*, PLATE 267
'Miskodeed,' *page 254*, PLATE 268
'Orange Elite,' *page 254*, PLATE 269
'Orange Toronto,' *pages 254–55*
'Oriental Beauty,' *page 255*, PLATE 270
'Oriental Splendour,' *page 255*, PLATE 76
'Perlina,' *page 255*, PLATE 77
'Pinocchio,' *page 255*
'Plaisir,' *page 255*, PLATE 74
'Quebec,' *page 255*
'Queen Ingrid,' *page 255*
'Red Reflection,' *pages 255–56*, PLATE 271
'Red Riding Hood,' *page 256*, PLATE 69
'Rockery Master,' *page 256*
'Sombrero,' *page 256*
'Sparkling Fire,' *page 256*, PLATE 272
'Sun Dance,' *page 256*, PLATE 273
'Sweet Lady,' *page 256*, PLATE 274
'Tango,' *page 256*, PLATE 275
'Toronto,' *page 256*, PLATE 72
'United States,' *page 256*
'Zampa,' *page 256*, PLATE 276
'Zampa Rose,' *page 256*, PLATE 277

LATE FLOWERING

LILY-FLOWERED GROUP
'Akita,' *page 259*, PLATE 279
'Aladdin,' *page 259*, PLATE 280
'Ballade,' *page 259*, PLATE 83
'Ballerina,' *page 259*, PLATE 80
'China Pink,' *pages 259–60*, PLATE 81
'Doctor Wisse Dekker,' *page 260*
'Dyanito,' *page 260*
'Elegant Lady,' *page 260*, PLATE 282
'Jacqueline,' *page 260*
'Jan van Zanten's Memory,' *page 260*, PLATE 278
'Lilac Time,' *page 260*
'Mariette,' *page 260*
'Marilyn,' *pages 260–61*, PLATE 85
'Marjolein,' *page 261*
'Maytime,' *page 261*, PLATE 86

'Mona Lisa,' *page 261*
'Moonshine,' *page 261*
'Queen of Sheba,' *page 261*, PLATE 84
'Red Shine,' *page 261*
'Sapporo,' *page 261*
'Sonnet,' *page 259*, PLATE 281
'Très Chic,' *page 261*
'West Point,' *page 261*, PLATE 79
'White Elegance,' *page 261*, PLATE 82
'White Triumphator,' *page 261*

PARROT GROUP
'Apricot Parrot,' *page 264*, PLATE 284
'Bird of Paradise,' *page 264*, PLATE 90
'Black Parrot,' *page 264*, PLATE 91
'Blue Parrot,' *page 264*, PLATE 283
'Destiny,' *page 264*
'Doorman's Record,' *page 264*, PLATE 285
'Erna Lindgreen,' *page 264*, PLATE 286
'Estella Rijnveld,' *pages 264–65*, PLATE 88
'Fantasy,' *page 265*
'Flaming Parrot,' *page 265*, PLATE 87
'Glasnost,' *page 265*
'Green Wave,' *page 265*, PLATE 94
'Holland Happening,' *page 265*
'James V. Forrestal,' *page 265*
'Karel Doorman,' *pages 265–66*, PLATE 287
'Libretto Parrot,' *page 266*, PLATE 89
'Onedin,' *page 266*
'Orange Favorite,' *page 266*
'Orangerie,' *page 266*, PLATE 288
'Professor Röntgen,' *page 266*, PLATE 289
'Rai,' *page 266*
'Red Champion,' *page 266*
'Red Parrot,' *page 267*
'Rococo,' *page 267*, PLATE 93
'Texas Flame,' *page 267*, PLATE 92
'Topparrot,' *page 267*, PLATE 290
'Weber's Parrot,' *page 267*, PLATE 291
'White Parrot,' *page 267*

FRINGED GROUP
'Aleppo,' *page 271*, PLATE 96
'American Eagle,' *page 271*, PLATE 292
'Arma,' *page 271*, PLATE 99
'Bellflower,' *page 271*, PLATE 294
'Burgundy Lace,' *page 271*, PLATE 98
'Canova,' *page 271*, PLATE 293
'Crystal Beauty,' *page 271*
'Fancy Frills,' *page 271*, PLATE 295
'Fringed Apeldoorn,' *page 271*

'Fringed Beauty,' *page 271*, PLATE 100
'Fringed Golden Apeldoorn,' *page 271*
'Fringed Gudoshnik,' *page 271*, PLATE 296
'Fringed Solstice,' *page 272*
'Hamilton,' *page 272*, PLATE 297
'Heidrun Harden,' *page 272*, PLATE 298
'Laverock,' *page 272*, PLATE 299
'Madison Garden,' *page 272*, PLATE 95
'Maja,' *page 272*, PLATE 97
'Max Durand,' *page 272*, PLATE 300
'Red Wing,' *page 272* , PLATE 301
'Swan Wings,' *page 272*, PLATE 302

SINGLE LATE GROUP
'Atlantis,' *page 275*
'Avignon,' *page 275*
'Big Smile,' *page 275*, PLATE 106
'Black Diamond,' *page 275*
'Blushing Beauty,' *page 275*, PLATE 103
'Broadway,' *page 275*
'Candy Club,' *page 275*, PLATE 303
'Caravelle,' *page 275*
'Cashmir,' *page 275*
'Colour Spectacle,' *page 275*, PLATE 305
'Cordell Hull,' *page 275*, PLATE 110
'Cri de Coeur,' *page 275*
'Cum Laude,' *page 276*, PLATE 306
'Delmonte,' *page 276*, PLATE 307
'Dillenburg,' *page 276*, PLATE 308
'Dordogne,' *page 276*
'Dreamland,' *page 276*, PLATE 109
'Esther,' *page 276*, PLATE 304
'Georgette,' *page 276*, PLATE 108
'Hocus Pocus,' *page 276*, PLATE 317
'Kingsblood,' *page 276*
'La Courtine,' *page 276*
'Lucette,' *page 276*, PLATE 318
'Magier,' *page 276*
'Maureen,' *pages 276, 281*
'Menton,' *page 281*, PLATE 102
'Montgomery,' *page 281*, PLATE 309
'Mrs. John T. Scheepers,' *page 281*, PLATE 310
'Perestroyka,' *page 281*
'Philippe de Comines,' *page 281*
'Picture,' *page 281*, PLATE 107
'Pink Diamond,' *page 281*, PLATE 311
'Pink Jewel,' *page 281*, PLATE 105
'Queen of Bartigons,' *page 281*, PLATE 312
'Queen of Night,' *page 281*, PLATE 104
'Recreado,' *page 282*, PLATE 313
'Red Georgette,' *page 282*, PLATE 314

'Renown,' *page 282*
'Rosa Listo,' *page 282*
'Sorbet,' *page 282*, PLATE 101
'Sweet Harmony,' *page 282*
'Temple of Beauty,' *page 282*, PLATE 315
'Temple's Favourite,' *page 282*
'Toyota,' *page 282*
'Vlammenspel,' *page 282*
'World's Expression,' *page 282*, PLATE 316

DOUBLE LATE GROUP
'Allegretto,' *page 286*
'Angelique,' *page 286*
'Black Hero,' *page 286*
'Bonanza,' *page 286*
'Carnaval de Nice,' *page 286*, PLATE 111
'Casablanca,' *page 286*, PLATE 112
'Creme Upstar,' *page 286*, PLATE 319
'Daladier,' *page 286*
'Gerbrand Kieft,' *page 286*, PLATE 320
'Maywonder,' *page 286*
'Miranda,' *pages 286–87*, PLATE 321
'Mount Tacoma,' *page 287*, PLATE 322
'Orange Princess,' *page 287*
'Red Nova,' *page 287*, PLATE 114
'Red Princess,' *page 287*
'Uncle Tom,' *page 287*
'Upstar,' *page 287*
'Wirosa,' *page 287*, PLATE 113

LATE-FLOWERING SPECIES
T. acuminata, *page 288*, PLATE 125
T. bakeri, *page 288*, PLATE 324
T. bakeri 'Lilac Wonder,' *page 288*, PLATE 123
T. batalinii, *page 288*
T. batalinii 'Apricot Jewel,' *page 288*
T. batalinii 'Bright Gem,' *page 288*, PLATE 120
T. batalinii 'Bronze Charm,' *page 288*
T. batalinii 'Red Gem,' *page 288*
T. batalinii 'Yellow Jewel,' *page 288, 290*
T. didieri, *page 290*, PLATE 118
T. hageri 'Splendens,' *page 290*, PLATE 121
T. linifolia, *page 290*, PLATE 117
T. marjolettii, *page 290*, PLATE 119
T. orphanidea, *page 290*, PLATE 115
T. orphanidea 'Flava,' *page 290*, PLATE 116
T. saxatilis, *page 290*
T. sprengeri, *page 290–91*, PLATE 129
T. tarda, *page 291*, PLATE 323
T. urumiensis, *page 291*, PLATE 124
T. vvedenskyi, *page 291*, PLATE 325

T. vvedenskyi 'Tangerine Beauty,' *page 291*
T. whittallii, *page 291*, PLATE 122

VIRIDIFLORA GROUP
'Artist,' *page 294*, PLATE 126
'China Town,' *page 294*, PLATE 128
'Esperanto,' *page 294*, PLATE 326
'Eye Catcher,' *page 294*, PLATE 127
'Golden Artist,' *page 294*, PLATE 327
'Green River,' *page 294*
'Groenland,' *page 294*
'Hollywood,' *page 294*
'Hollywood Star,' *page 294*, PLATE 328
'Spring Green,' *page 294*

NEW INTRODUCTIONS
Bearded and Fringed Tulip, PLATE 130
Cabbagelike Tulip, 'Ice Cream,' PLATE 133
Double Parrot Tulip, PLATE 135
Double Fringed Tulip, PLATE 134
Fringed Parrot Tulip, PLATE 132
Fringed Tulip, PLATE 329
Heavily-fringed Tulip, 'Cummings,' PLATE 131

THIEVES
Pink Thief, PLATE 137
Red Thief, PLATE 136

Designed by Mary Shanahan

Published in 1999 by Artisan,
a division of Workman Publishing Company, Inc.
708 Broadway New York, NY 10003

Library of Congress Cataloging-in-Publication Data

Baker, Christopher, 1967–
 Tulipa: a photographer's botanical / by Christopher Baker;
text by Willem Lemmers and Emma Sweeney.
 p. cm.
 ISBN 1-57965-122-4
 1. Tulips—Varieties. 2. Photography of plants. 3. Photography,
Artistic. I. Lemmers, Willem. II. Sweeney, Emma. III. Title.
 SB413.T9 B35 1999
 635.9'3432—dc21
 99-32474
 CIP

Printed in Italy
10 9 8 7 6 5 4 3 2 1
First Printing